JAMES WARREN
EMPIRE OF MONSTERS

JAMES WARREN

EMPIRE OF MONSTERS

THE MAN BEHIND
CREEPY, VAMPIRELLA,
AND **FAMOUS MONSTERS**

A Biography by
BILL SCHELLY

FANTAGRAPHICS BOOKS

EXECUTIVE EDITOR
Gary Groth

EDITOR
Kristy Valenti

EDITORIAL ASSISTANCE
Kassandra Davis
James Ganas
Eric Huberty
Rey Sagcal
Emily Sawan

DESIGNER
Keeli McCarthy

PRODUCTION
Paul Baresh

ASSOCIATE PUBLISHER
Eric Reynolds

PUBLISHER
Gary Groth

This edition of *James Warren, Empire of Monsters: The Man Behind Creepy, Vampirella and Famous Monsters* is copyright © 2019 Fantagraphics Books, Inc. Content copyright © 2019 Bill Schelly. Respective photographs © 2019 Jerry Bails, J. Michael Catron, Jamie Coville, David Lofvers, Sylvia Plachy, and Mike Zeck. All illustrations copyright © 2019 their respective copyright owners. All rights reserved. Permission to reproduce material must be obtained from the publisher.

COVER CREDITS
Photo courtesy of Jean Bails
Enrich Torres painted this Vampirella image from an original sketch by José González.

To order books call (800) 657-1100 or visit www.fantagraphics.com. Follow us on Twitter @fantagraphics and on Facebook at Facebook.com/Fantagraphics.

Fantagraphics Books
7563 Lake City Way NE
Seattle, Washington 98115

ISBN: 978-1-68396-147-5
Library of Congress Control Number: 2018936471
First Fantagraphics printing: 2019
Printed in China

CONTENTS

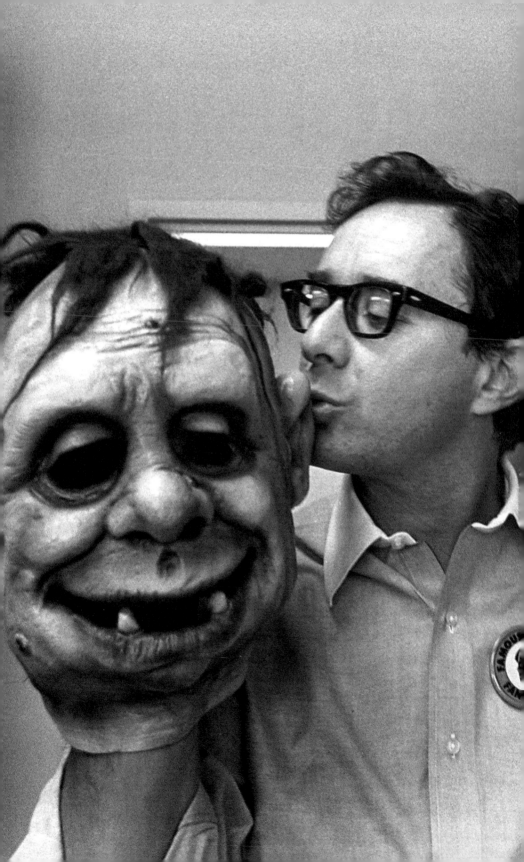

AUTHOR'S PREFACE

JAMES WARREN SUBSTANTIALLY contributed to the history of comics in America, even though he didn't write or draw them. He fostered appreciation of horror and science fiction cinema, although he wasn't a film critic, historian or news reporter. Instead, he made it possible for others to exercise their craft in those areas. He was a publisher. A plaque on his office wall proclaimed, "Someone has to make it happen." Over a span of twenty-five years (1958–1982), Warren fielded such immensely popular and fondly regarded horror-related magazines as *Famous Monsters of Filmland, Creepy, Eerie* and *Vampirella*, as well as *Screen Thrills Illustrated, Blazing Combat, 1984* and others. He published magazines edited by giants of the comics and satire field: *The Spirit* by Will Eisner, popularizer of the graphic novel, and *Help!*, by Harvey Kurtzman, creator of *Mad.* None of these titles would have existed had

Jack Davis art. Opposite: James Warren and friend ca. 1974. Courtesy of Sylvia Plachy.

Warren not had the vision, the resourcefulness and the sheer scrappiness to survive in the tough New York City publishing business.

He was more than merely the man who gave Gloria Steinem her first job in publishing, who put early work by Diane Arbus into print and who gave Robert Crumb's cartoons their first national exposure. He had creative abilities of his own, as an art director, cartoonist and designer, as well as the capacity to understand what fans of comics and cinema wanted to read. He was also a highly controversial figure: a bombastic, self-confessed provocateur loved by some and hated by others. Who was the "real" James Warren? Samuel L. Sherman, a Warren protégé who went on to produce horror cinema, recently observed, "Jim was always a great enigma. I guess he wanted to be mysterious. He didn't ever want his whole gestalt, his whole persona, laid out there on a table."

Not only did he keep the world at arm's length, building a wall around his personal life and inner self, but he promoted an image that was more mythmaking than revealing. Barton Banks, his longtime friend, said, "Half of everything Jim Warren says is absolutely true."

As a biographer, my job is to penetrate that mystery. Therefore, while this book includes a great deal of material gleaned from the relatively small number of interviews with Warren—including two long, previously unpublished interviews, as well as a talk I had with him in 2014—it goes beyond that. In the past two years, I interviewed many of Warren's friends, enemies and colleagues. In addition, my editor and publisher gave me access to a cornucopia of unpublished interviews with Warren personnel and freelancers from twenty years ago—people who have, in many cases, passed away. Among them are Bill DuBay, Archie Goodwin, Al Williamson and Bernie Wrightson. These voices from beyond the grave help convey an unvarnished picture of the man and his operation.

This book isn't a complete history of Warren Publishing, but it does talk about the company in some depth. What he published says a lot about him. Without an examination of the magazines and highlights of individual comics stories, this book would be incomplete. A publisher's legacy is found in the pages of his publications. Attention must be paid to the work itself,

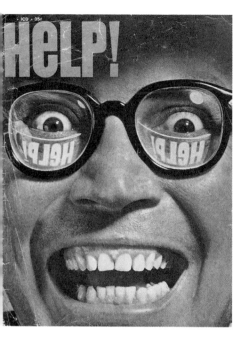
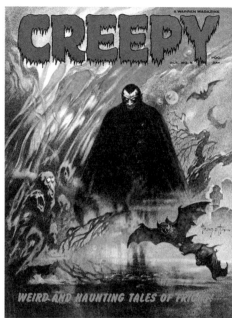
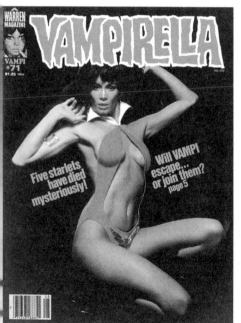

Top: *Help* #5 (1960) featuring Dave Garroway, and *Creepy* #5 (1965) with Frank Frazetta cover art. Bottom: *Vampirella* #71 (1978) featuring Barbara Leigh, and *Monster World* #5 (1965) featuring a Tor Johnson portrait by Gray Morrow.

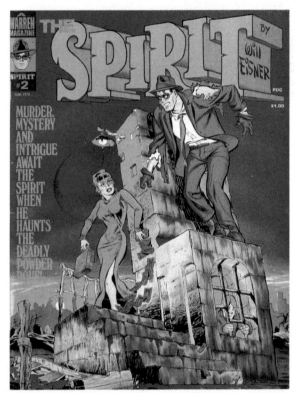

The Spirit magazine #2 (1974). Cover by Will Eisner. Opposite: Goodman Beaver. Art by Will Elder.

and what fine work it is! Consider: Warren published stories and art by more than thirty creative individuals now in the Comic-Con International: Hall of Fame, including Frank Frazetta, the supreme painter of fantasy imagery; Alex Toth, a true genius of comic art; and Wallace Wood, brilliant humorist and the premier SF comics artist. Add to the list top talents such as Neal Adams, Richard Corben, Jack Davis, Steve Ditko, Will Elder, Carmine Infantino, Gil Kane, Al Williamson and Bernie Wrightson, among others. And he gave both Archie Goodwin and Louise Simonson their first jobs in comics.

Warren provided a showcase that DC Comics, Marvel Comics or the other mainstream comic book publishers of the era couldn't, because he chose a format which was outside the purview of the repressive Comics Code Authority. He provided an alternative to super heroes and an island of creative

freedom. *Creepy*, *Eerie* and *Vampirella* consisted of uncensored comics before and after the unbridled underground comics movement was born, briefly flourished and essentially died. Warren Publishing filled the gap between the birth of the Code in late 1954 and the 1980s, when the Code was in substantial eclipse, comic book stores were proliferating coast to coast and Eisner's *A Contract with God* was able to make it onto bookstore shelves.

The crumbling of his operation, ending in the firm's filing for bankruptcy in 1983, is a saga in itself, capped by Warren's Houdini-like vanishing act from public view. Tracing its cause is an important part of this book, as is chronicling his reemergence a decade later. Return he did, to launch a lawsuit to regain control of his literary properties. In the center of the maelstrom was Warren himself, contradictions and all: a feisty man of enormous charm, colossal arrogance, surprising kindness and explosive anger, a man whose career rose to impressive heights, and ended in sudden, shocking collapse. It's the story of a man who survived two major health traumas, one as a young man, and another which brought him low as he reached middle age. But it's more than a tale of a complicated man to love-hate. At its heart, it's the story of a David who took on more than one publishing Goliath, the tale of a determined, talented entrepreneur whose ability to innovate, solve problems and confront threats on a daily basis commanded respect from his employees and competitors alike. Like his music idol, Frank Sinatra, he did it "his way." He was less a maverick than he was an empire builder. Indeed, Warren built an empire of monsters. And who doesn't love monsters?

—Bill Schelly

CHAPTER ONE

THE BOY WHO WOULD FLY

JIMMY WANTED TO FLY. As a toddler, his father and uncles tossed him into the air, from one to the other. "I loved it!" he recalled. "I always knew that when one threw me, another was going to catch me."[1]

When Edmund Goulding's film *The Dawn Patrol* was released in 1938, eight-year-old Jimmy Taubman's love affair with aviation became a boyhood obsession. It culminated in an actual plane ride in a Sopwith Camel when he was nine. "I got on my father's lap and they strapped us in. We went up and I'll never forget it. It was incredible! It was the kind of thing you dream about all your life after it happens."[2] Henceforth, Jimmy's school notebooks were full of drawings of the beloved Sopwith Camel and his other favorite airplanes, such as the Gee Bee. His art ability was first expressed in the margins of those notebooks. Perhaps because he was an only child, his dream involved an activity that he could do on his own. There were people who built the plane, maintained it and helped plan the missions. But when the plane achieved lift-off, the craft was completely in the hands of one person: the pilot.

Jimmy Taubman was the only son of Jewish immigrants, Benjamin and Reba. His father's parents met after coming to America. Henry Taubman was born in Romania in 1874. Fanny, his wife, was born in Russia three years later. They settled in Philadelphia, and had their first son, Samuel, shortly thereafter. Next came David, and then, in 1901, Jimmy's father Benjamin

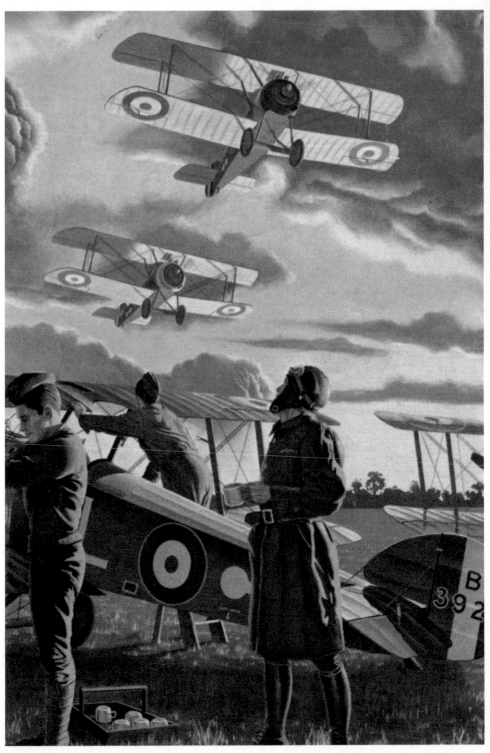

Sopwith Camels are featured in this cover painting by Harold Stevenson for *American Modeler* (March 1959).

Franklin Taubman was born. In the 1930s Federal census, Ben Taubman gave his occupation as "Manager, retail ladies' wear." His brother, David, worked with him. Samuel's calling was in advertising. Ben's sister, Beatrice, became a teacher. Jimmy's mother Reba (b. 1904) and her family (with a total of five siblings) emigrated from Kiev, Ukraine, stepping onto American soil on a dock in South Philadelphia. Due to the massive influx of European and Russian immigrants in the early decades of the twentieth century, boatloads of immigrants who couldn't be handled by the processing center on New York's Ellis Island were sent to disembark on a wharf in Philadelphia, on Washington Avenue. These immigrants initially settled in South Philadelphia, tough neighborhoods where the cheapest housing was available.

James Warren Taubman—called Jimmy until he left high school (and beyond by close friends and family members)—was born on July 29, 1930. The blessed event took place at Mount Sinai Hospital, now the Einstein Medical Center, in Philadelphia. He remembers his family as "very happy. [We were a] very close-knit family. Didn't have much money, but had a mother and father and a lot of aunts and uncles who gave me tons of love and encouragement to be an artist. Every generation in my family produced a professional artist. There were two before me—an uncle and an older cousin.[3]

"I was the firstborn son which in an Italian or Jewish family is a very big deal. My mother and those aunts and uncles surrounded me with tremendous encouragement, applause, support and enthusiasm for whatever the hell it was that I did. If I made a drawing with a Crayola, all five of them would rave about it and tell me how great it was and encourage me to do more. I had all this great support. It gives you great confidence. I thought that I could do anything because they made me feel that way."[4]

Life at home was one of loving indulgence, but the world outside was the opposite. He later said that they lived "in a slum area in South Philadelphia. The area I came from made the Dead End Kids look like the country club set."[5] Life in the schoolyard was tough. In later life, he attributed his pugilistic approach to publishing to that experience. "Some people don't understand until they have a fist in the face. I learned this a long time ago. As a kid in the schoolyard in South Philly, you learn that you would say to a guy, 'Don't

do that—don't push me.' You would be in line and he would push you. My daddy used to say to me, 'Ask them politely three times. If he doesn't do it by the third time, the fourth time with all your energy hit him in the nose. Because the nose bleeds first. He may kill you, particularly if he's three years older than you, but when they scrape you up off the ground and dust you off and send you to the school infirmary, you can bet your boots he will never touch you again.' And my daddy was right."[6]

Jimmy enjoyed the same forms of entertainment as all boys growing up in the late 1930s and early 1940s: newspaper comic strips, comic books, radio and movies. His favorite adventure strip was Chester Gould's *Dick Tracy*, along with Roy Crane's *Wash Tubbs and Captain Easy* and Milton Caniff's *Terry and the Pirates*. He loved the exciting stories, and the art which he tried to copy. He first demonstrated a nascent art ability with those beginning efforts. He especially loved drawing Roy Crane's hero: "God, I wanted to be Captain Easy. I would sit and draw his head profiles when I should have been paying attention to the teacher. I would have given anything for that peculiar hook at the top of Captain Easy's nose."[7]

Jimmy read Superman's debut in *Action Comics* #1, which appeared on newsstands in April 1938, and was mightily impressed by it. He later told interviewer Jon B. Cooke, "Superman to me was like seeing a movie in color for the first time. It was just astounding."[8] It would forever be linked in his brain with a smash hit color movie that came out a month later: *The Adventures of Robin Hood*, directed by Michael Curtiz and William Keighley, starring Errol Flynn and Olivia de Havilland. In the 1930s, moviegoing might be a weekly experience, but radio entertainment was available every day with a turn of the dial. Jimmy listened to many of the radio shows for children, such as *Little Orphan Annie* and *Terry and the Pirates*. These radio serials, usually released in fifteen-minute episodes per day, relentlessly hawked breakfast cereals, just as the popular daily dramas known as soap operas were invented to sell soap and other household products. On October 30, 1938, the Taubman family caught Orson Welles's Mercury Theatre radio adaptation of H. G. Wells's *The War of the Worlds* and, like many others, thought it was a genuine newscast of an actual alien invasion. Jimmy was too young to completely

understand, but recalled that his father was agitated by what he was hearing—agitated, but not frightened. As the grownup Warren would later say, "My father wasn't frightened of anything. He was fearless. He had no fear of heights and he gave that gift to me."[9]

The Dawn Patrol, a movie released in late December 1938, stirred something deep in him. He went back to see the film, which starred Errol Flynn, Basil Rathbone and David Niven, again and again. "As a kid, I built model airplanes because I first saw those planes in the great newspaper strips by Roy Crane and Milt Caniff. *The Dawn Patrol* was my

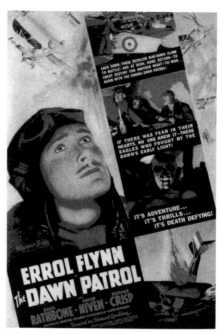

Edmund Goulding's film *The Dawn Patrol* (1938) inspired eight-year-old Jimmy Taubman's love affair with aviation. Courtesy of Heritage Auctions.

favorite boyhood movie. Errol Flynn was the adventurer I wanted to be."[10] Jimmy Taubman loved anything to do with "airplanes, adventurers, Hollywood, Howard Hughes, Wiley Post, Jimmy Doolittle."[11] He always gravitated toward comic strips, comic books, pulp magazines, serials and movies that involved aviation. His favorite among the aeronautical newspaper strips was Zack Mosley's *The Adventures of Smilin' Jack*, which reached its peak in popularity in 1940, when one survey proclaimed that it was the favorite comic strip of American children.

By the time Jimmy was in fourth grade, the Taubmans had moved to the North Philadelphia neighborhood known as Olney. It was a neighborhood not of tenements, but of duplex houses and single-family dwellings. It was a good place to raise children. Many of their neighbors were Jewish. According to writer D. Michaels, "Between 1920 and 1960, the vast majority of Philadelphia's Jews lived in the city, not the suburbs, in actual Jewish

neighborhoods. These were communities tied together by family, business, recreation, education and faith. It was an era of neighborhoods, of belonging, of place. [Growing] up as a Jew in Philadelphia in the decades leading up to and including the middle of the twentieth century [was a] powerful experience."[12] The Taubmans' home was at 1529 Conlyn St. in Olney, consisting of six rooms that rented for $45 a month. On the 1940 federal census, Ben Taubman reported an income of $2,800 in the prior year.

Jimmy began attending Julia Ward Howe School on North Thirteenth Street, nine blocks from home. When his family moved to a nicer abode at 5739 North Park Ave., the grade school was just around the corner. The Taubmans stayed at the North Park address almost to the end of the 1940s. The boy did well in school, and excelled in art class, where his ability to draw and paint set him apart. From the beginning, he achieved special recognition whenever he entered children's art competitions. His desire to be a publisher emerged soon after the move to Olney. He later said he had "printer's ink in my blood . . . since I was eight years old."[13] His earliest known publication was the *Howe School News*: "I was an editor at nine and a publisher at ten."[14] This coincided with the debut of a newspaper feature that hit like a bolt of lightning on June 2, 1940: Will Eisner's *The Spirit*.

Will Eisner's *The Spirit* appeared as a newspaper insert, with a complete story every Sunday. This one is dated August 25, 1940.

He already loved comics, but it was the arrival of Eisner's masterful work about the adventures of the blue-suited crime fighter of Central City that showed him the

artistic potential of the medium. While his parents were reading about the war in Europe on the front pages of the Sunday *Philadelphia Record*, Jimmy was poring over the special, full-color comic book insert (with a complete Spirit story each week). His appreciation and understanding of Eisner's sophisticated, urban-based tales increased through the 1940s.

North Broad Street, a block from the Taubman home, was one of the two main streets of commerce in Olney (the other being Fifth Street, twelve blocks to the east), where the kids from Howe School would go for candy, comic books and fountain drinks after school. The street was dominated by the massive, magnificent Cohen Theatre, built in 1925. At the time, it had the largest one-floor seating capacity—almost 2,000 seats—in the world. There, and at the other theaters nearby, Jimmy spent many a Saturday watching serials such as *Flying G-Men*, *Junior G-Men of the Air* and *Captain Midnight*, and features along the lines of *Dive Bomber* starring Errol Flynn. His other favorite film was *Gunga Din*, which, he said, "Ignited my sense of adventure. It made me want to be a soldier. It also made me want to be Cary Grant, who had one of the starring roles."[15] He would stay at the movie theater all day, forcing his mother to come looking for him. She would walk down the aisles calling his name, thoroughly embarrassing him.

Working as a retail salesman of mens' and ladies' wear wasn't what Jimmy's father wished to be doing, but providing for his family was his priority. Ben Taubman would come home at the end of the day and relax by listening to Enrico Caruso records on the family Victrola. His son's idea of great music was the popular big band music of the day. He particularly loved the Glenn Miller Orchestra and their big hit "In the Mood," which sat atop the American music charts for thirteen weeks in 1940. Movies continued to loom large in his life. He later identified what he called the "three defining films in my youth." The first was *Gunga Din*. Next came Walt Disney's *Fantasia*, which was released in Philadelphia in February 1941. "The color! The music! The fabulous artwork!" The third was *Citizen Kane*. "This picture showed me what talent can do when it's burning bright and focused in the right direction. The great story, the lighting, the visuals, the dialogue! I saw all three movies before I was twelve and they all influenced me creatively for the rest of my life."[16]

In the fall of 1941, Jimmy began attending Wagner Middle School on West Chelten Avenue. At this time, he launched *The Olney Times*, his second publishing endeavor. Using the primitive hectograph gelatin printing process, he made twenty-five copies and sold them to his classmates for two cents each. But even in middle school, Jimmy experienced some tough times: "My father taught me. He'd say, 'Don't judge a man by his success, judge him by his failures. That's the true measure of a man.' Anybody can be a success and be a great guy. But it's the guys who have to pick themselves up off the floor, they're the heroes. And he taught me this at a young age, 'cause I used to have the crap beat out of me when I was a kid. By bigger kids in the schoolyard."[17]

With the Japanese attack on Pearl Harbor on December 7, 1941, America was officially at war. Taubman's middle school years were set against the early part of World War II, when the Axis powers had the upper hand. His father, at forty-two years old, was required to register for the draft. Jimmy's radio was on constantly, bringing him his favorite serials, musical programs and the ubiquitous war news. According to a later interview in the *Village Voice*, "He listened to the radio and longed desperately to fly a P-38."[18] After joining the Boy Scouts and receiving his First Class badge, he became an Air Scout. "When you get to First Class, you could then have a specialty while you were getting your merit badges. In those days, there were only two—Air Scout and Sea Scout."[19] At night, he drew, made airplane models and read comics and pulp magazines until he'd fall asleep. His indulgent parents let him stay up to ten or eleven o'clock, as long as he got up to go to school. "I became a night person. When I wrote stories, drew monsters or supermen, my parents encouraged it."[20]

IN THE SUMMER OF 1944, hormones attacked young Jimmy Taubman. The family tradition was to spend time during the summer at the beach in Atlantic City, New Jersey. That's where he first saw a pretty girl named Gloria Reif. He was fourteen and she was twelve. "I fell instantly and permanently in love with her. Gloria was stunning, with beautiful long black hair that swirled around her face, thick bangs falling over her pretty forehead. We spent our teenaged years together, very much in love."[21] At summer's end, Gloria, who

also lived in Olney, returned to junior high, and Jimmy began his freshman year of high school. Because of his art talent and his interest in pursuing a career in that field, Taubman didn't follow the normal path taken by most of his middle school friends. He applied for admission to Central High School, an elite school that was (and remains) the second oldest continuous public high school in the United States. It stands at the corner of Ogontz Avenue and West Olney Avenue, not far from his house on North Park Avenue.

Central High School alumnus Arnold Roth, the noted cartoonist, recently recalled, "To get into Central High, you had to have maintained good marks, you had to achieve a certain level of scholarship as you approached high school. It was elite, but it was public school. We had more than a few who came from outside the city. They were recommended up from their junior highs. [They] came by subway or bus, like in New York City. I would say that at least half were Jewish. The rest were every race and creed, not just white boys. There were very talented black boys, Italian boys and so on."

It was a diverse environment for the time. "That was one of the things that made it such a great experience. You met boys from every part of the city. It was in a very nice neighborhood. There were open fields. It wasn't an overdeveloped area. There were a couple of tall apartment houses around there, but mostly it was large private homes, with a strip of stores nearby. Bordering to the south was a small US Army armory. During the war, for a long time, they used it to house German prisoners. Some of the Jewish students threw stuff at these German prisoners, so they took the Germans away and put Italian prisoners there. The school building was on a hill. Not a mountain, but a hill. You climbed up a long cement sidewalk. It had huge lawns, and occupied quite a large area, although I don't think the student body of the entire school was more than about two thousand. Looking down on it from above, it was E-shaped. It had a large library, which was privately endowed. The gymnasium was enormous."

Arnold Roth only knew Jim Taubman slightly, because Roth was an upperclassman, two years older. "We weren't in close contact, but we knew each other if we bumped into each other to and from school, or where the big stores were. We would pass a few words, but we weren't close buddies. I knew he was interested in art, and that type of thing."

Central High had an outstanding art instructor: Frederick Gill. "A student with Jim's artistic capabilities would have certainly taken at least one class from Mr. Gill," Roth said. "He was a great teacher who was brilliant. He could explain what was good without being snobbish, whether it was about drawing, about putting pictures together, composition. He would even stay after school, and help students who wanted to stay and work, which you could do. We were so lucky to have such a wonderful teacher." Gill was chairman of the art department, and went on to become a member of Central's Faculty Hall of Fame.

At first, it seems, Taubman continued to have problems getting along with some of the other students. Given how pugnacious he was in later life, it's not hard to speculate that he had a "big mouth" and it sometimes got him into trouble. He put it this way: "I was small. I'm five-foot-nine-inches. But because you're five-foot-nine and you take umbrage with somebody, it's very easy to have the crap knocked out of you." Remembering the words of his father, he echoed, "It's the ability to get up off the floor—the real heroes, the real champions are the ones who get up one more time."[22] Jim may not have been tall, but he was athletic, and played any number of sports through school, although they gradually became less important to him as his other school activities increased.

When the war in Europe ended on May 8, 1945, Taubman was a sophomore. He heard the news of V-J Day (August 15, 1945) when he was in Atlantic City with his family. "I was one of the few guys who was sorry the war ended so soon because I wanted to get into it that badly, even when I was fifteen years old. I wanted to be a part of the history that destroyed Hitler. When you're born under a Star of David and you're a Jew, it's easy to feel that way."[23]

Although his popularity in school was ascendant in his junior year, Jim had no one to talk with about what he called "the great literature of the times," the adventures of Superman and Batman.[24] "I read *The Spirit* by Will Eisner, which formulated a lot of my present thinking. [But] when I was fifteen, I had no place to go, and very few people to relate to when I wanted to indulge in my favorite pastime of talking about comics. Yes, there were always two

or three guys in school, or in the neighborhood, with whom I could have a sporadic talk session on comics. I even had a pen pal in Seattle, Washington."[25] When he got a job working in a newsstand until midnight every day, he had no difficulty absorbing vast quantities of four-color adventure.

The job provided opportunities for literary indulgence and spending money once he learned to drive and wanted to take Gloria on actual dates. Jim and Gloria were going steady, even though she couldn't attend Central High School, an all-boys school until 1983. She attended Olney High School, a nearby sports rival. He nevertheless included her (black bangs and all) in his comic strip in *The Centralizer*, the school's newspaper, of which he was the art editor. The strip was called *Lou Sleef*. At least fourteen episodes appeared during his senior year.

Despite the amount of attention and praise he received at school for his art ability, his father always pushed him to do better. "I was fortunate enough to win most of the prizes in grammar school, middle school and high school. Came in second in the Pennsylvania State Scholastic Art Competition. Second in the state. I remember coming home from school shouting: 'I came in second in the entire state competition!' My father said, 'First would have been better.' My father was a strong motivator."[26]

In his senior year at Central High, Jim Taubman had achieved the status of a "big man on campus." This is obvious from the biography he received in the 1948 *Alma Mater* yearbook:

> Four years ago, Jim set sail on a ship called ambition and since then has landed on an island called success. In Jim, Central finds one of its most popular and all-around students. His popularity was rewarded when he was chosen as Class Secretary, where he has done an excellent job. Jim is equally at home with the bowling ball or a paint brush as can be seen by his presence on the Varsity Bowling Team and in his capacity as Art Editor of the *Record Book* [the yearbook]. It is our sincere hope and belief that "Jim" will scale the heights unattainable by many of us. The 190th class bids fare well to a good fellow.

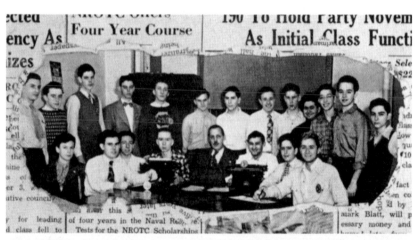

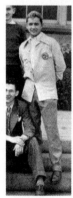

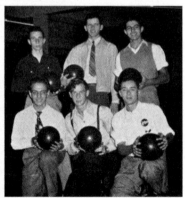

Jim Taubman's days at Central High School in Philadelphia. Top: "Holding Action," one of Taubman's *Lou Sleef* strips from that newspaper. Middle: Seated on the right end of the front row, with the staff of the school newspaper *The Centralizer*. Bottom row, two shots of Jim with his high school bowling team, flanking his senior year portrait. In the group shot, he is front row, right. Opposite: School pin designed by Taubman.

The appended list of his activities is impressive:

> Secretary of the 190th Class, Art Editor of *Record Book*, Art Editor of *Centralizer*, Mirror Staff, Field Days, Varsity Bowling Team, Chairman of Junior Prom Publicity Committee, Freshman Art Club. S. A. Representative, *Centralizer* War Mailing Committee, Intramural Softball team, Second Mention in Annual Scholastic Art Exhibit, 190 Pin Committee, Barnwell Honor Roll.

His design for the class pin depicts a woman drawn in a style resembling that of Will Eisner. He starred in the senior production of *Room Service*, a play which dealt with the difficulties and mix-ups associated with putting on a Broadway production. Taubman, the male lead, was singled out in the yearbook write-up: "Despite the fact that Jim Taubman was running a 103 fever and had a voice two tones above a whisper, the cast performed before a capacity crowd who acclaimed it favorably."[27]

As he approached graduation, it's clear that he had done a thorough job of "picking himself up" after the times when he was knocked down. That resilience would become a defining trait in the coming years, even as the knocks became increasingly daunting and the stakes higher.

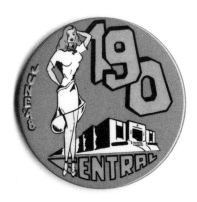

CHAPTER TWO

COLLEGE, MILITARY
AND MAKING A LIVING

A BLAZING SUCCESS in high school, Jim Taubman entered college in the fall of 1948 after a summer which saw the end of his relationship with Gloria Reif. The separation was his idea. "I wanted adventure and excitement," he recalled. "To get married young didn't represent adventure and excitement."[1]

Upon graduation, *The Centralizer* (under his auspices) published an article about the future plans of its editorial staff. Of Jim, it reported, "For two years, Taubman has tickled the funny bone of Centralites with his cartoon, *Lou Sleef*. Taubman has been accepted at the University of Pennsylvania, where he plans to take up interior decorating."[2] Although he was serious enough about this course of study to announce it to the student body at CHS, he never pursued it. His admiration for the work of Frank Lloyd Wright inspired him to study architecture at UPenn instead. (He had other opportunities as well, such as a scholarship to attend Tyler Art School at Temple University in Philadelphia.)

Taubman signed up for the university's Reserve Officers' Training Corps program, which offered college-based officer training for the US Air Force. By joining ROTC, he could receive a scholarship covering all or part of his college tuition, in return for entering active military service after graduation. As an ROTC cadet, he participated in military and officer training, including regular drills during the school year, and would take part in extended training

activities during the summer. He later said, "I was one of only three civilians in my class at Penn. The rest were ex-GIs who were all in their twenties and thirties, and here I was a kid of eighteen. I would sit with wide eyes and listen to them tell war stories, ranging from Omaha Beach, or the Battle of the Bulge, or Anzio, or the Battle of the Solomons or whatever. I used to curse myself for being born three to four years too late to get into that war."[3] He met his lifelong friend Barton Banks on campus. "Jim was a lot of fun," Banks recalled, "a fairly outrageous character. Always with some money-making scheme. There was a time when a bunch of us decided to go to Florida over Christmas break. He wanted to go, but couldn't afford it. To raise the money, he stood on the corner of Broad and Chestnut [in downtown Philadelphia] giving out Scotch tape samples on a freezing day in mid-December, wearing a kilt to attract attention."

The summer of 1949 was made up of fulfilling his ROTC duties and earning money for his sophomore year at UPenn. The nineteen-year-old spent time in Atlantic City, where he generated income by doing unsolicited custom paintings of entertainers performing in the local clubs and restaurants. He would offer the framed paintings to the entertainer or group for a substantial fee. (He claims he never had a turn-down.) It was an early case of Taubman creating a money-making opportunity out of thin air, one that wouldn't have occurred to others.

For his sophomore year, 1949–1950, Taubman continued to live with his folks, who, by this time, had moved to 1054 E. Upsal St. in Olney. He wasn't destined to complete college, or do more than take the introductory classes in architecture, because world events and personal resolve intervened: "I was restless and adventurous. When the Korean War broke out [in June 1950] I volunteered for Armored Infantry Officers Training. I had a good ROTC record at Penn and was accepted right away. I wanted to be the first four star Jewish general. I said goodbye to Penn and hello to Ft. Knox, Kentucky."[4] When he enlisted, he said, "I broke my mother's heart. By God, I was gonna get some war stories of my own."[5] He knew almost nothing about the politics of the conflict, only that his country was at war again. He would later say how odd it was to come from a left-leaning family ("close to the so-called

Communist line"[6]), yet go to war to fight Communism, but this was the height of the Cold War.

Youthful dreams of glory on the battlefield were soon crushed by a devastating personal injury. During a night training operation, he got too close to the .50 caliber end of a heavy machine gun. When he woke up, his ears were ringing and he couldn't hear anything. Some of the hearing came back, but the ringing would stay for life. He was diagnosed with acoustic trauma nerve damage and chronic tinnitus. Taubman was given a medical discharge in early 1951, and told to report to a veteran's hospital for treatment. "By that time," he said, "the ears were not only ringing, they were playing a medley from *South Pacific*."[7] Once the acoustic nerve was damaged, it couldn't be repaired. Moreover, the doctor advised him that his hearing would probably worsen as his life progressed.

"I was scared. It wasn't too much of a limitation per se, but for the first time I knew I was vulnerable. I wasn't Superman. I couldn't do everything I wanted. That took a while to get over. I didn't really get over it—I buried it. It's called denial. I said, 'Not me! I can't hear as well as the next guy but that's not going to stop me. I'll just keep pushing harder.'"[8] But this resolve took time. He was ashamed of his hearing loss, and never told his family how bad it was. His father tried to help him put it in perspective by comparing it to those who returned from the war maimed or in coffins.

This seems to be the event that triggered a split between the face he showed the world, and his inner self, as well as between the inner self he acknowledged, and a deeper truth that he would grapple with for the rest of his life. He was "damaged goods" just as he was coming into manhood. Rather than use the rudimentary hearing aids of the time, he tried to conceal the problem as best he could by relying on what remained of his auditory ability and becoming an expert lip-reader.

When Taubman returned home, he was dismayed to find that his mother had thrown away his comic book collection, which included the early issues of *Action Comics*, *Captain America*, *The Human Torch* and others from the World War II era. He blamed himself, because he had never told her how much they meant to him, and mourned their loss. Depressed, he moped

around the house, unsure of what sort of place he could find in the work force. Returning to college was too much, as he was adjusting to his injury (something that today would be categorized as a form of post-traumatic stress disorder): "The army experience had changed me. I was no longer interested in becoming Frank Lloyd Wright."[9] He compulsively read *Variety*, "to fantasize that I had something to do with show business."[10] Sometimes he thought about going West and trying to train as an animator for Walt Disney. Ultimately, he chose a direction that appealed to his entrepreneurial instincts: advertising.

Encouraged by his uncle Samuel Taubman, who owned an advertising firm, Jim decided to start his own one-man agency. He pulled together a portfolio to show potential clients and began creating new works, such as a drawing that he submitted to *Life* magazine. His spirits were buoyed when that drawing, and the letter that accompanied it, appeared in the April 2, 1951 issue of the popular magazine. His letter read, "Sirs: After studying Artzybasheff's modern man (Speaking of Pictures, *Life*, March 12) I decided *Life* editors could use a few basic changes. Here is my 'Improved Design for *Life* Editors.'" It was signed "James Warren Taubman." Jim's drawing showed an editor with gadgets attached to him to help him perform his job. "Always eager to improve themselves," the editor responded, "*Life*'s grateful editors are considering Reader Taubman's design."

It wouldn't be long before the Jim Taubman Agency, Ltd. had its first client. At the same time, he realized that he needed to hone his skills as an artist and his knowledge of the advertising business. He attended the Philadelphia Museum School of Art, as well as night classes at the Charles Morris School of Advertising. (One source goes so far as to state that he graduated from Charles Morris with a Bachelor of Arts in advertising.)[11] He found that working as a freelance designer suited him. Soon, for business purposes, he made a key adjustment to his firm's name, and his own. Sometime in late 1951 or early 1952, he dropped his last name, and would henceforth be known simply as James Warren. For his business, "The James Warren Agency, Ltd." looked and sounded better. (Warren was a sleeker, more all-American, and perhaps less Jewish-sounding name than Taubman.)

Sirs:

After studying Artzybasheff's modern man (Speaking of Pictures, LIFE, March 12) I decided LIFE editors could use a few basic changes. Here is my "Improved Design for LIFE Editors."

JAMES WARREN TAUBMAN
Philadelphia, Pa.

IMPROVED DESIGN FOR LIFE EDITORS
INCORPORATING THE BASIC VIRTUES OF EXISTING MODELS

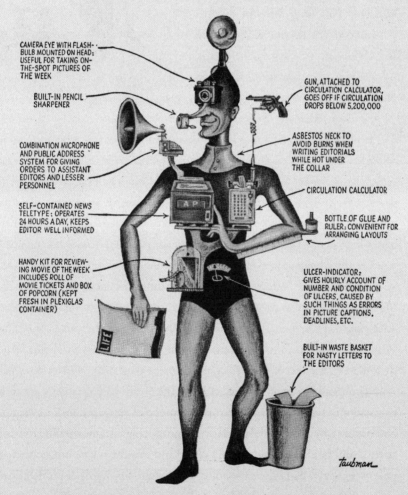

● Always eager to improve themselves, LIFE's grateful editors are considering Reader Taubman's design.—ED.

From *Life* magazine, April 2, 1951.

He continued working with a handful of clients over the next couple of years. By the time the Korean War armistice was signed (July 27, 1953), he was offered an in-house job by his client Caloric Appliance Corporation (a national manufacturer of kitchen stoves) as assistant advertising manager. Not long after he accepted the job, which paid $120 a week ($1,100 in current dollars), he picked up a copy of a magazine that would change his life.

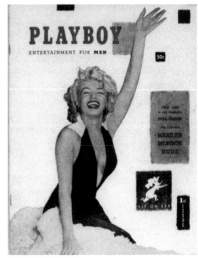

Playboy #1 (1953).

Marilyn Monroe broke out in 1953, when she went from a starlet to a major movie star. Her third movie of the year, after *Niagara* in February and *Gentlemen Prefer Blondes* in August, was *How to Marry a Millionaire*, released on November 5, just as the first issue of Hugh Hefner's *Playboy* (with Monroe cheerily waving on the cover) appeared on newsstands across the country. "If you're a man between the ages of eighteen and eighty," the first issue proclaimed, "*Playboy* is meant for you." Hefner's magazine was especially geared toward men such as Warren: young, on the rise, wanting to become a more modern sort of man than his father. Hefner and Warren had more than a few things in common. Although Hefner was four years older, they were of the same generation. When Warren was finishing his senior year at Central High in Philadelphia in 1948, Hefner was about to begin his senior year at the University of Illinois. (He graduated in February 1949.) They both had a nascent art ability as cartoonists and designers, an involvement in their school's newspapers and other publications and a history of producing amateur publications for friends and family. Hefner was a WASP and Warren a Jew, but neither was observant. Each had big dreams, and was inspired by another publication to create one of his own. For Hefner, it was the *Kinsey Report*, which ultimately led him to decide, in early 1953, to publish a magazine of sexual liberation.

He raised eight thousand dollars from family and friends to get started. He caught lightning in a bottle when he was able to obtain the rights to use the nude calendar photos of Marilyn Monroe, which was the principle reason his first issue sold an astonishing 80 percent of its print run (as opposed to the hoped-for 60 percent). Thanks to ambition, vision and luck, Hefner had hit a home run right out of the box, and was on his way.[12] Warren, in turn, was inspired by *Playboy* the moment he saw it, although it took him two years to act on it.

His energies were, for the time being, channeled into his job writing and designing ads for Caloric, and, as time went on, suggesting promotions. He threw himself into the job, sometimes putting in eighteen-hour workdays. He hired artists, auditioned models and worked with other freelancers. He even appeared in an occasional photo layout. A page in *Caloric Clippings*, the company circular, shows him posing shirtless with a bathing suit model next to a Caloric stove. Warren had a modicum of managerial responsibility, later saying that he was good at working with creative types because he knew they needed space and freedom to do their best work. This understanding served him well in entrepreneurial efforts to come.

HIS SUCCESS AT CALORIC in the mid-1950s is proof positive that Warren had largely adjusted to his hearing loss (and the ringing in his ears, which would never go away completely), with the main casualty being the effect it had on his enjoyment of music. It didn't stop him from an active social life when he began meeting large numbers of people at and through Caloric. He palled around with an older fellow employee named Thacher Longstreth, a wisecracking, bow-tied "blue blood" WASP who would go on to serve on the Philadelphia City Council and run for other offices in later years. With Longstreth, he reportedly dabbled in "a downtown Philly bachelor's life, 1950s-style: supper clubs, martinis, jazz clubs on Sansom Street."[13] It may have been his association with the moneyed Longstreth and his successful cronies, along with encounters with friends from high school who were on their way to careers in law and medicine, that motivated the twenty-six-year-old to look beyond the job at the stove-manufacturing firm.

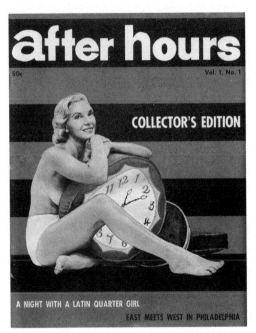

After Hours #1: Warren's "inexpensive replica of *Playboy*" debuted in January 1957.

The position was a good one, but what was initially exciting had, in its third year, begun to pall. It wasn't that he minded the long hours, but how many creative ways were there to sell stoves? They were utilitarian but not inspiring. Receiving incremental raises wasn't leading to the kind of life to which he aspired. As early as March of 1956, he was sending out résumés in search of a better position. It was about this time that Warren began dating a young woman named Phyllis Farkas. She was blonde, vivacious and fun-loving, a good match with his eccentric, energetic personality. Their romantic relationship would last about four years.

Warren was mesmerized by Hugh Hefner's *Playboy*, and, being plugged into the advertising grapevine, he was aware of the magazine's meteoric success. He saw how one man with a vision could make his mark in publishing with little seed money. Stories of Hefner producing the first issue on a card table on a shoestring budget became one of the most ubiquitous "urban legends" in 1950s publishing. Steven Watts, Hefner's biographer, wrote: "One of the great success stories in American publishing, *Playboy* surged upward in 1956 from eightieth place to become the forty-ninth largest-selling magazine in the country, passing *Esquire* in the process and posting a 102 percent gain, the largest in the industry. It had net sales of slightly over $3 million. By the end of 1959, its circulation had climbed to over one million copies a month while total revenue swelled to $5.5 million."[14] Clearly, Hefner had caught a major cultural wave. Imitators proliferated. Titles like *Dude* and

Gent began offering something superficially similar to *Playboy*, which meant including stories and articles in addition to the scantily clad pinup girls and saucy cartoons.

Warren asked himself, "If Hefner could do it, why can't I?" Creating his own version of Hefner's magazine didn't have the virtue of being an original idea, but it did, to the inexperienced Warren, look potentially profitable. Plus, he liked the idea of working for himself. In a certain sense, the decision meant he was going back to school yet again, this time to learn the magazine publishing business from square one. Hence, in mid-1956, while still working for Caloric, he came together with Daniel D. Goldberg, a friend five years his senior, to put together what he later called "an inexpensive replica of *Playboy*." It would be called *After Hours*. Goldberg's father was head of the local newsboys union, and could guarantee the magazine prime space on the newsstands around Philadelphia, including a coveted slot at the big stand in front of the Reading railroad terminal. Barton Banks recalled, "The distributor was All-State News Co., Inc., an outfit out of Chicago. All-State was owned by a man named Ray Kirk. I'm pretty sure Kirk gave Jim and Danny an advance to finance their expenses."

Warren: "I studied how Hefner crafted *Playboy* to make the public like what he liked. He managed to tap into the young readership who shared his vision.[15] The concept of being another Hugh Hefner appealed to me."[16] For a while, he smoked a pipe like Hefner. As an artist, writer and designer, Warren would do as much of the production work as possible. He was credited as editor in chief; Goldberg was circulation director. They named their company Jay Publications.

Warren quit Caloric in early 1957, when the first issue of *After Hours* appeared. The message on the inside of the front cover reads: "Tired? Busy? Can't possibly squeeze in another thing today? Hmmm? We have just the magazine for you. *After Hours* is devoted to the pleasures of the 25th hour, the extra hour of the day that is a necessity to everyone and most especially to you! Your time to relax and enjoy yourself! Forget your ordinary everyday-type problems and just live it up for a stolen hour. The pleasure clock starts ticking as you read this introduction, and by the end of your 25th hour,

you will have experienced picture stories, fiction, humor, exciting features and above all, sheer pleasure!"[17] Among the "picture stories" that it offered were "Photo Album of a Bride-To-Be," "Young Man with a Night Club" and "East Meets West." The short fiction tales have titles such as: "Strange City," "36 Men and a Redhead" and "Whatever Lilia Wants." There were also cartoons, the *After Hours* "Girl of the Month," and the main feature, "A Night with a Latin Quarter Girl."

The budget for *After Hours* allowed an interior printed on slick paper, with no interior color, but only two colors on the cover. It was a reasonably attractive effort, but by the time Warren got his magazine on the stands, they were flooded with a sea of *Playboy* imitations—more than forty in 1957, according to *Time* magazine. None had anything as sizzling as the nude Monroe calendar. The first issue of *After Hours* mostly offered photos of substantially uncovered young women. Just a few nipples were showing. This was enough for Jay Publications to unwittingly invite disaster.

On April 30, 1957, under the headline PUBLISHERS INDICTED ON SMUT CHARGES, the *Plainfield Courier News* reported a story out of Elizabeth, New Jersey, which began, "Publishers of seven magazines, including *Confidential*, along with some fifty individuals, have been indicted by the Union County Grand Jury as a result of a county-wide drive on the sale of allegedly obscene magazines and indecent literature. The other magazines listed include *Caper*, *After Hours*, *Adam*, *Jem* and *The Gent* and *The Dude*. Indictments were returned after a three-month inquiry. In addition to those

Publishers Indicted On Smut Charges

Elizabeth—Publishers of seven magazines, including "Confidential," along with some 50 individuals, have been indicted by the Union County Grand Jury as the result of a county-wide drive on the sale of allegedly obscene magazines and indecent literature.

Leader Orders Pair Turned Over to N. J.

Gov. Leader, of Pennsylvania, on Thursday granted the extradition of two Philadelphia men to New Jersey to answer charges of conspiracy in distributing obscene material.

They are Daniel Goldberg, 32, of Chandler st. near Loretta ave., and James Warren, 27, of E. Upsal st. near Mansfield. The men had been indicted by a Union County grand jury on charges of distributing a magazine in Elizabeth and other areas of the county.

Two Held Here As N. J. Presses Smut Charges

Two men were held in $500 bail each here yesterday for a further hearing on charges of conspiracy in the distribution of obscene material in New Jersey.

Held for reappearance on Aug. 29 before Magistrate Nathan A. Beifel were Daniel Goldberg, 32, of Chandler st. near Loretta ave., and James Warren, 27, of E. Upsal st. near Mansfield.

Left is from the *Philadelphia Inquirer* on August 6, 1957, and right is from the *Courier-Post* of Camden, New Jersey. The headlines weren't an inch high, as Warren later claimed, but they must have looked that way to him.

named in the indictments, more than twenty-five news dealers are mentioned as co-conspirators, but not listed as defendants." After naming the publisher of *Confidential* and *Caper*, it states, "A third indictment relates to Daniel Goldberg and James Warren of Jay Publishing Co. of Pennsylvania."

Warren and Goldberg were also charged in their own state. Banks recalled, "In those days in Philadelphia, there was a Puritan movement called Clean-up, Fix-up, Paint-up, a church sponsored effort to get all this so-called filth off the newsstands." Later, Warren told *Rolling Stone*: "They were busting distributors of all the Playboy-type books and they would have busted Hefner too, if he'd lived in Philadelphia. I happened to be one of the few publishers in town."[18] The indictments were motivated, according to Warren, by local politics, to make the powers that be look good. "That was when I became politically aware.[19]

"I was arrested by the district attorney, indicted, not only in Pennsylvania but in Elizabeth, New Jersey, along with about twenty other publishers, including *Playboy*, and labeled a pornographer. Headlines in the newspaper in Philadelphia were about an inch high. I don't think they had headlines like that since World War II was declared. It took me a while to get over that one. That made me grow up very fast."[20]

Legal developments occurred as *After Hours* #3 (left) and #4 were published. Right: Forrest J Ackerman contributed to *After Hours* #4, beginning a longtime working relationship with James Warren. Art by Robert Keith Murphy.

Banks, who was starting his career as a lawyer at this time, explained, "The magazine was mild [but] in 1957, it and its ilk were shocking to some people. What happened was, in Elizabeth, New Jersey, there was a very ambitious prosecutor named Russell Morse who wanted to become a senator, and he issued warrants for all of the girlie book publishers including *After Hours*, *Dude*, *Gent*, *Nugget*, *Rogue*, *Playboy*—everyone, you name it, including *Sunshine and Health*, and nudist magazines. I was a young lawyer, all of twenty-six, and Jim retained me. If I recall correctly, he was paying me fifteen dollars an hour which I thought was big money." Warren also retained attorney John Rogers Carroll.

Three more issues of *After Hours* were pumped out while the legal situation was up in the air. The fourth issue is somewhat notable for publishing a few photos of Bettie Page, who was a particular favorite of the magazine's editor in chief. It's also the only one with a glimmer of originality, in the form of several features provided, written or ghostwritten by a science fiction (SF) fan and literary agent out of Los Angeles, California, by the name of Forrest J Ackerman. (Although his middle name was James, Ackerman never used a period after the initial.) In his duties as a literary agent, he picked up a copy of *After Hours* and approached Jay Publications about placing material in its pages. Warren liked Ackerman's prose, which was punchy and pun-laden. One piece, titled "Screamoscope is Here!," was accompanied by stills from recent

SF movies (mainly ones with attractive women). He contributed another article, titled "Confessions of a Science Fiction Addict," accompanied by SF magazine covers and stills of scantily clad women from the movies. Ackerman, the Californian, sold Jay Publications a total of five features for $120.

Initial sales of the magazine had not been good, but this influx of new and different material offered the chance for a reversal of fortune. However, Prosecutor Morse succeeded in inducing Pennsylvania Governor George M. Leader to approve the extradition of Warren and Goldberg, and at summer's end, they were compelled to join the large group of other defendants at a trial in Union County, New Jersey. Warren: "[The case] was heard in front of a federal judge who examined it and threw it all out of court. All twenty of the publishers were exonerated. The case was known as *nolle prosequi*, which is a Latin term which means no case whatsoever. It meant that if anyone asks you, 'Have you been arrested?' you're allowed to say no. They expunge your arrest record. They even get your fingerprints back from the FBI. So, in effect, you were never arrested because the case should have never been brought to trial. But before that, I did a lot of heavyweight worrying."[21] The one-two punch of legal problems and poor sales brought about the end of *After Hours*.

For a man who wanted to be Hugh Hefner—rich, successful, respected—image was important to Warren. He imagined all his high school friends reading the headlines describing him as a "smut publisher," and knew they would most likely miss the small piece on his exoneration in the newspapers' back pages. A later profile read, "Though the case was not pressed, the experience drove him into a deep personal depression, during which he would hang out at the schoolyards in South Philly to play basketball with the high school kids. [Warren:] 'I was twenty-seven or twenty-eight years old. I wanted to go back to my youth. After all, an *adult* D.A. had smashed my life.'"[22]

His traumatic hearing loss was the first blow. The pornography arrest was the second. He later said it was one of the low points of his life. He was broke, had no job and the magazine was dead. He didn't want to go back to Caloric. He felt like a complete failure. Then he received a communication from someone who would help him turn things around.

CHAPTER THREE

"WELCOME, MONSTER LOVERS"

IN SEPTEMBER 1957, Forrest "Forry" J Ackerman spent a few days in New York City on his way home from the World Science Fiction Convention in London. He didn't often get to Manhattan, so he wanted to take advantage of the stopover to do a little business (he was the agent for about one hundred authors) and meet some people. One of those persons was James Warren, who had published some of Ackerman's work in the last issue of *After Hours*. Born on November 24, 1916, Ackerman was fourteen years Warren's senior. He grew up in California reading copies of *Amazing Stories* and going to "fantastic" films, his favorite being Fritz Lang's *Metropolis*. In 1932, Ackerman contributed to *The Time Traveler*, a seminal SF fanzine founded by Allen Glasser, Julius Schwartz and Mort Weisinger. After serving in the military at Fort MacArthur, California, during World War II, he occupied himself with his SF hobby while hawking the stories of a growing legion of literary clients, such as Ray Bradbury, Marion Zimmer Bradley and L. Ron Hubbard. In 1953, he was voted "number one fan personality" by the members of the World Science Fiction Society, and given a special Hugo Award.

Ackerman and Warren had developed a bantering relationship over the phone and in letters, so Warren planned a practical joke on the older man when he called on Ackerman at his hotel. Ackerman wrote, "I awaited his arrival in my cubicle (a broom closet that doubled for a room those days)

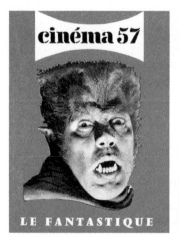
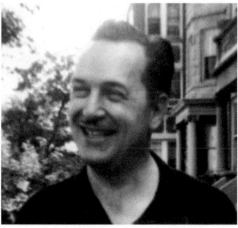

The French magazine *Cinéma 57* inspired the creation of *Famous Monsters of Filmland*. Right: 1962 photo of Forrest J Ackerman. Courtesy of Donald F. Glut.

in the old Chesterfield hotel. Came a knock at the door. I opened it. The scenario . . . was supposed to be that his girlfriend Phyllis Farkas would rush past me, rip open her blouse, throw herself on my bed and start screaming 'Rape!' Warren would be hiding around the corner. Before I could gather my wits, he would come bounding into the room and confront Ack the Ripper. Instead, I ruined everything by intuiting who she was and saying, 'You must be Jim Warren's girlfriend!' at which point Jim jumped into sight."[1]

Before long, Ackerman was eating blueberry pancakes with them at a coffee shop nearby. "I showed Warren the copy of the French [magazine] *Cinéma 57*."[2] Ackerman had purchased a half-dozen copies of the 144-page digest-sized magazine while on a side-trip to Paris. The cover of its twentieth issue (July–August 1957) features Henry Hull in his makeup from *The Werewolf of London* (1934) against a bright red background, with the words "Le Fantastique" printed along the bottom. The entire issue is filled with photos of classic monsters from the Universal horror films of the 1930s and 1940s: Frankenstein, Dracula, The Mummy and so on.

While the dust from the *After Hours* fiasco was settling, Warren was casting around for ideas. One was publishing a one-shot magazine about some sort of popular culture subject. Should it be about Elvis? Marilyn?

Brigitte Bardot? The images of classic monsters clicked with him. Warren: "I had always loved the old Universal horror movies of the 1930s. Being graphics oriented I was struck with the excitement of seeing page after page of these great scenes."[3] He followed trade magazines, and read in *Billboard* and elsewhere that Screen Gems was marketing a package of Universal horror films to local TV stations. He knew that the showing of *King Kong* on WOR's *Million Dollar Movie* in New York City in March of 1956 had drawn an enormous rating. He also was aware that Hammer Films' *Curse of Frankenstein* had been a surprise success at the Paramount Theater in New York when it opened in June 1957.

Warren wondered aloud about the possibility of reprinting *Cinéma 57* in English. Ackerman liked the idea, and urged him to write to Jacques Villeminot, the magazine's Parisian publisher. He did just that, but discovered that an actual reprint wouldn't work for a couple of reasons. First, the photos in the magazine were from disparate sources and would be next-to-impossible to reassemble. Second, the magazine's text was written by and for adult cinephiles. According to Ackerman, "When he had the French translated, he found it seemed much too serious and academic, something that would interest college professors. He figured that in this country monsterism appealed mainly to young people about eight to sixteen."[4] Warren: "My instincts told me the audience for this magazine definitely had to be kids. I knew that kids had that delightful, creative sense of wonder that would attract them to the mystique of monsters in a positive way, just as I had been."[5]

In October, *Shock Theater* debuted on WOR and twenty-six other major TV markets, starting with *Frankenstein* (1931). The ratings were much higher than expected, and suddenly "monster mania" was breaking out all over. Warren was convinced that a magazine version of *Shock Theater* would sell like crazy—but he had to strike while the iron was hot. He pitched the idea to Ackerman, who had already told him that he had a collection of some 30,000 stills from horror, fantasy and SF films, which he'd been amassing since 1929. Would Forry provide the photos and write the text for such a magazine? Ackerman agreed. He even had what he thought was the perfect title: *Wonderama*. It wasn't exactly the monster magazine that Warren envi-

sioned, but it was close enough that he asked Ackerman to prepare a simple mock-up for him to show potential distributors. To accompany Ackerman's sample, Warren prepared presentation materials which included the brochure that Screen Gems used to promote its *Shock Theater* program to potential TV stations. As with any new idea, though, getting someone else to believe in it was an uphill battle. Warren, who had been in sales and advertising since his medical discharge, could be persuasive, but was unable to get any of the distributors interested in *Wonderama*.

Part of the problem was timing. The magazine industry was still in turmoil after the giant American News Corporation closed its wholesale periodical division in May of that year. This left major magazines such as *Time*, *Life*, *Look*, the *New Yorker*, *Vogue* and *Mad* scrambling to secure distribution, not to mention numerous second-tier publications that needed new homes. Warren found it difficult to get a distributor to pay attention to a fledgling publisher with an idea for what looked like a rather preposterous one-shot. There were also underlying financial issues. He not only needed a distributor who thought the magazine would sell—he needed one who would work with him on a credit basis. That is, he needed the distributor to indemnify the printer from loss, if the printer extended him credit and printed the magazine in advance of being paid—just as he had done with *After Hours*.

His confidence in the idea remained high, but he was stymied until *Life* magazine came to the rescue on November 11 with a prominent, two-page spread about the monster craze under the banner, "Ghastly Look at a Film Fad." When it came to the attention of the people at Kable News (stories vary regarding whether Kable saw it and called Warren, or vice versa), they had to admit that he was on to something. But the name *Wonderama* would have to change. They told him to invent a new title with the word "monsters" in it, and they would handle the magazine on a credit basis. But, according to Warren, he needed another nine thousand dollars to go forward. He told the story this way:

> I walked into a bank in Philadelphia to plead for a loan. I said, "I'm
> not going to tell you anything about the magazine but I need this

loan." The banker said, "For collateral, you'll pledge your printing presses and your equipment. We require that as collateral against the loan." I said, "My entire equipment list consists of a typewriter, two yellow pads, a drawing board and me. I have a distributor, an idea for a magazine and I have a printer but I need nine thousand dollars." I told him I wasn't going to leave the bank without the money. I must have sounded threatening because I got the loan.[6]

Barton Banks recently said he was highly skeptical of this bank loan story. "I was Jim's financier and silent partner for what became *Famous Monsters of Filmland*, although he's never told anybody. He started that company with $2,000 that I borrowed from my father, and loaned to the corporation. I handled the incorporation of the company, and I was his partner for two years. Later, downstream, he might have had lines of credit at a bank, I don't know, but not at the beginning."

In any case, the one-shot was on. An ebullient Warren phoned Ackerman with the good news. Ackerman's excitement subsided a bit when he heard about the new title and emphasis. "I, rather than being flattered, was somewhat flattened," Ackerman said, "because I wasn't quite as enthusiastic about monsters. Nevertheless, I went along with the idea."[7]

Warren offered Ackerman $400 ($200 to start the job, and $200 upon completion), a new electric typewriter and one hundred copies of the issue, to write the copy and provide the movie stills to fill the pages of the yet-to-be-titled monster magazine. Also, according to Ackerman, the publisher promised a percentage of the profits. Could Forry drop everything to rush-produce the magazine? Time was of the essence, as no one knew when the monster bubble would burst. Warren would fly out to work with him on it over Thanksgiving week. Ackerman agreed with the plan, and would pick him up at the airport.

Ackerman was living in a house at 915 S. Sherbourne Dr., in Los Angeles. The two-story Spanish-style home, dubbed the Ackermansion, had thirteen rooms and a large garage that housed the overflow of his vast collection of movie memorabilia. When he met Warren at the airport on November 20, he had no idea that the publisher had boarded the plane in Las Vegas,

after taking the bus most of the way to save funds.[8] Creating the impression of a successful publisher would be an ongoing *modus operandi* for Warren throughout his life.

Soon, they arrived at Ackerman's home. Warren: "Twenty minutes after I walked into his living room I knew that this man—this six-foot-one Vincent Price look-alike—was the only person in the galaxy who could write the text I wanted for the magazine envisioned as *Famous Monsters of Filmland*."[9] Ackerman cleared off his dining room table, and the two of them began a process that continued virtually nonstop for the next week. "[I] blazed away twenty hours a day," Ackerman recalled. "I would turn out copy till three or four in the morning. Then we would drive over three blocks to Ships 24-hour restaurant for orange juice, hotcakes, bacon and coffee, after which I left Jim off at a nearby motel, went home to bed and four hours later picked him up again and we were off again."[10] Warren's part was principally to review Ackerman's work as it rolled off his typewriter, and make sure it was the "magazine version of *Shock Theater*" that he'd promised Kable News. He directed Ackerman to write in a humorous style calculated to make an eleven-year-old boy laugh. The writer hadn't intended any such style for *Wonderama*. "But," he said, "Warren set the policy from the start, or perhaps it could even be said to have originated with the distributor. However, since I exercise my funny bone regularly and am not above cracking a pun on rare occasions, it was not too difficult for me to conform."[11] A consummate professional, Ackerman seems to have had no problem being funny while his wife at the time, who was giving him "hell in my own home," was meeting with lawyers to draw up divorce papers.

When Warren waved goodbye, he had everything he needed to put the magazine together except for a cover and the introduction he'd hoped to wangle out of humorist Stan Freberg, through Ackerman's friend Ray Bradbury. (Freberg wasn't interested.) Equally important, the meeting gave them the opportunity to become better acquainted. Since Warren was a movie fan, and had more than a little of the fan mentality (such as hero worshipping his idols), there was a fair amount of common ground between them. Warren returned to his family home (where he lived until he moved to New York

City, a few years later), and, in the early days of December 1957, began organizing Ackerman's text and photos. Forrest Ackerman has been—understandably—considered the editor of the magazine because he is listed as such on its masthead, but the truth is that Warren was the editor in most respects. The concept of a monster magazine for eleven-year-olds was his, as were the final selection of the contents, the letter columns and the basic layouts—although he hired George Frenoy and John Watko to physically paste everything up on art boards for the printer. (They are credited as art directors.) Ackerman had nothing to do with the magazine's title.

For a brief period, it seems, the one-shot was named *Monsters of Filmland*, which is how it is billed in perhaps the first advertisement for it, which appeared in the May 1958 issue of *Galaxy* magazine. After the ad was prepared in December, Warren suggested the more alliterative *Fantastic Monsters of Filmland*. Kable counter-suggested *Famous*, and specified that the word *monsters* be dominant. (Warren sketched the logo on a napkin, then and there, which was very close to his design for the finished version.) Warren conceived and designed the all-important cover. He persuaded waitress Marion Moore to wear a low-cut black gown and pose next to Frankenstein's monster, or, rather, Warren wearing a Frankenstein mask. (In the photo, the mask appears to be much touched-up by an artist, probably Warren himself.) The monster is wearing a suit and ascot, looking ever-so-much like "the kind of man who reads

ATTENTION MONSTER LOVERS!

DO YOUR FRIENDS THINK YOU'RE A MONSTER?

Then hurry out and get a copy of **MONSTERS OF FILMLAND** magazine, a fascinating collection of photos & features on Hollywood's most famous fiends. Horrific and hilarious! Frankenstein himself recommends **MONSTERS OF FILMLAND** 35c at newsstands, or mail 50c to Monsters, 1054 E. Upsal St. Phila. 50, Pa. Sent prepaid.

Ad in *Galaxy* magazine (May 1958). The title of Warren's publication had not yet been finalized.

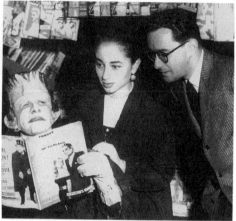

Famous Monsters of Filmland #1 (February 1958), with publicity photo of Warren and a young fan in makeup.

Playboy." It was a tribute, of sorts, to Hefner. Under a reproduction of the cover on the title page, the caption reads: "Our Ivy-League Frankenstein is unhappy because his ghoul friend Marion Moore insisted that he dress for dinner, and poor Frank had to clean all the skeletons out of his closet to get to the clothes."

The first thing one encounters inside is a full-page message from "the editors" (written by Ackerman). Under the heading, "Welcome Monster Lovers," it began, "You're stuck! The stuff this magazine is printed on, which looks so much like ordinary black printer's ink, is actually glue. YOU CANNOT PUT THIS MAGAZINE DOWN! Try as you may to struggle, it is impossible: like a zombie, you have no will of your own. For this unique magazine bears the fatal fascination of beauty for the beast, of monsters for maidens fair and monster-makers unfair." The table of contents lists articles such as, "Monsters are good for you," "Alice in Monsterland," "The Frankenstein Story," "How Hollywood Creates a Monster," "The Scream Test" and, to round out the issue, the "Monsterama Quiz." The issue featured large, sometimes full-page photographs of all the monsters from the classic Universal movies, including silent movies such as *The Phantom of the Opera* and *The Hunchback of Notre Dame.* All the major monsters were there: Frankenstein's monster, Dracula, the

Mummy, Dr. Jekyll and Mr. Hyde, the Wolf Man, et al., as well as monsters from recent films, such as the creature from *The Curse of Frankenstein*, and Leo G. Carroll from *Tarantula*. It included a two-page excerpt from Harvey Kurtzman and Will Elder's Frankenstein satire in *Humbug* #7, which was being readied in mid-December. The magazine's indicia stated that it was published and copyrighted by Central Publications, Inc. (echoes of Central High School), and gave Warren's home address as the location of its editorial office: 1054 East Upsal St., Philadelphia, Pennsylvania.

Famous Monsters of Filmland #1 is sixty-eight pages, all black and white except the covers. The paper isn't the slick stock used for *After Hours*, which Warren had initially wanted, but an average magazine-grade newsprint. On p. 66, below an appeal for letters, is the final line: "A particular debt is owed to Phyllis Farkas, whose haircut inspired the entire project.—J. W." It was an in-joke, based on Warren describing her new hairdo as "monstrous." Thus began his practice of putting his girlfriend into the magazine.

While assembling the magazine and readying it for the printer, his mind whirled with 1,001 ways to promote it. He arranged for color slides of the finished cover to be sent to all the TV stations running the *Shock Theater* package, hoping for them to show the cover on the air. He prepared packages for all of Kable's wholesalers (the people who put the magazines on the racks in various regions of the country) which included a color proof of the cover, and a letter advising them that the magazine had a humorous bent. He promoted a "My Favorite Monster" letter-writing contest for high school students (by placing announcements in high school newspapers across the country) which required them to buy the magazine in order to enter. He arranged for publicity photos to be taken at Philadelphia newsstands with "monster fan Fran Kenstine" in full Frankenstein's monster makeup and costume. It was Warren in P. T. Barnum mode, claiming to have tested the magazine with educators and doctors, to make sure it was appropriate for children. Then he was informed that Kable News had decided to reduce the print run from 200,000 to 150,000 copies. Arthur Ainger, an assistant to Kable's president, "discovered an article in his local newspaper which predicted the monster craze had peaked, and warned his boss '*FM* wouldn't go over as big as anticipated.'"[12]

Famous Monsters of Filmland went on sale February 27, 1958, in the middle of the worst snowstorm of the year. When the magazine was released, "Come Fly with Me" sung by Frank Sinatra was topping the charts, which, given Warren's hope that his new project would take flight (and his love of air travel), he could only take as a good omen. However, almost immediately, problems with the magazine's printing and distribution began to crop up. He learned that a number of wholesalers were refusing to take the book because they judged its printing inferior. He demanded a $3,000 settlement from Neo Gravure Printing Company of Weehawken, New Jersey, who had done the job. Then, in his own home town, he discovered that United News, the local wholesaler, had failed to distribute 2,000 copies of the magazine, which he found in bundles in the back of their warehouse. Warren fired off a letter to Kable News:

> Hell, I didn't take a wild guess on the monsters. I knew damn well that TV was lining up the industry for a horror kick, and that Hollywood would follow close behind. I honestly can't tell you how lousy I felt when I found out about this situation in my own home town. It took the starch right out of me. I'll be damned if I want to keep investing dough in a title that could sell like hell were they to put it out properly. I'd rather put my marbles in something I can keep on top of. I know I'm nobody in the publishing field, but if a couple other established publishers keep getting the same kind of deal, the industry is going to take a nose dive from the shortage of young blood, together with a continuing popularity of TV to keep people's noses out of magazines and glued to the screen in their living rooms. It's coming, sure as hell.[13]

Despite the inclement weather and other problems, when sales figures began coming in, it turned out that 90 percent of the print run had sold, an extraordinarily high number for any magazine. It sold so well that Kable went along with Warren's request to go back to press as soon as possible, to get more copies on the stands.

The second printing of *Famous Monsters of Filmland* came out about May 1, 1958, but sales of the additional 117,305 were weak. It didn't seem to indicate a lack of interest in the magazine. But, merely, that the moment had passed. It confirmed the conventional wisdom; timing is everything. Going back to print isn't worth it. The mistake had been Kable's decision to cut back from the original 200,000 print run. But even though Warren ended up paying back much or all of the advance he'd gotten for the second printing, it was clear there was an audience for the magazine. The first printing sold amazingly well, and his appeal for letters had resulted in a massive influx of mail, most of it clearly written by children. All were enthusiastic. Warren: "Although I had conceived it as a one-shot, I saw that we had a well-defined market out there . . . an untapped gang of young kids that viewed the monsters and themes we were producing as good things, not bad things, not evil. The monster became the protagonist."[14]

Everything Warren did, and sacrificed, to bring the magazine into the world will never be known. A few years later, in an article recounting what he had gone through to get *Famous Monsters* going on very little, he wrote (referring to himself in the third person): "Somehow the publisher found a distributor. Somehow, he managed to talk a printer into giving him credit. Somehow, he talked an editor into trusting him for the payment for writing the mag. Somehow, he pasted up the issue himself. And somehow, the issue hit the stands. All this was accomplished without outside (or investment) money. It meant that the publisher had to sleep in bus stations during the night on his trips to New York City distributors. It meant that coffee and Hershey bars had to substitute for lunches and dinners. It meant a hell of a lot of other things that hurt—especially when you're in your twenties and most of your contemporaries are holding down respectable jobs and drawing respectable salaries."[15]

Getting the magazine on the stands had been difficult, but there was one high point of the launch that made it worthwhile: "The soaring high point for *FM* for me was that beautiful, bright, shining moment I saw our first issue prominently displayed, full cover, right next to *Time* magazine, at a major newsstand at 42nd and Broadway—'Crossroads of the World'—in

New York City. Word had gotten out to the newsstands that *FM* was a hot smash hit one-shot magazine, and the newsstand venders were all displaying it full cover, up front. Everyone should have a chance at a breathtaking piece of sublime happiness at least once in their life. This was mine."[16]

MOST ACCOUNTS of the publication of the first issue of *Famous Monsters of Filmland* state that it was a meteoric success, gave Warren a financial windfall, and set him up as publisher of an ongoing, highly profitable magazine. The reality was a lot more complicated, due to problems with the printer, certain wholesalers and Kable News itself. It was the beginning of a bumpy relationship between Warren and Kable, one that was fraught with angry phone calls, accusations of betrayal and suggestions of underhanded dealing. When Ackerman asked about the promised percentage of profits on the first issue, Warren had to admit the truth: in the aftermath of the ill-advised second printing, about all he could do was take care of all the outstanding obligations. How was that possible, Ackerman wanted to know, when the magazine sold 90 percent of the printed copies? Warren blamed Neo Gravure, who he said charged four thousand dollars too much for the printing. (This may relate to the poor printing quality of part of the press run.) He also conceded that he had "a lot to learn about the magazine publishing business."[17]

Warren was discovering there were many ways potential profits could "fall through the cracks," because of how the magazine distribution business worked. The payment that the publisher received was based on the number of copies that were shipped from the distributor to wholesalers across the country (who put the magazines on the retail racks of their customers), less the number that were returned unsold (which were supposed to have the top third of the front cover torn off, to prevent resale). But, because publishers had to accept the sales figures provided by the distributor, they were vulnerable to being cheated and had no recourse. Distributors could and did sell copies of the magazines "off the books," for which the publisher received nothing. (They were reported as "undistributed copies.") But they were able to get away with it, because they catered to the most undercapitalized publishers (such as Warren).

Still, between the two printings, at least 150,000 kids had snatched up copies of *Famous Monsters* #1, proving there was a market. Warren declared his desire to continue the title as an ongoing, quarterly magazine. Was Ackerman up for it? Warren needed him, because the whole enterprise was built around the man's collection of movie stills. All he could offer at this time was an increase of Ackerman's editorial fee from $400 to $725 for the second issue, and a promise that it would eventually reach four figures. He also dangled the possibility of publishing an SF magazine with the Californian as editor—Ackerman's dream—once *FM* was established and solidly profitable. Ackerman agreed.[18]

Famous Monsters of Filmland #2 was scheduled for a fall 1958 release. The omens continued to look good. TV stations were lining up to run Screen Gems' "Son of Shock" package consisting of twenty more classic Universal horror films. The second issue was much like the first one. Once again, Warren posed behind a monster mask, this time by himself, holding a sign announcing "2nd Great Issue—First issue sold out!" It welcomes readers with giant headlines, stating: "Don't look now, but a monster is reading this magazine!" Then, in print below, "No, the Monster is not over your left shoulder. Nor it is anywhere behind you. It is, in fact, YOU!"

Ackerman came up with more pun-laden, jokey articles such as "Monsters are Badder than Ever," "Girls will be Ghouls," and "Public Vampire #1," accompanied by movie stills and other photographs of Lon Chaney Jr. as The Mummy and The Wolf Man, James Cagney as the Phantom of the Opera (from the movie *Man of a Thousand Faces*), Boris Karloff as Frankenstein's monster and Fu Manchu, Bela Lugosi as Dracula, and more. The "Monsterama Quiz" was back, and there was "Terrorvision," a piece about the *Shock Theater* program and local horror hosts, with a photo of John Zacherle as Roland on WCAU Philadelphia, as well as other such hosts around the country. It also reprinted a couple of pages from *Mad* which, influenced by *Famous Monsters* #1, ran a feature called "Son of Thing" drawn by Wallace Wood. (This may have been the occasion when Warren made friends with William M. Gaines, publisher of *Mad* magazine.)

The letter column included a missive from Ackerman's literary client Robert Bloch (author of the book *Psycho*), which reads "Congratulations on

a terrific job . . . a real Valentine from start to finish." The other letters were equally rhapsodic, except for one. It was from Richard A. Lupoff, a prominent member of SF fandom: "This magazine is being discussed hereabouts as 'Ackerman's Folly.'" It reflected the negative view that many older readers had, since the text of the magazine was clearly geared for a much younger audience, and particularly stung Ackerman because it came from a member of fandom. Warren responded to Lupoff in the magazine: "Editor Ackerman personally received over 700 letters from monster-lovers all over the world, praising him for his great piece of work on our first issue. He received only *one* letter (above) of the sour-grapes variety, from a reader who is obviously familiar with Ackerman's reputation as America's Number One Science-Fiction Fan, and who obviously disapproves of *Famous Monsters of Filmland*. Oh well, as Frankenstein said to the skeleton, 'to each his bone.'" The "700" figure for the letters was probably, like many of the figures Warren would provide in the coming years, more a symbol to make a point than an accurate number, although the response was certainly substantial and the letters were overwhelmingly positive. The bottom line is that the magazine wasn't for the Lupoffs of the world, although plenty of adults enjoyed it. It was for kids.

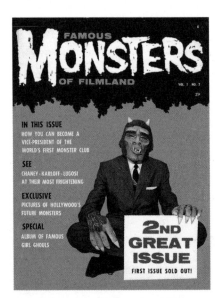

Famous Monsters #2 (October 1958).

New in the second issue is a section called "Monster Mail Order," with the accompanying text: "In answer to the thousands of readers who would like to have their own monster masks and other monster items, *Famous Monsters of Filmland* has created a mail order department—featuring exciting items for all monster-lovers at low cost." A shrunken head, a monster hand, a talking skull and Dracula teeth were among the initial offerings. The monster masks were the highlight, leading off with Frankenstein, and

the Screaming Skull. Each cost a mere two dollars. Copies of the first issue were offered for thirty-five cents. Another income-producing idea was the Famous Monster Club. "Hey gang," the full-page announcement began, "Here's what you've been waiting for. Here's how you can become a vice-president of the all-new Famous Monster Club. Monsters of the World, Unite! Join the only club in the world OF the monsters FOR the monsters BY the monsters!" For seventy-five cents, one would receive a membership card, badge and certificate, and a free five-line ad in an upcoming issue. Over time, the FM fan club would become an important ongoing aspect of the magazine, with photos of many members (nearly all eleven-to-fourteen-year-old boys), makeup contests, prizes for the best letters and so on. The club announcement was followed by an ad for subscriptions to the magazine at the rate of $2.00 for six issues, a savings of ten cents for the reader. Taken together, the subscriptions, products and fan club generated a much-needed cash infusion. Mail order sales of *FM* #1 would be especially profitable, since those customers paid full price directly to Warren, much more than the small per-copy price he got from newsstand sales through Kable News. (He acquired several hundred undistributed copies of each issue from an unidentified source.)

To earn still more in 1958, Warren produced, with Barton Banks, the "Rock & Shock Spooktacular," a program in local theaters featuring live music in person from Frankie Avalon, Bobby Darin and other less recognizable names. It was emceed by John Zacherle. There were interludes with actors portraying Frankenstein's monster and Igor. Banks recalled, "We did three shows a day in eight Stanley Warner theaters over a ten-day period, clearing the house after each show by telling the teenagers that Frankie Avalon and Bobby Darin would be signing autographs in the alley, which was just a ruse. This was before Bobby had a huge hit with *Mack the Knife*. After that, we never would have been able to afford him. We paid him $250 for a total of twenty-four performances. Jim and I had to split a mere $800 for our effort, although he was also able to sell copies of *Famous Monsters* in the lobby between shows."

Banks added, "One day, when I was working in my father's law firm, his receptionist came in and blurted that she'd gotten a phone call—the actor

James Warren and Barton Banks partnered to produce the Rock & Shock Spooktacular show in 1958.

playing Igor had been arrested for exposing himself to an audience member! My father turned to me and gasped, 'What the hell are you guys doing?'"

Warren eagerly awaited sales reports on *Famous Monsters of Filmland* #2, which went on sale shortly before Halloween. Kable had printed 200,000 (again using the Neo Gravure company, and who assured printing problems would not occur again). Everyone was optimistic, but when the reports began to arrive, they were disappointing. Of the print run, only 94,000 copies were sold, for a percentage of 47 percent.[19] This meant the issue would, at best, barely break even. Once again, another issue failed to provide the profits

from newsstand sales.[20] Fortunately, monies began coming in for the fan club, subscriptions and merchandise.

Warren attributed the low sell-through to the appearance of a couple of *FM* copycats. One was *Monster Parade* (cover-dated September); the other was *World Famous Creatures* (dated October). He was upset that anyone would try to cash in on a successful magazine that he had invented. What was even worse, *World Famous Creatures*, the most egregiously imitative of the two, was distributed by Kable News! Warren stormed into the Kable News office shouting that he had an exclusive contract. They informed him otherwise. The distributor couldn't have been happy with Warren when he filed a lawsuit against the publishers of *World Famous Creatures*, but they wanted to hold onto *Famous Monsters of Filmland*. According to Ackerman, "Warren sued *World Famous Creatures* for what was outrageously, demonstrably plagiarism, but a myopic judge couldn't see the facts before his face."[21]

Due to the delay in getting the sales figures on *FM #2*, work on the third issue was well along when news of the poor sales hit. Warren pushed ahead. He continued his practice of producing the cover on his own, eliminating the cost of a photographer by personally painting the cover (based on a file photo): a portrait of Lon Chaney as the original Phantom of the Opera, who, probably more than any other monster, became the "signature" face of the magazine. He insisted on a change of printer on *FM #3* to save money.

The third issue was the first to list Phyllis Farkas as the tongue-in-cheek "Man Aging Editor" on the masthead, which was almost certainly more than merely a title. Someone had to go through the mail, keep the subscription lists and do the other clerical work involved. Warren did much of it, and recruited family members and friends to pitch in. If you were going to spend time with him at this point in his life, he put you to work.

His fertile imagination hatched gimmick after gimmick to promote reader loyalty and raise cash: contests, special offers and pages devoted to the fan club which required a tremendous amount of work. He tried to interest advertisers to bring in further revenue. It didn't work. "Advertisers laughed at me when I told them I had a magazine that would appeal to a young audience. They thought it was weird. Awful. Decadent! Frankenstein, Dracula,

the Mummy, The Wolf Man—that's awful for young minds! After the third or fourth humiliation, I stopped trying to convince them they were wrong."[22]

Therefore, he concentrated on expanding his line of mail order merchandise. Before it was Captain Company, the business was conducted under the name General Promotions Co., which was a wholly owned subsidiary with a post office box address in Philadelphia. Warren: "The mail order business was first run out of my parents' house in Philadelphia. Every evening after dinner, my mother, my father and I would sit at the dining room table and open envelopes with orders from our readers for . . . monster merchandise. We often worked past midnight. I would then personally wrap and mail the orders the next day. Between editing and publishing the magazine, and running [General Promotions], I worked fifteen-hour days, seven days a week."[23] There were items he produced himself, such as "Monster stationery," and some were items that fit the magazine but were obtainable from overstock houses for pennies on the dollar, like copies of the 3-D comic book *The House of Terror* which had been published in 1954 after the 3-D comic book bubble had burst. Over the next several issues, the number of pages devoted to ads for mail order products increased.

Banks recalled, "My first wife, Carol, would go over to pick up the receipts. We would get envelopes in with coins scotch-taped. She would come to the door at 2 or 3 o'clock in the afternoon at his home, 1054 E. Upsal, and ring the bell. Jim would come down in his jockey shorts, open the door, and say 'Hi, Carol, come on in,' and he'd hand her the overnight bag that she would take to the bank."

Soon, he could no longer operate out of his family's home. In late 1959, Warren rented space at 1426 E. Washington Ln. for his office and merchandise. "Office space and warehouse space in New York was too expensive. I couldn't afford it. So, I had this inexpensive real estate space in Philadelphia, which we paid about $200 a month for, for a total warehouse and office."[24] As soon as possible, he wanted to move his editorial offices to Manhattan, but the merchandise operation would stay in Philadelphia. "Had we had that in New York, it would have cost $2,000. That was the reason for keeping it divided. It was tough on me because I did a lot of traveling back and forth."[25]

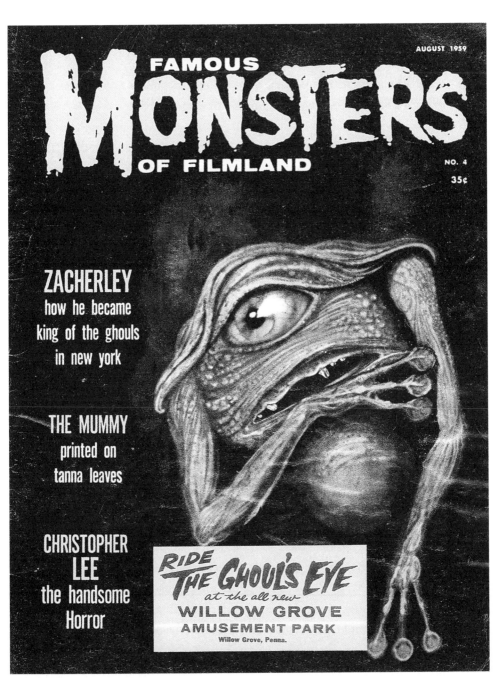

Famous Monsters #4. Art by Albert Nuetzell.

His working relationship with Ackerman was never without turbulence. They bickered over money, and they disagreed about the contents of the magazine. When Ackerman's client Albert Nuetzell was recruited to paint the cover of *Famous Monsters* #4, Warren was only able to pay him seventy-five dollars, which incensed Ackerman, who had expected $200. Warren had to get on the phone and quickly smooth things over, promising to pay Nuetzell $100 for the cover for the next issue, a portrait of Bela Lugosi. But he couldn't pay Ackerman the $1,000 that he wanted to do *FM* #5, forcing the writer to settle for a raise to $850 for the time being.

After receiving Ackerman's material for the fifth issue, Warren wrote, "I had to nix certain articles. Let us consider them. 'Field of the Future': look at the seven pics and compare them with the photos in #4. Not one of them is good enough to rate a place in *FM*! Forry, I will not show you letters from ten-year-old kids who comment on the quality of the pics. I cannot let you destroy the creation of *FM*—which you and you alone built, word for word and pic for pic—with second and third-rate material. Bad enough we may have to resort to lesser stuff around issues six and seven, but for blessed sakes (my lands!) let's not use them now!"[26] The publisher decreed that the photo-to-text ratio should be 75 percent images and 25 percent text, and paid particular attention to the visual side of the magazine. In fact, the final length of each article was determined after Warren had decided how the photos would be arranged.

Fortunately, merchandise sales in the fall of 1959 were robust. Silent partner Banks said, "Halloween in the monster business is like Christmas in the retail business. The closer we got to Halloween, the more we took in. It started with a trickle, $100 a week, and then it went to $200, then $400 a week, and we thought we were really rich. We had people drop shipping all the products. As much as we could, we had other people fulfilling our orders."

Nineteen-fifty-nine was a bumpy ride, but by year's end, when the sixth issue hit the stands (with a King Kong cover by Nuetzell), the percentage of sales had risen over 50 percent and was gradually creeping higher. Letters from readers (and those all-important subscriptions and new memberships to the Famous Monsters Club) continued to fill Warren's mailbox. It was

clear that his idea for a mass market magazine was viable. The monster craze was in full swing. The Shock Theater film packages continued to garner high ratings on local television stations in America, boding well for the magazine's immediate future.

To what did Warren attribute the appeal of *FM*? In an uncharacteristic foray in philosophizing, he later told April Smith of *Rolling Stone*, while talking about the movie *Frankenstein*, "A guy who didn't ask to be born, who was created . . . a poor, big, dumb klutz, who doesn't really want to harm anybody but is being harmed by the townspeople, by Igor, who beats him, and by the doctor, who created him but wants him for his own purposes. If you're going to create a life, then let him *live* his own life.

"The youngster says, 'Why did my mother and father create me? So that I could do what they do and say what they say, and accept what they say even though I don't agree with it?' I think they had an instant identification with Frankenstein and the other monsters, because here they didn't ask to be born yet had to live by rules other people were making, and when they asked why, it was, 'Shut up. Don't ask me why. Just do it.'"[27]

In describing this hypothetical youngster, Warren seemed to be remembering his own boyhood. He always had difficulty living by the rules and fulfilling the expectations of others. He didn't want to be like everyone else. He wanted to be his own, original sort of person. He was determined not to return to the buttoned-down life like he'd had at Caloric. Now, two years after the demise of *After Hours*, *Famous Monsters* had achieved lift-off. He was the pilot of his own craft, free to call his own shots. How hard would he fight to retain that freedom? He would give it his all.

CHAPTER FOUR

EXPANSION: 1960

HAVING GOTTEN A FOOTHOLD in publishing with *Famous Monsters of Filmland*, Warren looked to expand. One magazine, even with merchandise sales, wasn't enough to generate sufficient income. *FM* had worked because of the Shock Theater TV packages, which popularized movie monsters from horror films of the past. Was there another "hot" genre that could be exploited? What else was highly popular as the '50s were coming to a close?

One possible answer was Westerns. In the 1940s, the quickie "B" Westerns were joined by bigger budget "A" Westerns. As the form continued to evolve in the 1950s, virtually every important movie star worked in them. Meanwhile, "B" stars such as Roy Rogers brought the form to the small screen, and, by 1959, when TV production had moved from New York to Los Angeles and its rugged environs, many of the top-rated shows were Westerns. The most popular was *Gunsmoke*, the biggest show of the 1959–1960 season. Among the top twenty programs, there was also *Wagon Train*, *Have Gun-Will Travel*, *Wanted: Dead or Alive*, *The Rifleman*, *The Lawman*, *Cheyenne*, *Rawhide*, *Maverick* and *The Life and Legend of Wyatt Earp*. Jimmy Taubman's second favorite type of entertainment as a boy, after tales of aeronautic adventure, were Westerns.

As Warren mused about doing a Western-themed magazine of some sort, he suddenly thought of Harvey Kurtzman, whose humor magazine

Humbug had ended in late 1958 (about the same time *FM #2* appeared). He appreciated the work of the comics genius who had created *Mad* first as a comic book, then as a magazine, only to leave publisher William M. Gaines in 1956 after a dispute. As a fan of *Playboy*, Warren purchased both issues of *Trump*, the humor magazine Kurtzman did for Hugh Hefner, and then followed *Humbug*, which Kurtzman and others produced over the next two years. His classmate Arnold Roth, a partner with Kurtzman in *Humbug*, introduced Warren to Kurtzman, who, after *Humbug* died, was doing freelance work for *Esquire*, *TV Guide* and other magazines—and finding the going tough. At loose ends, Kurtzman agreed to meet privately with Warren, even though he was unimpressed by *Famous Monsters of Filmland* (which he'd seen, after allowing the publisher to reprint a couple of pages from *Humbug* in the first issue).

Kurtzman and Warren had certain things in common. Both were the sons of Russian Jewish parents, both were working in the magazine trade, and both had a great deal of admiration for Will Eisner and Hugh Hefner. That's where the similarities ended. Kurtzman was a creative individual with little business sense, and Warren was an entrepreneurial type first, and an artist and designer second. Kurtzman was soft-spoken, Warren was confrontational. They weren't well matched, but they came together for what was initially intended to be a one-shot project to make some quick money. Warren later described their meeting.

> I said, "All your life from *Mad* on down, you've worked with artists. And artists have to get paid for drawing. But I have a way of utilizing photos, eight by ten inch still photos, and making them commercially saleable if you pick the right subject, and you put the right spin on it, and you make it attractive enough editorially. We can produce a [humor] magazine using photos with funny captions." Harvey says, "Maybe." And I said, "No maybe. Let's sit down and do it. I want to put out a magazine called *Favorite Westerns of Filmland*, in which we're going to use photos but with funny captions. I want you to see how this can be done."[1]

Kurtzman finally agreed to do the one-shot for a substantial flat fee. The exact financial arrangement is unknown, only that he enjoyed putting together the magazine more than he anticipated. Writing funny captions and tongue-in-cheek text pieces came easily to him. He'd always enjoyed satirizing Westerns in his earlier magazines, and in a graphic novel of sorts called *Harvey Kurtzman's Jungle Book* that he had recently completed. However, he would be doing no artwork for this project, merely writing and designing it. Hesitant to have his name associated with it, Kurtzman hid behind the pseudonym "Remuda Charlie Stringer."

The magazine, with a cover featuring a photograph of Richard Boone with a bullet hole painted on his forehead, struck a nerve when it was published in February 1960 and sold well. As Warren later recalled, "[Kurtzman] produced one of the funniest magazines in the world," and it "sold like crazy." Kurtzman agreed to do another issue. Then Warren proposed another idea: a general, ongoing satire magazine that used the photo technique that had been so successful with *Favorite Westerns*. He recalled, "When I told Harvey this, I could almost see the wheels turning in his head, as he considered it. He was thinking, and trying to envision it and then it finally clicked. Once he could see it in his mind, he realized it could work, and he agreed to do it. Then it was a matter of working out the specifics."[2]

Kurtzman had enjoyed creative freedom at *Mad*, *Trump* and *Humbug*, and wanted to make sure he would have more than general assurances from Warren. For this reason, and because they would be sharing ownership of the magazine, a legal contract was drawn up. Warren: "Harvey had 50 percent of it. I said, 'I will give you 50 percent of the voting stock, which means that you, in effect, have control. In other words, no decisions can be made unless we both agree. As far as the dividend stock, you only get 25 percent . . . because I'm putting up the [money]."[3] This meant that if an issue earned a profit of $10,000, Warren would get $7,500 and Kurtzman would get $2,500. Kurtzman would also be paid a modest base salary. Another agreement was created to establish Kurtzman's ownership of anything he wrote or drew for the magazine. The two of them would own the rest of the material equally. Kurtzman's attorney reviewed the documents, while his client dreamed up a

name for the new humor magazine. The title *Help!* was lifted from the cover of *Trump* #1, where it appeared in large, bright red letters. Kurtzman added the subtitle *For Tired Minds*, a reference to the ubiquitous Geritol TV ads that offered "help for tired blood." Then he signed the contracts, rolled up his sleeves and got to work.[4]

WARREN NEEDED AN EDITOR to take over *Favorite Westerns of Film-land*, which he felt was successful enough to become an ongoing title. It turned out there was someone for the job already at his elbow. His name was Samuel "Sam" M. Sherman. He recently explained how his association with the publisher began: "I grew up in the Bronx. Our house was in the northeast Bronx, heading towards the Throgs Neck Bridge. I loved movies and comic books as a kid, but gave up the comics around age twelve, to focus mainly on movies and photography. I had an idea I wanted to be in the motion picture industry. I became friends with an older guy named Norman Michaels, who had a big collection of movie stills, bigger than I did. When *Famous Monsters of Filmland* #1 came out, we were impressed with it, and we studied it. We thought, 'He's using old stills from horror movies. Maybe we can rent old stills to him.' Norman had his collection and access to get more of them, plus contacts at film companies and other places like poster services. I had stills too. And if we didn't have just what Warren needed, we'd go out and find them.

"I wrote to Jim Warren and we started working together. He was in Philadelphia, I was in the Bronx. We would send him stills, and then he would return them with whatever payment had been agreed upon. We never held Jim up for money. We took whatever he wanted to pay us. We never asked him for more than we thought he could afford. All this was through the mail. We didn't meet in person in the beginning.

"Renting the stills led to other things. He said, 'I could use an article,' so I would write one. I found out he was a consummate movie fan. He began to expand his publishing, and asked me to do certain things, and I went along with it, although that wasn't my main thing. Whatever I was doing with him was an adjunct to other things I was doing to move my career along. I was doing many things at once. I was collecting old movies, I worked in the

industry, I was a student at City College Film Institute, I was very close to Joe Franklin [the popular TV host in the greater New York area], and was working with Joe on projects. At any given time, there could be a half dozen prime projects and a lot of secondary projects."

After Kurtzman began concentrating on *Help* magazine, Warren had hired Paul Laikin, a writer for Robert Sproul's *Cracked* magazine, to do *Favorite Westerns*, continuing the idea of making fun of the form. Sherman wasn't impressed. "Jim asked me what I thought of it, and I said, 'Not much. I *like* Westerns. I don't like things I like made fun of. You're not ingratiating yourself to the fans of Westerns. You're turning them off. You're not going to be successful with this.' He changed the title to *Wildest Westerns* with #3 [October 1960]. Then, Jim said, 'I want to take Laikin off this and make you the editor of *Wildest Westerns*.' For Jim, who was used to being in control, it was unusual, but I did take control and made it a more serious magazine.

"When he decided that I would be in charge of *Wildest Westerns* [with #4], I said, 'I want to bring my friend Bob Price in. He's very good. He's an art director for a market research company.' I said to Bob, 'Why don't we take over this magazine together, rather than just me?' He said he wasn't a writer, but it turned out he could write. He had good life experience, he'd been all over the country and he'd served in the navy in World War II, in the Pacific Theater of battle. Bob Price was a great guy. Jim met Bob Price and quickly accepted his talent, because he knew he was bright, and made him art director of the magazine."

An editorial office in Manhattan was now a necessity, so Warren rented his first office space in Manhattan, at 545 Fifth Ave. It was shared with Chester Productions. Harry Chester, a longtime Kurtzman friend and associate, would handle the production work for both *Famous Monsters* and *Help*. Warren agreed that Kurtzman needed a part-time editorial assistant, and hired a woman who wanted to break into publishing. Her name was Gloria Steinem. Steinem, then twenty-six years old, recalled, "I was Harvey's first assistant on *Help* magazine. I don't think I had ever read *Mad*. I had been off to India for a couple of years and was really involved in student politics. I was probably the least likely person to be his assistant. Somehow, he hired

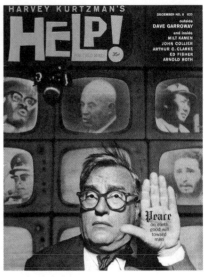

Help magazine featured celebrities on its covers in 1960 and 1961, including Jerry Lewis on #3 (October 1960) and Dave Garroway on #5 (December 1960).

me anyway, and he had enormous faith in the fact that I was not shy. In fact, I was very shy [but] I was typecast as the 'not-shy' person, so I was always sent out to get the celebrities for the [covers, although] I didn't have the foggiest idea of how to get them. It was a challenge. Harvey expected me to do it so I was going to do it."[5] She was quick and effective, managing to get popular comedians to appear on their cover for free, such as Sid Caesar, Ernie Kovacs, Jerry Lewis, Mort Sahl, Jonathan Winters and others. *Help* #1 appeared on newsstands in July 1960.

Based on the idea that *Help* could be the "new *Mad*," Warren was able to line up a more upscale distributor than Kable News. "You start at the top, and then work your way down. Independent News had *Mad*, *Playboy*, and DC comics, and they said no. But Hearst's International Circulation Distributors, or ICD, said yes. They were a better distributor than Kable News, where I had *Famous Monsters*. They had very successful magazines like *Cosmopolitan* and *Good Housekeeping* and got great newsstand coverage. When Kable found out I'd taken the 'new *Mad*' to ICD, they were furious. They punished me for it, very definitely, because they wanted *Help*."[6] The first issue had a print run of 200,000.

Warren was convinced that *Help* magazine would be a hit. Those hopes were dashed when the sales reports on the first issue arrived. The low percentage of sales meant he lost money on it. When asked to specify the percentage in later years, he said he couldn't remember, but that it was within striking distance of breaking even.[7] He assured Kurtzman that he would support the magazine until it caught on, making up for losses with profits from *Famous Monsters* and the sale of merchandise. Kurtzman and crew pumped out issues in rapid succession. Warren was impressed by Kurtzman's talent: "There were times when I watched him work. It was fascinating. He would do brilliant things that no one else would have been able to do. I don't know how to explain it. He was a unique, a one of a kind genius, when he was 'on.' Of course, he wasn't always 'on.' Some things he did weren't that great. Sometimes he was distracted. But when he was 'on,' what an amazing talent."[8]

With *Help* #3, Kurtzman introduced a new kind of feature that is now called "fumetti." The word is borrowed from the Italian: it's stories that are acted out in a series of photographs with added word and thought balloons. (Confusingly, in Italian, photographs with balloons are called "fotoromanzi." The word *fumetti* refers to hand-drawn comics, because *fumetti* means "little puffs of smoke," the approximate appearance of the word and thought balloons.) They hadn't made an impact in North America until they appeared in *Help*. The first was titled "On the Coney," the story of a man and woman who may well be the last human beings on earth. These photo-stories were something different, and generat- ed a positive response from readers. In designing them, Kurtzman was able to satisfy some of his desire to become a movie director. They were shot quickly—almost all in a single day—and appear in most succeeding issues.

Kurtzman fan John Benson dropped by the office and described the experience in his fanzine *Image*: "*Help*'s offices are the smallest in New York.

This gag from *Help* #11 could have appeared in *Famous Monsters*.

Help editor Harvey Kurtzman, the man who created *Mad* magazine.

Take the tiniest room you can imagine and then sub-divide it into foyer, office and work room. When I arrived, I was suddenly overcome by a tornado. Editors, publisher, artists (one, for example, who was submitting art samples for the first time), coffee-shop boy, all flew in at once, which left little room for anything else. The phone rang constantly throughout, and conversations were interrupted by it, all three of the office's lines sometimes being in use at once. Everyone acted as if this were normal procedure, and I'm sure it was."[9]

Later, Steinem said of Warren, "He's a great operator. We used to kid him about it—being a Sammy Glick-type character—you know, great big cufflinks." Warren later claimed he never wore cufflinks. "I don't know if it's true," she said, "but it's entered into the apocrypha of James Warren that he used to do things like ride around in summer with the windows rolled up so people would think he had air conditioning. The combination of him and Harvey Kurtzman was particularly interesting because Harvey Kurtzman is kind of shy and retiring and Jim is just the opposite—a total extrovert."[10]

THE 1960 WORLD SCIENCE FICTION CONVENTION (known as "Pittcon"), held over Labor Day weekend, was an unlikely place for Warren to publicize his magazines. He probably did at the urging of Forrest Ackerman, who attended the SF convention annually, and wanted *Famous Monsters of Filmland* represented there. The booth was equally designed to promote *Help*, and was manned by Warren and Kurtzman. Warren: "We had a display for *Help* magazine, with a life-size cutout of Mort Sahl as he appeared on the cover of *Help* #4. We had a big *Help* banner in the background, which was very nice, and we had a model there, who served as part of the display, in a bikini or something, and the door opens up at the other end of the hall, and

Isaac Asimov walks in. Takes one look at the model, who's right next to me, and runs—not trots—toward her. Ten feet away, he sinks to his knees, and slides the rest of the way on his hands and knees, on all fours, and bites her on the ass! . . . And of course, a crowd gathered. He made a big spectacle of it, and it was a lot of fun."[11]

Warren also met Harlan Ellison for the first time at that convention. "My recollection is that Forry Ackerman introduced me to Ellison. Harlan dazzled me for half a day, and then I saw some things I didn't like. Harlan is theater. When you have him around, he's theater, until he gets to you. The point that I knew that I could never be very friendly with him, or even want to be around him too long, was when we had lunch together. He had a girl with him who he was trying to impress, and . . . made an ass of himself by refusing what the waitress was bringing and saying, it's not hot enough, it's not cold enough, it's not done well, take it back. And he was serious about it. He didn't do it to be funny. He was serious. After the second time, I got up and left the table with my own date because I couldn't take it. He was putting on a big show, trying to make himself feel important. And this wasn't for me, particularly when I'm eating."[12] Later, in New York, he and Ellison became friendlier for a time. Warren introduced Ellison to his second wife.

In 1960, Warren was like a blur, he was moving so fast. Somehow, while spending long days publishing three magazines, and commuting to Philadelphia, where he was still living, he managed to take his fiancée Phyllis on dates in the city. Now that he had a few dollars in his pocket, he took her to supper clubs, nightclubs and dancing. Gregarious and fun-loving, he had a way of meeting people, becoming fast friends, and having a good time enjoying the nightlife that Manhattan had to offer. One of those places was the Peppermint Lounge.

The Peppermint Lounge was a discotheque located at 128 West 45th St. which was open from 1958 to 1965. It was a gay bar run by Genovese crime family associate Matty "The Horse" Ianniello, who managed several other clubs and gay bars in Manhattan. It became a hot spot and attracted a celebrity clientele, although it was small and had a capacity for just one hundred and seventy-eight people. Marilyn Monroe, Frank Sinatra, Jackie

Kennedy, Truman Capote and others were seen dancing to the music of the house band, Joey Dee and the Starliters. It may be where go-go dancing originated. Its main claim to fame was as the launchpad for the new dance craze the Twist when it hit in 1960. Chubby Checker's single "The Twist" reached number one on the Billboard Hot 100 on September 19, 1960. Sam Sherman recalled, "I'll never forget when he got involved with the Twist. All the society folks began going to the Peppermint Lounge, so Jim had to go there. 'We don't know the twist,' he said. 'We're going to learn it!' And every time I went over to his office, he'd demonstrate the Twist, and say, 'How do you like this?'" The Twist ended up on the cover of *Help*.

Warren and Farkas had announced their plan to get married on Halloween in *Famous Monsters* #8 (September 1960), the same issue with the announcement that the magazine was going bimonthly. "Exclusive! Phyllis Farkas says 'Yes!' After four years of brainwashing, Phyllis is about to become the bride of *Famous Monsters'* publisher Jim Warren. A Halloween wedding is planned. Until then, Phyllis will be feeding Warren plenty of vitamins—so he won't look 'all run down.'"

Sam Sherman: "Jim was about to get married. I remember him coming into the office on the day of his wedding. He had on a tuxedo and looked great. He walked out of the office to get married and that was the last we saw of him for a month. Phyllis called off the wedding at the last moment, eventually got married to someone else."[13] Warren disappeared for a month, which delayed the publication of *Famous Monsters* #11. Sherman speculated, "Maybe she wanted a more conventional life, a house in the suburbs and a picket fence. Jim never wanted that kind of life."[14] When Warren returned, he didn't release *FM* #11 until he added a new "Man Aging editor" to the masthead: Jacie Astrachan. There would be others in the coming years.

In the second half of 1960, he began working with cover painter Basil Gogos, whose work is the most celebrated to appear on the cover of *Famous Monsters of Filmland*. In *The Famous Monsters Chronicles II*, Gogos, who was born to a Greek family living in Egypt and immigrated to the United States when he was sixteen, expounded on working with Warren. "I had an agent who was able to find me magazine illustration work. During the late '50s, and

early '60s, there was a lot of work available. There were a lot of war illustrations, adventure stories, editorials . . . stuff of that nature. In those days, that was a haven for any young artist fresh out of school. He had work. So that's what he gave me . . . a lot of work. Not great work, not high priced . . . but it was work. Jim Warren turned out to be one of my agent's clients. Jim called me one day and asked: 'Could you do something for a monster magazine?' I said: 'I can do anything!' So, he ended up giving me a photo of Vincent Price from the film *House of Usher*. Jim told me to 'do it in a crazy way . . . crazy colors. Anything that comes to mind,' and I did. I worked in inks. It didn't take too long. When I was finished, I looked at it and thought, 'How am I going to show this to the client?' I felt embarrassed. It was so garish! I was taught to be a conservative painter. When my agent came by to pick it up, he wanted to know if I'd like to come with him and meet Jim. I told him, 'No. Just take it to him.' So, he took it in. Later, I received a call from Jim. He said, 'Brother, this is the greatest thing I've ever seen! Come right down . . . I want to meet you!' I went down to his offices and he just heaped the praise on me. 'This is fantastic! I want a lot more!' That's how it started. He was hugging me!" Gogos was a fan of the magazine before he ever worked for its publisher. "I had bought all the issues up to *FM* #9 when my painting first appeared. It was quite thrilling to see my cover on the stands!"[15]

Sometimes Warren gave Gogos a photograph to work from, often a black-and-white image. Gogos liked this, because it gave him complete freedom to create his own coloring. Sometimes the reference pictures were quite small, and he had to "enhance" them in wonderful ways. "We never tried to cheapen the character," he said. "Sometimes the face didn't have enough character, so, we just helped it along. If there was a scar, I'd play it up a little bit. Whatever feature I could build on, I did." Ackerman appreciated Gogos's work as much as Warren did, but the painter got all his instructions from the publisher. Warren told Gogos, "If I had my way, I would take you and [Frank] Frazetta, chain you both to chairs, and have you work for nobody but me."[16] Gogos was initially paid $125 per cover, which he thought was great, having gotten out of school recently, and because they were done so quickly. Later, when he spent more time on them, he would get $500 each. He did lots of other magazine covers

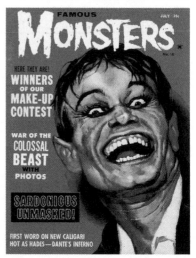

Basil Gogos's expressionist paintings enhanced the newsstand appeal of *Famous Monsters of Filmland*. Top are from issues #9 and #12. Bottom are from #17 and #18.

for men's "sweat" magazines and such, but his favorites were for Warren. "I loved doing them," he said. "It was a romance with me. I grew up with these movies. To eventually be paid to paint them was a great, great thing." Gogos decided to leave commercial art to concentrate on teaching in the fine arts arena, but resumed producing horror-themed commercial art in the 1990s.

LIKE *FAMOUS MONSTERS*, *Help* had to be produced on a shoestring budget, which meant finding material that cost little or nothing. Kurtzman: "*Help* was a trick magazine. We tried to do [it] for nothing. We would get old drawings and old photographs . . . and we would try to enhance them with captions."[17] They used public domain material and reprints. The "Public Gallery" was set up to present work by talented neophytes, or material culled from college humor magazines, at a rate of $5 per cartoon. But the main content of the first issues were movie stills and news photos with humorous balloons, mostly written by Kurtzman and Steinem, with suggestions from Warren, Chester and others.

Warren decided to add Kurtzman's name to the cover. The magazine became *Harvey Kurtzman's Help* with the fourth issue. When deadline crunch time came, Kurtzman, Warren, Steinem and Chester worked late into the night. Warren ordered sandwiches from the Stage Delicatessen, and the cups of coffee kept coming until the issue was completed and ready for the printer. There was considerable *esprit de corps*, and optimism that sales would build over time.

The quest for photographs led to an incident that Kurtzman found unsettling. He later told the story to Fantagraphics publisher Gary Groth. "This is the story as related to me," Groth recalled. "One day, [Kurtzman] accompanied Warren to a place in New York where Warren got stills for his magazines, the corporate headquarters of a film studio in New York, and I guess they kept their photographic archives there. There was an old guy who worked there. Warren greeted the guy, kind of a bent old guy who presumably had been the archivist there forever, and gave him some toys for his kids or grandkids. He hugged him and asked, 'How are you?' like they were old friends. Then this guy said, 'Excuse me, I'll be back in a few minutes, I've got to go down the hall.' And, as Harvey told it, the minute this guy walked out the door, Warren leapt over the counter and started pulling photos out of drawers and files, and stuffing them in his briefcase. Then he leapt back over the counter, straightened up, and acted like nothing had happened. Harvey was horrified! The guy came back, and Warren continued with his friendly conversation with the guy, 'It was great seeing you, blah blah blah.' He walked out, and Harvey

told me, in all seriousness, when they got to the street, he turned to Warren and said, deadly serious, 'Never do that again.' He was quite shaken by what he'd witnessed."[18] Both Denis Kitchen and Adele Kurtzman confirmed that Harvey told them substantially the same story.

This incident caused Kurtzman's estimation of Warren to drop, but they were probably not fated to work well together for long. Less than six months after the magazine's debut, an event occurred that almost led to its cancellation. When Warren was checking the proofs for *Help* #8, he discovered that it had a full-page photograph of Adolf Eichmann, one of the chief architects of the Holocaust, who had been apprehended in Argentina on May 11, 1960, and put on trial in Israel. The word balloon had him saying, "Ever get the feeling that the whole world's against you?"

He told Kurtzman they couldn't run it, that it was outrageous, and showed terrible insensitivity to the survivors of the Holocaust. According to Warren, Kurtzman said, "Jim, you agreed that I have full editorial control. You can't go back on your word."[19] He appealed to Kurtzman on the basis that it was in poor taste. Kurtzman argued that anything can be satirized, and, "It's handled in good taste." When he told Warren there was nothing he could do to stop him from running it, Warren responded: "Yes I can, Harvey. As of issue #7, I'm $80,000 in the hole. I'm pulling out. I'm canceling the magazine. It's all over, Harvey."[20] A day or two later, Kurtzman and Warren met, each accompanied by his attorney. When Warren's attorney explained to the publisher that closing down the magazine would give up any hope of recouping its losses, he gave in. The Eichmann photo and caption could run as is.

Kurtzman never publicly discussed this disagreement, except to say more generally, "Warren didn't get into the act. As a matter of fact, as we worked, Warren became more and more remote. We didn't see eye to eye with the format at all, but I don't remember exactly what our differences were."[21] Kurtzman was hypersensitive on the matter of editorial control. He feared "giving an inch" would open the door to more interference. There were other instances where Warren expressed dissatisfaction with certain items in the magazine, hoping at least to influence Kurtzman by the strength of his arguments. Kurtzman wouldn't budge. Due to the terms in his contract, he always prevailed.

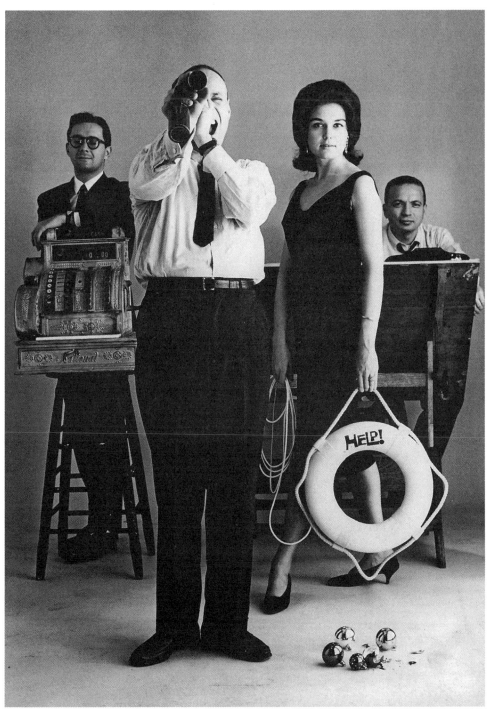

This photograph from *Help* #9 (April 1961) shows each member of the staff with a symbol of his or her role. Warren (a cash register, for finance), Kurtzman (a telephoto camera lens, for vision), Steinem (a life preserver, for general assistance) and Chester (a drawing board, for doing the production work).

For Warren, the Eichmann incident was a turning point in his relationship with Kurtzman. "As we looked at each other, we realized that things could never be the same anymore," he said. "We continued to work together, but there was no more palling around, no more informality, no more fun. I didn't like Harvey Kurtzman as a person."[22]

CHAPTER FIVE

UPS AND DOWNS

WARREN PROMISED ACKERMAN that he would publish a magazine on SF and fantasy movies once *Famous Monsters of Filmland* was established. He was as good as his word. Just as the monster magazine went bimonthly, Ackerman submitted photos and text for a new magazine called *Spacemen*. Although the first issue was dated July 1961, it appeared on newsstands on or about March 2. This helped maximize its chances, because it would (theoretically) be on sale for a full five months before unsold copies were pulled and returned.

The cover painting by Basil Gogos shows an astronaut's helmeted head against an all-black backdrop. Warren knew that black covers, especially those with high contrast, would "pop" on the stands, attracting browsers' eyes as they passed over a sea of titles. The blurbs on the cover announced, "First issue by the editors of *Famous Monsters*" and "Space photos and stories from movies you didn't see."

Ackerman's editorial informed readers, "This is not a space fact journal. Nor is it a science fiction periodical." Instead, it would be devoted to "great films" that show "how the mind of man has imagined the people and places and things of the Void Out There may look." It would not, in other words, cover the "race to the moon" that was so much a part of the American conversation in 1961. Like *FM*, it had a high photo-to-text ratio, and a letter

column logo by Jack Davis. *Spacemen* carried ads for the newly retitled Captain Company, a full ten pages of them.[1] Many were space-oriented in theme, such as a wireless telephone powered by the sun's rays, a giant full-color space map and so on, as well as back issues of *Famous Monsters* and a few monster-oriented items. The quarterly magazine became the fifth regularly published Warren title.

Famous Monsters of Filmland #11, with its Gorgo cover by Gogos, was the first issue of that title to appear in 1961, hitting the stands on February 9. It features more photos of the iconic horror film stars of the past, such as Boris Karloff from *The Body Snatcher*, Lon Chaney Jr. from *The Wolf Man* and *Son of Dracula*, and the actors (John Barrymore, Frederick March, Boris Karloff) who had played in a version of *Dr. Jekyll and Mr. Hyde*, as well as a story on the *Gorgo* movie. It includes a full-page ad for *Spacemen*, which states, "Spacemen,

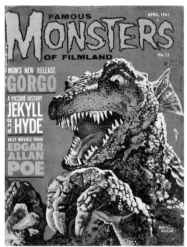

Famous Monsters #21 (April 1961).

tho it will frequently sparkle with Ackerman's famous humor, will be a less punfull, more serious publication than its parent. Its slant will be toward adults as well as teens and subteens." By this issue, the merchandise catalog had swelled to fifteen of the magazine's sixty-eight pages.

Warren: "Forry and I had a curse or a blessing: We both knew how to talk to ten-year-olds. There are probably some psychiatrists who'd say we peaked at ten and it's a case of retarded development. But more important, I genuinely liked our readers. They thought like I did."[2] He made a special effort to court the magazine's young readers by publishing many of their letters, as well as lists of names and photos of the fan club members. He even gave new members a free classified ad in a section, called *Screams from Monster Club Members*, where readers could offer items for sale or trade. The fan club material was put together by Warren (with assistance), not Ackerman.

Early in 1961, he rented a larger office in Manhattan, again in conjunction with Harry Chester's pre-press operation. It was at 422 Madison Ave. in a building with a Chock Full o' Nuts restaurant on the ground floor. Anticipating the new digs, he told a visitor, "We're moving into big new plushy offices on Madison Avenue [with] big windows. We hired an interior designer-decorator who . . . came in and spent all kinds of money and we have big beautiful offices. It'll be a carnival and a three-ring circus."[3] The office was ready to go on March 1. Sam Sherman said, "We had a whole floor. It wasn't a big floor, but that's what we had. Harry Chester was in the front toward the windows. He had a big room where all his people were. That's where Bob Price worked. Harvey was to the right. Jim had an office, of course, but Harvey's was bigger. I had a desk around the front, not far from Chester's area." Forry Ackerman was in New York and visited the new offices a day or two after the move. Among other things he was doing in the city, he hosted a gathering of fans at the Hotel Chesterfield, where he was staying. It was grandly called the "First Monster Fan Convention," but amounted to about thirty fans dropping by Ackerman's room to meet him and his publisher. Warren was always considering new ideas for magazines, looking for "the next big thing." When he ran into smart people, he pumped them for ideas.

One of those people in 1961 was Ted White, a well-known SF fan and writer. White recalled recently, "I spent the better part of a month going in and out of his office, under the illusion that I was going to be working for him soon. That's the few times I ever met Gloria Steinem, because she was working in that office. Jim told me that he was looking for an assistant to work under him [and] wanted me to come up with ideas for other kinds of magazines. I proposed a music magazine, and I proposed a magazine that actually was the closest that Jim wanted to do, which was to go to the next step beyond *Playboy*. This was circa 1961, mind you, and I wanted to call it *Eros*.[4] My concept was not pornographic, but definitely erotic and sensual. I said, 'You can't do this on the cheap. This has to be glossy stock with high production values and color, and Jim is getting real excited about it. But . . . a week or two later, he had significantly backed off on the whole idea, and

the next thing I heard, he was having one of his periodic hemorrhages as a publisher, and all bets were off. I never actually got paid a cent by him."[5]

Even though it was now based in New York, Warren's Central Publications, Inc. (which wouldn't be renamed Warren Publishing Co. for two more years) remained a thinly capitalized operation. He spent a great deal of time juggling the finances, and it was complicated when he was publishing several ongoing magazines. He would periodically find himself in a cash crunch. Sometimes, he called on his former silent partner, Barton Banks. "After he bought me out, there were times when he couldn't pay his printer," Banks recalled. "I had an SBIC, a small business investment company, chartered and financed by Uncle Sam through the US Small Business Administration—a venture capital company. There were a couple of times when we wrote him a 'loan commitment' letter stating that we were going to lend him $3,500 or $4,000 or some similar amount. The date would be a month from today. Jim took that to his printer and the letter convinced him to give Jim credit until his loan came in. In reality, what happened was, the printer gave him credit, he put the publication on the newsstand, and collected the money and paid the printer. We never intended to fund the commitment letter. It was a

A Warren cartoon in *Xero* #5 (July 1961), poking fun at SF fan Les Gerber for his youth and (in Warren's view) callow opinions.

way to get the books out of the printer, otherwise Jim would have been out of business."[6] Warren was always looking for a new way to generate capital.

Oddly, he continued a certain involvement with SF fandom; even odder, it was in *Xero*, the fanzine published by Richard Lupoff, who had disparaged *Famous Monsters* when it first came out. In the fanzine's fifth issue, two of his gag cartoons appeared, with accompanying tongue-in-cheek text by Bhob Stewart, who wrote, "Here in these cartoons, showing two sides of Les Gerber, a *Xero* discovery is unveiled. James Warren is one of the most promising neos around and could rise swiftly out of the ranks of neodom with proper encouragement. Jim was well-received by many big-name fans at the Pittcon. These cartoons reveal a deft line coupled with an incisive wit. We believe Jim Warren has a great future and possibly someday, with practice and persistence, he may develop his talent and sell some cartoons to *Help*."

Help #11, which came out shortly after the office move, turned out to be the last monthly issue. The magazine became a quarterly, which meant that the twelfth issue didn't reach newsstands until July. It introduced a new version of Harvey Kurtzman and Will Elder's character Goodman Beaver, who first appeared in *Harvey Kurtzman's Jungle Book* (1959). The new story was "Goodman Meets T*rz*n," wherein the round-eyed protagonist visits the jungle lord in the aftermath of the bloody Mau Mau uprisings of the 1950s. For reasons that aren't clear—perhaps Warren's indecision about continuing the magazine—readers had to wait until the end of December for the next issue.

Meanwhile, the monster craze gained momentum. The Aurora Plastic Model kits of Frankenstein's monster, the Hunchback of Notre Dame, The Mummy and the Phantom of the Opera were a huge sales success. Warren advised Aurora during its development of the models, then sold untold numbers of them through ads in *Famous Monsters*. Revenues from Captain Company in 1961 spiked as Halloween approached. His cash flow was further bolstered by sales of one of his most popular items: the giant six-foot poster of Frankenstein's monster by Jack Davis. Later, Warren told comics historian Roger Hill how it came to be: "Jack [Davis] stopped in one day at my office around the lunch hour, either to deliver some other job, or just to visit, and I told him of this idea I had to do a life-size poster of Frankenstein.

Back cover of *Famous Monsters of Filmland* #18 (July 1962).

Jack always carried a couple of brushes with him and a bottle of ink, and so he sat right down, in my office, and started working on this art. In the time it took us to order in sandwiches for lunch and eat them, he was finished. I couldn't believe it. I had never in my life seen an artist do anything like that, and do it so fast. He made it appear right before my eyes, and I was stunned. We then sent it out to have the negative shot, and before long, the six-foot posters were made and being mailed out to kids all over America."[7]

One day Warren took a call from a mother in Queens. "Mr. Warren, I want you to know that my kids have formed a monster club because they all love your magazines. They all bought masks from you through the mail, and they walk around the street wearing them. They're the cutest things in the

world. You have to take a picture of them and put them in the magazine." At first, he was reluctant but then he picked up on the woman's enthusiasm and sincerity, and said, "Okay, I'll send a photographer."

Gloria Steinem, who was within earshot at the time, had a friend who was a very good photographer, and she was sure this friend would be perfect for the job. "For $35?" Warren asked. "I'll call her right now," Gloria said. "She'll come in, and you can give her the instructions, and pay her cab fare, because she really needs the money now." The photographer, who was between jobs, was Diane Arbus.

About three days later, Arbus returned and laid a large print of one of the photos before him. "I looked at it," Warren said, "and I said 'Oh, my God!' I called the staff in and said 'Look at this.' There's dead stillness in the room. Nobody speaks. They're mesmerized by what they're seeing. Diane Arbus cannot take a picture with a camera without it having a Diane Arbus quality. It's got a stamp on it. It's incredibly bizarre and uncomfortable to look at. I said, 'It has a feeling to it that I can't describe.' I gave her $50 instead of $35. 'Because after we publish it, I want it up on my wall.'"[8] Arbus's photo, for unknown reasons, didn't see print until *FM #28* (May 1964) and when it did, it didn't carry a credit line. But her "creative signature," a disturbing

From *Famous Monsters of Filmland* #28 (July 1962).

darkness, made the images of the four masked children sitting on a brick stoop especially haunting.

Famous Monsters had plenty of ups and downs. The eighteenth issue (July 1962) featured sixteen-year-old Joe Dante's "Dante's Inferno" article, listing his choices for the fifty worst horror films ever made ("the feeble fifty"). Included are Edward D. Wood's *Bride of the Monster* and *Plan 9 from Outer Space*. A number of them were from American International Pictures. According to Warren, AIP President James H. Nicholson, who was planning to rerelease some of those films, was upset. Warren told Ackerman of the flare-up, and told him the movies they covered in *FM* shouldn't be criticized. To make amends, the publisher created something called the Famous Monsters Producer's Award and bestowed it on Nicholson for *The Pit and the Pendulum* (1962).[9] He had a publicity photo snapped of himself giving an enormous trophy to Nicholson, which appeared in *FM* #20 (November 1962), the issue on sale when Bobby "Boris" Pickett's song "Monster Mash" was number one on the Billboard 100 chart.

As December arrived, Warren was in a good mood because the first paperback book published by his company was about to see print. A new editorial assistant on *Help*, Charles Alverson, had been working on it for weeks. *Harvey Kurtzman's Fast-Acting Help!*, published by Gold Medal Books, reprinted material from the early issues of the magazine. The paperback book field was exploding in the late 1950s and early 1960s. The idea was to get his product in front of people who weren't buying *Help* in magazine form, and recoup some of its losses.

As another way of raising the profile of *Help* and getting coverage in other magazines, Kurtzman and Steinem told Warren they wanted to throw a *Help* Christmas party at the Algonquin Hotel for members of the city's literary cognoscenti. He agreed to pay for the invitation-only dinner and party, even though he wasn't convinced it would get them much publicity. The list of invitees included Arnold Roth, Roger Price, Orson Bean, Ed Fisher, Larry Siegel and Burt Bernstein, Leonard Bernstein's younger brother, who was an editor at the *New Yorker* (and a *Help* contributor). It was a congenial affair slightly marred when Harvey Kurtzman noticed Sam Sherman in the

room. According to Warren, Kurtzman pulled him aside and hissed, "What's a 'nothing' like Sherman doing here? He wasn't invited." Warren snapped, "I invited him! He contributes to my magazines. You invited your brother-in-law who hasn't contributed a thing to *Help* and he never will."[10] Seething, he stomped out of his own party with Sherman in tow.[11]

Sherman didn't take it personally. He saw it as part of an ongoing, low-level conflict between the clique headed by Kurtzman and the *Famous Monsters* people. "They thought they were high class and we were low class. Behind Jim's back, they're tearing him down, even though the office was paid for by *Famous Monsters*. It came to a head at the *Help* party. Jim told me later, 'I had a big argument over you with Harvey Kurtzman.' I think it was just that Harvey felt I wasn't part of the *Help* world, but Jim didn't tell it that way. I never had an argument with Harvey." The party didn't produce any notable publicity for the magazine, and that in itself was enough to rankle Warren. Gloria Steinem, who had thought the party was a great idea, left *Help* shortly after the Algonquin affair.

THE LAST THING WARREN WANTED to be was a trendsetter. He always hated his competitors, and that was certainly true of a new one that appeared as 1961 gave way to 1962. It was called *Castle of Frankenstein*, and like the reviled *World Famous Creatures*, it too was distributed by Kable News. It also bothered him when he heard that its publisher and executive editor, Calvin Beck (listed in the magazine by the pseudonym Charles Foster Kane), was saying that Warren "stole" the idea for *Famous Monsters* from him.

Did Beck really claim that Warren stole the idea? In a 1981 interview with Raymond Young, Beck recounted his initial attempt to get his magazine published: "I . . . made the rounds of magazine distributors. One was Kable News which, by some odd coincidence, launched *Famous Monsters of Filmland* a few months later in 1958. By some even stranger coincidence, *Famous Monsters* publisher Jim Warren and I bumped into one another *the very same day* I had my first conference up in Kable News' office. I was a pretty damned green kid with little business experience. Warren, on the other hand, was already streetwise tough from previous media battles. So all I could do was

writhe in frustration when the first issue of *Famous Monsters* hit the stands in early 1958."[12] Beck seems to be agreeing with interviewer Young's suggestion that Warren had merely beat him to the punch, rather than claiming he somehow stole his idea. Since Kable, at this early stage, didn't want a second monster magazine, Beck was forced to take his proposal to a smaller outfit called Acme News, which distributed a single issue with Beck's *Journal of Frankenstein* (the original title) in 1959. He didn't start work on *Castle of Frankenstein* until 1961.

The rumors of creative theft assert that while Beck was behind closed doors at Kable News pitching his idea for what became *Castle of Frankenstein*, Warren was talking with Beck's mother who went with him everywhere. She supposedly bragged about her son's idea for a monster magazine, and then Warren went in and sold Kable on doing such a magazine with him.

The flaw in the story, quite obviously, is that Warren wouldn't have been there if he didn't already have a presentation for the magazine that he wanted Kable to distribute. Warren could be incredibly persuasive, but he couldn't have successfully pitched a magazine idea that he only heard about in the distributor's lobby minutes earlier.[13]

Fans who were a little older than the target audience for *Famous Monsters* liked *Castle of Frankenstein*, which took a more serious approach to horror and fantasy films. The first issue was largely put together by Larry Ivie, succeeded by Bhob Stewart, but the issues only appeared about twice a year, so it wasn't any kind of threat to the dominance of *Famous Monsters*. Nevertheless, Warren despised the magazine, and never acknowledged that it was more than a cheap imitation (which it wasn't), although others did come along that were.

As their third year of working together began, things went from bad to worse between Kurtzman and Warren. They agreed that reprinting a *Spirit* story in the January issue was a good idea, since both had such great admiration for Will Eisner's work. The problem came as a result of the highlight of *Help* #13: the second installment of Goodman Beaver entitled "Goodman Goes Playboy." It was, and remains, one of the best Kurtzman-Elder collaborations, and a real creative highlight in the history of Warren Publishing. It satirizes the Hugh Hefner "swinging bachelor" lifestyle, and uses the

Panels from "Goodman Goes Playboy" by Harvey Kurtzman and Will Elder, from *Help* #13 (February 1962).

characters Archie, Jughead and their other Riverdale friends to demonstrate the effect *Playboy* was having on America's youth. Warren had no apparent objection when the issue went to press. However, within days, he received a letter from attorneys for Archie Publications alleging that it constituted "trade libel, and undermines the valuable property that my client has developed in these wholesome characters." It stated that Archie was going to sue Warren Publishing to "recover damages resulting from your act of copyright infringement and libel and request that you recall from sale all copies of the issue referred to."[14]

Archie Publications hadn't objected when Kurtzman and Elder produced "Starchie" in *Mad* back in 1954, which in many ways showed the characters in an even darker light. Denis Kitchen, a Kurtzman friend who became his literary agent, recently wrote: "Kurtzman was indignant, confident 'fair use' and satiric use protected them, and he assumed his publisher-partner would have his back, like Bill Gaines did at *Mad*. But Warren, according to Kurtzman, was instantly ready to cave, publicly apologize in the magazine, and avoid any cost of litigation. Harvey refused to cave on principle, so he and Will Elder were left adrift to defend themselves, without resources to properly do so. And they got utterly pulverized by Archie in a humiliating settlement. That experience thoroughly pissed them off."[15] A settlement was reached in March

($1,000 and an apology in print). Kurtzman: "We paid off, we settled out of court. I thought it was terrible. I wasn't able to fight [John Goldwater of Archie Publications] because I didn't have any money to fight, and my lawyer said I could fight and I could win [but] it would be a Pyrrhic victory. It's very sad."[16] Hefner thought the strip was hilarious, and it seemed to rekindle his interest in bringing Kurtzman into the pages of *Playboy* magazine itself. Indeed, a couple of months later, Hefner agreed to publish Kurtzman's idea for a female version of Goodman Beaver named Little Annie Fanny. Soon, Kurtzman was juggling his time between *Help* and *Playboy*, and Goodman vanished from the Warren magazine.

To keep *Help* on track, Kurtzman relied heavily on a new editorial assistant. Terry Gilliam, a college student and fan, moved from California to New York in August 1962 hoping to work with him. Since Charles Alverson had just left, Gilliam's timing couldn't have been better: "Harvey was looking for a new assistant, and bingo! Yours truly got the job. And it was the most wonderful thing. There I was in New York getting paid $50 a week with Harvey."[17] Gilliam was given a desk facing that of Sam Sherman in the office. He proved to be a talented, capable associate editor. Gilliam was astonished by the size of the *Help* operation: "This magazine was really being done by a very small handful of people." Nevertheless, with the creator of *Mad* magazine at the helm, it attracted letters, cartoons, phone calls and visits from a wide variety of talented people. Some of them, like Gilliam, were in New York for the first time, trying to break into the magazines. "It was an amazing time," he remembered. "Everybody was pouring in this

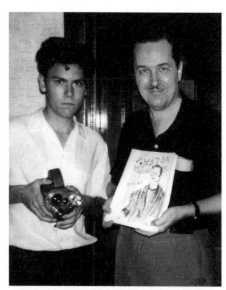

Don Glut was one of many young filmmakers inspired by *FM* and "the Ackermonster." This 1962 photo is courtesy of Donald F. Glut.

Mecca . . . and there was Harvey Kurtzman." Gilliam stayed with the magazine until its demise. His name was on the masthead for the first time in #17, the last issue of 1962.

It's not known when Warren was told or discovered that Kurtzman had landed a major new gig doing *Little Annie Fanny* for *Playboy*, but he must have known by Labor Day weekend, when he was in Chicago for the 1962 World Science Fiction Convention promoting *Spacemen* and his other magazines. That's when he met Hugh Hefner, who by this time was a major media star, and got his idol to sign a photo for him. He had it framed and gave it a permanent place of honor on his office wall. Its inscription read: "To all the monsters with best regards, Hugh M. Hefner, editor-publisher, *Playboy* magazine."

Earlier that year, Warren launched his sixth magazine. It wasn't the high-end, glossy *Eros* that Ted White had proposed, but the decidedly street level *Screen Thrills Illustrated.* The first issue was dated June 1962. Sam Sherman: "When [*Wildest Westerns*] got to the point where we felt that it was not going to be continued, we came up with an idea to do a catchall magazine that covered the things that the other magazines didn't: all the comic book characters that had been adapted into serials or films, the Bowery Boys, the Tarzan movies, Laurel and Hardy, the Marx Brothers, right down the line."[18] *Screen Thrills Illustrated* #1, with its memorable "half head" cover by Basil Gogos, appeared in April. It was edited by Sherman and his friend Bob Price. Sherman: "Warren was terrific because he let us do what we wanted. He let us loose with printer's ink and publisher's cost, let us do anything crazy we wanted to do. Jim was everything I wasn't when I met him: worldly, a businessman, clever, a good

Screen Thrills Illustrated #1 (June 1962). Cover by Basil Gogos.

promoter. He always said to me, 'I am your mentor!' And I guess I learned from Jim about entrepreneurialism and having to live by your wits and run a company without financing."[19]

Warren finally decided he'd had enough of living in his bedroom at his parents' house on Upsal Street. He had an office in Manhattan, and now it was time to live there, too. An ordinary apartment wouldn't do. It had to be something with a "wow factor," something Hefner-esque to impress his friends, colleagues, lady friends and, most of all, himself. Finally, he found it: a duplex, fourteenth floor penthouse in a building in Midtown known as The Embassy House. The address was 301 East 47th Street, not far from the United Nations. One could see the silver doors of Andy Warhol's first Factory a half a block away. The rent at the beginning was said to be a mere $400 a month. Warren, like Hefner, planned to do a great deal of his work at home, where he could comfortably work late into the night.

According to Russ Jones, an editor and artist who worked for Warren in 1963 and 1964, "[In] his penthouse apartment, the phones never stopped ringing. The living room had been converted into his office. Jim's desk faced the entrance, a bank of windows with a large patio to his right, a large sofa against the wall to his left. On the floor were piles of current Warren magazines. Upstairs was a small bedroom and bath, and downstairs another small bedroom that had been converted to a storage area. It was filled with art, magazine flats, filing cabinets and other cast-off office materials. I seem to recall another small room, next to the bathroom, where Sam Sherman was assembling his *Screen Thrills* motion picture magazine. A blank-eyed, 35mm projector sat on a table. Scores of film were piled in cardboard boxes. A small kitchen completed the tableau."[20] At some point, Warren had mirrored tiles put on his living room walls.

Artist Ernie Colón, who visited the apartment after Warren had been there a while, recalled, "Going to his apartment was quite an experience. He had a pure white shag rug, and a full-length portrait of himself, dressed precisely the way he greeted me at the door. I thought that was really like out of a great movie, you know? In the painting, he was dressed in a powder blue shirt with a white collar with the sleeves rolled up, and chino pants and

barefoot, and that is exactly how he came to the door. And I almost fell over when I walked into the living room and saw his portrait up there. He had a very beautiful girl there with him. Lots of photographs on the walls with famous people."[21] Anne T. Murphy, who worked at *Redbook* and would soon socialize with Warren, recalled him having a mounted papier mâché moose head on the wall.

One never knew who one would find there. Weegee, the famed crime-scene photographer who was down on his luck, was a fixture there for a while. *Naked City*, his book of photos published in 1945, was the inspiration for the 1948 film of the same name produced by Mark Hellinger. Weegee's real name was Arthur Fellig. Warren: "I took him to dinner one night at the Stage Delicatessen. He ordered two sandwiches, two platters, four desserts and another sandwich and cheesecake to go. He then told me he was being evicted from his apartment. I told him, 'Sleep in my apartment until you find a new place.' One week stretched into six months. The man was never without a cigar—even in bed. I loved him."[22] (Weegee passed away in 1968.)

Late one evening, a friend called and wanted to come over. Warren answered, "Not now, in about an hour. I've got to get Jane out of here." When the friend arrived, he saw Jane Fonda coming out of the apartment.[23] She was in New York City filming scenes for *Sunday in New York* in the spring of 1963, a film with Cliff Robertson and Rod Taylor. Warren has never revealed the nature of his involvement with the future star of *Barbarella*. Later, he would only say, "It was an amazing time to be running a magazine in New York. You could work eighteen hours and party a few more hours. The sexual revolution had broken open in the early 1960s. I was twenty-nine years old and I had more fun than anybody I know." [24]

FULL-PAGE ADS announcing an "exciting new motion picture" called *Screen Thrills* appeared on the back covers of *Famous Monsters* in the first half of 1963. It was James Warren's first attempt to make a movie. The story of this film had begun with Sam Sherman two years earlier. He recalled, "I had an idea of buying 35mm nitrate copies of silent movies that were out of copyright and compiling them into some kind of feature film, which would

Late 1963 announcement for James Warren's *Screen Thrills*, a widescreen movie which never materialized.

show the way movies had been done in the silent era. How a Western was done, how a horror picture was done, and so on." But the idea was "too small" for Warren. They brought in actor and comedian Milt Kamen to add comedy ad-libs, but Kamen wanted too much money. Then they filmed some material with comedian Will Jordan. Warren still wasn't satisfied. Time passed, and then he got the idea to ask for advice from his friend Shorty Yeaworth, who had directed *The Blob*. "Soon Shorty was undermining me with Jim," Sherman said, "telling him that he [Shorty] was the only one who could save the movie. So, contrary to my agreement with Jim, he turned the work print over to Shorty, who started milking Jim for payments. 'I've gotta get

this, I've gotta get that.' I was getting nothing, but Shorty was getting fees. I was upset, because Jim had violated my agreement with him, so I decided to leave. I talked my parents into financing a trip to Hollywood for me. I had no particular plan. I visited Forry Ackerman, who took me around to his friends in the film business.

"Eventually, Jim called me there. 'I'm sorry about the problem we had,' he said, kind of apologizing. 'I'll send you some money to help with your expenses. I want you to do articles for the magazines from there. I want you to work with Forry.' And he patched it up! So now I'm back working with the magazines, plus I met Denver Dixon, Al Adamson's father, in California, which led to the film career that I had later. I was there three months.

"Sometime after I got back—this thing stretched on for months—Jim took the film away from Yeaworth, because he saw that Shorty was conning him out of money. After all his attempts to change it and re-edit it, Yeaworth finally told Jim, 'I think we ought to go back to the way Sam had this originally. That was the best way.' Jim was furious! He tried to keep the project going, even bringing in Woody Allen to work on it, but ended up putting it aside. He and I agreed not to talk about the movie any more, and continued our friendship and magazines as if it never happened." Years later, Warren sold the aborted feature film back to Sherman for $1,000, a fraction of the money he'd sunk in it.

In 1963, the year when *Famous Monsters of Filmland* reached its peak in some respects, the price for a regular issue jumped from thirty-five cents to fifty cents, beginning with #21 (cover-dated February 1963, although it came out in December 1962). That extra money seemingly bought more pages, as the page count was established "permanently" at one hundred pages per issue, although about twenty-five pages per issue were taken up by the Captain Company catalog.

One of the new features was the first in a series of *Famous Monster* "film-books," which was a response to reader requests for more in-depth features. In reality, they were novelizations of the movies to the accompaniment of numerous stills. This was the *FM* version of "in-depth." But what really came to the fore in these issues, as never before, was Ackerman himself. In

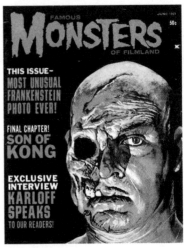

Still from *Bride of Frankenstein*, colorized by Basil Gogos, on *Famous Monsters* #21, and his fully painted cover for *Famous Monsters* #23.

the earlier issues, Warren had pushed back at Ackerman's attempts to put himself in the magazine, beyond the editorial on the opening page of each issue. Now, he finally allowed Ackerman to increase his presence in its pages (which, Ackerman assured him, the readers wanted). The 1963 issues had a noticeable increase in the number of photographs of its titular editor: Ackerman receiving an award from the Count Dracula Society, Ackerman giving a tour of the Ackermansion, Ackerman this and Ackerman that. Warren: "Forry had a sizable ego that required constant feeding and I knew this. He had a pathology that screamed out for recognition."[25] In these issues, it seems obvious that Ackerman's need for attention crossed into actual narcissism. It peaked with a three-part "interview" with Ackerman that ran from #24 through #26. (Paul Linden, who was bylined for the first two parts, was a pseudonym for Ackerman himself.)

In part one of the interview, one of the questions was, "What is your opinion of your publisher?" Ackerman answered, "I think [Warren] is the best thing that ever happened in my life. He 'saved' my life, in a way. He certainly changed it radically for the better. I had a miserable rotten time of it as a literary agent for nearly fifteen years, eking out a peanut butter existence

while trying to cope with the eccentricities of a number of nutty editors and neurotic clients. I was a splintered man, irritated, angry [and] frustrated, while trying to earn a living off 10 percent of about 100 other people. It wasn't until 1958 [actually late '57] that someone came along and took a $30,000 chance on me—and that benefactor—bless him—was Jim Warren."[26]

In *FM* #26, "Inside Darkest Ackerman," he wrote, "I am gratified, from my fan mail, that the majority of you have ratified the policy of *FM* as a personality publication and that, buyin' large, you buy the personality of Ye Ed. But in a batch of 370 'like' letters, last week, I suddenly hit one that stopped me stone cold dead in de casket, and it was from a girl. Said she: 'The one thing I like about other monster magazines is that I don't eternally have to read about Ackerman.' That really rocked me back on my reels, till I stopped to realize that they crucified Christ, shot Lincoln . . .'"

The publisher later said, "For one year, for six issues worth, we did it his way. We lost $35,000. [Ackerman] was extremely depressed over what had happened. The fans talked to him, and he listened, and we published and they were all wrong."[27] When sales figures on their spectacular King Kong issue (#25) arrived, they were truly alarming: only 64,000 copies of a 250,000-print run had sold. While this was likely an indicator that King Kong didn't have the same appeal as Frankenstein, Dracula and the others in the monster family, it was also a verdict on the Forry-heavy trend. This gave Warren enough empirical evidence to insist that Ackerman's "personality policy" was a failure. It wasn't because the popularity of the *Shock Theater* monsters was ebbing, as the ratings of those programs were as strong as ever.

Sam Sherman recalls an incident that happened at about this time. "I used to be along with [Warren] on a lot of adventures. He'd say, 'Come along with me, we're gonna do this, we're gonna do that.' Once I remember going with him to some publishing company. It was a paperback publishing company. It was very funny. We went in there, and, right in front of me, he negotiated a deal to put out a paperback book with highlights from *Famous Monsters*. He said he wanted a $5,000 advance for that. You'd say, 'How long did it take before he got a contract?' He got the $5,000 advance right then, at that meeting! The first meeting was the last meeting! Boy, was that great. We

left, and I said, 'Why'd you want to give them this book for $5,000?' And he said, 'Come with me to my bank.' So, we went to his bank and he deposited the check. He said, 'I only made the deal with them because I need $5,000 right now. I'm going to cancel the deal and give them back their money, but I need it right now.' He needed it to bridge something. I thought that was brilliant. He was so good at negotiating, and good at handling people." Ultimately, Warren didn't cancel the deal. *The Best from Famous Monsters of Filmland* was published by Paperback Library in June 1964, and sold well enough that other reprint editions followed.

This was one of many times Sherman witnessed his mentor in action. "Jim would drag me into things," he said, "suddenly, with no explanation." There were jaunts to visit a seedy film producer—Warren nicknamed him "The Fog," due to the cloud of cigar smoke that filled his apartment—or to the Café Bizarre in Greenwich Village, to see the eccentric monologist and comedian, Brother Theodore, do his nightclub act.

"Come with me," Warren would say, putting on a coat and heading out the door.

"Where are we going?"

"Don't worry about it, kid. Don't ask."

Life with Warren was never boring.

IN 1964, THE MONSTER CRAZE continued to grow. In the pages of *Bestsellers* for June 1964, a magazine for retailers, Warren opined, "No one knows the ceiling, but the ground floor is about $30 million this year. Unlike the Beatle fad, monsters have many more faces than four. And as old as *Dracula* and the *Phantom of the Opera* are, they never looked healthier than now. 1964 is our year to howl! And every magazine retailer is invited to join us!" As the year went on, sales of *Famous Monsters* came roaring back with such gusto that he decided to launch a sister magazine, which he called *Monster World*.

Monster World would be indistinguishable from *FM*: Stills from Ackerman's collection, with text written in the patented Ackerman style (though sometimes by others). The question arises: why publish two bimonthly monster magazines, appearing in alternate months, when it would seem

obvious to go monthly with *FM?* The answer is that a bimonthly magazine has a shelf-life of two months before unsold copies are pulled by the wholesaler. That allows twice as much time for it to be sold. Two different titles was the smarter way to go. *Monster World* #1 was dated November 1964, which meant it hit the stands in late August, before its target audience was back in school, and a few weeks before two new monster-oriented TV shows took America by storm.

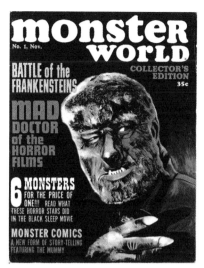

Monster World #1 (November 1964).

On September 18, 1964, a new show on ABC-TV called *The Addams Family* debuted, cleverly adapting Charles Addams's macabre cartoon family from the pages of the *New Yorker* into an original, droll situation comedy, starring John Astin as Gomez and Caroline Jones as his wife, Morticia. A week later, *The Munsters*, a more cartoonish show about a family of monsters, starring Fred Gwynne and Yvonne deCarlo as Herman and Lily Munster, debuted on CBS-TV.

Monster World effectively replaced both *Spacemen* and *Screen Thrills Illustrated* in the Warren publishing lineup. Neither had caught on. Ackerman would simply work on the two monster magazines. Sam Sherman was ready to move to the West Coast to pursue his ambitions as a film producer. It was time for Warren Publishing to try other things.

As Warren considered his publishing options, he studied the comic book business as exercised by the small number of publishers who had managed to survive the onset of the Comics Code Authority: ACG, Archie, Charlton, DC, Dell, Gold Key, Harvey and Marvel. Super heroes were resurgent at DC and Marvel, including revivals of characters popular during World War II. He would have loved to get into the four-color comics arena, but how could he compete or make an impact with his lack of financing? Then, in 1964, he found a way in.

Bill Harris, former editor and writer for Gold Key (a.k.a. Western Publishing) and King Comics, remembered, "When the World's Fair came to New York in 1964, Jim decided he wanted to do a comic book on it to sell at the Fair. His idea was, I thought, quite brilliant. Because the theme of the fair was the World of the Future, Jim chose to make the comic book *The Flintstones at the New York World's Fair*. Cavemen seeing the world of the future. In order for him to do that, though, he had to come to Western, which had the license for publishing not only Flintstone comics but most of the Hanna-Barbera stuff. That means that we had to actually produce the comic book for Jim. So, we did. I put it together. Al Kilgore wrote it for me and Fred [Fredericks] illustrated it. Mel Crawford, another of my favorite artists, did the cover. That book was my all-time favorite project of any kind."

It had to be out slightly before the fair opened. Harris: "We went up to Jim's apartment to hash out what we wanted. We ended up going there seven or eight times, and it was like going to a party over there. Kilgore and Fredericks were the funniest guys on Earth. Jim appreciated their humor. We'd sit around and shoot the jokes back and forth. It was like a vaudeville room. I got to like Jim a lot, and we stayed in touch for quite a while. Jim had a lot of enemies in the comic book business, but I've always defended him. He was always very generous with gifts. He got a lot of loyalty that way." The sixty-eight-page comic book was printed by Western Printing in their Poughkeepsie, New York, printing plant, and was hugely profitable for Warren. Harris concluded, "Jim was a smart guy, one of the smartest guys I've ever met, and he knew how to work what he did well. He was one of the most unforgettable characters I ever met."[28] Aside from the financial rewards, Warren got immense satisfaction having gotten a contract that DC Comics officials had considered a "lock" for Superman.

Soon, he would find another entry point into the comic book publishing industry, and, true to form, he did it differently than anyone else. He was the first publisher to believe in a black-and-white magazine of comics, and give it sufficient force to put it over.

CHAPTER SIX

CREEPY BEGINNINGS

STORIES IN COMICS FORM were a small part of Warren's publications from the start. He had successfully persuaded Harvey Kurtzman to let him use two pages of the satiric strip "Frankenstien and His Monster" in *Famous Monsters of Filmland* #1, shortly after the entire story appeared in *Humbug* #7. He was all in favor of bringing back Kurtzman's Goodman Beaver character in *Help*, and making the fumetti, a comics story told with photos rather than artwork, a central part of each issue. Although he'd dipped his toe in comics publishing with the Flintstones book, it was a one-shot that didn't lay the groundwork for a line of comics. The idea of putting out an ongoing magazine entirely devoted to horror stories in comics form might never have occurred to him, had it not been promulgated by two people: Larry Ivie and Russ Jones. In later life, both claimed to have created the magazine *Creepy*.

Ivie's interest in the idea can be traced to the publication of the magazine *Eerie* (1959), a fifty-two-page collection of comics stories published with Hastings Associates, Inc., not to be confused with the color comic books by the same title. A talented artist in his own right, Ivie had assisted his friend Al Williamson on the story "Lower Than Hell" for the black-and-white publication. Other stories in the issue were illustrated by Angelo Torres, Gray Morrow and Joe Orlando. Most of the scripts are said to have been written by former EC writer, Carl Wessler. It has a painted cover. In many ways, this publication is a virtual blueprint for *Creepy*. The Hastings *Eerie* was even distributed by

WARREN PUBLISHING COMPANY HAncock 4-5000

1426 EAST WASHINGTON LANE · PHILADELPHIA 38, PENNSYLVANIA

REPLY TO:
Warren Publishing Co.
301 E.47th St.
New York 17, N.Y.

September 11, 1963

Mr. Larry Ivie
31 W.76th St.
New York, N.Y.

Dear Larry:

This is a reminder that on or before October 2nd, 1963,
you are to present yourself at my office, together
with the dummy and comprehensive ideas for the new
magazine project we discussed in your hotel room in
our nation's capitol, Labor Day week end.

I have not forgotten. Look to thyself, and start working
on this project - which may very well change the course
of your life.

Sincerely,
James Warren
President

Warren Publishing Company

JW/dpm

Letter from Larry Ivie's files confirming that he pitched the idea that
would become *Creepy* to James Warren at the 1963 World Science
Fiction Convention, and that Warren was receptive.

Kable News. Although it was declared a bimonthly, it didn't progress to a
second issue for reasons unknown.

"Vampire," Ivie's prototype of a *Creepy*-style story, surfaced in mid-1962
in *Castle of Frankenstein* #2. He may have offered it first to Warren. According
to Ivie, "I had tried to get work in *Famous Monsters*. I took artwork to . . .
Warren's office, and was told they had absolutely no interest in new artists or
writers, so I took everything I had to show to him to other publishers. I took
some of the stuff to Calvin Beck."[1] Still, Ivie was among the people Warren
invited to his hotel room at the 1963 World Science Fiction convention in
Washington, D.C. It was there, Ivie said, that Warren emerged from the
bathroom wearing only a towel, and announced, "I'll pay one million dollars
to the person who gives me an idea for a magazine I can publish!"[2] Ivie pitched
the idea for *Creepy* although he didn't yet have a title. Warren agreed to look

at a presentation, and said, "I suppose you'll want to be editor." On this basis, Ivie felt it was understood that he would edit the magazine if it went forward.

Warren confirmed this discussion in a letter to Ivie dated September 11, 1963, a week after the convention. He wrote, "This is a reminder that on or before October 2, 1963, you [Ivie] are to present yourself at my office, together with the dummy and comprehensive ideas for the new magazine we discussed in your hotel room in our nation's capital, Labor Day weekend. Look to thyself, and start working on this project—which may very well change the course of your life."[3]

Enter Canadian-born Russ Jones, an artist of modest ability who was determined to break into the publishing arena. He was six years younger than Ivie, and about as different from Ivie as one can imagine. Ivie was a dreamer and an idea man who lacked practicality. Jones was an ambitious self-promoter who was good at manipulating people to get projects going. His way into the scene was through artist Wallace Wood, who was in the last stages of working for *Mad*. At the time, a young writer named Bill Pearson, having recently finished a stint in the military, was sleeping on Jones's couch at the Clifton apartments in New York City. Pearson: "Russ was very good at insinuating himself into the lives of people he wanted to work with. He was a seducer. He would find out what you liked, and he would provide it. Woody liked guns. All of a sudden, Jones was bringing him guns. Pistols, rifles, all kinds of guns. He didn't want to go the straight and narrow. He always had an angle." Giving Wood guns gave Jones the opportunity to visit Wood's apartment on West 74th Street. Soon he was assisting Wood on comic book stories for Charlton and other publishers. Wood and Jones collaborated on a failed proposal for a syndicated newspaper comic strip. Before that collapsed, Jones was able to get Wood to participate in a project for Warren Publishing.

According to Al Williamson, "Jones went to Warren and said, 'I'm working with Wally Wood. What kind of work do you have for us?' Then he went to Wood and said, 'I'm working with Jim Warren, and he wants us to work on such-and-such.'"[4] Probably inspired by the fumetti strips in *Help*, Warren had an idea for a magazine adapting the low-budget movie *The Horror of Party Beach* into photo-comics form, and gave them the job. (Most of the actual

work on it was done by Maurice Whitman and Bill Pearson, who said, "I was paying for sleeping on his couch by doing art projects for Russ.") After that, Jones worked with Wood on the first horror comic strip written and drawn at Warren's behest.

"The Mummy," a six-page comics adaptation of the 1932 film, was supposed to appear in *Famous Monsters*. Jones had sold Warren on running the strip. Pearson explained, "Jones and I penciled 'The Mummy.' We had a lot of stills to work from, and Woody inked it." It was the last of Wood's collaborations with the Canadian. By then, Wood decided that Jones was a "slimy character" and wanted no more to do with him. For the next such adaptation, "The Mummy's Hand," Jones collaborated with Joe Orlando. Despite having paid for "The Mummy," Warren was apparently uncertain about putting comics into *Famous Monsters*, and shelved it for several months. It didn't appear in *FM* at all, but in the first issue of *Monster World* which came out just a month before *Creepy* #1.

Meanwhile, Ivie had continued to work on what became *Creepy* even though Warren didn't keep that October 2 appointment, and wouldn't return his calls. The publisher's silence was probably because Russ Jones had gotten to him with a similar idea, and Jones was the more aggressive of the two. Jones: "My dream was to re-create EC, but not as a four-color comic book. In 1963 that would be the kiss of death. I approached Bill Gaines with my insane dream. Bill thought it was great, but had no interest in getting involved."[5] Thus, Jones says, he turned to Warren, who he described as a maverick, "a guy who didn't follow anyone's rules but his own."[6] To overcome Warren's reluctance, and help seal the deal, Jones decided to get as many artists as he could to sign onto the project, focusing mainly on EC alumni.

In the spring of 1964, Jones held a meeting in his apartment. Bill Pearson recalls that it was attended by Al Williamson, Maurice Whitman, Angelo Torres, Roy Krenkel, Archie Goodwin, Larry Ivie. Pearson isn't sure but thinks Frank Frazetta may also have been there. Notable in his absence was Wallace Wood, who was estranged from Jones by then.

They were generally enthusiastic, but wanted to know what kind of page rates were being offered. Jones told them that Warren "wasn't able to shell

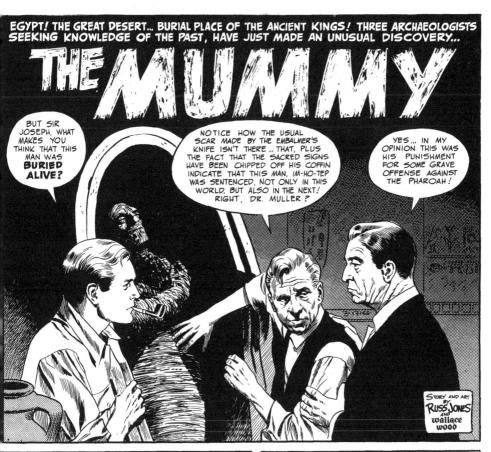

From *Monster World* #1 (1964).

out a lot of money for scripts. He didn't want to spend much for art, either. A double threat."[7] He said the rate for art would be $35 a page, both pencils and inks, until the magazine generated enough profits to pay more. (Dell and Gold Key were reportedly also paying $35 a page at this time. DC and Marvel paid more.) On the plus side, Warren would print the names of the writers and artists with each story, which meant the magazine would act as a sort of showcase for them. Only Marvel Comics was crediting the writers and artists on each story. Williamson, who was well-liked and became a ringleader of sorts, agreed, and the others fell into line. Jones said, "If anyone were to ask me how the whole thing came together, I would have to say without the supreme effort of Al Williamson it probably wouldn't have." At this time, when the super heroes were coming back, some in this group of non-super hero artists didn't have as much work as they needed. As Archie Goodwin later put it, "If [Warren] had started his line a year later, he wouldn't have been able to get the same people he got."[8] The rate of $10 a page for scripts was accepted by Goodwin, Pearson and Ivie. (Ivie had already completed a bunch of stories.)

Once Jones presented this roster of artists and writers to Warren as a fait accompli the publisher greenlit the project, despite his trepidations. He was concerned about becoming a target of those who had forced the comics industry to form the Comics Code Authority, which was charged with eliminating horror from comic books. In truth, Warren had no desire for a return of pre-Code horror. He wasn't an EC fan when the comics were originally published in the early 1950s. "I didn't like [EC comics]. The only thing I liked about them was the great talents of men like Kurtzman, but I didn't like the plots of [the horror comics] because they were too far out and they were in bad taste."[9] He wanted to present a new type of the horror comic book. If most of the artists had worked for EC, that was wonderful, but he decreed that his new comic book would show very little blood and gore.

Officially named editor of the new magazine, Russ Jones began assigning scripts. Archie Goodwin, who was then employed as an assistant editor for *Redbook*, agreed to write for it in his spare time. As to Ivie's claim of originating the idea for *Creepy*, Jones said, "I can't believe he'd make such a claim. Maybe

Pay stub from Larry Ivie's files, proving that Warren paid Ivie for playing an editorial role in the creation of *Creepy*.

he tried to promote a similar idea at one time or another, but I don't know if he did or not. Larry knew what I was doing, for he lived a scant few blocks from the Clifton."[10] Ivie gave Jones a package of presentation materials and several scripts to deliver to Warren. That the scripts were used and credited in the magazine proves Ivie's involvement at this stage. Beyond the stories themselves, there's a check stub showing that Warren paid Ivie for editorial work. Ivie: "At [Warren's] apartment, when he gave me the check (for $100.00) for 'editorial consultation,' I assumed this was my first payment as editor."[11] Warren has generally dismissed Ivie's part in creating *Creepy*, but there's no denying that he wrote that check and made that notation on the stub. It proves that Ivie was more than merely an early writer for *Creepy*.

Ivie's concept sketch for the cover of *Creepy* #1.

Ivie retained a copy of his initial cover sketch with the name *Creepy* on it, which was in the package of material that Jones picked up and was supposed to deliver to

Warren. Ivie: "Whether [Warren] saw [the cover sketch], or whether Russ Jones slipped it out of the package and kept it, I don't know. Russ might have claimed credit for the title but everybody had already seen my work on the presentation, so there's no question. There wouldn't have been a *Creepy* without what I gave to Warren."[12]

Al Williamson confirmed this. "I knew Larry, and he's not a liar. He's a very honest fellow, but he's not a businessman. He doesn't push himself on people, so people take advantage of him. [*Creepy*] was his idea, there's no question about it."[13]

Russ Jones never backed off of his claim of having invented and named *Creepy*, and drawing the original sketch for Uncle Creepy. Warren has maintained that Jack Davis originated the visage of Uncle Creepy, and has produced a rough, concept sketch of the horror host by Davis as proof. Warren said that he told him, "He should resemble John Carradine." He convinced a reluctant Davis (who was embarrassed about the gory stories he'd drawn for EC comics) to design the horror host, do the cover of the first issue and provide a number of head shots of the character, by sending him one of the brand-new Sony four-inch television sets, which cost $400. In the final analysis, it seems that Russ Jones's main contribution was being forceful enough to sell the idea to the publisher.

Warren threw a launch party for *Creepy* at Larry Ellman's Cattleman steakhouse in Manhattan. Guests included Frazetta, Williamson, Krenkel, Orlando, Torres and a few others. It was mainly for the artists, not the writers, although Archie Goodwin was there. Angelo Torres: "We gathered in a private dining room upstairs. After a great steak dinner, wine and dessert, Jim rose to address the crowd. He introduced Russ Jones as his editor, and Archie Goodwin, who would be the head writer. He then outlined for us what he hoped to accomplish with our help: a brand-new horror magazine called *Creepy* with the possibility of other titles in the future, including, possibly, a war book. I believe he closed with a request for us to consider his proposal, hoping a good number of us would hop on board. The pay rate was acceptable and there was the possibility of a raise as the magazines gained popularity. I liked the fact that Jim and his staff had full confidence in our ability and

trusted us in our interpretation of their stories. They also gave us free rein to render them as we saw fit. There was a general good feeling after the dinner broke up and I have no doubt many of us let Jim, Russ and Archie know we were interested.

"Archie Goodwin had been a friend within our group for some time before he began writing for the Warren books. We were immensely pleased to know he would be doing a lot of the writing for Jim and that might have been one of the reasons some of us chose to hop aboard. He turned out to be a prolific writer with a wry sense of humor and an ability to turn a good horror yarn. He would also prove himself quite able to handle a war story when *Blazing Combat* was created. He was much loved and respected by those who knew him and remained so throughout his career."

Warren's readers became aware of *Creepy* for the first time via an announcement in *Famous Monsters of Filmland* #31 (December 1964). Uncle Creepy, as drawn by Jack Davis, tells readers that, "*Creepy* will present to you, dear reader, the wildest, weirdest and most mind-warping tales ever told," and to, "Watch for it on newsstands on October 25." At the bottom of the page was the helpful notation: "*Creepy* is a magazine—not a comic book. Look for *Creepy* in the magazine racks!"

When the fifty-two-page *Creepy* #1 appeared, it didn't have a dark, spooky cover as one would expect. Instead, it featured a comical drawing of monsters crowded around the host Uncle Creepy, listening to him reading from the magazine. Large letters below the title proclaimed: "Comics to give you the creeps!" and "Collector's Edition." The backdrop was bright yellow. Why the comical, lighter approach? It was Warren's way of "easing" the potentially contentious magazine past wholesalers who might remember the anti-horror comics sentiment of the 1950s. If one simply glanced at the cover, one might think it was another monster magazine, or perhaps one of the *Mad* imitators that popped up from time to time.

Warren's talent as an art director and graphics person came to the fore. One of the most remarkable things about the magazine was how well-designed it was from the start. Like *FM*, it had an editorial "welcome" page. In this case, it was a head shot of Uncle Creepy (drawn by Jack Davis)

Creepy #1 (1964). Jack Davis art.

explaining what the potential reader was holding in his hands: "I'm Creepy, your nauseating host! I've scrounged around the lowest places imaginable to dig up the comic industry's greatest and most fiendish artists! Start reading and see for yourselves—as you feast your bloodshot eyeballs on comics guaranteed to leave you senseless with delight!" In keeping with the colorful cover, the background on the inside front cover is bright orange. The contents page has a crisp, clean look, with the names of the contributors in san serif text. Its 1960s sleekness is a perfect counterpoint to the gothic peregrinations of most of the seven stories that follow.

The script to "Voodoo!," the opening story, is credited to Russ Jones and Bill Pearson. Pearson recalled, "It was my first professional sale, and I was quite shocked and disappointed that Russ put his name on it. He'd done nothing but suggest the subject matter, i.e. 'Do a story about voodoo.' That was the extent of his contribution to that script."

Among the issue's highlights is "The Success Story!" a collaboration between Goodwin and Williamson which offers an inside look at the syndicated strip business. It tells the story of Baldo Smudge, a talentless opportunist who lands a syndicated strip deal by hiring others to write, pencil and ink the strip, each one not knowing that the rest of the work isn't by Smudge. Williamson drew Smudge to resemble himself, the writer to resemble Archie Goodwin, and the inker to look like Angelo Torres. In a 1992 interview with George Evans, Paul Wardle asked him about the real-life events that inspired "The Success Story!"

"The Success Story" by Archie Goodwin and Al Williamson.

"Werewolf!" by Larry Ivie and Frank Frazetta.

Evans: "That was about the guy who 'drew' *Dan Flagg*. He [Don Sherwood] had previously worked for George Wunder [doing coloring] on *Terry and the Pirates*. Sherwood had a rich relative who apparently financed the production of *Dan Flagg* for the first couple of months. Dan Flagg was a gung-ho major fighting America's wars all around the globe, a real right-wing, patriotic type of story. The first parts of it were art swipes from Alex Raymond's *Rip Kirby*, and as the schedule hit him, producing strips seven days a week plus the story, he began to hire other people to do it. These included Al Williamson, Alden McWilliams, myself and, I think, Wally Wood. He hired a whole slew of people and it turned out, as we talked with each other, that that's what was happening. He was buying the story, buying the art and everything else, but his name was signed very large and clear on all these strips. It was passed off as his strip. 'The Success Story' was almost totally true, except for the ending."[14] On top of the clever, semi-humorous story, Williamson's art looked different from his EC work. At this time, he was assisting John Prentice on *Rip Kirby*. Perhaps because of the subject matter of the *Creepy* strip, Williamson seems to have deliberately brought elements of the *Rip Kirby* style into this six-page story. The art is confident, fluid and highly expressive, full of varying textures and other sophisticated graphic techniques. His enjoyment in drawing it is evident in every panel.

Another highlight of *Creepy* #1 is the story "Werewolf!," not because of its script by Larry Ivie, but because it was drawn by Frank Frazetta. By this time in his career, the thirty-six-year-old Frazetta had found his métier as a painter of paperback book covers. He discovered that painting single images was more lucrative than drawing comics. "Werewolf!" was the last multi-page comics story of his career. What readers didn't know, because the work was uncredited, is that Frazetta was assisted by Larry Ivie: "I got a call from Frazetta saying, 'I'm supposed to have this story finished next Monday,' and it was Friday or Saturday right then, so it had to be done on the weekend. I had to go out to Frazetta's place to help him on the artwork."[15] Ivie, a capable artist in his own right, estimated later that he did layouts or pencils for about a third of the job, although Frazetta's imprimatur dominates every bit of it.[16] Frazetta also managed to turn out

a full-page drawing of Uncle Creepy for a subscription page on the inside of the issue's back cover.

The issue also had the outstanding "Vampires Fly at Dusk!," again from a Goodwin script, this time drawn by veteran artist Reed Crandall. Crandall had been working with Al Williamson on some freelance comic book work. When the call went out for former EC artists to draw for the new magazine, Williamson made a point of eliciting Crandall's participation. It was the first story in a body of work by Crandall that many feel is the best he ever did. He took full advantage of the graphic possibilities of the black-and-white presentation, adding a lot of texture and fine detail to every panel.

The two other stories that complete the issue are nearly as remarkable as those by Crandall, Frazetta and Williamson. Angelo Torres threw himself into the art for Goodwin's "Pursuit of the Vampire!," filling almost all the white space with shadows, shading, and figures shown in stark light and shadow. Just as Williamson showed off a different style in "The Success Story!," so Torres caused a stir by offering work that was more mature and interesting than anything he had done before. Gray Morrow's art for the story "Bewitched!" by Larry Ivie is also ambitious, and is the only one to heavily rely on Zip-A-Tone to fill in backgrounds and create the night sky. Morrow had begun in comics assisting Al Williamson and Wallace Wood, which led to his participation in the Warren magazines.

All seven stories were six pages long, just enough to set the plot spinning, and then hit the reader with a surprise ending, much like the EC horror comics of old. Archie Goodwin wrote three of the seven scripts. He would soon be doing even more per issue. He later told interviewer S. C. Ringgenberg, "I wrote a lot of material [in the early issues of *Creepy*]. I guess the artists seemed to like the scripts I was doing. Having read EC's and a lot of '50s horror comics, it was a nice break after I'd come home from *Redbook*. It was sort of a lark, knocking off a Warren script at night. And that's how I sort of drifted into it.

"The first year of doing it, it was incredibly easy. . . . I wasn't really approaching it as any kind of self-conscious writing. I was just generally amusing myself. 'Hey, this is almost like writing real comics.' And I had no

sense of fans or anyone reading the stuff, or anything. But later on, when it became a full-time job, then I began taking it a little more seriously. I met more people in the business, became aware of my peers. Once you are conscious of peer pressure and pleasing people that you like, and things like that, that starts making it tough."[17]

CREEPY #2 WENT ON SALE on (or about) January 28, 1965, introducing the classic *Creepy* cover logo. Warren designed the logos on the first and second issues: "My strength is not illustration, it's art direction and design. I did the original graphic concept and blueprints on all of our magazine titles. I designed and hand-lettered the final logos on every single title, from *Famous Monsters* to *Vampirella*."[18] (An exception is the logo to *Blazing Combat*. See Chapter 7.) This issue, and *Monster World* #3, which had the same publication dates, were the first to show the label "A Warren Magazine" on the cover, which was used on virtually all Warren publications henceforth.

The issue also introduced Frank Frazetta as its cover artist. Instead of the light, colorful artwork of Jack Davis, *Creepy* #2 featured a painted cover by this master of dark, dramatic fantasy imagery. Perhaps inspired by the interior story "Spawn of the Cat People," it depicts a man being surrounded and menaced by a pack of shadowy, vicious beasts. In the shadows is the blurb, "The Greatest Comic Artists in the world . . . bring you Tales of Suspense, Horror, Mystery, the Unknown, the Weird!" It was the first in a series of spectacular Frazetta covers. He recalled, "I liked the idea that I could pretty much work for him and do whatever the hell I pleased. So, I saw a great opportunity there to do what I like. He was a fun guy, but also full of crap. He's a great guy, very amiable, a lot of fun. He's a cocky little guy and he bullshits you a lot, but if you know him you can handle him, no problem. He was funny. He had this routine: 'We're a team, blah blah blah.' But you know, that works for other artists—it doesn't work for me. I'd say, 'Jim, cut the horseshit, will you? I'll do the work because I love working in a larger format, and because you stay off my back. I do whatever I like, I'm going to shock you from time to time'—and I did. But he didn't care what I did—'Just do it, bring it in!' He had faith in me to not go too far out in left field."[19]

This time, while Jones is still listed as editor, Archie Goodwin is credited as story editor. George Evans and Bob Lubbers were added to the mix of artists. The issue published the first *Creepy's Loathsome Lore*, which was a series of short, nonfiction comics about figures in horror, by Goodwin and Lubbers, and another of the one-pagers by Goodwin and Frazetta. The scripts and artwork were uniformly outstanding on "Spawn of the Cat People" by Goodwin and Crandall, "Welcome Stranger!" by Goodwin and Williamson and "Ogre's Castle" by Goodwin and Torres. Of this story, Angelo Torres said, "[It was] my second job for *Creepy*. I was living in Pennsylvania then, and I got a telegram from Jim Warren praising that job, which pleased the hell out of me. It was nice that he would go to all that trouble."[20]

Former EC writer Otto Binder teamed up with Gray Morrow for "Wardrobe of Monsters!," and also contributed "I, Robot," a new adaptation of the first of his popular Adam Link stories (originally published in *Amazing Stories* from 1939 to 1942). The visual side was handled by the same artist who had drawn the EC adaptation, Joe Orlando, albeit in a much different style. The letter column had brief congratulatory letters by John Prentice and Leonard Starr (*Apartment 3-G*).

Bill Harris helped out with *Creepy* #2: "I put together the first couple of letters pages for *Creepy*. The first issue . . . didn't come out all that long after the Flintstones at the New York World's Fair book. [I also] encouraged some of the writers and artists I worked with at Western or King Features to look for work at Warren Publishing. One I recall was Ben Oda, the lettering man, who was one of my all-time favorite people. He became one of Jim's favorites, too."[21]

Creepy #3 continued with more stories of vampires, werewolves and other monsters in classic permutations. It also had a *Creepy's Loathsome Lore* drawn by Jack Davis, the only interior story (of sorts) that he did for Warren. It looked like things were operating smoothly, but behind the scenes, trouble was brewing. The artists were to be paid after delivering their work to Jones, but they weren't receiving their checks. Jones, claiming to be caught in the middle, blamed Warren for what he called a "pay freeze."[22] What seems to have happened is that Jones was distracted because he was working on other

deals, and hadn't gotten the artwork to Warren. Goodwin recalled, "Al [Williamson] helped [Russ Jones] contact a lot of the EC artists. That worked pretty well for a while but as we began producing the book more, Russ didn't seem to be taking care of the editing job and he was starting to piss people off. They weren't getting paid. Warren wasn't aware of it. As soon as he found out, he fired Russ."[23] Part of it was a matter of editorial competence, according to Bill Pearson: "It was just obvious that Russ wasn't an editor, and didn't know what he was doing. He wasn't up to the job."

Creepy #4 (August 1965). Frank Frazetta art.

Jones blamed Warren. He claimed that Warren wouldn't write the checks and wasn't answering his phone. "The mood was not happy. It got worse. When [Warren] finally surfaced, I had a big blow-out with him. Jim accused me of, quote: 'Having aspirations of being a publisher.' End quote. So, sometime in 1965, I quit. But Jim, as usual, had the last word . . . in the form of a telegram. It stated that I was fired, and could not speak to anyone who worked for Warren Publishing Company. It's true. I could no longer speak to Frank, Gray, Joe, Reed, Angelo, George, Archie, Jack, et al. It was the most absurd piece of communication I've ever received, before or since."[24]

For his part, Warren said, "Russ Jones was a professional liar, a pathological liar, who caused a lot of problems. I had to personally correct the damage, which cost me a lot of money. So, I brought in Archie Goodwin as editor."[25] All the artists with outstanding vouchers for their work in *Creepy* #2 and #3 were paid, and they continued to work for Warren. He offered the editorial post to Goodwin. It took the younger man some time to agree to take the position, since it was a full-time job, which meant he would have to quit working at *Redbook*. Warren was already predisposed to like Goodwin, from talking with him and Joe Orlando about what *Creepy* should be, when the

project was in development. (He would have hired Orlando to edit *Creepy*, but couldn't afford him.) He sensed that Goodwin didn't want a freelance job, so he offered him a one–year contract. Even if the magazine went kaput, Goodwin would be paid his weekly salary for a year. In mid-July, he invited Goodwin and his soon-to-be-fiancée Anne T. Murphy to spend an afternoon with him by the pool at the Holiday Inn at LaGuardia Airport, where Warren went to unwind on weekends. They could sign the contract there. Part of what made the deal attractive to Goodwin was that he would not only be paid a salary as editor, but could make additional money by writing scripts. This is one of the reasons there were few other writers in the early issues of *Creepy*.

With *Creepy* #4, Archie Goodwin took his place on the masthead as editor. The page count went from fifty-two to sixty pages, and would soon increase to sixty-eight. Seldom in the history of comics had there been so much superb writing and artistry presented in a brand-new title. Fandom was buzzing. Word of mouth was causing anxious readers to snatch copies off the stands as soon as they appeared. Sales across the country were good. *Creepy* had found an audience, proving there were people in their mid-teens and older who were interested in reading comics. Some may have turned away due to the lack of color, but it was obvious that plenty of readers appreciated the beauty of artwork designed for monochromatic printing.

The Comics Code never became a problem. Goodwin wrote to Ron Parker, his friend, "Since we qualify as magazines, they don't know quite what to do about us. They've made occasional remarks but appear sort of powerless to really do anything. Warren claims to be prepared should they ever try anything and periodically mumbles something about Louie Nizer. So far, we've received only one letter from a complaining parent. . . . I think we've been pretty mild, emphasizing monsters rather than gore."[26]

ONCE HARVEY KURTZMAN'S main priority was creating the *Little Annie Fanny* comic strip for *Playboy*, one might think *Help* became a shadow of its former self, but that wasn't the case. The fans of *Mad* who aspired to become cartoonists in their own right found a sympathetic, supportive editor in Kurtzman, and began filling the magazine's pages with increasing frequency.

Gilbert Shelton's Wonder Wart-Hog led the charge with his debut in *Help* #16 (November 1962), and returned in most subsequent issues. Cartoons by Jay Lynch and Skip Williamson appeared in the *Public Gallery*, a section devoted to fan-submitted work, as did those of many other up-and-coming cartoonists. Then an unassuming cartoonist named Robert Crumb showed up twice in *Help* #22.

Kurtzman had printed an adoring fan letter from Crumb in #17. When Kurtzman had a chance to review Crumb's work, he was impressed. He ran a two-page Fritz the Cat strip (without the character's name affixed) and the six-page "Harlem" sketchbook. This was Crumb's first professional work, apart from the card designs he'd done for American Greetings in Cleveland. Two

Fritz the Cat by R. Crumb.

more Fritz pages saw print in #24, and the following issue offered his "Bulgaria" sketchbook. Because *Help* published early work by Crumb, Shelton and others, it's sometimes been called an "incubator" of the underground comix movement, which took off when Crumb published *Zap Comix* #1 in 1968.

In late 1964 and early 1965, two things occurred that were seemingly unrelated, but have raised the possibility, however slight, that Harvey Kurtzman and James Warren influenced the Beatles. The cover of *Help* #22 (dated January 1965) featured the startling image of the Beatles with bald heads. At the same time, producer Walter Shenson, who was in pre-production meetings for the second Beatles movie, needed a new title for his film. The script by Allen Owun was titled *With Eight Arms to Hold You*, but this was considered ungainly. Shenson wanted something shorter and snappier. Did someone show him a copy of the bald Beatles cover on the new issue of *Help*? Certainly, the producer was interested in "all things Beatle" at this time, and the cover was arresting enough to elicit his attention. In any case, a few weeks later the film was retitled *Help!* (exclamation point and all), in turn requiring the Beatles to provide a song by that title. Was all this set into motion by

the cover of the Warren publication? Kurtzman chalked it up to coincidence. Beatles authority Mark Lewisohn isn't so sure: "I've not heard of any connection between *Help* magazine and the film title," he said, but added, "I've a feeling it was more than coincidence, but have no proof either way."[27]

Beyond the cartoons, the most popular features in *Help* were the fumettis. The best fumetti of them all appeared in #24 (May 1965). It was the fourteen-page "Christopher's Punctured Romance," the

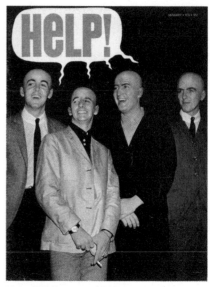

Help #22 (January 1965).

story of a man who is sexually excited by his daughter's Barbie doll. The father is played by John Cleese, from a script by Dave Crossley and photos taken by Martin Iger. Cleese and *Help* associate editor Terry Gilliam would meet again in England a few years later, and became founding members of Monty Python's Flying Circus.

Like Kurtzman, Warren became less involved in the later issues of *Help*. He argued that some of Kurtzman's cover ideas were too obscure to catch the eye of newsstand browsers, but his objections fell on deaf ears. "My feelings about Harvey deteriorated to the point where I put less energy into the magazine," he said. "I stopped caring."[28] Yet he kept *Help* going even though its losses drained profits from *Famous Monsters of Filmland* and Captain Company. Why? "A little thing called hope. I kept hoping that it would gradually improve and become a success, and then, I would have told Harvey to go find someone to buy me out."[29]

Kurtzman: "We just couldn't make the thing . . . grow. We didn't have much business success but we had a grand time making acquaintances and meeting people."[30] *Help* #26 (September 1965) was the last issue. When Terry Gilliam quit in 1965, Kurtzman had offered Robert Crumb the job as his

new editorial assistant. But, by the time Crumb moved from Cleveland to New York and reported for work, he found the magazine closing its doors. According to Crumb, when he walked into the *Help* office, he found Kurtzman looking forlorn as workmen were taking out file cabinets and desks.

"What's happening?" Crumb asked.

"Warren decided to fold the magazine," Kurtzman replied. "It wasn't making enough money. I'm sorry. I really feel bad about it."[31] To try to compensate, Kurtzman found Crumb jobs in New York in commercial art. Crumb always spoke highly of Kurtzman in the coming years, and worked with him again when the opportunity arose.

Warren's last word on working with Kurtzman on *Help* came in an interview years later: "We should never get too close to certain things that we love. We should view them from a distance. You view them from afar and you worship them and idolize them. But don't get close, because then you see the warts, and you see the seams that are bad. Suddenly your idol has feet of clay. And that happened with Harvey and me. He's still a genius and I respect him, but I didn't like Harvey Kurtzman as a person. He couldn't reconcile the fact that he had a deal with the guy who published *Famous Monsters*, and has people around him like Forry Ackerman. Harvey liked to associate with top talents, like Jack Davis, Arnold Roth and so on, and looked down on anyone who was less talented than he. He was a snob that way. *Help* was never a 'class' magazine, and 'high class' was very important to Harvey."[32]

Along with canceling *Help,* Warren also ended his distribution arrangement with Kable News. He was unhappy with them for many reasons, so he took his business to another lower-tier outfit called PDC. His first magazine distributed by PDC was *Creepy* #5, which showed up on newsstands in August 1965. *Famous Monsters of Filmland* made the switch with #35 at about the same time. *Monster World* followed suit with its fifth issue. Stung, Kable News made arrangements to have their own *Famous Monsters.* They hired Russ Jones and Lee Irgang to put together a similar magazine.[33] *Monster Mania* #1 was handsome enough, but it wouldn't stand the test of time. Like all the other *FM* imitators and competitors, it had a short lifespan, landing on the same ash heap as other such failures.

At the 1965 New York Comic Convention, Warren talks with Woody Gelman while Bill Harris (with pipe) looks on. Courtesy of Jean Bails.

By the time Archie Goodwin and Anne T. Murphy decided to get married, three weeks after Goodwin was working full-time for Warren, Murphy had come to some conclusions about her husband's employer. "I think Jim had a vision of himself as the guy who had everybody's number and who understood motivation, who could step in and get people to do what he wanted. I sensed he had an image of who I was based on one or two characteristics, and, in fact, I don't think he knew at all who I was. I sensed he created a stereotype, a central casting version that defined for him who you were."[34] In turn, Murphy didn't think she or Archie really knew Warren well, only the persona that Warren showed the world.

At the end of July 1965, comics fan David Kaler threw the first "full service" comic book convention, held at the Hotel Broadway Central in New York City. Unlike the first such gathering in the city the prior year, which took place in a single afternoon, this one sprawled over multiple days at a hotel where participants stayed, and, in addition to the dealers' room, masquerade and art show, offered programming in the form of panel discussions with prominent professionals and fans. One panel was titled "Comics and Fandom, Where Do We Go from Here?" On the dais, Rick Weingroff represented fandom, and Roy Thomas, James Warren and Murphy Anderson represented Marvel, Warren and DC comics, respectively. Warren's comments sparked outrage among many in the audience: "Let's get back to the basis of the discussion, which is, 'What good is fandom to publishing?' . . . At the risk of being attacked, I don't think fandom means one damn when it comes to publishing, and I'll tell you why. As I look out on most of you—excluding the first row, who are all pros—I'm not looking at an average bunch of kids who spend 10 cents or 25 cents for a comic book. I'm looking at a group of educated, higher-mentality-than-average, literate collectors, sort of junior Woody Gelmans.

"What kind of influence do you have for the publishers? None! Don't let any publisher ever tell you [that] you influence him. You don't. Stop shaking your head. I'm not finished. Now, I'll tell you why I say this." He talked about how he let Forrest Ackerman be guided by reader requests for a "personality publication" in 1963, and how sales had dropped as a result. "Most fans have absolutely no conception of the economies of publishing. When it all comes down to it, the help and the contributions that you make to publishing can be put into Mickey Mouse's watch pocket." He added, "Fans, I can do without, economically. Readers, I can't."[35]

CHAPTER SEVEN

ON THE FIRING LINE

BEFORE JAMES WARREN FIRED Russ Jones in early 1965, he had decided that his next magazine should be a hard-hitting war comic like those written (and sometimes drawn) by Harvey Kurtzman for EC. As the publisher examined issues of *Two-Fisted Tales* and *Frontline Combat*, he recognized the high quality of the stories and artwork and sensed that current events would have special relevance for a new generation of teenagers and young men.

On August 7, 1964, the United States Congress passed the Gulf of Tonkin Resolution, giving President Johnson the authority to send military forces to Southeast Asia. As 1965 arrived, American media provided daily updates on the preparations for the impending deployment. Although there was no formal declaration of war, 3,500 United States Marines were sent to South Vietnam on March 8, 1965. Public opinion in the country supported the action, but some, like Warren, remembered that the Korean War, also undeclared, resulted in 36,574 Americans killed, 7,926 MIA and over 100,000 wounded. He knew from his own brief stint in the army that military operations can change a person's entire life—assuming they survive at all—in a single moment.

One reason he opposed the war in Vietnam was because he didn't believe in the concept of "limited war." He felt that if the US was going in, it should do so decisively and quickly. However, Warren had been fascinated by military operations and strategy all his life: "I came to the subject rather naturally. I'm

the kind of guy that loves guns, hates bullets. A lot of people will say that's impossible, but it's not impossible. I've studied the great campaigns. I've studied modern warfare. I know how it's absolute sheer hell. That's the part I hated. The massing of men and the ability to command men and the ability to command a small unit from a squad up to a division and the type of talent that that took always mesmerized me. And so [*Blazing Combat*] came natural to me because the subject was my hobby. I didn't pick it because it was my favorite subject, I picked it because it was one of my favorite interests. And, that may be tough to understand."[1]

Archie Goodwin: "I don't know if it was [Russ Jones's] idea or Warren's idea to do *Blazing Combat*. When they first came to me about working for it, it was before Russ departed. My feeling is that probably between the two of them, they were talking about doing more titles and they thought if there seemed to be some interest in the EC horror type material, why not also try something like the EC war stuff?

"Anyway, I think the initial reaction to *Creepy* was good enough that Warren and Russ Jones . . . began looking around immediately for other EC style material that they might do in the same kind of black-and-white comic book format.[2] When I heard from Russ that that's what they were interested in doing, I was incredibly enthusiastic because—as an EC fan, while I loved all the EC books—the war stuff was always my favorite. So, I kind of leaped up and down at the chance to do the material. I think even as we were working on the second and third issues of *Creepy*, I probably began writing a script for *Blazing Combat* #1. I did four or five of them over one weekend and then the next two or three over a couple of months, as I was doing other material."[3] Goodwin assumed editorship of the magazine at the same time he agreed to edit *Creepy*, and named it ("an exciting variation on *Frontline Combat*"). Earlier working titles were *This is War* and *Two-Fisted Combat*.

Joe Orlando, as Warren's confidante at this time, was probably the first artist who heard about it, and quickly asserted his interest in doing the Vietnam-based stories. He told Goodwin, "If you need anything on Vietnam, let me do it because I've got a lot of photos for swipe and research."[4] Shortly thereaf-

ter, John Severin, a mainstay of the Kurtzman EC war comics, came aboard: "When [Kurtzman] went over to Warren and they were putting out *Help,* I did a couple of things for him over there. And as a result of this, I sort of ended up, when Warren started doing those comic books, getting into them.[5] I love black and white. I hate color. Unless you start out with nice slick paper and you're going to

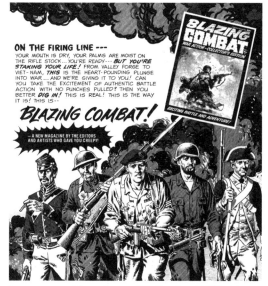

Announcement from *Creepy* #5 (October 1965): John Severin art.

give it a real color job, forget the color. I like black-and-white movies. You know what it is? I'm colorblind. I like black and white much better. I think you can do more with black and white. And unless you're going to try to be . . . an honest to god artist and paint your comic story—and some guys have done that and succeeded very well, Rich Corben being one—in general I would rather see it in black and white."[6] Severin created an illustration for the promotional page announcing the magazine in *Creepy* #5, which ran just five months after the deployment of ground troops to Vietnam.

Blazing Combat #1 begins with a story with an opening caption and title that reads, "Come with us to the Indochinese peninsula where continuous war has become a way of life since World War II . . . Your guide will be First Lieutenant Dave Crew, US Army advisor to a south Vietnamese infantry battalion . . . Come with us on a patrol to hunt . . . Vietcong!" Crew's narration conveys the hopelessness of the war even at that early stage, due to the guerilla tactics and size of the North Vietnamese Army, and the way the South Vietnamese troops, in their use of pointless torture which didn't elicit usable information, are almost as bad as the Vietcong.

In addition to "Enemy!" drawn by John Severin, two other artists who worked on the EC war comics are represented in the first issue. "Flying Tigers!" was by George Evans (with an assist from Al Micale), and "Cantigny!" had visuals by Reed Crandall. All turned in exceptionally fine jobs, as did Angelo Torres on "Aftermath!," and Gray Morrow on "Long View!" The only weak entry, art-wise, was a hodgepodge art job on "Mad Anthony!" by Tex Blaisdell, Russ Jones and Maurice Whitman. (Jones was the only one to sign the splash panel.)

Letterer Ben Oda designed the magazine's title logo based on a suggestion from Goodwin, who said, "It was my idea to do the flames inside it."[7] Oda did the interior lettering as well. Frank Frazetta painted the covers of all four issues of *Blazing Combat*. Warren: "Frazetta never delivered a job like I expected it. It was always 25 percent better. Or more. He never delivered what I thought. I was expecting an eight and he would deliver a twenty-seven. Every single time."[8] Goodwin recalled, "I don't think Frank ever, to any great extent, did cover sketches or layouts or anything. We would generally discuss a few ideas and next he would show up with a finished painting."[9] Frazetta's painting style, as applied not to fantasy but to real-world war, produced images that had a more visceral, hard-hitting quality.

All of *Blazing Combat* #2 was written by Goodwin. The stories were set in Vietnam, the American Revolution, the Civil War, World War I, World War II and two in the Korean War. Two new artists were added to the mix: Al Williamson (inking Angelo Torres on "Kassarine Pass!"), and Alex Toth ("Lone Hawk"). Toth loved working in black and white, which lent itself to all sorts of inking approaches. Two of the stories were drawn by Joe Orlando, including "Landscape!," another tough opener set in Vietnam.

In "Landscape!," a simple Vietnamese rice farmer watches as people in his village are first overrun by the Vietcong, then by the South Vietnamese army with the Americans. Both claim to want to make life in his village safer, yet both are destructive. He and his wife are killed by unidentified crossfire as the Americans prepare to burn his rice field for strategic reasons. The last panel shows the farmer's hat floating in his rice paddy. Goodwin: "When that issue came out, whoever reviews the books to approve them for

The Best from Famous Monsters of Filmland was published by Paperback Library in June 1964. By then, the "monster craze" was in full swing.

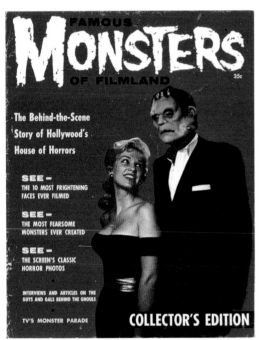

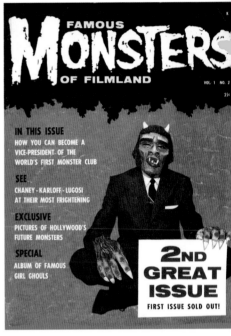

Top: *Famous Monsters of Filmland* #1 and #2, with James Warren wearing the monster masks. Bottom: *FM* #36 (art by Vic Prezio) and *FM* #94 (Sanjulián).

ILLUSTRATED TALES TO BEWITCH & BEDEVIL YOU

VAMPIRELLA

A WARREN MAGAZINE PDC $1.00 588856

VAMPI #19 SEPT. 1972

SUPER SPECIAL ISSUE

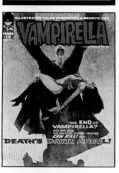
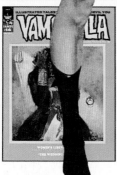
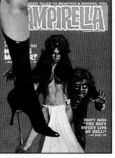
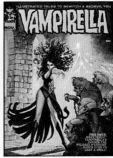

Vampirella #19 (September 1972) features the iconic, full-figure portrait of the vampire heroine by José González and Enrich Torres.

Top: *Favorite Westerns of Filmland* #2 (art by Jack Davis) and *Help* #1 (featuring comedian Sid Caesar), both cover-dated August 1960. Bottom: *Monster World* #1 and *Screen Thrills Illustrated* #8.

THE WORLD'S ONLY SPACE-MOVIE MAGAZINE

SPACEMEN
1965 YEARBOOK

50¢

Spacemen 1965 Yearbook. Art by Wallace Wood.

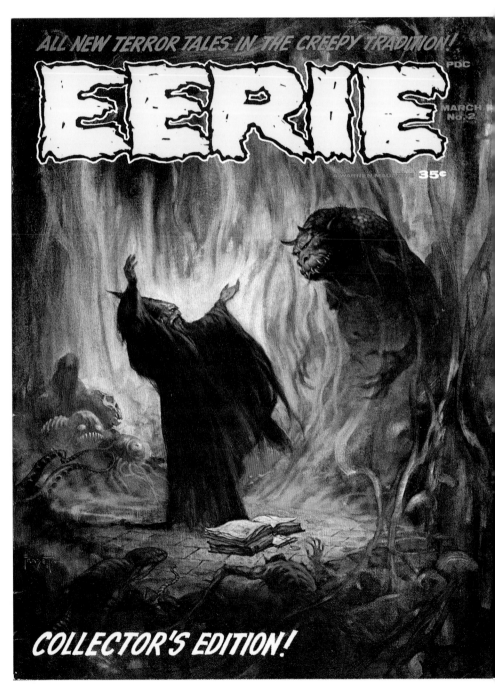

Frank Frazetta painted images. Above: *Eerie* #2. Opposite, top: *Creepy* #7 and Uncle Creepy portrait. Bottom: *Creepy* #9 and *Eerie* #3.

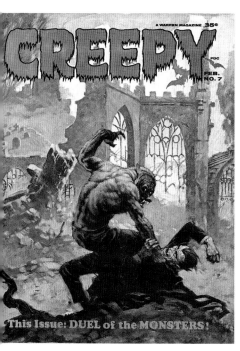

A WARREN MAGAZINE 35¢

CREEPY
PDC

FEB.
NO. 7

This Issue: DUEL of the MONSTERS!

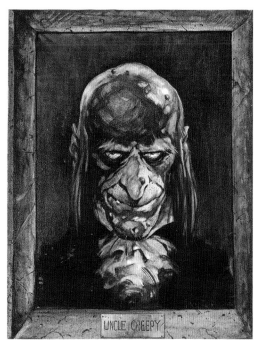

UNCLE CREEPY

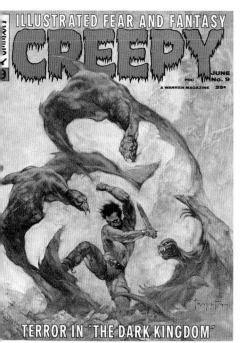

ILLUSTRATED FEAR AND FANTASY

CREEPY

JUNE
PDC No. 9

A WARREN MAGAZINE 35¢

TERROR IN "THE DARK KINGDOM"

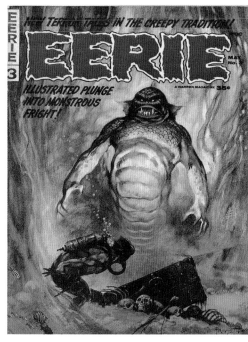

EERIE 3

NEW TERROR TALES IN THE CREEPY TRADITION!

EERIE
PDC

MAY
No. 3

A WARREN MAGAZINE 35¢

ILLUSTRATED PLUNGE INTO MONSTROUS FRIGHT!

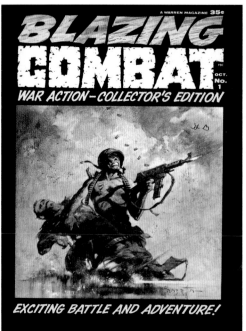

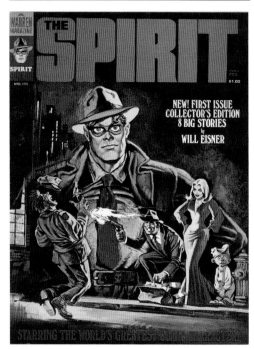

Top: *Blazing Combat* #1 (Frank Frazetta) and *1984* #4 (Patrick Woodroffe). Bottom: *The Spirit* #1 (Will Eisner and Basil Gogos) and *The Flintstones at the New York World's Fair* (1964).

Panels from "Landscape!" in *Blazing Combat* #2 (January 1966): Joe Orlando art.

distribution on military bases turned it down because the story made it look like—according to Warren's version of what he was told—it made it look like US soldiers were killing innocent civilians."[10] (Actually, only the Vietcong are shown killing civilians in the story.)

Work continued on the quarterly magazine. When interviewed by J. Michael Catron in 1993, the publisher recalled, "The staff consisted of Archie and myself. I see in front of me, crystal clear, the duplex penthouse apartment where we did this. Archie worked in what was the dining room, next to the kitchen. [He] always had the same thing for lunch [which] drove me insane. Archie Goodwin is the only human being on the face of the Earth who has had the same thing for lunch for forty-five years—a tuna fish sandwich!" Even though Warren heard right away that there were problems with military bases not taking the second issue, Warren remained hopeful. Meanwhile, he used the profits from *Creepy* and *Famous Monsters of Filmland* to keep *Blazing Combat* going, and to finance the launch of *Eerie* at the end of the year.

WHEN WARREN MADE HIS CONTENTIOUS APPEARANCE at the 1965 New York comic con, he had three comics-related magazines on the stands: *Blazing Combat* #1, *Creepy* #5 and *Help* #26, the final issue. He had switched to a new distributor. It was a time of transition for his company. He wanted to publish a Sherlock Holmes magazine with Reed Crandall

as the lead artist, but was unable to get the rights from the Arthur Conan Doyle Estate. One new magazine was already set: a twin for *Creepy*, like he had for *Famous Monsters*. After a debate among Jones, Goodwin and Warren, they chose the title *Eerie* from a list of possibilities that included *Ghastly*, *Spooky* and *Macabre*. It would be his fifth current title. Then a problem arose. According to Goodwin, they were "giving out scripts for it, so that we'd be ready to bring it out in October [1965]. Then Warren got a report from friends working at the distributor that a print order had gone through for a magazine called *Eerie*, but from a publisher other than Warren. This proved to be true. The rival publisher (Myron Fass) maintained his *Eerie* was ready to go and would be on sale in September, and would not give up the title. The president of [PDC] backed Fass up."[11]

Warren and Goodwin quickly put together a twenty-four-page, digest-sized "ashcan" edition (created not for distribution, but for the purpose of securing a copyright) with the title *Eerie*. The covers were black and white, and the interior stories were stories scheduled for *Creepy* #7 and 8. "It was . . . more like a fanzine than anything else," Warren said. "But, it had some very important information on it. On the cover, it had the title, *Eerie*, and . . . it had 'copyright, Warren Publishing Company' and the date. We immediately registered it at the Library of Congress. We sent a special messenger down by plane from LaGuardia Field to Washington and there was a man there in Washington waiting for him. He took the packet, ran to the Library of Congress [and] had it copyrighted. We sent out . . . about 500 copies to Philadelphia, New York, Chicago, Boston, Los Angeles, Detroit, St. Louis. We had agents—actual friends of ours in these cities—sell them on newsstands. We had attorneys there, taking a notarized affidavit that the book was sold off the newsstand and someone bought it. We did this in all these states. The copyright laws in this country are such that after you have interstate commerce on that, you are protected. We did this four hours before [Fass] was to go to press. Four hours. And we got his ass."[12] Did he really have attorneys at the ready in all those cities? Unlikely. But he could do this himself in New York and Philadelphia, and Los Angeles (through Ackerman). In any case, Warren and Goodwin wouldn't have to change their intended name for the

new magazine. Fass changed the title of his magazine to *Weird*, which turned out to be entirely made up of reprints of third-rate horror stories from comics published a decade earlier.

The "collector's edition" of *Eerie*, which had to be #2 due to the ashcan, was published in late December 1965. Its schedule, like *Creepy*'s, was bimonthly. In its contents, it differed only in its title and its horror host. At Warren's request, Jack Davis drew the round-faced, paunchy Cousin Eerie to resemble Charles Laughton, the fleshy actor who had starred in *The Hunchback of Notre Dame* in 1939. The bickering, competitive relationship between Cousin Eerie and Uncle Creepy began on the "welcome" page of *Eerie* #2. Eerie claimed his stories would be "even more bloodcurdling (Unc's not as young as he used to be)." Uncle Creepy riposted, "Don't let Fatso fool you . . . these fairy tales couldn't curdle milk, let alone blood!" However, Creepy conceded, "It may be better than fixing your horror habit with a (choke!) competitor's slimy servings."

In truth, the stories were interchangeable, but hardly a cause for complaint when one considers that *Eerie* #2 alone offered artwork and stories drawn by Crandall, Torres, Morrow, Orlando, Severin and Toth. It added two new artists to the mix: Gene Colan, who was six months into penciling the Sub-Mariner stories in Marvel's *Tales to Astonish*, and Johnny Craig (under the pen name Jay Taycee) who had written and drawn many of the finest stories in EC's *Vault of Horror* and *Crime SuspenStories*. It would be hard to imagine two more different artists: Colan, wild and free; Craig, tense and focused. Another artist new to Warren showed up first in *Eerie*: Steve Ditko.

Ditko was three months away from ending his stint as storyteller and artist of *The Amazing Spider-Man* when he came to Warren. He had co-created the web-spinner, and is now considered the third most important architect of the Marvel universe (after Jack Kirby and Stan Lee). He craved creative freedom and a new challenge, and found both at Warren. Ditko had many admirers, but none were prepared for his stunning work on "Room with a View" in *Eerie* #3. Inspired by the possibilities of the black-and-white presentation, he worked with pen and brush to create detailed images and shading effects like nothing he had done before. The issue's second claim to fame was a

special interior piece drawn by Frank Frazetta: a half-page, antismoking comic strip called "Easy Way to a Tuff Surfboard!" In *Eerie* #29 (September 1970), Warren wrote: "Created at our own expense, this half-page comics format ad (written by Archie Goodwin, drawn by Frank Frazetta) has been running in all Warren Magazines for the past five summers. It doesn't help sell our magazines, but we run it because we believe the message is important (more important than advertising revenue)—and deserves exposure in our pages."

He later expounded on his anti-smoking views: "One cannot get into the army at the tender age of nineteen, twenty, and not smoke. I was always fast as a kid [but] I found that the smoking took my wind away. I gave it up during basic training. I turned down $50-60,000 a year in 1970 dollars . . . on advertising because Liggett & Myers, Phillip Morris, the biggies, wanted to buy all our back covers. And I said no. It was very tough to turn down back covers, full covers, and also inside back covers, for cigarette ads, if they're waving that kind of money. I would never do that. It was bad for health."[13] The first time, and as often as possible in later reprints, he put the beautifully rendered public service message on the slick paper of the inside back cover where it would look its best. "Easy Way to a Tuff Surfboard!" qualifies as the last sequential piece of art from Frazetta, who was, ironically, a smoker.

BLAZING COMBAT #3 RAN A LETTER from Richard Kyle, the prominent comics fan who coined the terms "graphic story" and "graphic novel," which (presumably edited for the magazine) consisted of one question: "Do you seriously expect to make money with a war magazine that publishes nothing but antiwar stories?" Archie Goodwin responded, "Naturally, we are in business to make money, but it is our hope that *Blazing Combat* will sell because it is well-written, well-drawn and presents a realistic viewpoint of what war is like without insulting the intelligence of our readers. With the above exception, our mail indicates we are on the right track." He then followed with a couple of letters that expressed appreciation for a war comic "that shows what war really is."

Goodwin didn't realize the extent of Kyle's dislike for the Warren magazine. A few months later, in his *Graphic Story Review* column in the popular fanzine

Top: "Room with a View!" in *Eerie* #3 (May 1966) was Steve Ditko's first story for Warren. Bottom: The Goodwin-Frazetta "Easy Way to a Tuff Surfboard!" appeared in Warren magazines for years.

Fantasy Illustrated (#5, Spring 1966), Kyle wrote, "*Blazing Combat,* in . . . its morbid obsession with grotesquely unreal fantasies of war, its basic contempt for humanity, is not a magazine—by its very nature—to attract a genuinely wide audience, nor a healthy one." Kyle said they were a desecration of the Harvey Kurtzman legacy, without mentioning Goodwin by name anywhere in the piece. According to Goodwin's friend, John Benson, he was hurt by the column. Although it falls into the category of a "hatchet job," it may have been right in suggesting that the magazine could alienate some who wanted to read stories of "exciting battle and adventure" as promised on the cover. Between that and being banned from army bases, *Blazing Combat* was fighting an uphill battle, one that it wasn't winning. Nevertheless, Warren chose to continue: "After I got the sales reports on the second [issue], I had a pretty good hunch that we were in deep trouble, but, in all fairness to the work that Archie put in, I said, 'I'm going to sacrifice some money,' cause maybe it'll catch on, maybe those wholesalers will just forget about it, maybe we'll be okay.'"[14]

Blazing Combat #3 (April 1966), which debuted in the last week of January, offered the first of two stories for the title drawn by Wallace Wood: "The Battle of Britain!" It also had Colan's excellent "U-Boat," which showed the artist's talent was especially well suited to the ink wash technique. It also featured "Survival," a fine outing drawn by Alex Toth. Occasionally, one of Toth's experiments went wrong. One example is "The Edge" in *Blazing Combat* #4. He was returning to the territory he'd explored earlier with writer Harvey Kurtzman on the story "Thunderjet!" in EC's *Frontline Combat*: aerial warfare during the Korean War. In such stories, the jet planes are shown with just the sky as background. Toth said, "I liked 'The Edge,' but it suffered technical problems. My tones didn't reproduce on two of its pages . . . I used graded felt-tip markers for the cloud formations, and they washed out in the printing process. They were too light for the process camera to pick up."[15] Nevertheless, its writing and art were perhaps the most Kurtzman-esque of all of the *Blazing Combat* stories.

Top rate art jobs in #4 by Gene Colan, George Evans, Wallace Wood, John Severin and Angelo Torres are superseded by two that are especially notable. The first is "Thermopylae!," an eight-pager suggested and plotted by

Reed Crandall, which is, in essence, the same story that made up the center of Frank Miller and Lynn Varley's *300* graphic novel. Leonidas and three hundred Spartans attempt to buy time for other Greek armies to prepare for battle by repelling King Xerxes and his Persian hordes "sweeping through the north, pushing on toward Athens" at Thermopylae. A meticulous recreation of that battle by Crandall was framed by a page at the beginning and end rendered in wash tones, with two British soldiers in Greece during World War II discussing the Spartan battle, and taking heart from it. Fortunately, an editorial error in the story was fixed at the last minute, thanks to Archie's wife, Anne T. Murphy: "When Archie was working at Warren, I occasionally used my editing experience. I remember looking at the 'Thermopylae' story, ready for printers, and I said, 'Gee, where's the 'Y'?' Archie freaked!"[16]

The other outstanding art job in the issue is Russ Heath's work on Goodwin's otherwise unremarkable "Give and Take." American soldiers in 1944 push northward in Italy against savage German defensive action. The son of an Italian American winemaker in Fresno is thrilled to find one intact bottle of rare wine in the basement of a decimated farmhouse. When the enemy suddenly approaches, the Americans are forced to escape out the back door. The vintner's son can't leave the bottle of wine behind, and when he goes back for it, is killed. In the end, the dead soldier's friend smashes the bottle in anger and disgust.

Heath achieved uncanny realism in his rendering of the figures by using Craftint paper to add two gray tones to the regular line art. (The artist alternately applies two different liquid chemicals which activate hidden shading patterns imprinted on the special drawing paper.) He did this masterfully, borne of careful planning. When this is used on drawings based on photographs (which Heath had taken and even posed for, among others), the realistic effect is further enhanced. This meticulous work matters because his storytelling—the way the figures move through the panels, the use of close-ups and longshots, and so on—is done with consummate skill. Its two usages of the three-panel triptych to fix the eye and control the passage of time hark back to Kurtzman's use of this technique in the EC stories.

Blazing Combat ran a total of twenty-eight stories (plus a two-pager) in four issues. They were all short, mostly six and seven pages long. Six of

Last page of "Give and Take" in *Blazing Combat* #4 (July 1966). Story by Archie Goodwin, art by Russ Heath.

them are airplane stories. There were four stories each drawn by Crandall, Orlando and Severin, three each drawn by Toth and Torres, and two each by Morrow, Colan and Wood. While Goodwin only emulated Kurtzman in a few instances (apart from the large single-word story titles), he trod similar ground in terms of the war-is-hell message that came through loud and clear. From a creative standpoint, the magazine was a success. Or, more accurately, a *succés d'estime*, apart from Kyle's critical column.

Warren discussed the distribution and other problems that made the magazine's cancellation inevitable.[17] "The life or death of a publication—of our creation—depended on the whim of a wholesaler. I have to say that the wholesalers were not in danger of putting Einstein out of business. When a first issue came out from a small publisher, a tiny publisher like Warren, they really didn't pay too much attention. They didn't even know what the hell it was. They couldn't care less what it was. Problems started with the second and third issues when word got out what the content was.

"The people who saw that we were taking a negative attitude against what they thought was another World War II thought that we . . . were anti-American and we weren't supporting the war. And the story that I got back was that the American Legion, which was very much gung ho for Vietnam or any conflict involving American boys at that time, looked on us and saw us as traitors to our own country. I think that happened with the second issue." Warren seems to be suggesting that the American Legion was somehow behind the banning of *Blazing Combat* on military bases, and may have conducted a whispering campaign among wholesalers, labeling the magazine unpatriotic and un-American. "The sales were terrible. They were terrible with the third and, of course, they were terrible with the fourth."

No one—not the distributor, the wholesalers, the US Army or the American Legion—told Warren why the magazine was sabotaged before it could get to readers. "The people who were responsible for it didn't have the courage to write me a letter, or telephone me or tell me to my face at the conventions I attended—the distributing conventions or whatever—that I was un-American and that I was doing a shameful thing. It was done *sub rosa*." *Blazing Combat* was dead, and that was that.

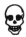

CHAPTER EIGHT

AN EMPIRE OF MONSTERS

WITH THE DEMISE OF *Blazing Combat*, Warren's line consisted entirely of monsters and horror: *Famous Monsters of Filmland*, *Monster World*, *Creepy* and *Eerie*. He had tried other kinds of magazines, but none of the other subjects clicked with the public. The humor sector was sufficiently served by *Mad*, *Cracked* and *Sick*. Western movies and comics had lost favor with preteens and teens. SF and fantasy films weren't being produced in sufficient numbers and quality to ignite mass interest and justify a magazine about them. Hence, providing frightening images and stories was the only rich vein available to him, because horror was one sector of entertainment that the massive baby boom generation couldn't readily find on neighborhood newsstands.

Even the appeal of monsters was beginning to falter. In the spring of 1966, both *The Addams Family* and *The Munsters* TV shows lost steam and would not be renewed for another season. The *Batman* TV show captured the youth market after its debut on January 12. Softer sales numbers for his monster magazines caused Warren to cancel *Monster World* with its tenth issue in mid-June. *Creepy* and *Eerie* continued to do well under Archie Goodwin's editorship. The unlikely chemistry of Warren and Goodwin worked. He respected Goodwin as an editor and writer, and Goodwin never seemed fazed by Warren's unpredictable, often confrontational behavior. Warren: "Archie and I were fans of Fred Astaire. We both fell in love with this guy at a young

age. We knew every movie he was in, every song he ever sang. I didn't think there was anybody but me [who loved Astaire] and suddenly I found out Archie was the same kind of guy. Go figure."[1] Comics artists who comprised a second wave of top professionals to enter into the Warren domain became a major factor in ensuring readers' ongoing interest, by providing new visions and visual variety to *Creepy* and *Eerie*. Three of the most important were Alex Toth, Steve Ditko and Gene Colan.

About the same time Alex Toth began doing work for *Blazing Combat*, he arrived in the pages of *Creepy* #5 (October 1965) with "Grave Undertaking," a tale of grave robbers set in 1820 England. This gave him the opportunity to create believable period atmosphere and, because much of the story took place at night, panels full of shadows. It had its experimental aspects, but was positively sedate compared to "The Stalkers" in #6 (December 1965), which had panel borders at crazy angles, and lettering (by Toth) that matched the angles in each panel. Yet, as wild as the work appeared, the story's readability is intact. It signaled that Toth would vary his approach to each tale, and stretch the limits of page layouts to the breaking point. Many of his pen lines are thick, suggesting that he may have been drawing the pages smaller than double-size, the usual size at the time. Yet this is belied by perhaps his most impressive, detailed, subtle art job for "The Monument" in *Eerie* #3 (May 1966). He lent his talents to a total of six horror stories during the Goodwin period. He would return for a longer stint almost a decade later, and with an even more experimental bunch of stories. Toth thrived in the atmosphere of creative freedom, and as a result, his body of work for the publisher is among his best and most highly regarded.

Steve Ditko followed his "Room with a View!" debut in *Eerie* #3 with fifteen more dazzling strips in consecutive issues of the Warren magazines, most of them employing India ink wash tones. His next story was "The Spirit of the Thing!" in *Creepy* #9, the first of the painted stories. It was a good first attempt, but when Ditko saw it in print, he adjusted his painting technique and stayed away from the darker tones. His wash tones improved with each story until he had completely mastered the technique. Again, it was the freedom at Warren that allowed Ditko to try something new, and

"The Monument" from *Eerie* #3. Art by Alex Toth.

the results were stellar. He didn't entirely eschew straight pen and ink. "Collector's Edition!" in *Creepy* #10 is probably his ultimate effort in pure line art, putting as much shading and detail into it as did Reed Crandall, the other exemplar of that approach.

Panel from "Where Sorcery Lives!" in *Creepy* #14. Art by Steve Ditko.

If anyone was born to work in wash tones, it was Gene Colan. Inkers never knew how to delineate his pencil work because it was so impressionistic, and often lacked clear-cut hard outlines. His work for Warren, beginning when the publisher expanded to a second comics title, was a revelation, and generated a great deal of interest and admiration among readers. "To Pay the Piper" in *Eerie* #2 was the beginning, and "Fitting Punishment" in *Creepy* #8 followed. After doing two stories in *Blazing Combat*, Colan began contributing to *Eerie*, which became his home. Colan had stories in ten issues in a row. Some appeared to be done rather quickly, but all were visual treats. Perhaps the wildest in both subject matter and layouts was "Hatchet Man" in *Eerie* #4.

The working methods of Warren and Goodwin took on a pattern. Many of their editorial meetings took place in the penthouse apartment. It was, Goodwin said, "a moment I would always look forward to once a month. We would get the cover engravings and Jim, who liked to sleep late, would come down out of the shower with a bath towel wrapped around him and usually with shaving cream on his face, to go over the cover engravings with us."[2] The period when all the covers were painted by Frank Frazetta was coming to an end. Warren paid $250 for such paintings, but refused to return the original art except to Frazetta, who insisted on it. Goodwin: "When I worked for Warren, there were no creator rights. I would nag Jim Warren that we should give back the original artwork. I could never make him budge on it."[3]

The first non-Frazetta cover (apart from Jack Davis's cover on *Creepy* #1) appeared on *Creepy* #8 (April 1966). The artist was Gray Morrow. He liked working with Goodwin: "Archie was generally encouraging about everything. He was one of the most receptive and pleasant editors I've ever worked with. I had noticed the popularity of sword and sandal movies then enjoying a big following and suggested we do a Conan/Steve Reeves type of story instead of the usual vampire, witch or werewolf tale. Goodwin agreed and did "Dark Kingdom" for *Creepy* #9. My first cover for Warren was for *Monster World* [#5, October 1965], the Tor Johnson one. Sometimes on *Creepy* and *Eerie*, the assignment was to do a cover based on this interior story, or sometimes it was a suggestion of my own. Usually the media was acrylic. Sometimes colored inks. I think I usually had a week or two to deliver them."[4]

Morrow, like a lot of people, was a bit dumbfounded by some of his publisher's behavior: "Jim Warren was a rather flamboyant person, given to attention-getting outbursts such as firing off a blank pistol at one of his parties to make an announcement, slumping around in robe and pajamas in mid-day, having a round bed and a fridge full of Pepsi, and wearing a Mercedes-Benz emblem for a belt buckle. Eccentric, yes! But, certainly colorful."[5]

Anne T. Murphy was unimpressed by what she considered Warren's pointless attempts to impress: "Jim once insisted on taxiing us two blocks for a business dinner. It's acceptable if people are on crutches, but this is New York! Let's face it, Jim Warren thought he was Hugh Hefner and he really wasn't. It was a big deal when they sent out for grilled cheese sandwiches on the expense account. He didn't have to aspire to be Hefner."[6]

Nevertheless, appearing in his magazines meant rubbing shoulders with the best in the business. Warren respected the creative people who worked for him: "I never clashed with an artist. You either give them the job and get out of the way, and if you're going to have to come and say, no, this should be this way, this way, this way—then don't use him. Either accept it the way it is, or else. I would never clash. I never clashed with any of my guys. Never. Because when you do, you're telling them what to do with that hand. And you don't do that to an artist."[7] When asked if he had artists redraw panels, he replied, "Not often. I would ask them to do something in a certain way,

but never re-do a panel. I think that's demeaning. When they're out of the room, I'd redraw it, and they never knew it."[8]

He understood that publishers and creatives were fated to have conflicts. "Creative people are different than non-creative people. They are childlike in their attitude towards life. I didn't say immature. I said childlike, because children create. . . . I've rarely met a good, creative person who didn't have this, a little bit of childlike attitude, a sense of wonder. It's a magnificent thing."[9] But this childlike quality meant they "don't have a sense of reality when it comes to the common, ordinary things that businessmen take for granted, like money, profit, etc. And I don't think creative people will ever change. And if you took that away from them, they wouldn't be creative. There will be a constant grinding. . . . This has gone on for a long time. I'm sure that Michelangelo felt screwed by the Pope after he did the Sistine Chapel because he didn't get reprint rights or whatever. He didn't have a big sign out front saying 'Sistine Chapel. Painted by Michelangelo.' This goes on all the time. I've had discussions about this with Ray Bradbury and other great [talents], and I accept it.

"Guys like me create work for guys like them. What that means is the publisher has to exist and beat his brains out every waking hour in order to create an atmosphere and a structure to employ creative people. Conversely, if there is no creative guy, then the publisher goes into something else. The entrepreneur can usually survive. The creative guy cannot survive unless there's somebody to have a place to show his creative work. Got to have the entrepreneur. You've got to have the guy who puts his money where his mouth is. There's an imbalance, but yet the two of them have to exist side by side. There will never be any great love or respect or understanding between the two."[10]

Yet, Warren was a creative person himself. Even Kurtzman acknowledged this. ("Warren's got a good graphic mind. He's got visual talent.")[11] And this was unusual, as Warren has said: "I talk with publishers who have never drawn a panel in their life and never written a script in their life. And I think I'm better than they are. The first thirty years of my life were spent as a freelance artist and writer and entrepreneur, and I understand the torment of creativity. I think I understand . . . what my guys go through more than they do."[12]

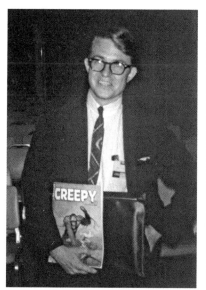
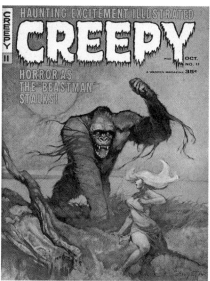

Archie Goodwin with *Creepy* #11 (October 1966) at John Benson's 1966 New York Comic Convention. Courtesy of Jack C. Harris. Art by Frazetta.

This greater understanding of creators doesn't mean he coddled them, but it was one of the main reasons why *Creepy* and *Eerie* were able to attract such talented individuals and present such outstanding work. More artists began drawing stories for him at this time, such as Dan Adkins (who was assisting Wallace Wood at Tower Comics), Jerry Grandenetti (who got his start on *The Spirit* with Eisner, and had already been ghosting the Adam Link adaptations for Joe Orlando), Neal Adams (who had done the *Ben Casey* syndicated strip, but whose only comic book work prior to Warren was a bit of art for Archie Comics in late 1959), Tom Sutton (whose first published strip was for Warren) and Jeffrey Jones (another artist whose first professional comic strip appeared in Warren's magazines). Those who were in the early stages of their careers found that appearing in the pages of *Creepy* and *Eerie* helped increase the demand for their work. They gave their all to the assignments, knowing some highly talented individuals had come before.

It helped that Archie Goodwin wrote stories for them that played to their strengths. Like Warren, Goodwin was an artist himself, and could have

been a successful syndicated cartoonist. He understood how to write stories that lent themselves to visual interpretation. Wanting to keep the quality of the writing high, he decided to "borrow from the best" by adapting famous horror stories in the public domain, most notably by Edgar Allan Poe, but also by Bram Stoker, Ambrose Bierce and Robert Louis Stevenson. Artist Reed Crandall, who excelled at period detail, turned out a trio of superb Poe adaptations, beginning with "The Tell-Tale Heart!" in *Creepy* #3. Then came the equally impressive "The Cask of Amontillado!" in #6, followed by "Hop Frog" in #11. Crandall also handled the *Creepy* version of Stoker's "The Judge's House!" in #5 and "The Squaw!" in #13, as well as both parts of Goodwin's continuation of Stoker's *Dracula* titled "The Coffin of Dracula!" in #8 and #9. While others drew subsequent literary adaptations, somehow Crandall's illustrative work seemed to suit the source material best. In any case, these adaptations added a new dimension, and perhaps sent some readers back to the source material (where they discovered that Goodwin wasn't always 100 percent true to the originals).

Creepy #13 featured a story that brought together both parts of Warren's empire of monsters. It was "Scream Test!," written by John Benson and Bhob Stewart, and drawn by Angelo Torres. A young female reporter visits the owner of an abandoned movie theater because of "reports of strange music coming from the old Alhambra on Bank Street." Ivan Kire, the elderly owner of the theater, it turns out, has been playing the old Wurlitzer organ and showing silent horror films for his own amusement. Benson and Torres tried something new in the magazine: using photographic images from the films within the hand-drawn comics story, creating a sort of merger between *Famous Monsters* and *Creepy*. While he shows the reporter the Lon Chaney *Phantom of the Opera*, she wonders, "Why does Kire identify so strongly with Lon Chaney?" Noticing that Kire is wearing a form-fitting mask over his features, she rips it off to expose his burned face, just as Chaney's ghastly unmasked face is revealed on the big screen. "Scream Test!" was Angelo Torres's last story for the publisher. "I did about eight or ten. I lost count. By my fifth or sixth, I was getting tired of doing werewolves and vampires, and I tried to vary it, as you can see, with the style, to make it more interesting. I always love horror

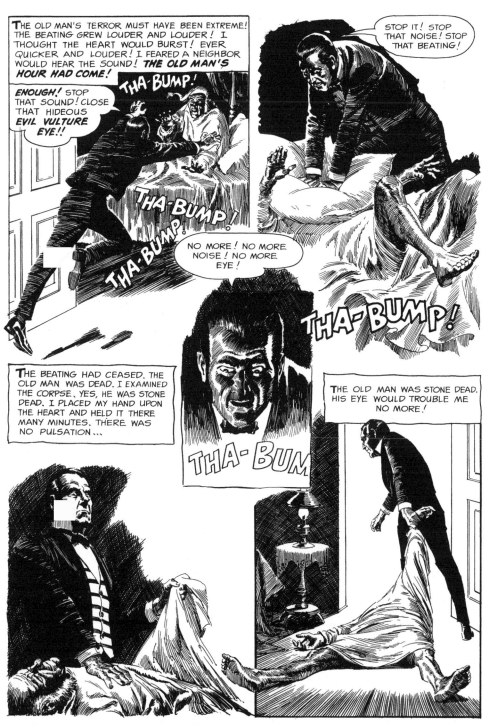

An outstanding page of art by Reed Crandall from Archie Goodwin's adaptation of "The Tell-Tale Heart!" in *Creepy* #3.

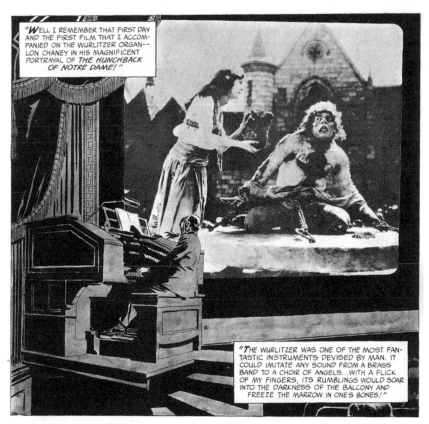

Climactic panel from "Scream Test!" in *Creepy* #13, a marriage of photo and art by Angelo Torres. Story by John Benson and Bhob Stewart.

movies, *Frankenstein*, and the others, but drawing the stuff, unless you do something interesting like this one with washes and using stills, can be a pain. I finally said, 'I'm tired of this. I don't want to do any more.' I did one more and finished it on the road. I mailed it in and said, 'That's it. I've had it.'"[13] Torres went on to other things, eventually finding a lucrative slot as the regular artist for movie and television satires in *Mad* magazine.

Gil Kane was another artist who came into James Warren's orbit at this time. They first met at the 1965 New York comic con, when Kane entered into a spirited exchange with Warren during the "Comics and Fandom, Where Do We Go from Here?" panel, regarding the effect of fandom on mainstream

comic books. Now, oddly, Warren wanted him to draw an Archie-type character for a comic book that he was considering. Kane would seem to be the wrong person for that sort of job, but perhaps it was just a carrot to draw the longtime DC artist into his domain. Kane: "I became quasi-friendly with Warren, and he put me in a studio in his building."[14] The Archie idea went nowhere, but Warren was able to induce Kane into doing a pair of *Creepy's Loathsome Lore* pages, which appeared in #15 and #16. This was when Kane had tired of *Green Lantern* and *The Atom*, and was looking for ways to become a publisher himself. He recalled, "I used to talk to Archie [Goodwin] and I found out how [magazine publishing] worked. I finally talked Kable Distributing into this new idea I had, a combination of prose and comics, paperbacks and comics."[15] The magazine, which had quite an impact considering its unfortunate fate, was Gil Kane's *His Name is Savage*, published about a year later.

Magazine publishing, as many who tried it in the 1960s discovered, was not for the faint of heart. Publishing and distribution could be a cutthroat business. As Warren later explained, this accounted for the apparent dichotomy in his personality, between nice guy and a hard-as-nails businessman: "I cultivated very carefully that persona of being a tough, hard, greasy son-of-a-bitch prick. I did it deliberately. It's uncomfortable to say why. The people who know me, know what I am inside. It was the armor that I used. It was an armor plating that I put on myself, and wanted to make people think that I was how I was described. Because I felt that if I didn't, they would have destroyed me, and gotten to me. And I felt that if I had that armor, I had some protective coating, because if I conducted the company like I really am inside, I don't think the company would have lasted too long."

When asked who are the people who want to destroy you, he clarified, "The people that you run into, and you have to deal with in New York, in business. I came to New York when I was twenty-nine, and I saw sharks that are unbelievable. I have wholesaler stories that would kill you. And I saw people who, if they sensed that you were fair and decent and able to harpoon, they would go for your throat in a second, kill you, leave you lying there bleeding, and go out and have a pizza. And I'm talking about my friends!

"I saw that atmosphere when I came to New York. Here I was, with very little money, in New York, publishing, dealing with printers, and unions, and paper people, and wholesalers and distributors. Forget about the talent. I mean, the talent themselves brought problems that were insane, and because I had no wife or family or kids, I was available twenty-four hours a day. I wish I had a dollar for every time Wally Wood called me drunk at three in the morning and said, 'I'm coming over.' And he came over, and I opened the door for him, and he vomited all over my carpet. More than once. Now, that's an extreme.

"We're playing for high stakes [in] New York. So, I knew that if I didn't cultivate that, that people would get to me. And so, if you come out with a reputation as a gunslinger, they're going to think twice before they stab you in the back. And I found that it worked, because it kept them away."[16]

As tough as Warren could be, and as resourceful as he was in coming up with money-making promotions and other schemes, he was helpless to prevent events that converged against his publishing company just as it was on firm footing. Suddenly, unexpectedly, it looked like Warren Publishing was doomed.

CHAPTER NINE

DOWNTURN

WARREN GOT ALONG WELL with Goodwin, but there was always some uneasiness between him and Ackerman. Sometimes, the editor and publisher on the masthead of *Famous Monsters* aired their differing visions for the magazine in its pages. In the letter column in *FM* #39 (June 1966), Ackerman printed a letter from Steve B. Kaplan of Freehold, New Jersey, the latest in a series of letters from discontented older readers who complained about the juvenile nature of the magazine's captions and articles. Kaplan concluded, "You must admit that there has been a noticeable fall in the magazine's quality, at least in a literary sense. I certainly don't respect the Ackermonster as I used to. More respect for his readers is definitely in order."

Ackerman responded, "What I never seem to be able to put across to you and any number of readers like you is that the *publisher* dictates the policy of the magazine and I, as editor, only follow orders. Mr. Warren wants a funny, punny juvenile pair of monster magazines because his experience has convinced him that that is what the majority of his readers want to buy. I, personally, would infinitely prefer to write on a high literary level for readers with college degrees but *Spacemen* magazine was our experiment in an imagi-movie publication of higher quality and it was a miserable financial flop. Mr. Warren scarcely needs emphasize that [*FM*] is a publishing success unapproached by a million miles by anyone else in the world."[1]

Still, the magazine brought Ackerman plenty of balm for his ego. In the first week of March 1966, he received his second award for *Famous Monsters* from the Count Dracula Society. At the banquet in Los Angeles, he was seated opposite Lon Chaney Jr., and was thrilled to banter with him about the early days of the actor's career. (Chaney was also there to receive an award.)

Ackerman would later contrast this "high" with health issues that hit him in the fall. He said, "On the way to my fiftieth birthday [November 24, 1966], I had a whole set of heart attacks attributed to Warren."[2] He found his ideas for the magazine regularly rejected by his publisher, who would often say, "You may very well be right, but I'm boss."[3] Nevertheless, the magazine kept arriving on newsstands on schedule.

If one digs into the back pages of *FM* #43, one finds the legally required Statement of Ownership, Management and Circulation, listing both the average number of copies sold of each issue during the preceding twelve months, and the sales of single issue nearest to the filing date. That single issue would likely have been #41, which went on sale in mid-August 1966. It showed that sales were declining. The total paid circulation on average over the past year was 132,180 and for #41 (published during the summer, a better sales season than any other) had dropped to 112,067, about 15 percent. Since the percentage of copies sold remained consistent, about 61 percent, the reason for the drop seems mostly determined by a reduced number of copies printed, from an average of 211,611 to 183,050.[4] One could conclude that Warren cut the print run because it was more profitable for him to do so. Sales fluctuations were commonplace. A significant area of the country might be buried in a regional snow storm, or suffering from a series of tornados, or, in the case of Florida, hit by a particularly destructive hurricane. Or, there could be shipping strikes and slowdowns. Warren was a master at handling shifting sales currents, and devising promotions and other schemes to compensate for cash shortfalls. The pressures could make him more combative than ever, which may be why Ackerman blamed him for his heart attacks.

Like any savvy businessman, some of Warren's gambles and hunches didn't pay off. One that did was switching to World Color Press for his printing. It may have begun as early as *Creepy* #11 (October 1966). Going with

the firm based in Sparta, Illinois, who did nearly all of the four-color mainstream comics (even though nearly all of his magazines had black-and-white interiors) was the beginning of positive, long-term relationship—although it would soon be tested. One gamble that didn't pay off was choosing 1966 to close down his Philadelphia warehouse and move Captain Company to New York City. Once he was living in Manhattan, keeping an eye on operations at the Philadelphia location was no longer possible. The exact date of the move in 1966 is hard to determine because it took place over a period of months, and the new mailing address didn't appear in all the magazines at the same time. It was complete by the end of the year.

Warren's stockpile of back issues took up a lot of shelf space, as did the masks, models and other items that were kept in stock. The problem was that the rent for the same square footage went from $400 a month in Philadelphia to $4,000 a month in New York, even when the bulk of the back issues were stored in a public warehouse in Brooklyn. The increased cost was difficult for a small publishing company to absorb. He committed to the move before the serious sales erosion that came in the wake of a new pop culture phenomenon.

No one could have predicted that the *Batman* TV show would be such a big hit, or the explosion of Bat-merchandising that followed. It was the first mass-media event of its kind, with all manner of costumes, games, card sets, models, record albums and other items being produced, which relatively affluent baby boomers and their parents could afford. Certainly, in the fall of 1966, the Batman, Robin and Joker costumes were the hottest items for Halloween. Warren didn't sell those, but he did offer "The Official Adventures of Batman and Robin" record album, and ran full-page ads for the new Batman and Superboy models from Aurora ("2 Great Comic Strip Heroes!") and the Aurora Batmobile model kit (which he promoted through a tie-in with Mr. Chips chocolate cookies). He also devoted a full page to marketing individual, two-hundred-foot edits of each chapter of *The Batman* serial from 1943 (at $5.49 each) and the whole (edited) serial for $28.95 and $1 postage. Batman had deflected the attention of America's youth from the monster craze. Ackerman admitted, "We lost about 25 percent of our monster fans when the Batman craze started out. When *Batman* became a hit television

show in 1966, the young readers of *Famous Monsters* stopped buying [it] and began pouring their hard-earned allowances into Bat paraphernalia. Profits nosedived. The magazine circulations dropped, including those of *Creepy* and *Eerie*. After years of mail orders pouring in for monsterish masks, etc., orders slowed to a trickle."[5] [6] Warren increased the price of *Creepy* and *Eerie* from thirty-five to forty cents.

The publisher himself didn't specifically cite the *Batman* TV show's success as the thing that deflated the monster craze: "What happened is what happens with most companies, even governments. We hit a bad period. We ran into tough times. As luck would have it, at the same time we had this additional overhead take a chunk of our cash flow [to have Captain Company in New York City], we suffered a downturn in the magazine marketplace. This happens in our business, and you just wait until they go up again. But both events happening at the same time hurt us badly."[7] Suddenly he found himself in a financial crisis. He had never been flush with cash, but now red ink threatened to engulf him.

Normally, he paid freelance writers and artists for *Creepy* and *Eerie* when they turned in their assignments, cash on acceptance. By the beginning of 1967, editor Archie Goodwin began hearing complaints from freelancers whose checks were late or who had not been paid at all, and who couldn't get Warren on the phone. Anne T. Murphy: "[Archie] was in a very uncomfortable position with Warren, because the artists were complaining about not being paid. Archie had to deal with them, and Warren was giving him the runaround. Archie actually talked to me about the company being in trouble and maybe we could loan Warren some money from our savings. I said, 'No way!' That's our money. It's not like you own part of the company.' If Warren couldn't keep the company going, I didn't want to throw our savings after it. If Warren had told Archie 'Here's the situation' and Archie had been able to tell the artists that. . . . But he didn't feel comfortable being the go-between and stringing them along. I think that's one of his strengths that people understood about Archie, that he was that kind of a manager."[8]

Goodwin resigned in June. He began writing King Features' *Secret Agent X-9* (being drawn by Al Williamson), and in the fall, started freelancing

for Stan Lee at Marvel Comics. Marvel was expanding its comic book line, granting the heroes who shared *Tales of Suspense* and *Tales to Astonish* their own titles. He was given the Iron Man assignment. The last Warren book that bore his name as editor was *Creepy* #17 (October 1967).

The publisher accepted responsibility for the exodus of his best artists: "It's not that we were dumped on. It's just that there was no work for them because we couldn't afford to pay the rates they wanted, and even the ones that we could afford to pay had to wait 30 days and sometimes 60, sometimes 70. And faced with that, they decided the hell with it because Warren's going down the tubes. So they said, 'Why should we get caught up in this? Let's not work for him.' So reprints were run because our first rule is survival."[9] *Eerie* #13 and 14 were all-reprint, behind new covers by Vic Prezio. *Creepy* was often half-reprint, or used material from disparate sources that the publisher obtained for very little.

He also lost Frank Frazetta as his cover artist. Frazetta had become too busy with high-paying work: "Others were paying me $1,000 and $10,000 for commissioned work, so how the hell could I work for Warren? It's very difficult."[10] Still, the artist did add to his original twenty-one cover paintings in the coming years, to bring the total up to twenty-nine. One was for what became a notable collaboration a couple of years later between Frazetta, Harlan Ellison and Neal Adams. *Famous Monsters* went all-reprint, or virtually all-reprint. Ackerman acknowledged, "People who have been with [*FM*] since the first will be disappointed, because there will be . . . reprints and devices that are necessary just to save money."[11] This was a financial blow for him, since it meant his editorial fees were reduced.

Readers who habitually picked up the company's magazines had no idea of the behind-the-scenes problems. All they could see was that Archie Goodwin was gone, and the magazines were filled with reprints and substandard art. Warren: "There was not a slight dip in the quality [of our magazines]. There was a landslide crash in the quality. It was an awful time for Warren Publishing. I overprinted a lot, sales were awful industrywide, the price of paper shot up and all kinds of poor business factors converged at once. To make payroll, I emptied out my personal savings. I moved our New York

office into a cubbyhole on 42nd Street that was about the size of a telephone booth. We had a skeleton staff, maybe about seven or eight people including myself. And we owed our printer over $250,000—a lot of money back then."[12]

This situation would be enough to finish most publishers. Indeed, some have said Warren Publishing should have been finished, largely because he hadn't really purchased more than first time publication rights to the stories in *Creepy* and *Eerie*. Unlike DC and Marvel, Warren hadn't put a brief statement on the back of each paycheck to freelancers, to the effect that by cashing it, the individual was selling all rights to the work in perpetuity to the publisher. This verbiage was the cornerstone of the pernicious policy known as work-for-hire. He simply reprinted with impunity and was never challenged on this score.[13]

If his company crashed, Warren's employment options weren't attractive. He was the type of individual who wanted, even needed, to be the boss. He claimed to have received offers for lucrative jobs, and one can see why an advertising firm or large publisher would see the value of adding a person with his experience. But, had he accepted, how long would he last in such a job, given his personality and eccentricities? He stubbornly dug in, and vowed to turn things around. He was not yet forty, hadn't yet achieved his goals for the company, and still had plenty of fight left in him.

AT NO TIME IN HIS WORKING LIFE was Warren busier and "under the gun" more than the second half of 1967. The pressures were enormous. He needed a new editor as soon as possible. He assumed the title on the masthead, but needed help right away. He called on his friend Bill Harris. "Yes," Harris confirmed, "I did some 'editorial consulting' for Jim Warren. I wouldn't say I edited any issues. Jim did that himself. But I did backstop him." When Harris showed up, Warren pointed him to a stack of scripts which had been deemed acceptable by Goodwin, but hadn't yet been bought. Harris became a story editor of sorts, and probably also helped put the letter columns together in *Creepy* #18 through #20. Harris selected a few scripts, one by Clark Dimond and Terry Bisson, and sent them off to artists who promised quick turnaround. He also had a finished story written and drawn

by Johnny Craig (Jay Taycee) on hand, which was slated for *Creepy* #18.

To the notion that Warren himself was the true editor of those issues, Clark Dimond disagrees. "Warren never edited a damn thing. [Bill Harris] did. [Harris] did the issues between [Goodwin] and [next editor, Bill] Parente. He commissioned ["Out of Our Head!," my] script that appeared in *Creepy* #18. Then Warren stopped paying. I camped out in Warren's office at lunch hour every day until I got my money. He finally paid me and told me I'd never work for him again and neither would my grandson or anybody he knew unto seven generations. I said thanks for the money and left."[14] Some were paid after a long wait. Others received nothing.

Russ Jones showed up one day with a bunch of finished (completely drawn) stories that he sold to Warren at bargain prices. The stories had been prepared for book projects (some previously published, some not) that would fit nicely into Warren's magazines. In *Creepy* #19, there were two of them. The first was "The Mark of the Beast," an adaptation of a Kipling story by Craig Tennis and Johnny Craig, from *Christopher Lee's Treasury of Terror* (1966). The other was the previously unpublished twenty-page adaptation of *Carmilla* (the story by Sheridan Le Fanu) written by John Benson and drawn by Bob Jenney for a book project abandoned by Jones. That Warren was willing to traffic with the much-reviled Jones on any basis was a measure of how low he had fallen, not only because of the way they parted company in 1965, but because Jones went on to edit a direct competitor to *Famous Monsters*.

True to form, the Jones deal was more than a little shady. John Benson had never been paid for "Carmilla," yet Jones didn't hesitate to sell it and other stories of similar provenance for a quick buck. Benson was shocked to find it in the magazine. By that time, Harris had moved on. Benson: "When I complained to Warren about his running my adaptation of "Carmilla," I said I had told Bill Harris, when he was Warren editor, that Russ Jones had never paid me and if Jones tried to peddle it to Warren he should know that Jones really didn't have the right to do so. Warren said that Harris never told him, which may have been true, since Harris wasn't there long. Then he said he would offer me a special deal to make up for the error. He would buy some scripts from me and he'd pay the special rate of $25 per script. Who was he

fooling? I had previously sold scripts to him at $10 a page, and I already knew he'd dropped the rate to one-third of that to $25 for a complete script. A special deal? It's not the fact that he was underhandedly offering me a 'special deal' that was open to everyone. What got me is that the ploy was so pathetic, so obvious. Couldn't he come up with something better than that?"[15] In any case, Jones had already accepted payment for the strip and had vanished, so Benson received nothing.

Warren also saved money by reducing the page count of his magazines from 68 to 52 pages, and reusing Albert Nuetzell's cover from *Famous Monsters* #4 (August 1959) on *Creepy* #20. The search for an editor was difficult, considering how little he was willing to pay (even when the individual could augment a base salary by writing scripts for the magazines). Nevertheless, in a world where there are always people trying to break into print, it didn't take too long for him to find someone who accepted what he offered.

William ("Bill") Elio Parente was born in Queens, New York, on April 24, 1932. After a stint in the army in the mid-1950s, he began looking for work as a writer. Since he was interested in comics, he became cognizant of the growing comics fandom movement and the dozens of amateur fanzines being published. The earliest known example of his nonfiction writing is in G. B. Love's *Rocket's Blast Special* #7 (1967), which was devoted to EC Comics. Despite Parente's awkward, overwrought prose, the resulting magazine looks good at first glance. It was likely his chief calling card when he interviewed with Warren, who was desperate and exhausted, having worked long days without a break since Goodwin's departure six months earlier.

Parente was given a crash course in magazine editing the Warren way, and appeared on the masthead as editor with *Creepy* #21 and *Eerie* #16, both dated July 1968. *Creepy* #21 had a cover by Gutenberg Monteiro highlighting the issue's adaptation of H. P. Lovecraft's horror story "Rats in the Walls," with a credible art job by Bob Jenney. However, Parente let an art team get through the door whose work would be a blight on the magazines: Tony Tallarico and Bill Fraccio. They had years of experience drawing for bottom-of-the-barrel Charlton at $6.50 a page, becoming an art team in the process. They had been able to expand to Dell in the 1960s (where the pay was better) because

Dell's comic book editor was a neophyte, and they were fast and reliable. There they had done poor artwork on titles like *Car 54, Where are You?*, *The Beverly Hillbillies* and many others. Hence, they were willing to work for Warren's rates, especially now that Dell was beginning to cut back on its comics line (which had been largely unsuccessful). For the black-and-white publisher, they used the joint pen names Tony Williamson and Tony Williamsune. Their work lacked many things: competent draftsmanship, depth in panel, atmosphere and visual appeal. They would go on to do thirty-four stories for *Creepy, Eerie* and *Vampirella* during this period. It's no surprise that none of the stories drawn by this team over the three-year period were reprinted (until the circa 2008 Dark Horse archival series).

On the other hand, Bill Parente showed himself to be a competent script writer, which mattered because he wrote twenty-five of them during his two-year stint with Warren. Another bright spot was the arrival of Tom Sutton, a talented artist whose work was uneven, but on a good day, was very good indeed. His first story, in *Eerie* #11 (September 1967), which he also wrote, was "The Monster from One Billion B. C.," which included wonderful imagery of many of the classic movie monsters. (It was reprinted four months later in *Famous Monsters* #48, where it was cover-featured.) Sutton's relationship with Warren was to be tempestuous, starting with the fact that Warren published the story without paying him (or, apparently, sending him a complimentary copy to inform him that it was printed not once, but twice). Sutton recalled, "I said, 'Shit, I'll go over and see this guy,' and I did. He said, "Yeah, yeah, yeah. I'll get a check off to you."[16] Sutton proved to be a major find: an inventive, slick comics artist, and a superb cover painter, beginning on *Creepy* #22, depicting a scene from the inside story "No Fair!" which he drew from a Parente script.

Ernie Colón was another artist of considerable mettle who appeared at this juncture. He debuted with "Strange Expedition" in #22, working from another Parente story. Colón: "I don't recall exactly what brought me there in the first place. He was enthusiastic about my work. We took it from there." His impression upon meeting Warren? "Eccentric, likeable, very forthright, very quick to get to the point, and most of all, he gave me a completely free

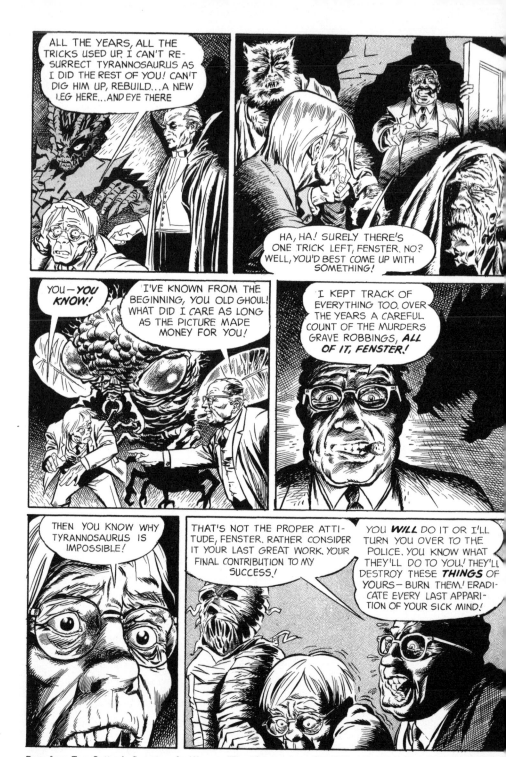

Page from Tom Sutton's first story for Warren, "The Monster from One Billion B. C." in *Eerie* #11 (September 1967).

hand, which considering that I'm probably one of the most inconsistent artists in the industry, took a lot of courage.

"I was able to experiment, and try different media, whether it was ball-point, which I then started to fall in love with, and a whole bunch of other ways of doing things—wash drawings and so forth—using photographs, not using them—and he didn't care. He just wanted to see the best that you could do. Jim Warren was one of the best things that I fell into, as I say, because of his freedom, his leeway. As far as I can remember, he barely edited my work at all. He would say 'What's the point of this story?' and 'Are you sure you've got to the point?' and I'd say, 'Let me look it over one more time. But he would never sit there and blue-pencil anything. He'd ask questions about it, which I thought was very Socratic of him. It worked."[17]

The coming issues had other highlights, such as new stories drawn by Reed Crandall, Gene Colan and Dan Adkins, as well as more from Sutton and Colón, but in the main, the best work was in the reprints. Much of the also-ran material would have been rejected during the Goodwin period. Fledgling writers found acceptance by editor Parente as the end of the 1960s approached. Some came from the fanzine world, such as the prolific Buddy Saunders, Don Glut and T. Casey Brennan, and they were willing to work for the twenty-five dollars paid for each script—although it was more than a pittance to some of them. Buddy Saunders: "Twenty-five dollars was actually a fair amount of money for me. Once I had an idea in mind, I could write both drafts of the script in just barely over a day, so I was making that much in a day which wasn't bad for a college student."[18] Another was Nicola "Nick" Cuti, whose first story "Grub!" appeared in *Creepy* #28. With that issue, the page count returned to sixty-eight pages, with a price hike from forty to fifty cents a copy.

TWO YEARS AFTER THE ONSET OF BAD TIMES, Warren Publishing suddenly began hyping a brand new magazine in teaser ads in *Eerie* and *Creepy*, leading up to the actual announcement in *Creepy* #29 (September 1969): "*Vampirella* is here!" the lettering proclaims, above a drawing by Frank Frazetta (flanked by the Tallarico/Fraccio versions of Uncle Creepy

and Cousin Eerie) which continues, " . . . and *Vampirella* is here to stay! She's fresh in from Transylvania, with her own magazine, along with the creepiest, eeriest artists and writers she could find! And her mag is all about the most amazing fantastic females you've ever seen!! She promises to give you the best in bewitching comics—right now . . . look for *Vampirella* on newsstands July 15th. What more do you want . . . blood? She's got it! Go get it!!!"

Amazingly, from scraping along in the doldrums, Warren was launching a new magazine. "I learned that one from my father. He said, 'When you're down and out, and really at your lowest, that's the time to go for the moon. Go for the home run, not a single.' Which is what the company did. It was the worst time to do it. We had no money, no credit line, nothing, no anything . . . except an idea for a woman character in my head, sketches in my notebook . . . and enough energy for a game-winning home run."[19]

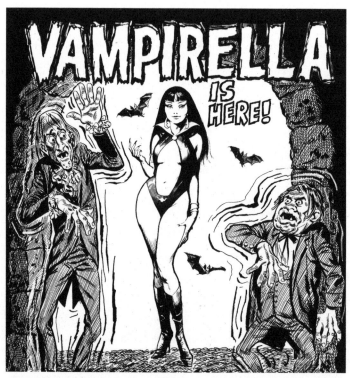

Introducing Vampirella. *Creepy* #29 (September 1969). Art by Frazetta and Williamsune (Tallarico and Fraccio).

CHAPTER TEN

VAMPIRELLA

"FOUR YEARS AGO, I gave a talk to the comic convention," James Warren began, "and I haven't been invited back since, because I did offend some people. So now, after four years, they said, 'Jimmy, you've been a good boy, and we want you back.'"[1] He was speaking at the slightly renamed New York Comic Art Convention in July 1969. This time, he was on a panel titled "Economics and the Comics," along with Dick Giordano from DC and Roy Thomas from Marvel. In the course of discussing such topics as the rising prices of comics and magazines, Warren was asked if he would publish a super hero magazine. "Hell no! Who can top Stan Lee? In my field, I'm tops, and I'm going to stay with the things I know. I'd rather be the best guy doing one small thing, than a mediocre guy trying to do everything. I hate mediocrity. Mediocrity stinks!" When the discussion turned to "the stupidity of the average newsdealer," he quipped, "First God created the retailer. For practice. Then he created the amoeba." He held up a copy of *Vampirella* #1 (which hadn't yet appeared on newsstands), and told how he'd had some resistance to the skimpiness of her costume from wholesalers. When they asked if her breasts could be covered up more, he refused, supposedly telling them, "No, because if we cover them up, we're gonna ruin the character that Frank Frazetta created. And Frank gets very mad. He's Italian. He'll come down and kill you." It was obviously a made-up story, but the fans loved it. Anything

the others on the panel said after that was anticlimactic.

This was the first year comic con organizer Phil Seuling went solo, fully sponsoring the convention himself. The scuttlebutt was that Seuling was overextended (in the amount of $3,000) and might lose money on it. For instance, the number of fans signing up for the convention banquet fell far short of expectations. After the event was over, the news fanzine *New-fangles* reported, "At Phil Seuling's NYC comic con, there was a loss of $140 . . . on the luncheon.

The True Fantastic Story of Tiny Tim (Fall 1968).

Despite this, there was a profit made on the con, thanks to auctions, sale of material and admissions—and the whole thing was made worthwhile. Phil can now guarantee next year's con, he says."[2] Warren became one of the con's chief supporters.

Having been humbled by circumstances, he was no longer "above" courting fandom. This was the year that he handed out the first-ever Warren Awards (which were conceived by Bill Parente) at the con. It added luster to the event, while promoting his magazines. "We're proud of our people and we want to show it publicly," he explained at the start of the award ceremony. "The award will be presented every year at the comic con. I imagine there will always be a comic con. If there isn't, we will run one ourselves!" Then he pulled a large, gleaming trophy into view. He set it on the podium, and impishly muttered, "Hmm! It's a big mother!" Frank Frazetta came forward to accept the trophy for winning the "Best Artwork" category. Warren announced that the "Best Artist" category would henceforth be known as the Frank Frazetta Award, eliciting tremendous applause. Others were on hand to accept awards in the other categories, although most were accepted by proxies on behalf

of winners who could not attend.[3] In his remarks, he told fans that better things were on the horizon for his magazines. The fan press reported, "Jim Warren says he is phasing reprints out of *Creepy* and *Eerie*, financial problems having eased."[4]

ALL THROUGH 1968, Warren had been doing everything he could to reverse his fortunes. But even if *Creepy, Eerie* and *Famous Monsters of Filmland* were returned to fiscal health, and the enormous printing bill was paid off, the fact remained that he needed to field more than three magazines (and resulting annuals and yearbooks) to make enough money, to get the best volume discount on printing rates and to have more clout with his distributor. He needed to add a couple more titles. He had tried with *Teen Love Stories*, a comic book that reprinted romance comics published in England by Fleetway. Quarterly issues began appearing in July 1967 but failed to gain traction. Neither did two issues of a music magazine called *Freak Out, USA*, essentially *Tiger Beat* for slightly older teens. His only notable success beyond his core titles was *The True Fantastic Story of Tiny Tim* (1968), a one-shot rushed to the stands to capitalize on the brief fad for the eccentric musician who had become famous from his appearances on *Rowan & Martin's Laugh-In* and *The Tonight Show.*

Then came *Vampirella*. In *Horror Biz* magazine #4 (Spring–Summer 1999), Warren recounted the creation of his most famous character to Dave Baumuller, the magazine's editor and publisher: "I [decided] to launch my first major comic book character. I had been musing over a female heroine. The time felt right. It was late at night and I found myself at the drawing board. What should she look like? Who should she look like?" Then his thoughts drifted back to Gloria Reif, his childhood sweetheart, who he hadn't seen in twenty years. "Absentmindedly, I sketched a picture of Gloria's face. There was no way I could keep the memory of that first love out of my head, where it had been lying dormant for years. I got out a photograph of Gloria taken on the front steps of her house when she was sixteen." The photograph is a full-figure shot of her, looking wholesome in her white sweater, skirt over the knees and penny loafers. Her face is turned away so it's marginally not

a profile, but she's obviously pretty. The main feature is her shoulder length, dark tresses and bangs. "[I] knew immediately who our Vampirella would look like," he concluded.

He turned to Frazetta to create the first drawing of the as-yet unnamed heroine. "I [told] him I wanted the new character to have an aura of sexuality and mystery. I specifically wanted red and black as her signature colors: red costume, with long black hair and black boots. Frank recalls my being particularly adamant about her black hair style. I emphasized that when the readers view her, they should see an instant image of two colors only: red and black. Red for excitement. Black for mystery. Red costume framed by black hair and boots."[5] (Frazetta originally saw her as blonde.)

Warren didn't like Frazetta's initial costume design. One day, aspiring cartoonist Trina Robbins was showing the publisher her latest work, when she became involved in the process. "I was sitting in Warren's office, where he was talking to me about the fact that my artwork was nowhere good enough to appear in his magazines, which was very true," Trina recalled in a recent interview. "Frazetta called to discuss a sketch of Vampirella that he'd sent to Jim. Warren said it wasn't right. Frank had drawn her wearing, more or less, a basic bikini, but Jim had something else in mind. It became clear that Frank wasn't getting the idea as Jim tried to describe it, so Jim turned to me and described the costume, the way the top was open in front and attached to a collar, the boots and so on. I drew it as he was talking. 'That's it!,' he said, pointing to my sketch. 'Now describe it exactly to Frank,' he said, handing me the phone."

What resulted was the drawing in *Creepy* #29 which gave readers their first glimpse at Vampirella ("Vampi"). The logo on that page is by Warren, and it's clear this is before the final script of her first story had been completed or accepted, because it states she's from Transylvania—not Drakulon, as it would be in the actual story. Frazetta hadn't cared for the design, but after Warren approved the drawing, duly painted the cover of *Vampirella* #1 (September 1969). When he was asked about it, years later, his memory was vague: "We discussed it. It was so long ago. I remember he told me about this funny costume, she's kind of a vampire-type girl. Maybe I did a sketch

or two."[6] Frazetta's original painting would be sold at auction, eventually, for either $77,000 or $88,000 (accounts vary).

The part of Vampirella that wasn't invented by Warren and Frazetta (with an assist from Robbins) came from Ackerman. Warren chose him to write the feature, even though Ackerman wasn't much of a comics fan, because he was confident in the man's writing ability. Having just seen the film adaptation of French illustrator Jean-Claude Forest's comic book character Barbarella, Ackerman got an idea for one possible name for the Warren vampire heroine. Warren: "Forry submitted to me a list of proposed names for our new comic book character. One of the names on the list was Vampirella. I chose it."[7]

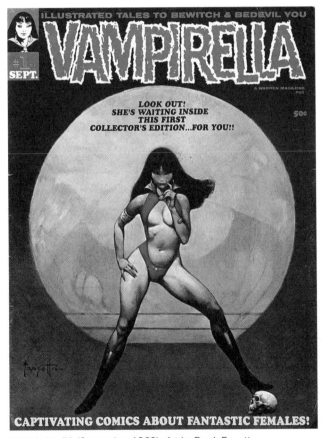

Vampirella #1 (September 1969). Art by Frank Frazetta.

In mid-July 1969, *Vampirella* #1 (September 1969) was published, about the same time that the Vampi teaser appeared in *Creepy* #29. (Coincidentally, another female character introduced her new costume that same week. The "new" Wonder Girl in *Teen Titans* #23 also sported a red costume, with long black hair and black boots.) However, Warren wasn't satisfied with the introductory story. He considered Ackerman's script "too frothy, too light, too satirical," and didn't think Tom Sutton was the right artist for the character. "It just wasn't what I wanted," he said. Nevertheless, the impact of the new magazine was immediate and spectacular. Vampi added a new element to Warren's monsters-and-horror formula: sensuality. Her abbreviated costume enabled her to cavort seminude on the covers (and sometimes completely nude in the stories) which undoubtedly played a big part in her success. Apart from the lightweight, insubstantial Vampirella stories written by Ackerman (for the first three issues) and drawn by Tom Sutton that headed each issue, the rest of the pages were filled with the same type of horror anthology material as in *Creepy* and *Eerie*. Don Glut wrote a lot of the scripts, which, when illustrated by Neal Adams (some reproduced from the pencils only) and Jerry Grandenetti, turned out rather well. So did some stories with early work by young African American artist Billy Graham.

As for Vampi herself, it took time for the character in the magazine to match the image in Warren's mind: "I struggled with various writers and artists for many issues. Suddenly, she came alive in the twelfth issue with Archie [Goodwin] writing an entirely new origin. The minute I took one look at Pepe González's artwork, I knew we had it! We survived twelve issues but there it was. By that time, we were back on our feet financially and on solid ground again, ready to go forward."[8]

What would Gloria Steinem think of Vampirella? Warren speculated, "Probably the same thing she thinks of Wonder Woman. Vampi is every bit the equal of most men. There's nothing wishy-washy or second-rate-feminine [or] weak sister about Vampi. Vampi'll kick the shit out of you—man, woman, beast, child—she doesn't care. P.S. She has her period every month, and she's woman, and she may cry in some cases where men won't cry. I've seen women do that. Because they've been programmed. But that's the whole

thing—we've been programmed to think that to be a woman is to be inferior. And by the way, I can't change. Intellectually I can accept Women's Lib. Emotionally, I can't."[9]

Vampirella magazine wasn't the only reason for the ultimate recovery of Warren Publishing, although it played a large part in it. *Creepy* and *Eerie* began improving about the time the early issues of *Vampirella* were coming out. Toward the end of Bill Parente's editing tenure came "Rock God," a collaboration of sorts among Frank Frazetta, Harlan Ellison and Neal Adams. The result appeared in *Creepy* #32 (April 1970).

The genesis of "Rock God" has one similarity to the way the origin of Vampirella was created. The cover image, also a Frazetta painting, came first. The elements were brought together by Warren, not Parente. Despite a somewhat edgy relationship with Ellison due to their early encounters, Warren was at his silver-tongued best when he contacted the writer, who was then at the top of the SF field. Ellison later told writer Clifford Meth, "I'd known him since 1961. Warren introduced me to my second wife, Billie. He was a very

Harlan Ellison wrote "Rock God!" to correspond with Frazetta's cover to *Creepy* #32 (April 1970). Then Neal Adams adapted Ellison's prose story into sequential art form.

charming guy and he got me to do my story 'Rock God' around a Frazetta cover. The art for that story was by Neal Adams."[10]

Adams, also near his zenith in popularity for his work at DC comics, agreed to do the job: "I wasn't given a script. I was given a short story, with the admonition that Harlan Ellison required that I do the job. Otherwise he wasn't going to allow Warren to do it. So there were certain odd and curious responsibilities on my shoulders. I broke down [Ellison's story] into a comic book story." This meant Adams spent about twice as long on the artwork than he would when working from a finished script. Reconciling the Frazetta image from his cover painting with the requirements of Ellison's story was another challenge. "In the story . . . this creature got to be such an immense size [whereas] the creature that Frank did . . . was maybe eight feet tall or maybe even twelve feet tall. Certainly not the dimensions, the quality, the nature of the Harlan Ellison description. So I realized . . . I would end up failing to match the nature of the character that Frank had drawn. I thought I would try to keep as much of the quality of the anatomy and the look of the character as Frank had done, while turning it into what I thought Harlan was looking for."[11] Then he had to figure out how to portray the druids in the story, and decide on the nature of the sacrificial elements in those ancient times.

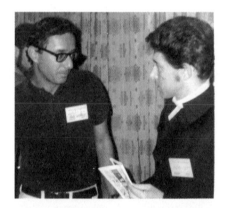

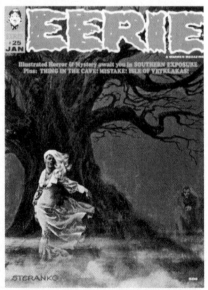

Warren and Steranko at a New York comic con, and Steranko's *Eerie* cover (#25, January 1970). Courtesy of Michael Catron.

Ellison was delighted with the Adams adaptation. "I said I wanted to buy [the original art] from Neal. That was part of the deal. But later Warren said, 'It all belongs to me,' and I said, 'No, it belongs to Neal.' So that was it. I said, 'Screw you—I'll never do anything for you again.'"[12] A falling out between two such headstrong individuals was hardly surprising.

Another headstrong individual crossed paths briefly with Warren. His name was Jim Steranko, or just "Steranko" (as he signed his work). He painted the cover of *Eerie* #25 (January 1970), a moody, gothic scene of a girl in a flowing dress running from a Dracula-like, dark figure. Steranko was pursuing a career as a painter of book covers, after making his reputation in comics at Marvel with *Nick Fury, Agent of S.H.I.E.L.D.* Warren was unimpressed with the cover. "I think Jim Steranko is one of the greats. I rate him up there with Will Eisner when it comes to design. Illustrator, no. Because [the cover] he did for us [was] awful. And the only reason I published it was because I wanted to get inside work, which I never got." He was asked, "How were they awful?" by interviewer Gary Groth. All he would say was "They were not cover paintings."[13]

WARREN CULTIVATED THE IMAGE of a playboy, but his social life must have needed a pick-me-up when he took out a large "personals" advertisement in *Screw* magazine, the weekly pornographic tabloid newspaper which was launched in the last months of 1968:

> Wanted: Girl, uninhibited, warm, oversexed, erotic, knowledgeable, understanding, superior mind, cheerful, clean, sweet-smelling, pretty face, good body, great legs & ass, not a pro, not a crazy wild swinger, trustworthy, looks good in clothes & out of them, loyal, knows how to pleasure a man.
>
> By: Hard-working publisher, 30's, single, over-sexed, wealthy, semi-intellectual, tough, wise, egotistical, sense of humor, good body, lean, always ready to come, done almost everything, knows almost everybody, divides time between New York, California & St.

Thomas, has spacious, comfortable East Side apartment with bidet, big kitchen, wall-to-wall coziness.

For: Semi mistress or constant companion; rubbing his back, rubbing his front, making his coffee, making his dinner, watering his plants, movies, shows, showers, being wild, being quiet.

Rewards: Some money, new clothes, good times, a good guy to come with, nice guy to be with, great guy to know.

Interested? Send photo(s) and letter to: President, Captain Company, P. O. Box 5987, Grand Central Station, New York, New York, 10017.[14]

In this ad, he utterly, completely and unconsciously revealed his personality for all to see. (The fact that he used the name Captain Company would seem to indicate that he wasn't worried about the ad being linked to him.) It's the quintessential statement by Warren himself of the image he wanted to project. The question is, how much did he believe the Hefner-like image? Obviously, he wasn't "wealthy" at this time. But he was, perhaps, lonely. The response to the ad is unknown. We do know that in the fall of 1969, Warren got married, although his bride did not, apparently, contact him through the personals ad. All he has said on the matter is that he was married "once for about twenty minutes under the influence of

WANTED:
Girl, uninhibited, warm, oversexed, erotic, knowledgeable, understanding, superior mind, cheerful, clean, sweet-smelling, pretty face, good body, great legs & ass, not a pro, not a crazy wild swinger, trustworthy, looks good in clothes & out of them, loyal, knows how to pleasure a man.

BY:
Hard-working publisher, 30's, single, over-sexed, wealthy, semi-intellectual, tough, wise, egotistical, sense of humor, good body, lean, always ready to come, done almost everything, knows almost everybody, divides time between New York, California & St. Thomas, has spacious, comfortable East Side apartment with bidet, big kitchen, wall-to-wall coziness.

FOR:
Semi mistress or constant companion; rubbing his back, rubbing his front, making his coffee, making his dinner, watering his plants, movies, shows, showers, being wild, being quiet.

REWARDS:
Some money, new clothes, good times, a good guy to come with, nice guy to be with, great guy to know.

INTERESTED?
Send photo(s) and letter to: President, Captain Company, P.O. Box 5987, Grand Central Station, New York, New York 10017.

Warren's ad in *Screw* magazine.

psilocybin."[15] Sam Sherman: "I think she was a female attorney. He was in his building, and he was looking around with binoculars. And he found this pretty gal sunbathing on the roof of a building. This is the legend. Then he started making big signs and flashing them to her. 'Let's meet for a drink.' They got together and they were married. Jim was a great ladies' man. He'd meet somebody and get to know them very quickly." Ackerman: "When Warren was thirty-nine, he finally married a thirty-nine-year-old woman across the street from his apartment."[16]

Barton Banks, Warren's old friend, was on hand for the wedding. The bride was half or three-quarters Cherokee. They were set to get married at the Warwick Hotel in Philadelphia. Banks: "Jim's parents were nice people. His mother, Reba, was a sweetheart. He was an only child. His father was a real nice guy. They were not wealthy. I would say they were lower middle class. And they loved Jim to pieces. I don't think they ever understood him. I don't think many people did." When he asked Reba Taubman if she was happy about the upcoming wedding, she responded, "Am I happy? Ben and I don't know whether to stick our heads in the oven or go outside and throw ourselves in front of a bus."

Banks: "Jim had a hard time finding a rabbi to officiate because the bride wasn't Jewish, so he got Buzzy from Brooklyn, a semi-pro baseball player who doubled as a rabbi, to officiate. There was Jewish food on one table for Jim's relatives, and Native American food on another table, for his bride's family. Her father was, like, six foot two, and Ben Taubman couldn't have been taller than five foot four. People were listening to the Dallas Cowboys and Philadelphia Eagles football game on their radios through earplugs, and whenever the Eagles scored, everyone was going 'Right on!' in the middle of the ceremony. It was a three-ring circus, but I wouldn't expect anything else from Jim. The marriage lasted no more than a few weeks." Banks's final comment on the brief marriage: "Jim did a lot of stuff for shock value."

ALTHOUGH *CREEPY* AND *EERIE* had not yet fully recovered from the downturn, a competitor decided it was the right time to make inroads. Major Magazines, Inc., publishers of the humor periodical *Cracked*, put out

a new magazine called *Web of Horror* in the fall of 1969 which became the recipient of the pent-up creativity of a number of the best young artists in comics. Clark Dimond: "We were all pretty pissed off at Warren at the time. I had suggested to Terry [Bisson] that we start our own magazine."[17] Bisson was named editor. *Web of Horror* #1 (December 1969) had all-new stories and art, but apart from a painted cover by Jeff Jones, offered middling fare drawn by such artists as Wayne Howard, Syd Shores and Donald Norman. However, an inside front cover by Bernie Wrightson seemed to promise better things to come. With its second issue, dated February 1970, the magazine spread its wings, featuring complete, new stories by Wrightson, and very good (if early) work by Mike Kaluta, Ralph Reese and Roger Brand. Stories were written by Bisson, Dimond and comics veteran Otto Binder, among others.

Fandom welcomed the magazine with open arms. "*Web of Horror* absolutely blew me away when it came out," comic book writer-artist Michael T. Gilbert said. "This seemed like a real opportunity for a new EC, spearheaded by Wrightson (Ingels), Kaluta (Williamson) and Reese (Wood). It was great while it lasted."[18] The key to attracting those talents, and adding Frank Brunner and Bruce Jones to the mix in issue #3 (April 1970), was that owner Robert Sproul was paying three times the Warren rate, and paying when the work was turned in (rather than sixty to ninety days late).

Predictably, Warren despised *Web of Horror*: "Robert Sproul . . . is the kind of guy [who] waits until someone else invests thousands of dollars determining if there is a market in something, and then just rides in. I call this theft."[19] He knew that young readers only had so much spending money. Buying an imitator meant less money to spend on his magazines. In early 1970, he sent a letter asking for loyalty from his freelancers. It read, in part:

> A few weeks ago, a new magazine hit the newsstands. It's called *Web of Horror* and is an exact duplication of our own *Creepy* and *Eerie*. It differs from our seven other competitors in that it contains all new material [instead of] 15-year-old reprints. *Web of Horror* . . . is published by a Mr. Robert C. Sproul. Mr. Sproul also publishes a *Mad* imitator (*Cracked*) and an exact imitation of our own *Famous*

Monsters, as well as other imitations of other peoples' ideas. Because he brings out these copies well after they've been established, he lessens considerably his risk factor; he doesn't risk his own money on his own ideas. Instead, he utilizes that money elsewhere. For instance, his rates for artists and writers are higher than ours. He can afford to pay these rates inasmuch as he never invested or risks the huge sums of money that were necessary to establish *Creepy* and *Eerie*. *We* did—and . . . when we recoup that investment, we'll be in a better position to pay higher rates to our writers and artists.

The market structure in our industry today dictates that there is no room for survival on the newsstands for nine or ten titles in the *Creepy-Eerie* category. The seven reprint titles spend nothing for editorial, so they get by on an extremely low sale. Our new competitor, *Web of Horror*, is using new stories, and new art. It is reasonable to expect that they might ask you to work for them.

I am asking for your loyalty. We'll give you as much work as you can handle. With our three titles . . . we have enough work to keep you busy continuously. We're asking you to stay with us exclusively. We're asking you not to work for the imitators. We're asking you to reflect on this thing called original creativity—and decide who deserves *your own* original creativity, them or us. I hope it will be us.

We wouldn't dare attempt to tell a man who he should or shouldn't work for—but I don't think we are out of line when we ask you not to enrich our competition in light of the facts presented. So, if you are going to work for the competition please telephone me (collect, if you are out of town) and let me know where you stand.

Thanks,
James Warren

Few, it would seem, acceded to Warren's request to call him and inform him they were being "disloyal."

Web of Horror proved to be short-lived, ending when Robert Sproul vanished, along with the completed artwork for the fourth issue (which has never been recovered). "The publisher just packed up and left town," Bernie Wrightson recalled. "Bruce Jones and I went out to the office . . . in Queens or Long Island. We walked in and the office was empty. They were just gone. [Later,] the publisher turned up in Florida."[20] Wrightson moved on to other projects, creating a sensation in mainstream four-color comics when he teamed up with Len Wein to co-create *Swamp Thing* (who was spun off into his own title in August 1972). Bill Parente's last consecutive issues as editor were *Creepy* #33 and *Vampirella* #5 (both dated June 1970). He's shown on the masthead for several more issues, sometimes as "contributing editor," indicating that scripts he had bought and edited were used in those issues. After Parente's exit, Warren turned to Archie Goodwin for help.

Goodwin's return to Warren Publishing as an editorial consultant (given the title associate editor) was not only because he needed someone to review the scripts. It was because he recognized deficiencies in his magazines. He asked Goodwin to write a memo addressing ways to improve them, which he could forward to his freelancers. It went out April 3, 1970:

> Dear Jim,
>
> Since you've asked me to give you a hand with the editing on *Creepy*, *Eerie* and *Vampirella*, I've set down some thoughts about what I feel are the books' weak points and what might be done about them, as well as suggested some directions they might take. Most of the writers and a good many of the artists are relatively new to the field, consequently the work sometimes falls below professional standards. But generally, it also shows talent and enthusiasm. (Our rates being what they are, you know they've gotta have enthusiasm.) Two very important qualities; because all the professional standards in the world can't replace them. But professionalism can embellish them. In general, that's what I think the books need . . . embellishment and sharper definition of the basic talent already exhibited in them.

In the nine-page memo, Goodwin addressed issues such as clarity, point of view, character, settings, mood, mechanics and aspects of the art. In general, he suggested more attention be paid to character and motivation, and that the stories be set in a greater variety of settings. He also asked the writers to lighten up on stage directions, and allow the artists to interpret the visuals as they saw fit. Toward the memo's end, he wrote:

> When I was first editing *Creepy* and *Eerie*, it dawned on me some-
> where along the line, that we could probably never duplicate EC's
> successful approach to horror comics. They were excellent, but in a
> way, they belong to the 1950s. If the books should be like anything,
> it's probably the old *Weird Tales* [which] would have horror by Love-
> craft, sword and sorcery by Howard and occasional science fiction by
> Long. The bulk of our stories will still be of the twist-ending variety,
> but I think we should start trying others which don't necessarily
> depend on a trick ending, but do evoke a definite mood of horror
> and the supernatural. In the future, we'll probably experiment with
> longer stories so that more complex themes can be developed, and
> perhaps occasionally try stories using continuing characters."[21]

These suggestions became the foundation for the second great era of War-ren magazines, which fans have sometimes called "the Warren renaissance."

Goodwin brought in a writer who would be a prolific contributor to the Warren canon. Doug Moench had joined comics fandom in Chicago in the early 1960s, and became friends with Don Glut, who was very active in the local fan scene. Moench told interviewer S. C. Ringgenberg, "One day years later [Glut] told me he had sold a comics story to Warren for *Creepy*. I was cocky enough so that my immediate thought was, 'If he can do it, I can do it.' So, I sat down and wrote a seven page *Creepy*-type story. Then the next day I wrote another one, and the next day, and the next day, and the next day. Monday through Friday. Had five stories. I sent the five of them to Warren blind, just by mail and then I promptly forgot all about it. One day in the mail, there's an envelope from Warren Publishing and I open it

up and it was for a hundred and twenty-five dollars. And I thought, 'Wow, they bought one of those stories!' There was no note or anything, just a check. And a hundred and twenty-five dollars for a seven-page story, or a six-page story—whichever one they bought—that's not bad. Then I opened the flap on the check and it was for all five stories, twenty-five dollars each. I sort of sank, but then, on the other hand, good news! They liked all five of them, and bought all five. So, that was the start of it, and eventually I did hear from the editor, Archie Goodwin, who . . . became a good really, really good friend."[22] His first story in print was "Snow Job!" in *Eerie* #29 (September 1970) with art by Jack Sparling.

An important new cover artist appeared in this period: Ken Kelly. His first cover appeared on *Vampirella* #6 (July 1970). Kelly was the nephew of Frank Frazetta's wife, Ellie, and became interested in painting after the end of his stint in the military. He spent almost a year in Europe with his wife, learning to paint. When he finally came up with a piece that he thought was worthy, "[I] went home immediately, left my wife and child in Europe. Came home alone, went right to Frank's house, and said, 'Frank, here it is. What do you think? Can I get started yet?' That's when he touched it up, touched up the [girl's face], which really pissed me off. I thought mine was fine. He said, 'Take this in to Jim Warren. I'll tell him you're coming. We'll see whether he wants you.' That's how it started. I took the train to Manhattan, and I introduced myself to Warren [who] liked the cover. Not only did he buy the cover, he gave me thirteen more covers to do initially just to get me started. I'm sure that was a favor to Frank. It pays to know someone."[23]

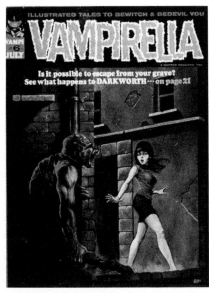

Vampirella #6. Ken Kelly art.

Creepy #35 (September 1970), which came out in early July 1970,

published Warren's "Editorial to the President of the United States" on the inside front cover, a response to the Kent State shootings. (Kent State is referred to, albeit obliquely.) The same antiwar editorial appeared in *Vampirella* #7 and *Eerie* #29. When the Vietnam war continued to drag on two years later, he ran the more pointed, "If you won't send in this coupon, shut up about the war" page. The coupon read, "I understand legislation is pending in Congress to end the war in Southeast Asia. As a concerned citizen, I urge you to support this legislation. If you do you will have my support." It appeared on the back cover of *Vampirella* #19 and *Creepy* #47 (both September 1972), in the heat of the Presidential nomination season. "I'm proud of the anti-Vietnam war ads that I wrote and put on the back of *Creepy* and *Eerie*," Warren said. "We took a lot of flak for that."[24]

Shortly thereafter, Warren began receiving input from an aspiring writer-editor named John R. Cochran, who sent him long letters criticizing specific elements in the latest issues of *Creepy* and *Eerie*. Cochran's only comics-related writing up to that point had been penning the article "Batman and Robin Were Lovers" in the March 1965 issue of satire magazine, *The Realist*. Warren began giving him freelance editing work to do at home in the evenings. The first issue in which his input might be felt is *Creepy* #36 (November 1970), more likely #37.

At the same time, future Warren star writer-artist Richard Corben debuted with "Frozen Beauty" in *Creepy* #36. Richard Vance Corben was born in 1940 on a farm in Anderson, Missouri. After earning a Bachelor of Fine Arts from the Kansas City Art Institute, he worked briefly as an animator, then began doing stories and art for underground comix, which were on the rise. These included *Slow Death*, *Skull* and *Fever Dreams*, and soon, he self-published *Rowlf* and *Fantagor*. He was an entrepreneurial, savvy creator who was willing to work for Warren as long as he got his original art back, and eventually retain the copyrights to stories he both wrote and drew.

Whenever Warren attended one of the New York comic conventions, he would be approached by fans—some of them quite outspoken. At the 1970 con, during a Q&A session after a panel, he was infuriated when a fan stood up and asked, "Why are you publishing the kind of crap you're publishing?"

AN EDITORIAL
TO
THE PRESIDENT OF THE UNITED STATES
AND ALL THE
MEMBERS OF CONGRESS

---ON BEHALF OF OUR READERS,
MOST OF WHOM ARE FROM 10 TO 18 YEARS OLD...

WE are a magazine publishing company that is in business to entertain and enlighten our audience. We don't publish politically-oriented magazines (3 of our titles are comics-format), but we do get involved in the serious issues of our times.

BOTH this company and our young readers have felt for some time now that our country is in deep trouble. Our first personal taste of this trouble occurred in 1965 when we came out with BLAZING COMBAT Magazine. Blazing Combat was a comic book that grimly pointed out that war is hell, and in-human—and not the glamorous, adventurous matter often depicted in the mass media. Editor Archie Goodwin wrote some of the finest anti-war stories ever seen in comics form.

"UNPATRIOTIC?"

It was a publication we were proud of. Yet, Blazing Combat was a failure on the newsstands. It lasted 4 issues.

WE suspect that part of the reason it failed was because some of the people involved in the sales and distribution of our product didn't like the attitude we took on Viet Nam. Back in 1965 it was considered, by most, extremely unpatriotic not to support our country's position. We received complaints

along about our second issue. We ignored them, but could not ignore the economic effect of losing thousands of dollars each issue. We ceased publication.

SMOKING DOESN'T PAY!

WHY RISK YOUR HEALTH FOR CIGARETTES?

"MORE IMPORTANT THAN AD REVENUE"

WE were angry—that a magazine we thought deserved to live—had died, possibly because it proclaimed a message that said "War is hell—and the Viet Nam war is not only hell, it's absolute insanity for our country." And so Blazing Combat went quietly out of business.

STILL another involvement for us is the running of our Anti-Cigarette Smoking ad.

CREATED at our own expense, this half-page Comics-Format ad "EASY WAY TO A TUFF SURF-BOARD!" (written by Archie Goodwin, drawn by Frank Frazetta) has been running in all Warren Magazines for the past 5 summers. It's not the kind of ad you'll see in any other publication in America. It doesn't help sell our magazines, but we run it because we believe the message is important

(more important than advertising revenue)—and deserves exposure in our pages.

NOW we must again speak out, concerning that most urgent issue—our involvement in Southeast Asia.

WE realize that only you, Mr. President, can end this war—the longest and costliest war in our history. Failing this, only You—the Members of Congress—can stop the President from continuing a war that is taking the lives and limbs of our youth, soiling our national conscience, and splitting this country down the middle.

MOST of us readers are under 21. We can't vote—yet. But we don't have to be 21 to die in a war that was a mistake to begin with.

That's why we are angry with you adults, Mr. President and Members of Congress. You adults have let this drag on for half of our lives. We've tried to tell you this in our demonstrations. We tried to tell you this at Kent State. Were you listening?

PERHAPS you don't listen because you think we're children. You may even think it strange or odd that words like these appear in a magazine such as this. But we're deadly serious about what we're now saying.

DO something about it NOW.

BEFORE another human life is wasted — give us PEACE, NOW!

James Warren,
President
WARREN PUBLISHING CO.

Warren's back-page anti-Vietnam war ad.

That fan was Don McGregor, who went on to a long career as a comic book writer. At this time, he was still trying to break into the business. McGregor told interviewer Richard J. Arndt, "Jim just went ballistic! There was a big, thunderous response to this. After the panel was over, Jim Warren came and stalked me out. He said, 'Who in the hell are you? How dare you ask me a question like that?'" But Warren actually liked McGregor's chutzpah. Later at the con, after he found out that McGregor was an aspiring writer, he told him, "I'll let you submit a story to Archie Goodwin."[25] Goodwin bought that story, "When Wakes the Dreamer," which eventually saw print in *Eerie* #45 (February 1973). The first to appear, however, was "The Fadeaway Walk," in *Creepy* #40 (July 1971). That was McGregor's first professional sale to see print. His story "The Men Who Called Him Monster" in *Creepy* #43 (January 1972) had what may be the first interracial kiss in comic books. Spanish artist Luis Garcia misinterpreted an authorial description ("this is the clincher") to indicate a kiss, and so the older, black detective (who looks like Sidney Poitier) kisses his client, a white woman. By the time it saw print, McGregor had begun a five-year stint on staff at Marvel. (He would return in the late 1970s with more scripts for Warren.)

Back in autumn of 1970, both magazine and merchandise sales had picked up enough that Warren decided to take the plunge, and moved his operation into a much larger space. It became his company's office for the rest of its existence: 145 E. 32nd St., in Midtown Manhattan. It included Captain Company, located on the same floor. One exited the elevator on the seventh floor, turned left and was presented with the receptionist's area, a tiny little room with glass in the front, and an open foyer with chairs. In that area, Warren had a reader board installed, with a daily announcement such as, "Warren Publishing welcomes [the name of the freelancer or visitor expected that day]." It was his way of making his guests feel valued and welcome.

To the left of the foyer was the editorial department and production area, which was a U-shape. There was room for several people to work in the production area, doing the layouts, pasting up the ad pages, and so on. Passing through the production bullpen, there were a couple of other rooms. One was for assistant editors, another for the photostat machine. The walls were white. To

the right were offices for Warren's secretary, and members of his financial team (those in charge of circulation, accounting and other management functions). Behind the business area on the right was the Captain Company warehouse.

In his office, Warren worked in a "U" area, made up of a credenza along a paneled wall and two other tables, so that there was plenty of room to keep relevant papers and artwork spread out for ready access. Often his briefcase was open on his desk, as he was always shuttling papers to and from his office and apartment. The "U," with its entry behind his executive chair, created a buffer between him and visitors. Before long, he had the office decorated much as it would appear in photographs over the next decade. When he was facing the door, the wall to his right was an impressive display of framed covers from his magazines. The wall to his left was decorated with photos of colleagues, a framed *Peanuts* original daily strip (he said it was "probably my favorite comic strip"), posters and other items. On the left front corner of his desk was a vintage cash register, a reminder that sales were the engine that fueled the business. Opposite, next to the door, was a shelf with knick-knacks. Behind him, toward the windows, were bookcases with many books of relevance to his publishing operation.

WARREN'S DELIGHT at the demise of *Web of Horror* was short-lived. In the fall of 1970, a new competitor named Skywald Publications emerged, which presented a more substantial threat. Its first publication was *Nightmare* #1, dated December 1970, quickly followed by *Psycho* and *Scream*, all in the general mode of the Warren magazines. The company was formed by former Marvel Comics production manager Sol Brodsky and publishing entrepreneur Israel Waldman, who had made his living publishing cheap comic book reprints for sale through grocery and discount stores in the late 1950s and early 1960s. The tenor of the Skywald magazines was more lurid than the comparatively tasteful fare of the Warren magazines. Warren was beside himself at this development. Marvel Comics' *Savage Tales*, another black-and-white comic magazine, was also published in 1970. When a new imitator came out, he fretted over the effect on his sales.

He continued to expect his freelancers not to work for the competition, i.e. the other black-and-white magazines. Although he later admitted it was the wrong thing to do, the policy was in place well into 1972, according to correspondence reproduced in the fanzine *Canar* #7 (March 1973). As *Creepy* editor J. R. Cochran wrote to freelancer E. A. Fedory, "[I] just saw a copy of [Skywald's] *Psycho* #6 and was quite surprised to see your work therein. Every comic on the stands in black and white is in competition with Warren Publishing. We do not accept work by writers who work for the competition. We expect our writers to share a common loyalty with us in putting out the best black-and-white comics around! If they choose to work for our competition, we cannot use them."[26]

Tom Sutton: "I remember the loyalty oath. I couldn't stop laughing for two days. I just trashed it. I never paid any attention to it. But that was typical of Jim. He really thought, I think, that he could impose his will on you. But it was so crazy that you couldn't really get angry with him. It was so dumb. I mean, you really think this is intimidating? Gee! Not to be able to work for Jim."[27] The problem was that Warren couldn't follow through on his pledge, "We'll give you all the work you can handle."

Case in point: Doug Moench. "I was writing furiously," Moench recalled, "a story a day for many, many days, and eventually I heard from John Cochran, who said, 'Look, these are good but there's too many. We're at the point now where if we keep buying everything you send, then you're going to be the only writer in every issue, and we can't have that. So, I'm going to send this latest bunch of stories back. I'm not even going to read them because right now, in the next *Creepy*, you have three stories as it is.' I was upset, but I said, 'All right.' So, he sent them back and then I sent them to Skywald. A lot of times they had stuff that was just as good, or maybe even better than some of that *Creepy* and *Eerie* stuff. So, I sent [scripts] to them and they bought them. And then Jim Warren flipped out. I was supposed to be loyal and, you know, how dare I be a traitor and sell to the competition? I tried to explain it to him: 'I'm not looking at it that way. You guys can't buy everything I write, but I want to sell everything possible, so how can I not try?' Eventually I

was writing so many that I was sending some not just to Skywald, but also to *House of Mystery* and *House of Secrets* at DC.

"They started buying them and now Warren's really getting pissed off. I finally came to the point where I said, 'If everything I write has to be for you, then you have to buy everything I write.' He said, 'Well, uh, we can't do that.' And I said, 'Yeah, I understand that. That's why I'm selling them elsewhere.' And this went back and forth, back and forth, and finally he sent this really long letter and I was fed up. My next letter back to Jim Warren was: 'Dear Jim. Fuck you. Sincerely, Doug.'

"I thought I was quitting, obviously, but back then there was a thing that the Post Office did called Special Delivery, and it really *was* special delivery. They would come to your house at midnight with a special delivery. And that's what happened. My doorbell rang at midnight once, and I opened the door and the guy said, 'Mailman. Special Delivery.' It was a big box and it was filled with presents from Jim Warren, after I had just sent him the kiss-off. Of course, all the presents were from Captain Company, you know, a big Vampirella poster and books that he was selling from Captain Company, and toys and this, that and the other. And I got a raise. I said, 'Okay, I guess I didn't quit.' I never understood Jim Warren. I'm one of many, I guess. I did not work exclusively for him [except] for a while, when they were buying everything."[28]

Archie Goodwin's period as associate editor lasted about eight months. Warren needed an in-house editor to handle the whole job. In a letter in May 1971, he offered J. R. Cochran the position, at a salary of $7,800 (about $48,000 today) a year: "The hours are 9:15 a.m. to 5:15—but of course here at Warren Publishing everyone is expected to *think* about the job during every waking hour. Only *I* think about the company when I'm sleeping. You join us at a time in our growth in which your contribution will be very valuable and although the hours will be long, the standards immensely high, and the pressures unbelievably difficult—we all feel that you will be able to function well within the framework of our organization."[29] When Cochran showed up for work in the middle or the end of June, he discovered that he was the entirety of the editorial department, and that Billy Graham, another recent

hire, was the entirety of the art department. Cochran's job consisted of doing the layouts, reviewing manuscripts, interacting with writers and writing copy for Captain Company ads.

When interviewed about his time with Warren in subsequent years, Archie Goodwin said little that was negative about the experience, at least not for publication. While it's true that he was with the firm mostly during good times (1965 and 1966), he was certainly knowledgeable about Warren's combative nature and his other faults, not to mention working in a small business that was thinly staffed. Being an editor there wasn't easy for him, and it wouldn't be for his successors. Cochran was much more forthcoming. Much of this came out in *Canar* #31–32 in 1976, in an interview titled "The J. R. Cochran Story." He told interviewer John Baljé that the problems began as soon as he walked in the door.[30]

To start with, Cochran was expected to draw from a large backlog of scripts, many of which he would have rejected, and could only buy a limited number of new stories. "I was obliged," he said, "to run [the backlogged stories] ahead of those of my own choosing. As the new man, I could only accept a limited number of scripts per month and those only on a 'freeze' basis, meaning I wasn't able to put invoices through for a four- to-six-week hiatus. We had to get rid of the other shit first, stuff that in some cases was years old." When he did buy a script, he could pay only twenty-five dollars for a six- to-eight-page story, and thirty-five dollars for a nine-to -twelve-page story. Some writers (he singled out Steve Skeates) wouldn't work with him, writing directly to Warren. Other established writers went over his head if Cochran rejected a script. There was also a lot of clerical work involved, such as sorting through mail for the letters columns and fan-page submissions, retyping, sending out form letters and comp issues, etc. As he said, "When you make truck with people's hopes, you're bound to be hit with an avalanche of junk."

He also didn't like Warren's management style, such as the way he chose the Captain Company ads. "He personally selected and placed in true King Tut fashion every single ad in all four books [and] used to put off choosing the ads until the last possible minute and then with a full editorial contingent at his side. He seemed to get off on hanging the people up, making them

wait on him hand and foot while he went through his specialty act of playing corporate banana." He said the publisher made lists of people who didn't thank him for his annual Christmas present, and contradicted Warren's claim that he let people work flexible hours (claiming he didn't even like it if people went out for lunch rather than ate at their desks). As he put it, "The list is endless. Suffice it to say that it was a poor man's version of the salt mines." But then, he acknowledged, "[I] don't have terribly much regard for Warren."

CHAPTER ELEVEN
RECOVERY

IN THE FALL OF 1970, an unexpected visitor showed up at Warren's office. His name was Josep (José) Toutain Vila. Born in 1932 in Barcelona, he was a cartoonist best known in the early 1950s for the Spanish crime series *Sylvia Milones*. To capitalize on the demand for comics artists in Paris, the twenty-one-year-old cartoonist formed a studio in Barcelona in 1953 which he called Selecciones Ilustradas (SI). Eventually, SI became the source of comics artists for many European publishers, especially in the United Kingdom, which ushered in a period of major expansion for the agency. By the dawn of the 1970s, he decided it was time to make a sojourn to America, and see what business he could generate for his studio. It was a time when more illustrative styles were showing up in some of the mainstream titles from DC and Marvel, and particularly in Warren's magazines, of which he was well aware. After preparing a beautiful portfolio of the work of many of his best artists, Toutain flew to New York City and began visiting publishers. Among them were Dell, DC and Marvel. Then he appeared, without an appointment, in the anteroom of Warren Publishing.

As Warren described it, Toutain was a tall, thin man who wore an English-style neckerchief and a beautifully cut suit. He arrived just as Warren was getting ready to leave the office. Warren was instantly mesmerized

by Toutain and the quality of the work in the portfolio the man placed before him. Toutain told him he had just visited Carmine Infantino and Stan Lee.

"Did they buy any of it?" Warren asked.

"Not yet," Toutain replied. "They are thinking about it."[1]

Warren saw opportunity. He had purchased material from Britain's Fleetway for his *Teen Love Stories*, so he wasn't averse to the idea of using art produced in a foreign country. (Indeed, that work probably originated from the drawing boards of Selecciones Ilustradas.) He took Toutain out to dinner and, by the end of the meal, they had agreed on the basic terms of a business relationship that would have an enormous effect on both men's futures.

Per David A. Roach in *Masters of Spanish Comic Book Art*, "At their first meeting, Toutain had proposed an unusual publishing agreement. Warren could keep the copyright to the stories he published (with the occasional exception) and reprint them as many times as he liked. Toutain, for his part, could sell Warren material to the rest of the world, which he did with great enthusiasm. Warren historian David Horne has identified twenty countries, from Finland to Japan, South America to Australia which issued their own Warren titles."[2] Warren was thrilled at the prospect of finding both a dream artist for Vampirella (José González's work had been the first thing in the portfolio), and a well-connected, motivated agent who would expand foreign sales, bringing in a major income stream for Warren Publishing.[3]

The first script sent to SI was "The Escape!," which appeared in *Vampirella* #11 (May 1971). José (a.k.a. Pepe) González became the artist for Vampirella from #12 (July 1971) onward. He also drew the new "Origin of Vampirella," penned by J. R. Cochran for the *Vampirella 1972 Annual* (which actually came out in July 1971). That story marked an important moment in the relationship between the two comics impresarios. They had agreed to a per-panel rate, rather than a per-page rate. Even though there was a rush to get it done by the deadline, Toutain, at the last minute, read the script. On May 5, 1971, he wrote:

Dear Jim,

Last night I read the script "The Origin of Vampirella," which Pepe González has started drawing and whose deadline is June 1. When

I read it, I realized there was a big problem. The script is rather bad. It is padded with repeated situations. I don't like criticizing a script writer. If the problem arose only from the quality of the script, I wouldn't have said anything. [There is] an average of more than 7 panels per page, with the following disadvantages. 1) González will not be able to do a good job if he has to draw so many panels on each page. 2) This story is urgent. The more panels there are, the less time will González be able to spend on each one. 3) (Most important) Charging per panel, this story is going to cost you $58 per page.

This was when Warren was paying $40 for a page of finished art. (It was probably Toutain who wanted to have his artists be paid per panel.) Toutain went on to outline his solution, which involved cutting some panels. He had to make the decision on the spot, and was clearly wary of the publisher's reaction. ("I'm touching wood from now on until I know your reaction.") He needn't have worried. Warren wrote:

Dear José,

I am glad you were able to see the problem on the script "The Origin of Vampirella." After reading your letter twice I came to the conclusion that José Toutain and Jim Warren both think the same way and are going to get along very well together; you did exactly what I would have done in the same circumstances, and I am very happy with your decision. You know, Joe, there are not too many people whom I would trust with this job—but I want you to know that you are one of them. I have the fullest confidence in SI and in your personal ability to watch over our work.

Sincerely,

James Warren

He quickly realized that he had a good thing going with SI, and was pleased that his opposite number (so to speak) thought in terms that made sense to him. González instantly became a favorite with his readers.

Another Spanish artist who made a big splash with fans was Esteban Maroto, whose debut in *Vampirella* #14 (November 1971) was "Wolf Hunt," a truly spectacular introduction to his work. Many more Spaniards began producing pages for Warren's magazines, such as José M. Beá, Luis García Mozos (as Luis García), Félix Mas, and L. M. Roca. And, there were the painted covers of Manuel Pérez Clemente, a.k.a. Sanjulián, beginning with *Vampirella* #12 (July 1971). Why the shift to so many Spanish artists? According to Bill DuBay, who started working there before the "Spanish invasion" began, "[The Spanish artists] were a lot better. Look and see who was working with Jim when the shift was made. There were people like me, Bill Black, Billy Graham and a lot of young guys who thought they were hot stuff. We loved comics, we did the best we possibly could, but we were essentially still amateurs."[4] None of the American artists could draw beautiful and sensuous women like the Spaniards could.

IT TOOK WARREN until early 1971 to pay off the printing bill and make good on outstanding company debts.[5] Although that worry was eased, he was still combative by his very nature. Teenagers Paul Levitz and Paul Kupperberg, editors of the widely circulated fanzine *Et Cetera*, which provided its readers with news of upcoming events in comics, went Warren's office in April 1971 for an interview. Kupperberg recently published the raw interview on the internet. Here are some excerpts:

> Levitz: What's coming up in your mags? Any new magazines you're publishing? What's coming up? You've gone a little further into the merchandising recently, with the Vampirella dolls.
>
> Warren: Vamp-*PER*-Rella!
>
> Levitz: [correcting his pronunciation] *Vampirella*. Sorry. Is anything further coming of that?
>
> Warren: Yes!
>
> Levitz: Okay! What?
>
> Warren: I can't tell you.
>
> Levitz: All right.

Warren: You want an honest answer or you want a lot of crap to put in your fanzine?

Levitz: I'd prefer an honest answer.

Warren: The reason I can't tell you is because I have a policy in this company . . . not to divulge information because if anything happens to stop it from happening we end up looking bad. You look bad, as the publisher of false information, the reader is misinformed and all the great things of all times sometimes never happen and everybody ends up getting misinformed. . . . So, I'd rather say we have a lot of plans and they're all great and we're very happy about them. When they happen, we'll tell you.

Levitz: Does that include some possible new magazines?

Warren: Of course!

Kupperberg: Is anything happening . . .

Warren: Hey! You said you weren't going to double-team me there. Don't switch thoughts.

Kupperberg: No, it's on the same subject.

Warren: Oh. Okay.

Kupperberg: Anything happening in like three, four weeks that definitely will happen that you can talk about?

Warren: Gee, that's a tough one, Paul. . . . Yes sir, something is happening, but I can't tell you 'cause it won't break for maybe a week or two after your deadline. You miss by a couple of weeks.

Levitz: Okay then . . . Let's see. Recently, Skywald has started its own line of horror magazines . . .

Warren: If you can call them that.

Levitz: Do you think . . . they will be the slightest competition?

Kupperberg: They've got some good artists.

Warren: Are you ready for a burst of ego?

Kupperberg: Yes.

Warren: They don't got Jim Warren! Now, there's no way that can appear in print without making me look like the supreme horse's ass of all time. So, don't print it.

Kupperberg: Sure, okay. But what about writing? I mean, they've got Gardner Fox . . .

Warren: We discovered Gardner Fox! In our field. We cultivated and developed Gardner Fox.

Levitz: Skywald is coming out with a new book, *Science Fiction Odyssey*, which will be done on the basis of buying first-time rights to a story's publication and this way they're going to get super-pros, the greats of SF.

Warren: Who are they?

Levitz: So far the one that I know of that's a . . .

Kupperberg: I think you should have said "reputed greats."

Warren: Good thinking.

Levitz: Harry Harrison is definitely one of the greater SF writers.

Warren: In your opinion.

Levitz: Yes.

Warren: Good! Preface it with "in your opinion."

Levitz: Okay. They definitely have a story by him in the first issue . . .

Warren: Big deal!

Levitz: Ah . . . they have quite a few other people . . .

Warren: Who are these people? Tell me about them!

Kupperberg: Niven, Gardner Fox, Carr, and they think that by doing this they will be getting better writers.

Levitz: What is your opinion on that? Do you think it will work?

Warren: Oh. You ask a lot of questions at once. Do I think it'll work? My opinion . . . Um, you really threw me a curveball question. It's like asking "Do you still beat your wife?"

Many years later, Warren addressed the issue of "pushing peoples' buttons" and his anger issues. He learned as a youth that he did better at sports when his team was behind. He'd get angry and consequently perform better. He deliberately made others angry, thinking this would motivate them to rise to the challenge. "I . . . thought that anyone who creates—writer, artist, or anyone involved in the process of creating something that didn't exist

before—all work the same way, and they had to be forged into steel. Do you know how steel is forged? Steel needs fire. Without fire you can't make steel. Fire burns. It's hot and it hurts, but it's the only way you can make steel and get the brilliance. I functioned that way. I thought other people did, too. So, I deliberately pushed people's buttons."[6]

At least he had a sense of humor. Cochran: "I remember telling Warren something like, 'I wish Wally Wood drew like he used to at EC.'" And Warren said something like, 'I wish I could fuck like I used to.'"[7]

Comics writer Len Wein, who sold a number of scripts to him in the 1970s, had a favorite Warren story: "It was at a meeting of A.C.B.A. [the Academy of Comic Book Arts] at the National Cartoonists Society building. They had a bar area, and a [meeting room] on the second or third floor. That's where we had our meetings. One night, everyone was in the room. Neal Adams is standing in one corner. . . . The conversation level is right at the point where no one could hear anything anyone could say. One of those things. And Warren was trying to get a word in edgewise. He was trying to say something, and had lost control of the conversation, and everything was going crackers. There were a number of different tables. We weren't all at the same table. There was a hardwood floor. And I watched him take a glass he was drinking from, now empty, stretch his arm straight out at his side, and drop the glass to the floor. It hit the hardwood floor, shattered, and you know, what everyone always does, there's total silence in a second? Jim says, 'Now, as I was saying . . .' and went back to his conversation."[8]

Still, Warren was loyal to his friends. His protégé Sam Sherman became a distributor and producer of low-budget horror films with his Independent-International Pictures, teaming with director Al Adamson. One day, Sherman showed up in Warren's offices. "When I was finishing up work on *Dracula vs. Frankenstein*, which turned out to be Lon Chaney Jr.'s last movie, I visited Jim," Sherman recalled. "I asked him, 'Can you help me publicize my movie? Maybe do something in *Famous Monsters*?' He ended up giving me the front cover [of *FM* #89] and most of the issue, a whole big thing. He really came through for me."

He did alienate people. According to Mike Royer: "Some of the work I did for Jim Warren, I'm proud of. Some of it, I look at it and think, 'God, I

hope nobody ever looks at this.' Jim Warren was . . . a friggin' jerk! The last job I ever did for him was one of the best jobs I did for him. Still had its problems, but for me, it was one of the best jobs I ever did." It was "He who Laughs Last . . . is Grotesque!" written by Al Hewetson, which saw print in *Eerie* #34 (July 1971). "I did not want to send him the original art. He was paying a whopping $39 to pencil, ink and letter, and you never got your originals back. I went to the expense—in those days, which was horrendous—to have [photostats] made of the original art. And I sent him the stats. A few days later, I get a phone call saying, 'How *dare* you unilaterally decide to send me stats instead of the original art? I can't work from this stuff. You send me the art or you don't get a check!' In the meantime, I had tweaked the originals, and when the book was printed, he printed from the stats. So, the next time I saw him in person was at a weekend science fiction convention in Los Angeles, and I walked up to him, and said, "Jim, if you were on the other side of the street, bleeding in the gutter, I would only cross the street if I had a box of salt."[9]

Nick Cuti was one of the most prolific writers for *Creepy* and *Eerie* in the early 1970s. When he asked for a raise, Warren gave him the honorary title "contributing editor" instead. Cuti then found a job working as Wallace Wood's assistant on the *Sally Forth* strip for *Overseas Weekly*. Sometime later, Wood brought Cuti along with him to a meeting with Warren, to discuss a new magazine idea. Nick Cuti recalled, "Woody wanted to do a magazine for Warren. He wanted to call it *POW!* It was going to be an adult-oriented magazine of comics stories. One evening, the three of us got together after office hours in Warren's office, to talk about the magazine. Frank Frazetta was going to do the cover. [But] Jim and Woody couldn't come to an equitable agreement on the magazine finances, a partnership, whatever. I don't even recall exactly what they had disagreed about.

"Jim said, 'Look, to show that there's no hard feelings, why don't we have dinner, my treat?' We went to a Chinese restaurant and we were eating away, and Jim said, 'You know, I really want to do this magazine.' Woody says, 'So do I, but obviously, we can't come to an agreement.' Then Woody came up with an idea. [He said] 'I'll tell you what. We'll do the magazine, but only

"I Wonder Who's Squeezing Her Now?" Script by Nicola Cuti, art by Ernie Colón and Wallace Wood. Intended for the aborted *POW!* #1, it didn't see print until the late 1970s.

if Nick can be the editor. He'll be the buffer between us.' Because Woody and Jim both had very big egos, and I was just starting out, so I hadn't had a chance to inflate my ego yet, I guess. I said, 'Sure! I'd be happy to.' This was Woody's idea, and Warren agreed to it right away. Because both of them got along with me."[10]

Cuti set about getting in touch with the different artists who they wanted, such as Vaughn Bodé, Jeff Jones, Gray Morrow, Ernie Colón and Frank Frazetta. Frazetta was going to do a cover recreating the scene of King Kong on the top of the Empire State building, but instead of the ape, it would be a sexy girl fighting off the biplanes and such. Scripts were prepared, and the

artists got to work. Then it hit a snag. Cuti: "I went over to Warren's offices to have a meeting with Jim. He said that I would not be editor of the magazine. I would only be assistant editor. Jim was going to be editor. I became pretty furious about that. I told him that if that's the way he felt, he could take his money and his magazine and that would be the end of it. I stormed out of the office. But when I got home, I thought to myself, 'I did the work.' I felt I ought to keep the money because I did do the work. I did hand out assignments, even wrote a few stories myself.

"Jim got furious. So he said, 'Then I'm not paying you for these stories that you wrote.' And that went to court. With [Wallace Wood] Woody's encouragement. Woody said, you've got to sue the guy, and so I did, in the Small Claims Court. It wasn't a huge sum of money. The amount was about $250. But it was more or less the principle of it. I presented my case, Jim presented his case. Woody was there with me, backing me up. Woody and I sang all the way home because we knew we had won the case. And this was confirmed when I got the actual judgment." When Cuti walked out, Warren apparently lost interest in the project. One story had been completed for it, "I Wonder Who's Squeezing Her Now," written by Cuti, and drawn by Ernie Colón and Wallace Wood, which eventually appeared in the publisher's new magazine *1984* #5 (February 1979). It's a shame. Despite the juvenile-sounding title, *POW!* would have been a logical next step for Warren: a comics magazine for readers who had reached full adulthood. The Frazetta cover of the woman on the Empire State Building was used on *Eerie* #81 (February 1977).

Cuti: "About a year later, I was at a convention. It was packed solid with people, and all of a sudden I looked in front of me, and there's Jim Warren, my deadly enemy. I couldn't turn around. He hated me as much as I hated him. Then I thought, 'this is ridiculous,' and I stuck out my hand and said, 'Jim, how are you?' He smiled and took my hand, and we started chatting like we were old buddies. He said to me, 'Nick, if you ever need a job, you got it. You're the only person who's ever beaten me in court.'"

During that encounter, in the crush of the convention crowd, Warren asked Cuti, "Are you still working for Wally?" When Cuti nodded, Warren said, "Give him a message. Tell him that he's a very sick person and he should

get some help." He didn't explain what he meant, but Cuti found out from Wood. During a work day, the receptionist put through a call to Warren from Wallace Wood.

"Jim, I need some help," Wood said. "I've been arrested by the police, and they're only going to give me one phone call. I don't have a lawyer, and I know you've got lawyers galore. Could you help me out?"

"Sure. Where are you being held?"

"I don't know the name of the precinct. I'll try and find out." When he returned to the phone, Wood said, "Oh, the hell with this place. I'm gonna bust out of here."

"No, don't do that!" Warren said. "I'll get you out on bail."

Then Wood hung up the phone, leaving Warren up in the air.

A few minutes later, he got a call from a man identifying himself as a policeman. "Do you know Wallace Wood? You were the one who he called for his one phone call."

"Yes, yes, of course I know Wally Wood. I'm going to send a lawyer down to your precinct!"

"It's too late," the cop said. "He tried to break out, and we had to shoot him. He's dead."

Warren screamed, *"You killed Wally Wood?"*

"Yeah, he tried to break out. We had to shoot him."

Warren was getting hysterical, until the phone rang again and he heard Wallace Wood's voice. "It was just a joke, Jim. I'm alive." It was a prank cooked up by Wood and Ralph Reese, who played a member of New York's finest.

ON JULY 2, 1971, Warren was the keynote speaker at the 1971 New York Comic Art Convention, held at the Statler-Hilton Hotel. When a transcript was published, writer Carter Scholz prefaced it by observing, "When James Warren stepped up to the podium to address the 1971 Comic Art Convention, he appeared drawn, harried, more than a bit on edge. In the earlier parts of the speech, a noticeable tremor occasionally edged its way into his voice."[11]

After some initial remarks, stating that Warren Publishing recognized the importance of fandom and addressing the fans who are "members of a forum

that doesn't exist anywhere else in the world," he began, "Today, now, I want to hold you spellbound [by taking] a look at the deep, dark, up till now unknown secrets of a creativity of a different nature. The creativity of surviving as a business enterprise in the comics industry." He stated that the comics industry consisted of six groups: the creative people, the printers, the magazine wholesalers and distributors, the readers and fans, the general

Warren giving the keynote speech at the 1971 New York Comic Art Convention. Courtesy of Mike Zeck.

public and the publishers. Of the creative people, he said, that while they will often complain about the publisher, they're really "at war" with the readers, in that they are always trying to gain the interest of readers, that this is a never-ending challenge that can torment the creative people.

Of the printers, and printing plants, he began by pointing out that "the comics industry is one that depends mainly on discretionary income." When there's a recession, as there was at the time he was making this speech, it was particularly tough on them because of the degree that they invest in their companies, and, "two major comic book-producing printing plants have gone out of business in the last five years." (He didn't name them.)

Of the third group, the magazine distributors and wholesalers ("my favorite"), he said they still do business the way they did 100 years ago. "There are only two businesses or professions that still do business the same way as they did a hundred years ago: magazine wholesalers and prostitutes. And that's all."

Of the readers and fans, he said, "You people are really something. You're fanatics, you're absolute fanatics. If I went up to a normal person and I said, 'Phil Seuling just died suddenly,' they'd say, 'Oh, that's terrible! What a shame!' But if I went up to a comic fan and I said, 'Phil Seuling just died suddenly,' he'd say, 'Gee, I wonder who's gonna run the comic con next year?'" (The audience laughed and applauded.)

The fifth group was "another favorite," he said. "The general public. The critics. The Comics Code Authority." (There were hisses and boos.) He got the biggest rise from the audience when he got to the Comics Code. "The Comics Code. Oh boy. Now don't knock the Comics Code. For years, it has stood for everything in America that is decent, and good and stupid." Then he took Code administrator Leonard Darvin to task for saying, in *The New York Post* (on April 3, 1971), that, perhaps the Code could be revised to acknowledge the existence of "the war against drugs," showing they are dangerous, while being careful "not to present knowledge about drugs." Putting the paper aside, Warren said, "God forbid we should impart knowledge to our readers about drugs! Don't dare tell them anything about it! It's not healthy for them to know the difference between a barbiturate or an amphetamine. The Comics Code. What bullshit!" (Loud applause from the audience.)

On the subject of censorship: "I've been accused of being an irresponsible publisher. I'm a *responsible* publisher. I'm concerned about my reader's world because it's also my world, and I'm selfish. I want their world to have more peace, less smog, more fun, less tanks, more freedom for them to be themselves. And yet it seems that the answer proposed by organizations like teachers and the Comics Code is more regimentation, more organization of your young thinking. Get the thinking organized, says the Code and the educational

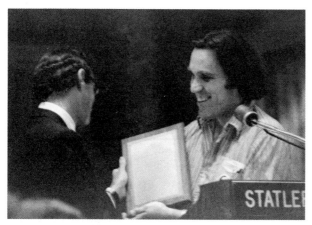

After Warren's speech, con organizer Phil Seuling gave him an award. Courtesy of Mike Zeck.

experts. And we'll conquer poverty, disease and pollution. Maybe. But no one will be wandering his own way with his own thoughts. This is upsetting, because you cannot produce a Mark Twain, a Ray Bradbury or a Fellini by telling him he can't read my comic books. Not every reader is a budding Ray Bradbury. But then, he *could* be if he isn't stifled and it isn't stifled out of him.

"The last category," Warren said. "The publisher. It's a wonderful job for people who have never had a nervous breakdown but always wanted one. Warren Publishing has a reputation of sorts for hating its competition. That's true. We do. Does Hertz like Avis? Does Crest like Colgate? Of course not!" He recounted how Stan Lee told him he thought there was room on the newsstands "for all of us." He said: "Stan's thinking was okay during the golden age of comics. And up to a few years ago it was okay. Y'know, once comic publishing was a lot of exciting profitable fun. But not now. The economics have narrowed profit margins. Staggering costs have been forcing publishers to wonder about their survival. All of them. The decline of comics was signaled by television and sealed by the supermarkets and the shopping centers and the gradual disappearance of the corner newsstand, the drugstore, and the corner cigar stand. And how do we survive? By utilizing the best talent, we can find to work for us. But more than anything else, we'll survive by making constantly correct business decisions, and nothing more."

He concluded, "In the final analysis, let me tell you that I love my company and I love the characters we've created, *Creepy*, *Eerie* and *Vampirella*, and I love my work. And we're both here today because of a unique love story. You [are] here because of the pure love that you have for the subject of comics. I'm here because of my personal love for comics, and for my own passion for creating a good product. And that's some love affair." After the long applause died down, Phil Seuling came to the podium and presented Warren with a plaque which read "to James Warren, for bringing challenge, vitality and new concepts to the publishing of comic art."

Directly following the keynote address, he presided over the presentation of the 1971 Warren Awards, the third time such awards were handed out at the New York con. A group assembled on the dais consisting of Mark Hanerfeld, T. Casey Brennan, Nick Cuti, Billy Graham and Archie Goodwin

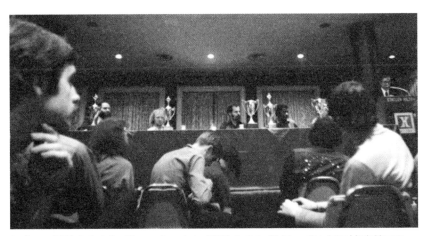

Audience POV shot at the Warren Awards in 1971. Left-to-Right on the dais: Mark Haner-feld, T. Casey Brennan, Nicola Cuti, Billy Graham, Archie Goodwin (obscured) and James Warren at the podium. Courtesy of Mike Zeck.

(even though he was no longer working there). Only two of the winners were there. Casey Brennan accepted the Ray Bradbury Award for Best Story ("On the Wings of a Bird!" in *Creepy* #36), and Archie Goodwin for "all around Best Writer," principally, it seems, for his "improvement" of Vampirella in the story "Death's Dark Angel," in *Vampirella* #12. That story also won the Frank Frazetta cup for best inside artwork for Spanish artist José González. Frazetta himself was awarded the Jack Davis Cup for the second year in a row, for best cover artist (*Vampirella* #7). Frazetta showed up later at the convention. His award was accepted during the ceremony by Mark Hanerfeld.

EVEN AS HE TOUTED his firm's recovery, there was no getting around the fact that Warren was paying freelance artists the low page rate of $40.00 in early 1972. In February, when Tom Sutton asked for a raise of $10.00 per page, Warren responded: "This represents a 25 percent increase over the $40.00 per page rate you are now receiving. I am confused. Does this mean that the work you now want to give us will be 25 percent better? Or will this work contain 25 percent more detailing?"[12] When Sutton came back with the comment that he couldn't believe the publisher couldn't afford to pay him more, Warren was particularly incensed.

Tom, if you don't believe me, that means you know more about Warren Publishing than Jim Warren, our Board of Directors, our entire accounting firm and everyone concerned with the business aspects of our company. And if this is so, Tom, then I invite you to talk to our Directors—and maybe you can get them to give you a job running the Company.[13]

The pay may not be too great, the hours are long, the pressures are immense, the competitive factors are overwhelming, and you might have to sign your name personally to bank loans in six figures (this means that if the company defaults on the loans, Tom Sutton spends the next 10 or 15 years of his life paying off this debt)—but I'm sure that you'll be eager to run our company, despite all these minor factors.

I saw your last job and the job was great. And we don't take any credit for helping to make you great, Tom. All we do is pay you and publish you, and show you to the world. Maybe other companies will see this job and give you work for a higher rate than we can afford. If so, great for Tom Sutton. And we charge you nothing for that, Tom, nothing.

The point is: your talent must be equated with fiscal responsibility, or we're both out of business—and I suspect you may not completely understand this. . . .[14]

His letters showed other sides to his mercurial personality. A subsequent letter to Sutton was virtually a love note written to thank him for making some changes in the artwork for his latest job.

Tom,
You are a real, genuine, one hundred per cent pussy cat!
Knowing me as you do, you know that I never express words of endearment like this to anyone, particularly artists. However, after seeing the job you just turned in on "Musical Chairs," I realized,

Tom, that you not only followed our instructions beautifully, but you improved upon them deliciously . . . and we love you for it!

Back to work for me. In running a publishing company I must be more cunning than Satan and more generous than Jesus. I am not well-fitted for either role, so I fret about it.

Love and kisses,

Sincerely,

James Warren[15]

After the day's work in the office was done, Warren would return home, have dinner, and sit on the couch writing letters. He penned untold numbers of handwritten letters to his freelancers and others, which he didn't have time to deal with during regular hours. When he got an advance look at an article written by Alex Toth for Jud Hurd's *Cartoonist PROfiles* magazine, he extended a compliment. "[It's] not difficult for me to respond to the main theme in your article wherein you describe the importance of 'the ability to tell a story.' Alex, I won't get long-winded about it. I just want to say that I thought your observations and comments were excellent, and that your remarks should be Required Reading, not only for every budding would-be comics man, but also for every pro now working (with very, very few exceptions). We are going to send copies of the issue containing your article to all of our creative people."[16]

In a letter dated February 3, 1972, he wrote to cover artist Kenneth Smith:

Dear Ken,

I have a reputation in certain circles for being a champion thorough-bred; however, even thoroughbreds sometimes behave like horse's asses. Can you find it in your heart to forgive a thoroughbred-horses' ass, and consent to come back and do some great work for Warren Publishing? We all want you, we all need you, and we all love you. So as not to burden you with excessive letter writing, I have indicated below a multiple-choice answer form to make it easy for you: (Please check one)

() Yes, I forgive you, and would like you to send me a script, or I will do my own script.

() No, you Bastard. Go to hell!

Enclosed is a copy, with a stamped self-addressed envelope, for your convenience.

Sincerely,

James Warren

John Cochran sold Warren the script for "The Disenfranchised" in *Eerie* #39 (April 1972), and for "Crazy Mazie" in *Eerie* #44 (December 1972), both drawn by Tom Sutton. But he had had enough. On June 5, 1972, after a total of two years of working with Warren both freelance and in-house, Cochran left to become a freelancer (for a while, he was still credited as an editorial consultant on the masthead, probably because scripts he had edited from other writers were seeing print). After he left, his most important contribution, the new origin of Vampirella in the *Vampirella 1972 Annual*, was rewritten by Budd Lewis at a later editor's request, when it appeared in *Vampirella* #46 (October 1975). All subsequent reprints would be Lewis's version.

Fans found their way to 145 E. 32nd St. and rode the elevator to the seventh floor. They could buy back issues of the magazines or other Captain Company merchandise, which the receptionist, sometimes Flo Steinberg (formerly Stan Lee's secretary at Marvel Comics, now working for Captain Company), would pull from the shelves of the adjacent facility. They seldom met Warren, but one hot day in August 1972, one fan did.

When thirteen-year-old Tim Lynch was with his parents on a trip to New York City, he persuaded them to take him to "the Warren building." He wrote in a reminiscence in *Spooky*, the Warren fanzine, "I . . . turned the knob and entered the esteemed offices of *Eerie*, *Vampi*, *Creepy*, *FM*. Flo Steinberg rose from a desk on my right. Ponytailed, tube-topped and hip hugger-jeaned, I knew her from an article in *Rolling Stone* on 'The Marvel Age.'"[17] He purchased a copy of the *Vampirella 1972 Annual*, and was leaving when his mother remarked that, "the cover was not appropriate for people of my age, or any age. Flo asked if we'd like to step into Jim Warren's office

to discuss the matter. She graciously flung open Jim Warren's office door. He . . . ushered us in to sit down. I was 'frozen' in front of two adults, one of who was my mother, that were going to go at it."

The discussion was brief. Warren politely explained that he had been playing chess with a girl on the beach the day before who was wearing a bikini that covered as much as Vampirella's costume, and she was in approximately the same position. "'What's wrong with that?' he asked." While Lynch's mother was temporarily at a loss for words, Warren breezily escorted them out of his office, and into the Captain Company headquarters. "Metal rack after rack of toys, mags, you name it!" Lynch wrote. "We eventually stopped at one shelf of goodies where upon he began loading . . . my arms with an issue of *Eerie*, a Dr. Evil doll in a box, an unassembled shrink-wrapped Superboy model, the RKO soundtrack to King Kong, not to mention all of the FM Monster Pin back badges. At that point, he seemed to think enough was enough and bid adieu." With a big smile from Flo, he and his mother backed out the office door, their arms loaded with merchandise.

CHAPTER TWELVE

ENTER: BILL DUBAY

BILL DUBAY'S FIRST MEETING with James Warren set the tone for their working relationship. It occurred in mid-September 1969. "I'd come up from Fort Bragg, North Carolina, where I was stationed in the military," DuBay recalled. "This was when he was in the little office on East 42nd Street. He kept me waiting until about five o'clock. When I was finally ushered into his office, my first contact was basically an insult to the tune of, 'What makes you think you're an artist? What makes you think you're good enough to work here, for me?'"[1]

"I shot back, 'Because I'm the best who ever was!' I then whipped [out] a couple of pages from my portfolio and threw them on his desk. 'That's why I think I'm good enough!' We struck up an instant adversarial friendship— and I walked out with a script."[2] Despite his bravado, DuBay never dreamed that he would become the editor who shepherded the Warren magazines to their second great period, and become the most important single force in the Warren comics, apart from the publisher himself, since Archie Goodwin. But it was a bumpy road, and it wouldn't happen overnight.

Like Warren, Bill DuBay showed an innate interest in the publishing world as a youth, with the comics fanzine *Fantasy Hero* when he was twelve years old. He enlisted the help of his best friend, Marty Arbunich, to write and publish *The Yancy Street Journal* and *Voice of Comicdom*. DuBay contrib-

uted to many other amateur publications in the early-to-mid 1960s, most often as an artist. He had been a fan of the "new EC" since the inception of Warren's comics, and, as Creepy Fan Club member No. 582, submitted a piece to the fan page which was published in *Creepy* #12 (December 1966). He broke into professional comics with art in Charlton's *Go-Go Comics* when he was a senior in high school. Then he was drafted into the US Army and became editor of *The Ft. Bragg Paraglide*. "It was a good training ground. I got to see all my mistakes in print instantaneously. That was always helpful and humiliating. It was hard work, but sported major benefits. Newspapers teach you to perform quickly and accurately and to respect a deadline."[3] Then, after his meeting with Warren in New York City and his military discharge shortly thereafter, he returned to San Francisco and began freelancing for *Creepy* and *Eerie* as an artist and writer.

DuBay's first art job was drawing the R. Michael Rosen-written "Movie Dissector" in *Creepy* #32 (April 1970), the same issue as the Ellison-Adams "Rock God!" He later admitted that he was far from "the best who ever was." DuBay: "I wrote and drew my earliest and absolute most horrible stories. 'Frog Prince,' 'Devil's Hand,' 'Final Ingredient,' 'Life Species,' 'Futurization Computation'—all bad. And there was a bunch of even worse stuff, usually perpetrated by myself in collusion with some similarly witless collaborator. 'Ice Scream,' 'Girl on the Red Asteroid' . . . 'Movie Dissector.' Just thinking about them hurts! But, like the newspaper, they were all a good training ground." While DuBay's art ability was lacking in spontaneity and drafting fundamentals, he was second to none in terms of the effort he put into each page.

Then he got a call from Warren, probably in late 1971, asking him to move to New York City and become his art director. Billy Graham had just quit. DuBay: "Because I'd written and drawn so many bad stories for him—far more than any other young, underpaid contributor—he felt that I was 'the go-to guy.' I went." He had another reason to go to New York: he felt he'd been promised work by Dick Giordano at DC, and Roy Thomas at Marvel. When he arrived, he found out otherwise. "I had talked to Dick Giordano. Dick was the kind of guy that would never say no. 'Yeah, of course, as soon as I get some work here, it goes to you first.' That never happened. And the

same thing happened over at Marvel. Roy [Thomas] . . . always said 'yes.' I was married, I had a family. At least Jim was upfront and square with me."[4] DuBay's start date was January 11, 1972. He appeared on the masthead (as art director) for the first time in *Creepy* #46 (July 1972).

He was put through a mill like no editor before him. A few weeks after he was on the payroll, Warren wrote a correspondent, "The betting around Warren Publishing is seven-to-five against [DuBay] being able to tolerate James Warren for more than eight weeks. We are hoping he will, but God knows if he can put up with the Wrath of Warren."[5] But, in DuBay, he found someone who was resilient, ambitious and willing to work long hours.

"My basic training with Jim lasted about a year," DuBay recalled. "He wasn't involved in handing out the stories. He didn't even really know what the stories were. John Cochran and I would hand the finished issues to Warren, and Jim would rip them up. He wanted them about a week ahead of when they were due so that we could make adequate changes, and that's what he got. The changes weren't usually large, but there were a lot of them. Jim had an eagle eye. He would catch everything. If there was a double word mistake, for example, 'and and,' those kinds of things that most people just read past, it leapt off the page at Jim. You put a book in front of him, and the minute he'd turn to that page, and—there it is! Continuity mistakes in the art. Mistakes in the art itself. 'I don't like Vampirella's face this way. Would it look better with her eyes lowered and she was looking with a sideways glance? I hate the cover. I want to put Day-Glo on it.' Jim was the best art director I've ever seen. He'd say, 'I want more ad pages.' 'Take this story out and drop in six more ad pages.' 'I want shorter stories.' Things like that."[6]

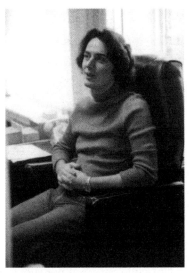

Bill DuBay. Courtesy of Sherry Berne Wallack.

DuBay wasn't initially in line to replace Cochran, who was becoming

restive. Warren's first choice was a young comics writer named Marvin (Marv) Wolfman, who was on the premises working as an editorial trainee. At roughly the same time that DuBay arrived, Wolfman was reading the scripts as they arrived and being groomed for the top editorial spot. It was during his six-to-eight month tenure, which ended before he could be listed on the masthead, that Stephen King submitted work to the company. Wolfman had published one of King's first stories in his fanzine *Stories of Suspense* #2 (March 1966).[7] When King heard that Wolfman was working at Warren, he felt he had an "in" and submitted three story ideas. The envelope arrived after Wolfman accepted an offer from Roy Thomas to work at Marvel, and got lost in the stacks of mail that accumulated when DuBay had become managing editor, on his way to taking over the top position. Warren: "The result was that a man called Stephen King—the most prolific and useful writer in the history of the universe—never heard from me, never even got the courtesy of my rejection slip. It was one of the most atrocious mistakes in the history of Warren Publishing."[8]

DuBay found working for the publisher difficult. Once, Warren told DuBay, not long after he had moved to New York, that one had to be gentle when reviewing a prospective artist's work. "They're sensitive creatures," Warren explained. "Look, there's an artist stopping by in a half hour. I'll show you how it's done." Soon, the artist arrived and laid his portfolio out on the desk. "What?" screamed Warren. "This is absolute shit! This is the worst crap I've ever seen in my life!" DuBay was convinced his boss had lost his mind. Later, Warren revealed that it had been a setup.[9]

More than once, he stormed out of the office after experiencing the "Wrath of Warren," and sometimes comptroller Richard Conway had to talk him into coming back. "Look," Conway said, "you're as close as Jim's ever going to come to getting what he wants, so come back, take his shit and it'll be worth your while."[10] Sometimes he didn't return immediately. This may explain why, on March 30, 1973, Warren phoned the editor of Skywald, his chief competitor. In "My Days in Horror Comics," Al Hewetson wrote, "[He] called me up at home last night and asked me to edit the Warren line. A job offer. *Eerie*, *Creepy* and all that. I said no. Today, Herschel [Waldman]

asked me how much money he had offered. I said I hadn't bothered to ask."[11] DuBay and his boss worked out their differences, and the publisher finally made him full editor. He's first listed as such (rather than managing editor) in the August and September 1973 issues.

Another new hire from this period would go on to become a company linchpin: Bill Mohalley. In July 1972, he answered an ad for a production artist. Mohalley talked to DuBay first, then was ushered into Warren's office. Although he had been a fan of *Famous Monsters of Filmland* since he was seven years old, he had no idea that he was interviewing with its publisher. Then, when he was shaking hands with Warren, he saw all the framed covers along the office wall. He knew he would accept whatever was offered, and was immediately put to work pasting up ads for Captain Company. Soon, Mohalley was given the job of putting together the issues of *Famous Monsters*, which remained the firm's best-selling title.

Mohalley had a thick skin. "One day I came out of Warren's office after he had been shouting at me for about a half hour," he said, "and Flo Steinberg, whose desk was nearby, was crying. I asked her what was wrong. She looked up at me and asked, 'How can you stand him treating you that way?'

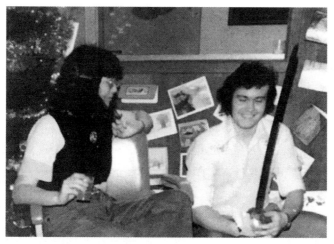

Flo Steinberg and Bill Mohalley at a Warren Christmas party. Mohalley, a fan of medieval weaponry, seems to have received a sword from Santa. Courtesy of Sherry Berne Wallack.

My reaction was that I was working on *Famous Monsters,* which I loved, so who cared about a little yelling?"

Flo Steinberg spent most of her time with Warren Publishing working for the Captain Company mail order department, doing purchasing and other related duties. When she published her own underground comic book *Big Apple Comix* in 1975 (with work by Wallace Wood, Archie Goodwin and others), Warren allowed her to have the books delivered to his premises and stored there, alongside his own back issue inventory, for which she later said she was grateful.

With *Creepy* #52 (April 1973), the magazine increased its frequency from bimonthly to nine times per year. An even bigger change took place in *Eerie.* The Warren comics had always had an anthology format, with no continuing characters other than its horror hosts. But after *Vampirella* was such a success, Warren realized that continuing characters were another way to hook readers. The downside was that they might make it harder for a new reader to jump aboard. He tried serialized characters in *Eerie,* thus making it more than a carbon copy of *Creepy.* The first such continuing character was Steve Skeates's Prince Targo in *Eerie* #36 (November 1971), followed by Dax the Warrior in *Eerie* #39 (April 1972). Targo appeared just three times, but Dax ran for twelve installments. It was actually a reprint of Esteban Maroto's character Manly, who had originated in Spanish comics. With the addition of "The Son of Dracula" and ". . . The End!," starring The Mummy, *Eerie* #48 (June 1973) was the first issue almost entirely oriented toward continuing characters. Warren noted an uptick in sales for *Eerie,* and decreed the policy a success.

WARREN PUBLISHING WAS ONCE AGAIN flying high. *Famous Monsters of Filmland,* which had been mostly reprints for years, published its first all-new issue since 1966. All four of the publications were selling well, and income from foreign sales burgeoned. The firm was generating profits that dwarfed those of any earlier period. As a result, Warren was finally able to raise the page rates for freelancers. It was partly due to pressure from the Spanish art agent, Toutain, partly to better compete with DC and Marvel for top talent, and partly to help lure some of his former star artists back

to the fold. From 1973 to 1975, rates doubled, and soon had passed $100 a page. DuBay said they went up still higher by mid-decade: "When a lot of the Spaniards came in, they weren't about to work for low rates. So, Jim was paying them $125 a page, as I recall, starting them off. $135, $150, is pretty much what they went up to in a couple of years. It was, I think, a better rate than Marvel and DCs at that point. We could pretty much ask anyone to work for us, and they would, which was kind of nice. I heard stories and saw some of the things that had been written in magazines like *The Comics Journal* that were saying Warren was using these people because they were cheap, and I had to laugh it off. Jim was spending a lot of money on those books and we were doing the best we could do to make them look good, to keep the quality up."[12]

At the same time, Warren decided to go big in his personal life. He finally had the means to build his dream house. For some time, he had owned a small house in Westhampton, Long Island, near the beach. Now he purchased prime beachfront property on Dune Road. Warren: "It's a great house. I designed it. It was built for partying and for fun."[13] The Hamptons season starts on Memorial Day and ends Labor Day, but he was out there in the beginning of May, opening the house, and stayed until October. Four Persian cats kept him company, and he had guests almost every weekend.

His passion for aviation, particularly the planes he loved as a boy, was obvious to any visitor, since he had a full-size replica of a Sopwith Camel built and on display in his front yard. It was the training model with two cockpits, the one he flew in as a boy. At night, it was lit by ground-lights placed in a circle around it, making a striking display. The house was modern, non-traditional construction. On one side were vertical propane tanks with anatomically correct line drawings of a naked male and female figure. (Neighbors whose windows looked out on the tanks complained to no avail.) The house was painted Warren's favorite color: yellow, the color of optimism, confidence, spontaneity and enthusiasm for life.

One entered into the living room, where there was a jukebox with some of his favorite tunes on it, such as "In the Mood" by Glenn Miller. Each room was decorated with a different color motif. Walking straight through the

house, toward big windows with an ocean view, one emerged onto a wooden deck with a rectangular swimming pool, and stairs down to the beach. The view from his bedroom was even more spectacular.

He had grown up on the beach at Atlantic City; now he had his own private beach to enjoy with friends, colleagues and family. There was enough room for a helicopter to land, which happened from time to time when he hired a chopper to fly him or a guest to or from the city. Most visitors had to rely on the Montauk Branch of the Long Island Rail Road or the Montauk Highway to get there. Reporter Duane Swierczynski later wrote, "Warren was famous for his summer birthday parties, complete with hot dogs, cocktails and a fireworks display staged by the famed Gucci family, that *Newsday* called 'summer's flashiest event.' Warren's adopted family—Warren Publishing staffers, along with scads of show-business friends he'd made over the years, including Howard Cosell and Mel Brooks—showed up every year to drink and make merry. The surprises never stopped. One year, on a whim, he hired a bagpipe band to serenade his guests."[14] This account smacks a bit of myth-making on Warren's part, but all who speak of the beach house agree that it was a fun place to spend a weekend.

In interviews, Warren perpetuated the idea that he had Hefner-like success with women, attributing it largely to the symbols of his success: "I've been a bachelor all my life in sort of a glamour profession. You know, when you're a publisher and you've got a couple of bucks and you've got a plane and you've got a home on the beach. . . . At a party, a long time ago, I think in fact it was Gloria Steinem who said, 'Watch out for him—he's laid everything except the Atlantic Cable.'"[15] Barton Banks, who enjoyed his giant hot tub more than once, scoffed at the idea that Warren owned a helicopter or a plane outright. "Of course, they were rented. Could he even get a pilot's license with his hearing problem?" But there's no doubt the house in Westhampton was well-appointed, and became the center of his social life. It was confirmation that he was a success, both in the eyes of his guests and in his own.

The fall of 1973 saw the last appearance of new work by Reed Crandall in the Warren magazines. The story "Soul and Shadow," written by Gardner Fox, was his swan song, although it wasn't intended as such. His art had dete-

riorated, due to health problems, alcoholism and a certain lack of motivation. Warren thought the artist was just going through a bad patch and didn't want to give up on him. At the time, he said, "Crandall . . . is my favorite artist. When we send him a story, he sometimes sends it in four months late, with a ten-page letter telling why it is so late. We sometimes send him a telegram and he doesn't answer it because he is hunting. I kid him about it, and I only kid people I like."[16] At the boss's behest, DuBay got Crandall interested in doing an ambitious adaptation of the H. G. Wells book *The Time Machine.*

It was never finished. Having completed a total of thirty-three stories for Warren's comics, which included some of the most admired stories to appear in those pages, the artist was unable to continue. He left the art field to take care of his ailing mother in Wichita, Kansas, where he suffered a stroke and spent his remaining years in a nursing home. He died of a heart attack in 1982.

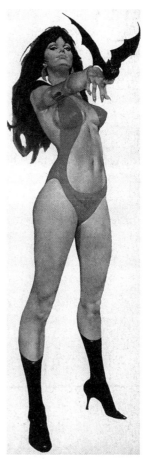

Iconic Vampirella image drawn by José González and painted by Enrich Torres.

As Warren got Vampirella into better focus as a character in her own magazine, he received perhaps the most famous painting of the former resident of Drakulon. One day, he unwrapped a gorgeous Vampi painting by José González, which became the quintessential image of the character. (It was actually painted by Enrich Torres from an original drawing by González.) The image was used on the cover of *Vampirella* #19 (September 1972), and was offered as a six-foot poster for $2.98 plus postage, or free with a two-year subscription to the magazine.

One of the most remembered incidents involving Warren and Vampirella occurred at the 1973 New York Comic Art Convention, when a fourteen-and-a-half-year-old girl named Heidi Saha made an appearance as the female blood-

sucker. Saha was born in 1959, the daughter of two prominent science fiction fans, Art and Taimi Saha. With her parents, Heidi attended many SF and comic book conventions, usually participating in the masquerade contest, although some fans grumbled because her mother made her costumes (they were supposed to be made by the contestant). By the time she became a teenager, Heidi was an honor student whose enthusiasm for being the center of attention was waning, but her parents had visions of a career in the movies for their daughter.

Warren issued the thirty-two-page special (with a two-color cover) *An Illustrated History of Heidi Saha*, subtitled "Fantasy Fandom's Famous Femme," a limited edition sold by mail order, along with a poster of Heidi dressed and looking more or less like the character Sheena, the jungle goddess. "It was my way of paying [the Sahas] back for Heidi wearing a Vampirella costume, promoting a Warren property," he later explained. "But it wasn't a quid pro quo, it was because they wanted to promote her into the movies."[17] Only about five hundred copies of the magazine (perhaps less) were printed. It was advertised for several years in the ad section of the magazines beginning in late 1973.

At Ackerman's urging, and with Warren's approval (in the interest of promoting his character), arrangements were made for Saha to appear at the 1973 New York Comic Art Convention as Vampirella. The Sahas' friend, Perdida Boardman, made Heidi's polyester costume, and it was professional quality. They added the black wig with bangs, gold bat-shaped earrings and black boots (which were exactly copied from the González poster). Another Vampirella, played by twentysomething Angelique Trouvere, entered the contest. At first, the crowd's response was positive, but when they found out Warren had sponsored Heidi—that she was a "ringer"—they seemed to turn on her. When Heidi was selected as third-place win-

An *Illustrated History of Heidi Saha* was a vanity magazine produced by Warren to thank Ms. Saha for modeling a Vampirella costume at the 1973 New York Comic Art Convention.

ner, there were audible boos from the crowd. "Poor Heidi," recalled Trouvere. "She stood on that stage, holding her pose like a real trooper amid the boos and heckling. It must have hurt like hell. If the crowd had a problem with James Warren or her parents, they shouldn't have taken it out on an innocent kid."[1819]

The Warren Publishing booth display at the 1973 New York con. Fan in the foreground is Mark Gruenwald. Photo: David Lofvers.

An Illustrated History of Heidi Saha sold poorly and became one of the rarest of Warren collectibles. Although it contained no suggestive photographs (and none of Heidi as Vampirella), its rarity led to rumors that it was somehow scandalous, even a magazine for pedophiles. While it's true that Ackerman's text was overheated, it's merely a series of scrapbook pictures of Saha as she was growing up and posing in costumes as a child. Fandom didn't hear from her again until, in 1996, she sold her Vampirella costume at a Sotheby's auction. Four years later, she penned an obituary titled "Art Saha, My Father" for the January 2000 issue of *Locus* magazine (v.44 #468).

DUBAY: "JUST PRIOR TO SUMMER, Jim had what he called the Big Push. His magazines sold the best in the summertime, when school was out. I don't remember the exact number, probably a 10 to 20 percent increase. Maybe even more than that. So, prior to summer, we'd push out two, three, sometimes four magazines a week, and it was a hellish time. It was all the regular magazines, plus plenty of special things, like annuals. Very exhausting work.

"Virtually every summer from year one, I went to him at the end of it and said, 'I am out of here. I'm never going to do this again.' And virtually every summer, he made me an offer I couldn't refuse, from more money to a beach house in the Hamptons to an apartment in New York. He paid for my apartment in a very nice place called Waterside. Cary Grant lived there at

the time, so you know it was a nice place. It was also a couple of blocks away from the office, so it benefited him, too. There were bonuses, and more and more money and lots of things. Trips overseas. So, he treated me fantastically, in that way."[20]

Ghosting his own brief biography, Warren once wrote: "There really aren't that many people who can work with him. But most often they walk away finding themselves inadequate to the demands and expectations he levies. So be it."[21] Having invested a great deal of time in training him, and recognizing the effort DuBay put into his job, Warren provided every possible inducement to keep him on board.

DuBay always maintained that his boss, by nature, was a generous guy. "That's part of who Jim was. Maybe when people went directly to Jim, he'd balk at it, but I know that when I went to him and said, 'Look, here's a guy who's really working his heart out for us,' Jim never balked [at paying the person an increased page rate]. Jim was always right there with that. If someone came to him and said, 'I deserve a raise,' maybe he'd question that. But I have to say that when I went to him and said someone deserves [it]. . . never once did he turn it down. For the most part, we got some fairly decent Christmas bonuses. Maybe the lowest was $500 [up] to $12,500, I think, was the top. He treated his employees very well. But he expected a lot from us."[22]

DuBay's work ethic and standards, particularly in terms of the quality of the graphics in the magazines, raised the quality of the product. The magazines looked better than ever, and the content improved as well. He jettisoned nearly all of the writers who had been working for Parente and Cochran, and brought in his own: Budd Lewis, Rich Margopoulos, Gerry Boudreau, Kevin Pagan and Jim Stenstrum (among others). Doug Moench and Steve Skeates were the most notable survivors from the earlier regimes. DuBay was a tough taskmaster. Hardly a script was given to an artist without being rewritten. He also oversaw the rise and artistic domination of the Spanish artists, which received a mixed reception by fandom but were (according to DuBay) immensely popular with the general public. Vampirella had never looked as exquisite. Fandom's objections had to do with the Spaniards' emphasis on pictorial beauty over storytelling. But DuBay also brought back such

fan favorites as Alex Toth, John Severin and Wallace Wood, and oversaw the development of color inserts to better present the work of Richard Corben. (This led to the publication of the mail order, all-reprint, all-color magazine *Comix International*, which debuted in early 1974. Its first issue consisted solely of Corben reprints, and quickly became a collector's item.) The overall artistic upgrade was largely made possible because the higher page rates attracted better artists.

In early 1974, Bernie Wrightson received a telegram from James Warren, and called on him. He'd ignored a couple of earlier entreaties from the publisher, but now he was tired of working for DC. He arrived at the offices without an appointment. When Warren saw him in the bull-pen area with his portfolio, he invited him into his office. "[He was] very nice, very cordial and courtly," Wrightson later recalled.

After a bit of banter, Warren asked, "How much is DC paying you?"

"Sixty-five dollars a page, which is their top rate."

"I'll pay you $110 a page."

"Does this mean I get to keep the originals?"

"The originals are yours. That's no problem. However, the rights . . . are all mine." Wrightson hadn't expected anything else. "You'll get your originals back," Warren continued, "and you can sell them, you can do whatever you want with them. But if you sell them, and the guy you sell it to sells it to somebody else, and he sells it somewhere, and it sells and sells and sells," he said, "if the tenth guy who sells it prints it somewhere without my permission, you're going to get in trouble. I'm going to hold you responsible for that. You [must] make it very clear when you sell it that it's just the originals and there are no publication rights involved." Wrightson said, "I thought, 'Okay. Fair enough.' Because none of that concerned me anyway. And I started working for him."[23]

A couple of weeks after Wrightson's last issue of *Swamp Thing* came out (#11, the July–August 1974 issue), *Creepy* #62 (May 1974), with his first story for Warren Publishing, went on sale. It was an adaptation of Edgar Allan Poe's "The Black Cat," which Wrightson wrote and drew. (That issue also contained the first of nearly thirty frontispieces featuring the horror

hosts that the artist drew for *Creepy* and *Eerie*.) He loved working in black and white, and for a larger size than regular comic books. He said, "I have nothing but nice things to say about Warren, strangely enough. I may be the only person in the world that does. I think Warren is a terrific person. I got tired of color comics, just got tired of seeing bad reproduction and terrible heavy color on top of fine line stuff. And just decided I wanted to try black-and-white comics for a while. By this time, Warren was once again top-of-

"The Black Cat" by Bernie Wrightson.

the-heap in black-and-white horror comics."[24] Wrightson was particularly excited when he was handed a script that would be a breakthrough for a writer who became one of the best to work for the company. The writer was Bruce Jones, and the script was titled "Jenifer."

Jones's first work for Warren was the story and art for "The Thing in Loch Ness" in *Creepy* #41 (September 1971). At that time, he was more focused on the art than the writing. The pencils for his strip "Prototype" in *Eerie* #36 (November 1971) had so impressed Wrightson in the elevator to the offices that he told Jones, "This should be published as is. It doesn't need ink." Partly because the company paid so little for scripts at the time, and partly because several were rejected by DuBay, Jones didn't become a regular writer there until his breakthrough with "Jenifer" in 1974. The disturbing story of a man who rescues a pathetic, deformed girl from harm only to be turned into her sex slave, remains a work of singular vision and quality of execution in the Warren canon. [See chapter 14 for more on Bruce Jones.]

Frank Frazetta's final Warren cover (other than reprints) appeared on *Vampirella* #31 (March 1974), although it was painted for the movie poster for the film *Luana, The Girl Tarzan* (1968) and used on the paperback novelization as well. (The unused female King Kong cover done earlier for *POW!*

Panel from "Jenifer" in *Creepy* #63. Story by Bruce Jones, art by Bernie Wrightson.

was used for *Eerie* #81 in 1977.) Ultimately, Frazetta did some twenty-nine covers for Warren, twenty-one of them in the period from 1965 to 1967. The covers in 1974 and 1975 were mostly by Spanish artist Manuel Sanjulián and Ken Kelly.

In the mid-1970s, Warren came up with the concept of a "perma-loan." Perma-loan allowed artists or staffers to take original artwork home to enjoy, with the proviso that it was still owned by the publisher and could be recalled at any time—such as, certainly, before they left his employ. The covers were particularly desirable. From Warren's point of view, it was another perquisite that he could offer to those who had been loyal, when further pay raises weren't forthcoming. Although he was returning art to especially desirable artists who requested it, there were still many pages that were not being returned, especially those by the Spanish artists, which were piling up in a storage room. DuBay confirmed that he and others borrowed artwork under this policy.[25] DuBay himself returned a brace of perma-loaned art pieces on one of the occasions when he intended to quit.

In 1974, Warren was interviewed by two mainstream publications that seldom (if ever) did stories on publishers of horror and comics magazines: *Rolling Stone* and the *Village Voice*. These were the only major profiles of this type done in the 1970s about Jim Warren. They revealed the issue uppermost in the publisher's mind that year: the tidal wave of Marvel black-and-white magazines, an event that was a serious matter for him. He had already publicly

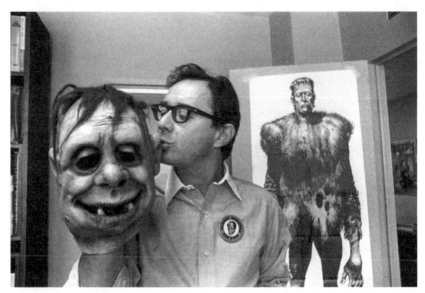

James Warren in his office in 1974, photographed by Sylvia Plachy for *The Village Voice*. This is the entire image, which was cropped for the frontispiece of this book. Courtesy of Sylvia Plachy.

expressed his animus toward Stan Lee, albeit obliquely, when, at the 1971 New York comic con, he went into a harangue about his mistreatment by the publisher's association, by being left out of a survey of wholesalers. Even though the person responsible, not named but obviously Stan Lee, apologized, Warren used the con to polish his ongoing vendetta against Lee. In "Citizen Pain, The Publisher Who Built a Vampire Empire" in *Rolling Stone* (April 25, 1974), April Smith wrote of this vendetta:

> "I hate Marvel," Warren says, cracking the words like a South Side Philly tough. "but they didn't bother to check out where I was born."
> "He despises me," acknowledges Stan Lee, the lanky, silver-haired publisher of Marvel. "If I had any sense I'd hire a bodyguard." But he remains calm in the face of this challenge.
> "We never pay much attention to the other companies," says Lee, sitting relaxed on a bright blue couch in the Marvel office overlooking Madison Avenue. "We just go ahead and do our thing.

I wish Warren luck. We don't edit our books according to what he's doing, despite the way he might feel about it. I know he has often said to people we're out to destroy him. It's not that at all. We're just out to do the best we can and sell a lot of magazines.

"I figure if we do well," he continues, "it has to help him and anybody else who is in the business. I think he's a *nut*, the way he carries on because we're putting out these books, but we never pay much attention to the competition."[26]

Later that year, when he was being interviewed by the *Village Voice* reporter Ron Carlson, Warren pointed to a photo of Stan Lee that he had taped to a desk drawer where he could see it as he worked. "You know who that is? That's Stan Lee of 'the big money boys' [Marvel], and every time I start to get lazy I look at him. Hell, no. I don't consider any of these imitations compliments! There is only so much horror room on the shelf and they cut into it."[27]

Marvel had dabbled in the magazine field before, but it wasn't until 1973 that they committed to creating a solid presence of black-and-white comics on newsstands, going head-to-head with Warren. Titles included *Dracula Lives*, *Monsters Unleashed*, *Tales of the Zombie*, *Vampire Tales* and the humor magazine *Crazy*. In the next two years, they added many more. This flood of competition drove Skywald out of business. Warren was determined to triumph, despite the onslaught. Anthony Tollin, who was working for the publisher in the production department, recalled, "He called us in, and said he was prepared to lose $5,000 on each issue, because Captain Company would make it up." In other words, knowing he couldn't beat Marvel in quantity of titles, he decided to beat them in quality. He would hire the best artists, give the best value for the price, have the most eye-catching covers and take every conceivable measure to increase the loyalty of his readers.

One step was to bring Archie Goodwin back. Warren's admiration for him was undiminished after they parted company in 1970. Toward the end of 1973, they bumped into each other, and chatted briefly about what each was up to. It led to Warren offering him an editorial position. Later, he said,

"I saw he wasn't happy doing what he was doing. So I grabbed Archie back with us. But I did it in the wrong way, and it turned sour." His return was hailed in the magazines, which featured his photo next to the headline "The Return of Archie Goodwin," with text that read, "After a too-long hiatus, Archie has returned to the Warren fold. He will take over as editor of *Creepy* and *Vampirella*. In addition, Archie will be writing for us again. Welcome back, Archie!" Goodwin's first issue of *Creepy* presented stories written by T. Casey Brennan, Rich Margopoulos, Carl Wessler and Steve Skeates, and stories both written and drawn by José M. Beá, Tom Sutton and Richard Corben. Events happened so quickly that *The Comic Reader* (March 1974) announced his "return to Warren" in the same issue it announced "Goodwin Resigns."

Warren sold the idea to DuBay by telling him Goodwin handling two magazines would lighten DuBay's work load. It's unclear if Goodwin knew he would be supervised by DuBay, but he soon found out that he would have none of the editorial autonomy of earlier times. As a colleague theorized in retrospect, "I think Bill was probably afraid of Archie, because he knew how highly Jim thought of him. He would have perceived Archie as a threat."

The publisher was distracted by other things at this time. He seemed to be flying off to Europe or elsewhere at the drop of a hat. Many of the trips involved meetings with Josep Toutain in Barcelona to discuss foreign sales and other matters. He also visited Israel during the Yom Kippur War in October 1973. According to *Rolling Stone*, "[Warren] keeps a small model of an Israeli tank on his desk and shows photographs of himself on the Sinai front during the 1973 war (he was listed as a foreign correspondent). During that October, he donated enough money to Israel to buy an airplane."[28] (Later, he gave his parents a trip to Israel as a gift.) He often went to France on the annual anniversary of D-Day.

"I was a history buff, military history, World War II as a specialty. I'm a student of that, particularly D-Day, Normandy. This is a group that I met with every June 6th. They're real fanatics. They relive the Normandy landings every year. I would go over there many, many years and be with them. They invited me to be with them. They wear the uniforms and everything is authentic. They would go from England on the boat, and they'd land exactly the time

of D-Day. And they go on the beach. They're not play-actors, and there's no frivolity. They're all Frenchmen. They do it because they know that it was a remarkable experience. And in the same way that we have these buffs who re-enact Civil War battles, they've been doing this in France since the end of World War II."[29]

WARREN REMAINED AS UNPREDICTABLE as ever. Hence, it's no surprise that one hears contradictory information from people who worked for him. Some got their originals back, others didn't. He was generous; no, he was cheap. Some say office hours were ironclad, others say there was flexibility. But then, some said he was a pussycat, others said he was a monster. All these contradictory reports were true at one time or another; all were facets of the "real Jim Warren" and the way he conducted business. He was never about cooperation. He liked to tussle with the people around him, even in small, insignificant ways. It was how he amused himself, and how he did business. Shortly thereafter, if not at that first meeting, Bernie Wrightson experienced one of the man's ongoing pranks with his freelancers.

"He did this with everybody. He would insist on making a $1.00 bet with you, and it was some trick thing that was rigged so he couldn't lose. But it looked to you like a sure thing, so you put your dollar on his desk. Then, he'd show you how you were wrong, and he won the bet. He'd make you sign the dollar bill. 'Sign it across the front, as big as you can.' I sign it and slide it across to him. He opens a drawer, and pulls out a wad of dollar bills in a rubber band, and shows them to me. He's got signatures from Jack Davis, Frank Frazetta, Reed Crandall and Al Williamson. It's like he ran this trick on everybody who ever worked with him, and he had this collection of signed dollar bills."[30]

Wrightson had occasion to experience other aspects of the man's personality after working for him about a year. Due to some personal problems, Wrightson hadn't paid his phone bill, and his service was shut off. He needed $300 to have it turned on. At the time, he was midway through drawing a story for Warren, so he went into the office and asked the publisher for an advance on the job. "I said, 'I'm dependable and I get the work done on time.' And he

said, 'No. I do not pay artists in advance. And here's why. I believe you, you're dependable, but . . . shit happens. I give you this money in advance, you could walk out of the office, cross the street and get hit by a truck.' He said, 'That's very unfortunate. It's a big loss to the art world. But, I'm out my money.' He goes on for an hour along these lines. Making absolute perfect sense why he cannot give me an advance, and finally ends up saying, 'However, I will give you a personal loan.' And he takes out his personal checkbook, and wrote me a check for the amount." Wrightson's phone service was restored, and he delivered the story on time.

Then, months later, Wrightson needed to move. "I was living upstate, and I wanted to move to Queens. I had some back rent that had to be covered, and [needed] rent for the new place. It came to four or five hundred dollars. And I didn't have the money, because I was just living job to job. So, I went into his office, and, remembering the last time, asked him for a personal loan to cover things. He said, 'No. I do not give artists personal loans, and here's why.' He gives me all the same reasons that he gave me the last time, but this time applies them to a personal loan. Then he ends up saying, 'But what I can do, is give you an advance on the job you're doing for me.' This was with a perfectly straight face, like he didn't even remember the last time. And I just went along with it. I thought it was great! I loved it!"

CHAPTER THIRTEEN

WILL EISNER AND
THE SPIRIT MAGAZINE

WHEN ASKED IN 1970 about *The Spirit* comics newspaper insert of the '40s and '50s, Warren stated his unwavering praise for the work and its creator. "Will Eisner ranks number one in my book of all-time greats. *The Spirit* was one of the greatest comic strips. I used to identify with him." But, he was asked, would a Spirit revival be possible? "Revive the Spirit? No, it cannot be done. *The Spirit* is a product of the '40s. You can't take a guy from one era and put him in another. Commissioner Dolan doesn't fit now because a police commissioner of a major metropolitan city doesn't have the problems that Dolan did with organized crime."[1]

Warren hadn't met Eisner when *Help* magazine reprinted a Spirit story in 1962, since all arrangements had been handled over the telephone. Although there's no record of it, Eisner and Warren could have met at the 1971 New York comic con, the same convention where Eisner was introduced to Denis Kitchen, owner of underground comix publishing company Kitchen Sink Press. Kitchen convinced Eisner to "test the waters" by doing a Spirit cover for *Snarf Comix* #2 (November 1972). He felt the readers of underground comix would appreciate the Spirit, and they did. Kitchen commenced publishing comic books reprints of 1940s–1950s *The Spirit*, which featured new Eisner covers.

Bill DuBay later said he was the one who showed those Kitchen Sink comic books to Jim Warren, who immediately began calculating whether a Warren-style *Spirit* magazine would make sense. It wouldn't be like trying to update the Spirit. It would be like a "period" movie, set in the 1940s. He knew that fandom would support the revival of the Spirit, but would general readers? Would there be enough of them? Captain Company ads would help, and adding another magazine would give him six ongoing titles (counting *Comix International*), which qualified him for a lower rate with the printer.

With all these thoughts roiling in his head, Warren contacted Eisner, told him he had a publishing proposal for him, and invited him to lunch. At the restaurant, Eisner informed him that he had just come from the offices of Marvel Comics, where Stan Lee said they were interested in reprinting *The Spirit*. Eisner had said the very thing to increase Warren's determination to make a deal with him, then and there. Warren pitched himself as a small publisher with a reputation for putting out a high-quality product—much higher, in his view, than Marvel—and that he would personally oversee every aspect of a *Spirit* magazine. That made sense to Eisner, who feared his character would be just one of hundreds of properties at Marvel. He also recognized that the publisher was a genuine, knowledgeable fan of the feature. There was another factor. "Marvel wanted me to create new material or allow them to find somebody to create new material," Eisner said. "I really wasn't interested in that."[2] Furthermore, Warren could offer a higher prestige format, since magazines were more respectable than comic books. He assured Eisner that he could sell 100,000 copies of a black-and-white magazine reprinting the classic stories, ten times more than the average underground comic book. Before long, they had reached agreement on the terms of the deal. Eisner had a special request: that Warren buy Kitchen Sink's unsold copies of the two Spirit reprints that they had just published. Warren agreed. (He eventually sold all the remaining Kitchen Sink issues of *The Spirit* through Captain Company.)

Warren would always consider making this deal with Eisner the most exciting event of his publishing career. He said, "Will Eisner is the Chairman of the Board. Will is the Orson Welles of comics, only thinner and better looking. If Will had gone into movies instead of comics he would be a com-

bination of Welles, Hitchcock and Scorsese."[3] He said that he had worked with two authentic geniuses—Kurtzman and Frazetta—and Eisner was in their class. He saw other benefits of adding *The Spirit*, which was created to appeal to both adults and young readers. In the guise of a costumed hero/detective comic, Eisner told clever, astute and highly creative short stories, often investigating the workings of fate and the role of happenstance in ordinary lives. As Warren told *Rolling Stone*, "We get 'em at monsters and we take 'em straight up. It's known as vertical growth."[4]

Just as he had celebrated the beginning of *Creepy* with a dinner party at Cattlemen's restaurant, Warren celebrated his pact with Eisner by throwing a similar bash, this time at the Plaza Hotel in uptown Manhattan. It would be equally for Rich Corben, who was on a rare visit to New York (from his home in Kansas City, Missouri).

The British freelance Warren Publishing writer Jack Butterworth was in attendance: "When Warren started publishing *The Spirit*, Jim Warren . . . sprang a banquet at [the Plaza], overlooking Central Park. He invited Will Eisner, Rich Corben, Bernie Wrightson, Jeff Jones and Archie Goodwin, who had come back as an editor. Gerry Boudreau, Howard Chaykin and Louise Jones were there. I was so glad I came. It was an incredible time. This tall, lanky guy . . . got up and said, 'Are you Jack Butterworth?' I said, 'Yes.' 'I'm Rich Corben.' I went into temporary shock, but I told him that I loved the work he did on [my script for] 'Top to Bottom.'

"*Blazing Saddles* was one of the things that came up [for discussion]. Chaykin was really taken with it as a movie, as a total alternative of the West. Totally funny. And that was what got me to see the movie. He and Wrightson would be talking, and Rich [Corben] would be there, kind of quiet. Jeff Jones and Louise [Jones] came up to Rich Corben, while he and I were standing together, and they said that he could be expecting to hear from Bruce Jones."[5] They informed him that Bruce had packed up his car a few weeks earlier, and was moving back to Kansas City. When they asked him why, he reportedly answered, "Rich Corben!" (This was before Bruce Jones had written much for Warren. Eventually, the writer did contact Corben, and they did some of their best work together.) According to reports, the party at the Plaza was a

rousing success. Warren joshed Goodwin by having him served a tuna fish sandwich for dinner (before having it replaced by the real entrée). There was no hint that a major flap had occurred while preparing the first issue of the new Spirit magazine.

Eisner wanted to do new covers for the magazine, which he would draw and ink in his normal manner. Warren insisted that the covers be painted like all his other magazines. He assured Eisner that DuBay would pick the right artist who, given a penciled drawing by Eisner as a guide, would produce a painted version that would please him. DuBay gave the assignment to Sanjulián. When completed, a proof was sent to Eisner for his approval. Warren: "I'm in my office, sitting at my desk, reading something, at peace with the world, and VOOOOM! In comes Lee J. Cobb (without a pipe), and I thought, 'Will [Eisner] may be sixty years old but if one of his punches connect, he'll knock me through the wall!' Thank God I had a nice wide desk because it stopped him from throwing himself across the desk and choking me! He had fury! But when he calmed down, we learned exactly what it was that had set him on fire. What we were doing with the Sanjulián painting was taking the Will Eisner out of *The Spirit* and making it something else. We fixed it."[6] They ended up having Eisner create an inked overlay, and Basil Gogos (then DuBay, and later Ken Kelly) provide a color painting to run beneath it. The result was a compromise that satisfied both Warren and Eisner.

Eisner was given the title editor in chief of *The Spirit* magazine, but it was DuBay who managed and supervised its production, which included working with original art that wasn't always in the best shape. Since the stories had been designed for color printing, the decision was made to add gray tones to the art, with the exception of the single story in each issue that was printed in color. Eis-

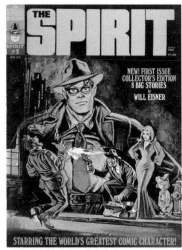

The Spirit #1 (April 1974). Pencils by Will Eisner. Painted by Basil Gogos.

ner himself tinkered with the artwork, especially the splash panels, to make them more impressive in the new format. The result was stunning. *The Spirit* #1 hit newsstands at the end of January 1974, the same time as the first issue of *Creepy* to list Archie Goodwin as editor.

It had been a disaster with Kurtzman, but seems to have worked out fine with Eisner. Warren invited Will Eisner and his wife, Ann, to his home in Westhampton. (DuBay had dubbed Warren's place the "Big Yellow Palace.") On one occasion, ostensibly there for a business meeting, Eisner was photographed naked in the pool with other guests. Skinny-dipping was a normal occurrence at the beach house. Warren was in excellent physical shape, looking much as he did in photos of him as a high school athlete, and, in the appropriate sort of company, thought nothing of shedding his swimsuit in the presence of others, many of whom did the same.

He loved having house guests. All his closest friends were invited at one time or another. One was Rhodia Mann, Warren's latest "man aging editor" (given the honor on the masthead of *Famous Monsters of Filmland* in 1974 and 1975). The daughter of Polish and Romanian parents who escaped to Kenya to avoid Nazi genocide, she had grown up in the African nation, then moved to Manhattan in the 1960s. She began designing beaded jewelry inspired by native crafts, which led to trips back and forth between Africa and the US. While in New York in the 1970s, she and James Warren became a couple. She had a strong literary aptitude, and helped him with a little editing; later, she became an acclaimed writer of books about her adopted land. Sherry Berne, the Captain Company production person from 1975–1976, remembers the willowy blonde attending the 1975 office Christmas party wrapped in an enormous fur coat, being teased by "the boss" in his Santa outfit.

The guests in Westhampton were often driven from the station in Warren's customized taxicab. "The yellow cab was built for me by Checker Cab. It's about twelve to thirteen inches longer than a regular cab. It seated eight people. When you have a house in the Hamptons, and you have a lot of houseguests . . . you either have a bus, or you have something that you're comfortable in. My houseman picked them up at the station. And this was perfect, because the 1950s Checker cabs were very high. They're not like cars

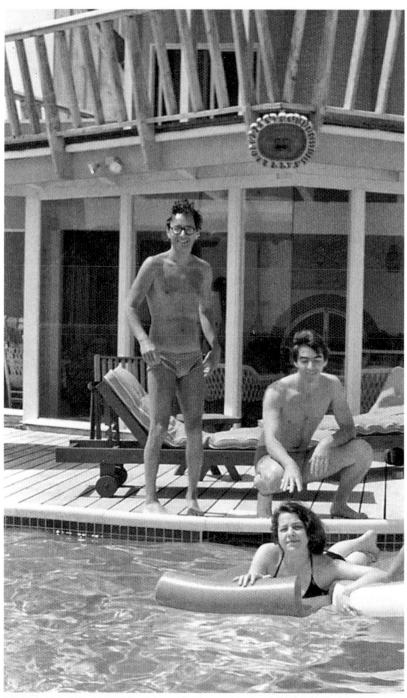

Warren enjoying the summer at his beach house in Westhampton, New York. Courtesy of Sherry Berne Wallack.

of today. They're like English taxicabs. They're high and they're comfortable. It took all the houseguests, so we didn't have to go in separate cars when we went to dinner. Besides, it was fun."[7]

He explained why he had a houseman: "When you have a place like that, it's a lot of work. It's not the kind of work you want to do yourself, because if you do, all you're doing is work. Deck chairs have to be put out, lunch has to be served, beds have to be made, and I don't want the houseguests to do any of that. So, I had a houseman. He serves drinks, he takes your baggage out to the chopper when you're leaving. Nobody has to pick up anything. That's the way I liked it."[8] His houseman, who was there mainly on weekends, was, for a while, a young lady nicknamed Bones. Another was known as Kato.

He indulged his every whim, and he had a lot of them. During the American Bicentennial, "I had my own drum and bugle corps, and they serenaded [us] every Sunday afternoon. I hired them, I trained them and I paid for their uniforms. All they had to do was march in the local parades and serenade me every Sunday. Like the Spirit of '76—the drum and fifes."[9]

DuBay: "Jim loved life. Lived it to the fullest. I mean, with his yellow beach house out there, and his yellow Sopwith Camel and his yellow taxi. His estate and his skinny-dipping with all the people there, and right on the beach, and the fireworks—the Gucci fireworks, in Westhampton. Jim went to battle with the township of Westhampton over not being able to have fireworks. They said no. So, he got a big barge with something like $8,500 worth of Gucci fireworks, loaded it out into the ocean there off the beach and had a big display to celebrate Jim Warren's birthday."[10]

IN *FAMOUS MONSTERS* #112, readers found a seven-page announcement (titled "Monsters of the World, Unite!") for the "First Annual Famous Monsters Convention." It was an idea whose time had come: a con especially for fans of the monster magazine. Warren had cultivated contacts with the magazine's readers by publishing their photos, letters and advertisements. In 1961, there had been gatherings in New York (the First Monster Fan Convention) and Los Angeles at the Ackermansion (dubbed the First Karloffornia Monster Convention), but these grandly titled affairs were actually small

gatherings for local fans. Ackerman reached out to other fans of the magazine with his much-vaunted, five-week "goodwill tour" in 1963, visiting *FM* fan clubs across the country. Now, a decade later, according to the breathless prose in the con booklet, "the groundswell could be denied no longer and it was realized the time had come for the biggest event of them all: the birth of our nation-wide Famous Monstercon."[11] Warren was billed as the con's "organizer and co-sponsor." The booklet included profiles of Warren and most of his associates: Ackerman, Phil Seuling, Ken Kelly, Verne Langdon, Sam Sherman and Basil Gogos, plus a brief piece by Robert Bloch ("My Five Favorite Fright Flicks").

Having cemented his relationship with Seuling in the early 1970s, he and Seuling put on the convention at the Hotel Commodore, site of previous comic book cons. Halloween weekend at the Commodore was already booked so the *FM* event was held November 8–11, 1974. Admission was $8.50 in advance, or $10 at the door. It was well-attended, with Warren and Ackerman at its center. Ackerman showed a half-hour sound film of the original Ackermansion, followed by a slide show presentation about his new, larger sanctum. Verne Langdon gave a presentation of movie makeup techniques, and Warren was made up as Frankenstein's monster, much to the fans' amusement. There was a costume contest, an art show, an exhibit of all the Don Post masks, and, of course, Warren had plenty of space to hawk his posters, magazines and other Captain Company merchandise. Other exhibitors were on hand, as well, and business was brisk. In the evenings, films such as *Island of Lost Souls* and *The Invisible Man* were unspooled. Midway through the affair, Ackerman complained that his hand was completely exhausted from all the autographs he was called upon to sign, often on multiple issues of *FM* and movie stills. The magazine claimed attendance of 3,500, which was almost certainly inflated; but the photos attest to its success, enough for it to return at the same venue a year later. It was initially given two write-ups in *Famous Monsters*: #115 (five pages) and #116 (twelve pages), replete with numerous photos. Still more photo-features of the event were spotted into the magazine throughout the year. The conventions were an ambitious undertaking which went over well.

Under DuBay's editorship from 1973 through 1975, the Warren comics magazines had many highlights. One was the adaptation of the horror stories of Edgar Allan Poe. It began with "The Black Cat" by Wrightson in *Creepy* #62, followed by Richard Corben's full-color interpretation of "The Raven" in *Creepy* #67. These stories inspired an outpouring of fourteen more Poe adaptations culminating in two all-Poe issues of *Creepy*, #69 and #70, entirely adapted by Rich Margopoulos, and drawn by the Spanish artists José Ortiz, Vincente Alcazar, Luis Bermejo, Martin Salvador, Isodro Monés and Adolfo Abellán. (Richard Corben also appears in both.) These issues were two of Warren Publishing's finest publications, not only for their evident quality, but because they were mainstream magazines presenting adaptations of a master of horror whose work was respected for its literary as well as its frightening qualities.

DuBay also brought Alex Toth back, after a decade hiatus. Toth had done ten stories for Warren, six in *Creepy* and *Eerie* and four in *Blazing Combat*. Now he returned and did fifteen more horror tales. The first was the gentle alien story "Daddy and The Pie" written by DuBay himself, followed by two Skeates-penned stories of "The Hacker," and Gerry Boudreau's "Phantom of Pleasure Island." Toth's work had evolved in the ensuing years, as it did throughout his career. Now he was less interested in experimentation and flashiness, and more in using shapes—often black shapes—to create depth-in-panel.

One of DuBay's favorite writers was Jim Stenstrum, whose first published story at Warren (or anywhere) was "The Third Night of Mourning" in *Creepy* #49 (November 1972). Next was the eighteen-page "Forgive Us Our Debts" in *Creepy* #50 (January 1973). He only got fifty dollars for it, despite its length. Stenstrum: "In 1972, the rate for a six- to eight-page story was thirty-five dollars, and fifty dollars for a nine- to twelve-page story. That was the max they paid for any story, regardless of length." In 1974, the rates for writers went up. "Due to Bill DuBay's efforts, the writer and artist rates at Warren increased in late 1973. I remember getting a check for $104 for writing the eight-page "Thrillkill" in early 1974, so that's thirteen dollars a page. The highest rate for writers when I left in 1981 was forty dollars a page."

Stenstrum quickly developed into a quirky, clever and unorthodox writer, a favorite of both editor DuBay and the readers. He wrote a total of sixty-one scripts for Warren—not the most prolific, but a major player in the Warren renaissance. With "Thrillkill" in *Creepy* #75 (November 1975), the story of a young man in a clock tower who is shooting people at random, he and collaborator Neal Adams produced a work that's considered perhaps the finest to appear in any Warren magazine. The description on the contents page reads, "Joe Bobby Lang was young. Shy. Unable to communicate. And it seemed no one wanted to bother with a lonely, disturbed youngster. But Bobby found a sure-fire attention grabber. He went out on a roof. Pulled out his rifle. And started pumping bullets into a rush hour crowd!"

Neal Adams: "In 'Thrillkill,' when that bullet rips through that woman and comes out her lower belly, there's something about that shot and other shots that just shock the hell out of you. You can't look at that drawing without being shocked. You've never seen that before. So the images and the tracking of those images make it very, very real. Not like a movie. It's more dense and closer to the viewer. You're seeing it played out not in slow motion, but in the slow motion of the mind, where you slow it down. These things are happening right in front of you, and you can't pull away. You can't hold the comic book across the room.

"Only in the case of the guy [the shooter], did I take photographs of a person, and use the photographs as the basis of my drawings. Other people were just drawn. The reality of that person made just one step above the other people that you saw in the pictures, made that person more real. It was almost as if you were looking at photographs of a real person who was really doing this. It pulls you into a kind of reality. You're just taken aback. 'Where am I?' 'Am I reading a comic book here? I'm seeing a story that seems so damn real!' So it throws you, and I understand that, and that's all intentional. It's my terrible, viscous mind."[12]

Stenstrum: "Like everyone else who saw Neal's work, I was blown away. The violence was shocking and disturbingly realistic. Originally, Rich Corben was going to illustrate the story, which is why it was jammed into eight pages—so it could be in color. But Neal Adams came available for a brief

"Thrillkill" by Jim Stenstrum and Neal Adams. *Creepy* #75 (November 1975).

Ending panels of "Thrillkill."

window and DuBay snapped him up. I'm glad he did. I can't imagine anybody else's artwork on that story."

Despite the quality that his magazines were sometimes attaining with "Thrillkill" and other fine stories, Warren didn't consider comics—even the best ones that he published—to qualify as true works of art. About the same time that "Thrillkill" saw print, he was interviewed by Gary Groth and Michael Catron in a hotel lobby in Washington, D.C. Warren's love affair with airplanes and aeronautics unabated, he was in the nation's capital to fly to London on one of the earliest flights of the Concorde, the new supersonic passenger jet airliner. When they got on the subject of whether comics, at their best, can be

"art with a capital *a*," Groth and Catron maintained that certain comics should legitimately be considered works of art. Warren would have none of it: "The people who claim comics are art have to do this to justify their interest in the field. Don't kid yourself. It is not art. Are you going to put a comic strip panel next to Rembrandt and say that they're both the same? Shakespeare is art. A good story in a DC comic book is not. I don't care how good it is. Picasso's *Guernica* is art. The cover of the latest issue of *Creepy* is not. It's damn good graphics. I love Walt Disney but *Snow White and the Seven Dwarfs* is not art. I have my own built-in barometer. There are just some things you know instinctively. When [you] start talking about comics as an art form, I say . . . bullshit. And by the way, this is a field that I earn my living in. I don't want to defame it, but I don't kid myself. That's my opinion. People will disagree with me, but so what? I don't buy it."[13] In this view, Warren departed from that of Eisner, who always firmly believed comics were a literary art form.

The conversation turned to the lack of literacy in America. Warren: "I've had a few college graduates apply to our company for employment over the past three or four months, and I don't believe they could pass an eleventh-grade spelling test." Groth asked him to explain. "There are many reasons. This generation, unfortunately, is a victim of poor leadership and bad educational theories which have proven false. And we're going to pay for that. We're going to pay for that for the next fifty years. The theories of education have changed [and] produced uneducated people, according to the material that I've read, compared to the educated people of twenty years ago, of thirty years ago. In the old days, the three big influences on youngsters were the home, the church and the school. There's been a breakdown in the home, an almost total breakdown in the church and in the school. I think it's a general breakdown in a lot of things that used to be better. People are a little lazy now and they want the easy way out. It's going to reduce the quality of the leadership in business, in government and elsewhere. And I'm a pessimist about that."[14]

IN THE 1970s, Warren began thinking that he had a property that could succeed in the movies: Vampirella. The first mention of a Vampi film goes back

at least as far as *Vampirella* #19 (1972), in the article "Everything you always wanted to know about Vampirella," which stated, "Plans are . . . underway for a full-length motion picture. Musing on the translation of Vampirella into movies, Warren . . . mentioned Paula Prentiss and Raquel Welch as likely candidates for the coveted role of Vampirella—a girl whose time has arrived!" At the time, this was probably in the realm of fantasy, but by mid-decade, a concrete project was in the works. He summarized the process in 1999 for *Horror Biz* magazine: "Back in 1975, an American movie producer structured a deal with Hammer Films, a British company, to produce a theatrical full-length film on Vampirella. The financing was to come from Hammer and . . . Henry White. I retained final approval of many facets of the production: the script, principal players (such as Vampirella), advertising, etc."[15] Warren became embroiled in reading scripts, contractual negotiations and discussing everything from casting to merchandising. Because of its potential upside, it became a top priority.

Years later, Barbara Leigh recalled the beginnings of the project. "I first heard about [the movie] in a general casting call being held here in Los Angeles. It was for the movie *Vampirella*, [to be] produced by Michael Carreras and Hammer Films. I went on the interview, and that was the first time I'd heard of the character."[16] It wasn't long before Leigh learned about the publisher who had cocreated Vampirella and would be involved in the film. Although she wouldn't be confirmed for the role until she had a screen test (something Warren insisted on), she appeared on stage as Vampirella at the 1975 Famous Monsters Convention.

Michael Carreras, producer and owner of Hammer Films, was also at that convention, along with Peter Cushing, who was mobbed by fans. Leigh: "Michael Carreras . . . loved women heroes, especially Raquel Welch in *One Million Years B.C.*, which he produced. And he loved Jane Fonda in *Barbarella*. Films like that. He liked SF films with the woman being the lead. Unusual for his time. He did all the great vampire films with Christopher Lee and Peter Cushing. Even today, those are my favorites, like *The Horror of Dracula*. I loved Peter Cushing and Christopher Lee, and got a chance to

meet them both."[17] Leigh also liked Warren a great deal. All were excited about the upcoming movie.

In order to hype the convention, and *Famous Monsters* magazine itself, Warren arranged for Forrest Ackerman and Peter Cushing to be interviewed by Tom Snyder on the NBC-TV *Tomorrow* show. Ackerman showed up wearing his Dracula cape (which Bela Lugosi had worn). The show seemed to do the trick, because the second convention reportedly drew more fans than the first. Sales of the magazine increased as the decade reached its halfway point. None of its imitators had been able to diminish the *FM* juggernaut. Only changing times, it seems, could do that. Greater sales lay ahead for the flagship title.

CHAPTER FOURTEEN

LOUISE JONES, EDITOR

AFTER WARREN BUTTONED UP the beach house in the fall of 1975, and was back in Manhattan to oversee the final preparations for the second Famous Monsters Convention, he was hit with Bill DuBay's resignation as editor. DuBay recalled, "As a lifelong fanboy, I didn't think it could get better than that. But working for Jim Warren, as grateful as I was for the opportunities he gave me, had been hell. I felt completely fried, utterly exhausted and thoroughly used and abused. So, I wrote the most gentlemanly farewell editorial I could muster and walked away. My first stint editing the Warren magazines culminated in my writing a book-length Vampirella story that revolved around and guest-starred Will Eisner's Spirit [in *Vampirella* #50], the first time Will had ever allowed his character to guest star with another comics icon. I had no plans and figured I'd let life take me where it would. Pretty much right away, I got a call from Marv Wolfman, asking me if I'd like to contribute to Marvel's new humor magazine *Crazy*. Silver-tongued devil told me he'd always liked my humor art and said that my style would 'mesh perfectly' with what they wanted and where they were going. So, I joined them." With DuBay's exit, who could step in and handle not only the editorial duties but the Wrath of Warren? As it turned out, DuBay's successor was already on staff, in the person of his editorial assistant Louise Jones.

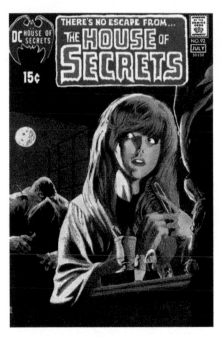

Louise "Weezie" Jones modeled for Bernie Wrightson's *House of Secrets* #92 cover. Courtesy of Louise Jones.

Mary Louise Jones (b. Alexander), who most people called Weezie, was born in Georgia in 1946. While attending Georgia State University, she met a student named Jeffrey Jones, who was already an excellent artist. Her introduction to comics as a serious medium occurred at this time, when Jeffrey showed her the Goodwin-edited issues of the Warren line. She especially liked *Blazing Combat*. They married in 1966, and had a daughter, Julianna, a year later. To pursue an art career for Jeffrey, the young family moved to New York City.

In the city, they made connections quickly, becoming part of the regular, informal gatherings of comics people which had been going on for some time. They eventually took over hosting them at their apartment. In those freewheeling evenings, they socialized with the young comics crowd in the city: Bernie Wrightson, Mike Kaluta, Vaughn Bodé, Alan Weiss, Roger and Michelle Brand, Flo Steinberg and many others, plus established professionals, notably Neal Adams. She modeled for Bernie Wrightson's first Swamp Thing cover (*House of Secrets* #92, June–July 1971). Two of her closest friends were Archie Goodwin and his wife Anne T. Murphy, who said, "Weezie . . . and I

were very friendly, as were our kids when they were little. Her daughter was my daughter's best friend for many years."[1]

When Julianna was no longer an infant, Jones found a job working in the circulation department of Macfadden Publishing, earning a rock bottom salary. As the wife of Jeffrey Jones and friend of Goodwin and Murphy, she attended the Eisner-Corben party at the Plaza Hotel, in late 1973, when DuBay met her for the first time, although he didn't find out about her interest in comic art until the "after party" at his apartment.

In August of 1974, Louise Jones's friend Michelle Brand, who was working at Warren at the time, told her there was an opening in the publisher's production department. Jones had done nothing in comics except scripting "Dragon Slayer," a strip drawn by her husband which appeared in *Monsters and Heroes* #2 (1967). The Warren job didn't pay well, just slightly more than Macfadden. Weezie: "The pay was lousy, like $120 a week, but you could live in a basement studio apartment in Manhattan for $100 a month on the Upper West Side. At that point, I had an apartment on the first floor of an elevator building, and it even had a bedroom, for $150 a month." She felt that she had been hired by DuBay because of her cuteness. "There was no reason in the world why I should have qualified for the job. I mean, I was actually not great at production. But it turned out I was good at other things."

The production department was supervised by DuBay (or "Dube" as he liked to be called). "The work was generally shared," Jones recalled recently. "DuBay was the guy on top, and then Mohalley was underneath him, and I would have been under Mohalley." The production department pasted up all the editorial and advertising pages in the front and back of every magazine, and got everything ready to be sent to the printer. Mohalley's chief responsibility was putting together each issue of *Famous Monsters of Filmland*, after Warren reviewed the material submitted by Ackerman. *Famous Monsters* was selling well at this time, and had extra status because it was the chief engine for the Captain Company catalog.

Weezie: "I started off with the production job, and they kept saying, 'Gee, we wish we had someone to do the letters page,' and I'd say, 'I can do the letters page.' They'd say, 'We need this advertising copy, and nobody has

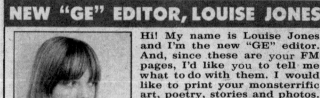

Hi! My name is Louise Jones and I'm the new "GE" editor. And, since these are your FM pages, I'd like you to tell me what to do with them. I would like to print your monsterrific art, poetry, stories and photos. I want to hear about the books you've read and the films you've seen. What do you think about the monster-filled T.V. shows this year? I'd like your opinion. Write me and I'll print your letters, articles, and ads. I want you to have as much fun putting "GE" together as I do!

Famous Monsters #113 (January 1975).

time to do it,' and I said 'I'll do it.' I would always say that. And that's the reason that I ended up being an assistant editor. As far as I know, I was offered the assistant editor job because I was there in production, but was willing to do a lot of editorial stuff." Just three months after being hired, she became the editor of the *Graveyard Examiner* column, a reader-created dispatch, in *Famous Monsters* (#113, January 1975). Four months later, she was officially made assistant editor. Jones was grateful to DuBay for getting her out of production and into editorial. "[DuBay] seemed fairly autocratic, fairly in charge, but I never found him to be particularly obnoxious. We were all very young." For the most part, she had no problems working with him, or with Warren.

"Then DuBay wanted to leave. He was tired of commuting. He had moved out of the fancy apartment near the river, and he'd gotten a house in Connecticut. It was a long commute. Warren was looking outside the company at other people to come in. When DuBay had gone away on vacation, I'd done a month's worth of getting the books out in a timely fashion, being the editor essentially, and I loved it. I really loved being an editor! It was fun, and I guess I did an okay job when I was filling in. So, I went to Warren and said, 'I want to be the editor of the line.' He said, 'Girls can't edit horror comics!' which was poking me, essentially. I said, 'Look, of course I can. I will edit all of the books without an assistant for the salary I have now for six months, and I'll get the books on schedule (which they weren't.) And then we'll see.'

He said, 'Sure,' because he wasn't stupid. But he could have said. 'No,' because that was a crazy offer. He could have said, 'Anybody who'd make an offer like that is out of their mind!' But he said, 'Sure, go ahead.' So, I did. And I managed to do all the things I said I would do. So, he hired me, made me the editor of the line and gave me a big raise."

On July 23, 1976, Warren Publishing issued a press release stating that Bill DuBay was leaving as editor and would be replaced by Louise Jones. DuBay opened a studio in Connecticut, which he dubbed The Cartoon Factory. There was still material that DuBay had edited before his departure, but Jones was in charge. She would continue on the mastheads of the three magazines until April 1980. When Jones ascended to the full editorship, she had a confrontation with Warren, who had the habit of yelling at people. "That was early on," Jones recalled, "when I had just taken over editorial. I said, 'You don't yell at me. You can tell me things, but you don't tell me things at the top of your lungs.' And he was fine after that. You had to stand up to him."

According to DuBay, Warren was unsure about Jones as full editor: "As I recall, Jim was a little reluctant to go with her as the editor. On my way out the door, Jim says, 'Come here. I've got an offer for you.' He told me that things weren't working out quite the way I'd said they would with [Weezie]. He said there was a 'flat-out refusal to take any of his guff!' Surprise! Surprise! He made a generous offer and asked me to stay. I declined. 'At least write or draw a few stories.' I told him I'd think about writing, and that was all, because I felt that I'd pretty much found my niche as a cartoonist. But this was Warren. You know that old expression about a pit bull never letting go? That's him! Relentless to the core! He made another offer: twice my monthly mortgage—every month—for the use of my name on the mastheads of his titles. I capitulated. I think he listed me as consulting editor in *Creepy, Eerie, Vampirella* and *The Spirit*."

Warren didn't want to end his business relationship with DuBay, who theorized, "I think he had a lot invested in me. I had a lot invested in him. I think we probably knew each other better than any other editor-publisher combination that I can think of. He trusted me with his magazines, which was an honor in itself. It's not something he let loose of real freely. I don't think

he wanted me to go anyplace else." It wasn't an attempt to tie him up, like an exclusive contract. "I did work elsewhere. I did work for *Playboy*, for *Cracked* magazine, *Crazy* magazine, *Sick* magazine. It lasted, I don't know, a year, two years, whatever it took for him to lure me back [to edit new magazines]."[2]

DuBay didn't end up consulting much with Jones. "[She] made it clear I was neither wanted nor needed. This went on for more than a year." Jones was handling the job well, and didn't need his advice. She had a healthy "take" on Warren, which allowed her to work for him: Weezie: "He was [a] real character. He was whatever he ever felt like being at any given moment. He could be the most charming man on Earth, or the most utter pain in the neck. He could be viciously cutting if he chose to be. He could be angry and raging or very kind and nice and gentle. He was whatever he felt like being. I think it was all the real Jim Warren. He had the talent of being whatever he wanted to be. Heaven help me, I liked him. Sometimes I'd want to kill him, but at his core he was amazingly likable. Very amusing. He was a very smart man, too. The charm wasn't false—nor was the fury. It was all part of the nature of a very complex individual."[3]

Her knack of getting along with everyone, even those with difficult personalities, could partly be attributed to her background. "One of the things that helped me," she said, "is that I come from the South, where nobody ever says exactly what they mean. You learn to listen for what people are *really* saying." This ability to listen, and then "read between the lines," meant she was able to be responsive both to her freelance writers and artists, and to Warren himself. "If any of the male writers didn't like a female editor," she said, "I didn't know about it."

DuBay's return to the masthead as "contributing editor" with *Creepy* #81(July 1976) coincided with two things: the debut of Joe Brancatelli's column *The Comic Books*, which would discuss current developments in the comics industry in each issue, and Warren's offer of a $500 reward for information leading to the arrest of the individual who was selling counterfeit copies of the *Eerie* #1 ashcan edition. Warren: "Someone with larceny in their heart produced a number of counterfeit copies and sold them to unsuspecting collectors and fans for, I think, $100.00 a copy. I remember the day it happened.

"Someone has to make it happen." James Warren at work, mid-1970s. Courtesy of Sherry Berne Wallack.

My secretary came into my office, her face white, her eyes wide open. She said, 'Mr. Warren, two men from the FBI are here to see you.' My hearing is not too good and I thought she said, 'two men from the FBI are here to arrest you.' As they came through the door, all I could think of was the hotel towel that I had taken the week before while in Barcelona. It turned out the FBI had been called in to investigate the counterfeiting and illegal sales of our *Eerie* #1 issue."[4]

In his reward offer, he wrote: "It has recently come to our attention that this issue has been counterfeited and sold to unsuspecting collectors and fans for considerable sums of money. Warren Publishing intends to vigorously pursue its legal rights in this matter and will prosecute to the fullest extent

of the law." He then asked anyone who had recently purchased a copy of *Eerie* #1 to send it directly to his attention, with "all details concerning the purchase price, from whom the purchase was made, etc." The copy would be returned, once its provenance was determined. (There were flaws in the reprint that made such identification possible.) He told the FBI who he thought the culprit might be, but never found out if they caught the perpetrator.

WHEN WEEZIE BECAME EDITOR, the books were selling well. If one can judge by the circulation figures published in *Vampirella* and the other magazines, the company was almost at its peak. "Yes, it was doing fine," Jones confirmed. "I was told by Mike Schneider, the sales manager, that sales went up when I took over the editorial, but I don't know if that was true or not. Schneider was not supposed to show us sales figures, but he actually did. Occasionally, I was able to get him to show me exactly what the sales figures were. That was important. I would run experimental issues, and then I would want to see what happened, so I'd know what worked and what didn't. Not every experiment was a good one, but some of them actually worked out pretty well. The sports issues were not a good idea. People who read comic books aren't interested in sports. It seemed to me that it should have been the same demographic, but it obviously wasn't."

DuBay had upgraded the magazines considerably. Jones continued to find ways to improve them. If Archie Goodwin's editorial reign in the 1960s had been Warren Publishing's golden age, the Jones era can be deemed its silver age. Goodwin later said, "The high quality . . . perhaps reached its peak with the editorial services of Louise Jones. There was no drastic change, but under Jones the editorial blend of the magazines attained a nice balance between the European and American art styles resulting in some of the most visually pleasurable combinations of talents assembled on a regular basis."[5]

Jones speculated, "Maybe I just had the sort of mind where I like the same thing that most of my readers do. I had some very good writers and some very good artists working for me. Part of it was luck, and part of it was the people I was working with. I think maybe I was good at picking people who were really good at what they did. Maybe that's my skill."

A lot of her job involved working with the Spanish artists through Selecciones Ilustradas. She didn't have direct contact with individual artists. "We would talk with José Toutain, who would come through the office once a year or so. I don't know how he arranged things on his end. It went through his office and he dealt with it. We would ask for specific artists on specific stories. Some artists were good with the 'straight' stuff, and some would be good with the more fanciful stuff. Ortiz was good for anything. He was wonderful. What a fine artist he was. Ramon Torrents did some really nice, realistic stuff. Luis Bermejo was good for anything. And then Pepe González, who did Vampirella, was good for the fantasy [stories]." She couldn't speak Spanish to Toutain, but Elizabeth "Liz" Alomar, Warren's longtime secretary, could. Weezie: "Liz was there the whole time I was there. She helped with dealings with the Spanish artists, although Toutain was dismissive of her Spanish because it wasn't Castilian Spanish." As for the writers, her favorite was Bruce Jones, who had made little headway with DuBay. "Bruce Jones was great," she said, "but he hated DuBay and DuBay hated him—because Bruce was very good looking, better looking than DuBay. And Bruce was a very good writer, maybe better than DuBay. It was a macho thing, 'Who's the dominant wolf?'"

Bruce Jones was born in 1944 and grew up in a number of cities in Kansas and Missouri, settling in Kansas City in 1966. "I was raised in the burbs . . . as in *Leave It To Beaver.* My parents got me subscriptions to Walt Disney comics early on, so Carl Barks was influential. I habitually read the Sunday newspaper funnies. In my childhood, super hero comics were in steep decline. Science fiction and mystery-horror ruled, so that got in my blood. In school, I got A's in art and English while flunking math. During math and history, I stared out the window and made up stories in my head, the teacher's voice a distant drone.

"I never studied writing, unless reading alone is studying. I attended KU and Washburn University and continued to study fine art and art history until 1966. I took some commercial art classes, but nearly all my courses were on the Fine Art side. By the mid-'60s, mainstream magazines were turning to photography or going under, one after the other. Illustration began to decline.

Comics, on the other hand, struggled along and could be a regular paying gig even if they were shadows of their former days. They had fast turnaround and short deadlines but steady work." His first artwork in a Warren magazine appeared on the fan page in *Eerie* #16 (July 1968), which was done shortly before he moved to Manhattan.

"I'd seen Jeff Jones's work in Larry Ivie's magazine *Monsters and Heroes* and called him up. We hit it off right away, two guys the same age just starting out. Jeff and Weezie Jones lived on West 79th Street in Manhattan. Bernie Wrightson lived in an apartment on the floor above Jeff that he shared with Mike Kaluta, and, I think, Alan Weiss. Jeff and Weezie's place became a kind of hub for hanging out." He was there for *Web of Horror*, and then made it into Warren magazines. Why didn't he do more for Warren, after his initial breakthrough?

"DuBay rejected my stuff. I don't know why." Finally, Jones and his wife had enough of the city, and moved back to Kansas City. But on the eve of the move, DuBay finally bought a script: "Jenifer" (*Creepy* #63, July 1974). Jones: "A few days before we moved back to KC, Jeff and Bernie showed up at the door. Bernie started raving about DuBay loving the 'Jenifer' script and that he [Bernie] was going to draw it." Then, after moving back to Kansas City, "The phone began to ring off the hook. Roy Thomas called and I did art and stories for Marvel's science fiction books, scripting for Red Sonja and Conan. Sometime right before or after DuBay left, 'Jenifer' hit the stands and I was a six-year overnight success. By pure serendipity, Weezie took over the editing reins and wanted more stories. I was back writing comics. She was great. She had terrific editorial instincts. She had pretty much cut me loose. I think she only turned down maybe one of my scripts in all the Warren years."

Weezie: "Bruce was really funny. Every time he would call me and say, 'I've got the best story ever to send you,' it was *always* not great. The ones that he would just send in were usually excellent. But when he'd call me in advance—I don't know if it was a preemptive strike to convince me that what he was sending me was so good, and that I couldn't tell. Or, if, indeed, his aesthetic was different than mine, and these *were* his favorites. I have no idea, I've never asked him."

Bill DuBay continued sending in stories. Almost all of them were wordy, some with thick captions in nearly every panel. Weezie more or less left DuBay's stories alone. The wordiness seemed to spread to other writers, such as Budd Lewis, Gerry Boudreau and Rich Margopoulos, all DuBay favorites during his tenure. Bruce Jones later said, "Warren was very good, or his editors were very good, about allowing you to do whatever you wanted to do with panel sizes, because the format was so large that you could get away with that. And one of the things I used to love was that I could write—I could be as verbose as I wanted to be. I never tried to write shit that was just for the sake of writing, but I tried to incorporate the fact that you could write more, because the pages were simply bigger."[6]

"You can't blame them," she said. "People did tend to look at what was being bought. That happened on letters pages, too. I experimented, and found that if you tended to publish letters with negative comments, you'd get more letters with negative comments next time. And if you publish almost all positive comments, you'd get positive comments, because people wanted their comments to be published."

Bruce Jones's scripts benefited from being drawn by the best in the business, among them Russ Heath, Al Williamson, Rich Corben and Carmine Infantino. Heath returned to Warren in 1976, a decade after his work in *Blazing Combat*. His first new story was Dave Sim's script "The Shadow of the Axe!" Heath recalled, "They sent me a script about a werewolf and I sent it back and said, 'Why don't you send me a story about an axe murder? I can relate to that! I'm a realist, I don't believe in werewolves.' It's not that I couldn't do supernatural stuff because I used to do a lot of it."[7]

Al Williamson also came back, albeit briefly: "Bruce Jones called me and asked me if I would do a couple of jobs. And Weezie Jones was the editor at the time, so I figured with Weezie Jones and Bruce Jones at the helm, I wasn't going to get screwed, and that they'd look out for my interests."[8] Rich Corben was, by 1976, a superstar at Warren Publishing in a category all his own. This was partly because much of his work was printed in color, but primarily because his artistic style and aesthetic sensibility was so different from most of the other artists, who had gotten their start in mainstream

comics. He had sprung from the underground comix, and his work never lost a certain subversive quality. He was just as much a force in the Jones era as he had been during DuBay's tenure as editor.

Carmine Infantino became a regular artist under Jones's editorial reign. Jones: "Carmine Infantino was fired at DC as the publisher. Warren, because I think he loved the idea of having the former head of a major competitor as his employee, told him that he could come in and work in our office, and we would give him as many scripts as he wanted. He would be allowed to just sit there and draw and draw and draw. Now, Carmine could draw a lot because he was fast. So, I had a giant pile of Carmine material that I would have to try to get different people to ink so that it would look different, and wouldn't look like too much of the same thing. I found that to be a little difficult. Everybody enjoyed inking him a couple of times, but then it was like, 'No, I've inked Carmine now, and I've got other things that I want to do.' So, it became more challenging." Infantino's style looked a little out of place, but his drawing ability and design sense had not deserted him. Overall, the magazines benefited from his work.

Bernie Wrightson inked pencils by Carmine Infantino on "Country Pie" in *Creepy* #83 (October 1976).

All four artists appeared in *Creepy* #83 (October 1976), a landmark issue because it offered four of Bruce Jones's best scripts, and paired him with the stellar talents of Heath, Williamson, Corben and Infantino. The same issue featured two of DuBay's best scripts, drawn by John Severin and José Ortiz, respectively. To this impressive lineup, add a frontispiece by Bernie Wrightson (and his inking of one of the Infantino strips) and a cover by Frazetta (albeit a reprint). This was more than a mind-boggling lineup of talents. It was their best work in a Warren magazine, or (arguably) anywhere. It was head and shoulders above nearly everything being published in American comic books at the time. Even though newsstand distribution was deteriorating, resulting in falling sales for their competitors, the Warren comic magazines were holding steady.

One of the finest stories was the Jones-Heath "Process of Elimination," about a man who returns home to his upper middle class home, to his beautiful wife and two young children, whom he loves, and kills them. What could motivate him to do this, when he clearly cares about them deeply? Only one reason: to save them from a lingering death. The final page shows a mushroom cloud forming from an atomic explosion over the city. You realize that he had foreknowledge of this event, and killing his family was an act of mercy.

Another of the highlights is "In Deep," a Jones-Corben ten-pager (with eight of them in color) about a young husband and wife who are capsized in the ocean, and cling to a life preserver hoping for rescue. They become so exhausted that they can't help eventually falling asleep. When the husband awakes, he finds his wife, still clinging to the preserver, has drowned. He fends off hungry seagulls, and a shark attack which takes nearly all her body. After he's rescued, he's found holding just one piece of his wife: her heart. Both of these stories are typical of Bruce Jones: contemporary, involving relationships with loved ones, and with the horror arising from physical harm rather than fantasy elements. Jones loved Corben's work on "In Deep," and his other stories as well: "I think it was sheer coincidence, though, that Weezie gave Corb so many of my scripts. I was always delighted when she did. He and Heath and Williamson were my favorite artists at Warren. I was blessed."

I PULL INTO MY DRIVEWAY AND CUT THE ENGINE. I SIT THERE **ALONE** FOR A MOMENT, BREATHING QUIETLY, HESITANT TO LEAVE THE SANCTITY AND SOLITUDE AN AUTOMOBILE CAN OFFER. MY RIGHT HAND, I NOTICE, IS **TREMBLING** SLIGHTLY.

MY EYES **FOCUS** ON THE SUN-BAKED WOOD OF THE **GARAGE** DOOR. ABSENTLY, I REMEMBER GWYN ASKING ME TO **PAINT** IT. I PULL IN A RAGGED BREATH. IT WILL **NEVER** GET PAINTED NOW.

MY THROAT MOVES CONVULSIVELY. THE DULL BEGINNINGS OF A **HEADACHE** PECK AT THE BASE OF MY SKULL. I NEED A **DRINK**.

"QUIT SITTING HERE **THINKING**," MY MIND SAYS. "THIS LOOKS **SUSPICIOUS**." I REACH OUT MY HAND **CAREFULLY** TO THE GLOVE COMPARTMENT AND OPEN IT. MY FINGERS **HESITATE** A MOMENT, THEN REACH INSIDE...

...AND **WITHDRAW** THE CONTENTS.

Process of elimination

Above and opposite: From *Creepy* #83. Story by Bruce Jones, art by Russ Heath.

Warren never looked over Louise Jones's shoulder: "I don't think he actually cared about the scripts. [Warren] cared more about the art. I had to go in and convince him to let me use Leo Duranona. Because he was Warren, he had to act like he didn't want him, even though the work that I showed him was obviously superior. But then he kind of condescended to allow me to use who I wanted to use.

"I had a lot of affection for Jim, in kind of a weird way. And, honestly, for all of his drama—and he *was* a dramatic person—he was not that bad to work for. In some ways, he was generous. He gave me editorial freedom in many respects, and believe me, that's worth more to me than money. I pretty much got to do what I wanted. I got offers to leave every year, sometimes every six months, and work for somebody else. Jenette Kahn really wanted me to come over and work at DC. But I liked being in control."

Warren later addressed this policy: "It's not that I didn't want to know what they were doing. I was dying to see what they were doing in steps, but I realized that I didn't want to get close to [my editors]. I didn't want to open myself up to them because I knew that if I did, I wasn't sure that I had the guts to be able to handle it without going to pieces."[9] Whatever the reason, he let his editors mostly alone, and they appreciated it. The only exception was Ackerman, but in that case, they were something like co-editors. He never gave the Californian full control of *Famous Monsters*.

In July 1976, another new employee came into the company. He would have an effect on the part of the magazines that Warren was most passionate

Revelers at the Warren Christmas party in 1975. Among them are (top left) Liz Alomar and Bill Mohalley, Jim Warren as Santa and Louise Jones and Bill DuBay next to him. In the bottom row, Flo Steinberg is second from right. Courtesy of Sherry Berne Wallack.

about: the covers. His name was Kim McQuaite. A graduate of the Pratt Institute, he was freelancing in commercial art when an employment agency sent him to Warren Publishing. Bill Mohalley offered him a job in the production department. Much of what he did at first was pasting lettering onto the pages and using a rapidograph [ink pen] and an ellipse template to draw the balloons. There was a lot of it. "It was sort of Zen-like work," he said. "It didn't take a lot of brain power." The job was nine-to-five, except when they got close to crunch time, and they had a printing deadline to meet. Then there was occasionally overtime. He did this for almost two years. "Esprits de corps was very good when I was there. It was very positive, very supportive. There was never any nastiness or backbiting. It was a great time!"

In March 1978, he was promoted to art director. McQuaite: "In the beginning, I didn't have much interaction with Jim Warren at all, because I was just a production guy. I don't remember how I got to be art director. I've always had a big mouth. And I think I was probably just suggesting ideas.

'Let's do this,' or 'Could we do that?' It might have started when I suggested a different kind of interior graphics. 'Let's have some space and have an illustration, or a different kind of heading.' . . . That's how I got into it, working on the letters pages and trying to make them look better, and more exciting. That's when I starting working directly with her [Louise Jones] on some things. Jim always held Hugh Hefner up to great esteem, and I think he also liked *New York* magazine, in terms of what [Milton] Glaser was doing with it. When I started moving into it, I thought, 'If he likes those, why can't these magazines echo them? The next step was probably 'Do you want to take a look at a cover?' It wasn't like they were looking for somebody. I grew into it. Weezie and I hit it off really well.

"I would work with Weezie closely first. She would pick what the lead story was going to be, or what the cover would focus around. She probably talked that over with Jim. Then she would get together with me. We would discuss it. I would do some real quick thumbnails. And we did it together, it wasn't just me. We would identify an artist who we liked and thought could do a real good job with what the concept was. We were always interviewing artists—we got into the habit of sort of expanding the cover artists. At one point, we went through an agent. That's how we found Terrance Lindall, who did the cover for *Vampirella* #86 with the curved logo." There were other new artists. "We probably ran a basic cover concept by Warren, and who we wanted to paint it. He had faith in Weezie, and me, eventually, and we knew that he wanted something strong, powerful."

McQuaite was responsible for four covers a month and six or seven one-shot covers per year. "It generally took the artists two weeks to finish a cover. I worked on the cover logos. *Eerie* #95 (September 1978) was the first "cleaned up" logo. Then he revamped the logo on *Creepy* with #117 (May 1980)—the first logo change in the magazine's history. All of these changes were carefully reviewed and approved by Warren. McQuaite ended up doing the art or part of the art for numerous covers after becoming art director, notably the Aliens cover on *Creepy* #96.

"Jim loved Day-Glo colors. Bright colors. Strong presentation. Lots of contrast. He would have [World Color Press in] Sparta pump up the contrast,

so that it would end up having darker darks and lighter lights. When we did blacks, he directed that it be a combination of all the four-color plates, not just the black plate, in order to get as dense a black as possible. So, it would be 100 percent black, but also 47 percent each of the blue, yellow and red plates on top of that, to be just under the 240 percent total ink coverage which was the maximum that Sparta would allow, without it gumming up their presses. On one cover, I had a panel with bold white type against our Warren super-black background. It was the focus of the cover and the hook to get people to buy the issue. He wanted it strong and I'd made it strong. He looked at it a minute, frowning, then said, 'It really needs to be stronger. Can't we get more contrast?' I was actually stunned, and . . . I remember laughing, saying, 'It's absolute paper white, against your super black. You can't get more contrast in this world!'"

The toughest time working there continued to be the "big push" in the spring. While much of the work was being done in May and June, Warren would be away. Weezie: "Then he would come in, and he would yell at us, and tell us how things would have been better if we made the red type white, or the white type red. You know, change the size of it, or whatever. Once I heard about gorilla behavior—from Jane Goodall, or was it Dian Fossey?—I understood what he was doing. It was almost like a ceremonial thing, and kind of funny. You say, 'Oh, here it goes again,' and we'd go through the ceremony again. Once I acknowledged that he was the superior being, who knew all and had all power, and then he would go away again." Warren spent most of the summer on vacation in the Hamptons, although he was a phone call away if needed, and dropped into the office from time to time.

Jones hadn't been editor long before Warren decided to cancel *The Spirit* magazine with its sixteenth issue (October 1976). The first issue had reportedly sold a whopping 175,000 copies, but after that, sales dropped to the level of the other magazines, in the 90,000-copy range. However, further reader erosion brought it down to levels that Warren could no longer sustain. "[Jim and I] had a lot of business arguments," Eisner said, "but we got along very well. As far as I'm concerned, he was a fine person who I enjoyed working with. Other people had tough things to say about him, but there are always

three sides to every story. Jim should be credited with publishing books with a high art standard. The book ran as long as he could sell enough copies to keep it worthwhile."[10]

Eisner asked Denis Kitchen if he was interested in continuing the magazine. He was. The Kitchen Sink Press business model was such that a profit could be made even if the magazine sold fewer copies than Warren found acceptable. He picked up *The Spirit* magazine with #17 (Winter 1977), and continued it until 1983. Kitchen: "Numbers aside, Will told me more than once that Warren 'wasn't easy to deal with' and that was a non-economic factor for him. But he never went beyond that vague commentary. So far as I know, he and Jim parted ways amicably."[11]

CHAPTER FIFTEEN

WARREN'S SILVER AGE CONTINUES

THE COMEBACK STORY of James Warren's publishing company was one of increasing achievement and success each year after 1970. He had a button made for himself and his staff that read, "We're not big. We're good." Having to use substandard material during the downturn of the late 1960s had been galling; now he could justifiably be proud of the material in *Creepy*, *Eerie* and *Vampirella*.

It hadn't taken long for him to realize that Louise Jones was fully capable of handling the editorial chores. The freelancers appreciated not having their stories routinely rewritten (as DuBay had done). She had inherited writers who were capable of producing stories that were, within their genre, unusually creative and often quite sophisticated. A substantial amount of the art continued to be done by Spanish artists, but she also gave American comic book artists of stature more work. The Warren rates were excellent, and the ability to journey beyond the limits of the Comics Code was a continual advantage over their four-color comic book competitors.

Russ Heath and Bruce Jones teamed up to produce some of the finest stories the company ever published, none better than "Yellow Heat" in *Vampirella* #58 (March 1977). Bruce Jones later recalled, "I met Russ in person on 'Yellow Heat' by sheer coincidence. I was living in a condo in Kansas City and the phone rang one day and it was Russ, calling from down the street.

HE THOUGHT OF THE BEAUTIFUL YOUNG NATIVE GIRL AND HIS HEART DID STRANGE THINGS. HE SAW HER DARK, *SMOOTH* THIGHS, *SUPPLE* WAIST, *HIGH PROUD BREASTS* AND *FULL MOUTH* AND FOR A MOMENT ALL THE *MENTAL ANGUISH* OF THE DAY DISAPPEARED. IF IT COULD *ONLY BE!*... IF HE COULD REALLY HAVE HER! HIS FRIEND'S WOULD BE *MAD* WITH ENVY... HIS PARENTS *DE-LIRIOUS* WITH PRIDE...

A *MOVEMENT* IN THE TALL GRASS AHEAD OF HIM BROKE HIS REVERIE. SOMETHING OF *SIZEABLE* PROPORTIONS WAS MOVING CAUTIOUSLY THIS WAY. UTHU HELD HIS BREATH, EYES SEARCHING *SHARPLY* IN THE DARKNESS. A TWIG SNAPPED IN FRONT OF HIM... AND THEN HE SAW THE HIGH, PROUD HEAD OF AN IMPALA.

HIS FINGERS TIGHTENED ABOUT THE SPEAR SHAFT IN EXPECTATION. THERE WAS A SUDDEN *FLURRY* OF *SOUND* BEFORE HIM. THE LITHE ANIMAL *SHOT* FORWARD, BOUNDING OVER HIS HEAD.

UTHU STOOD UP QUICKLY. HIS HEART STOPPED.

"*I AM A FOOL,*" HE THOUGHT AGAIN. "*BECAUSE OF MY STUPIDITY AND GREED I HAVE BROUGHT DEATH UPON MYSELF.*" HE HELD THE SPEAR BEFORE HIM IMPOTENTLY BACKING AWAY SLOWLY IN DREAD. HOW *TOTALLY* FUTILE NOW SEEMED THE RULES FOR THE TEST OF A WARRIOR-- HOW *GROSSLY* UNFAIR. THE YELLOW EYES OF THE LIONESS FLASHED *RED* IN THE MOON-LIGHT... THE MOUTH OPENED... THE BODY TENSED...

...AND LEAPT!

Page from "Yellow Heat!" Story by Bruce Jones, art by Russ Heath.

I think he was in from New York visiting a girlfriend in Overland Park or something. He came over and we gabbed and he asked to borrow a book of mine on Africa to use as reference for 'Yellow Heat.' We got on great. Major talent, nice guy. I always turned in my scripts in 'ready to go' form, with all directions and dialogue there, and he just took off on them." In this case, Heath used a soft pencil on a pebbled drawing paper to create a sumptuous, tactile world for the story of a young African tribesman who must prove his manhood before he can satiate his desire for a beautiful village maiden. But, in the end, when he's allowed to enter a tent and "have" her, she's shown roasting on a spit. He's a cannibal and is thrilled to have "won" the girl. Bruce Jones: "I know [Russ] loved the ending of 'Yellow Heat,' and would chuckle about it every time I saw him. I think his realistic style was what complemented our working relationship." They teamed for four more stories in 1978 and 1979. The scripter said, "I learned from working at Warren that it was actually possible to make a living writing and drawing, despite what my parents warned."

The late 1970s issues also benefited from the writing talent of Jim Stenstrum, whose "The Super-Abnormal Phenomena Survival Kit" in *Creepy* #79 (May 1976) was a particular favorite of Weezie and her second husband, Walter Simonson. It's a tongue-in-cheek tale that reads like a multi-page ad for a Captain Company product, a utility belt for kids to deal with monster attacks of any kind. It was drawn by John Severin, despite the fact that Stenstrum was a more than capable artist. "I took a couple stabs at doing artwork for Warren early on," he said. "I never liked drawing my own stuff. But the main reason was I could write four scripts in the time it would take me to illustrate one story. I also enjoyed writing more, and there were plenty of fantastic artists in the Warren stable who could draw my stories better than I could." One was John Severin, one of the finest in the business. His work in the Warren magazines in the 1970s is among his best. He drew twenty-one stories, including inking Wallace Wood to memorable effect on Archie Goodwin's "Creeps!" in *Creepy* #78 (March 1976).

In 1977, a new title called *Warren Presents* appeared. It was really an umbrella for a series of specials and one-shots, generally attempts to exploit the latest popular culture trend. The numbering of the issues is confusing,

but most Warren fans consider the special titled *UFO and Alien Comix*, with a cover by Jim Warren and Kim McQuaite, to be the first issue of *Warren Presents*. There would be ten issues over the next two years.

Another notable event of 1977, which began the prior year, and would have many repercussions, was the start of a new series in *Eerie* magazine. Bill DuBay created it at Warren's request. DuBay: "We established and incorporated The Cartoon Factory and set up shop in a beautiful old Victorian house on Main Street in Ridgefield, Connecticut. Then Warren called again. 'Got a big job for you! Come on down!' When I got there, Jim introduced me to Howard Peretz of Package Play Development, a toy line packager. He and Jim wanted me to design a new series for *Eerie* magazine that would enable them to reuse old toy molds from the 1950s on brand new 1970s toys. The old molds? Cowboys and Indians, complete with horses, stagecoaches and cheap plastic edge flaps. Jim wanted me to 'make it fit' into *Eerie* because he and Peretz were certain that cyclical trends were about to make cowboys popular again—despite the then-recent demise of even the most stalwart Old West shows, *Gunsmoke* and *Bonanza*.

"The prospect wasn't particularly attractive, but, back at the studio, I laid it out for Budd [Lewis] and Jim [Stenstrum]. They were even less enthused than I. Nonetheless, we went to work. Unlike Warren and Peretz, we didn't think Westerns were coming back. We couldn't see Jim readdressing his *Wildest Western* title, but thought that if there was going to be a new trend, it would probably have more to do with robots and spaceships. (This was in 1976, before the first *Star Wars* trailer.) We explored everything from cowboys and aliens to cowboys and monsters and cowboys and rocket ships. We ended up settling on a time traveler who looked like a cowboy and partnered with a gun-slinging grandfather from the Old West and a wise-talking sentient robot in a ten gallon Stetson."

According to DuBay, "Stenstrum thought the entire premise ridiculous and announced that he wanted no part of it. His focus was on developing two of his own series, *Joe Guy* and *Rex Havoc*. Budd and I pressed on, added the chess master facet to the development and brought Jim and Howard the character the Rook. They wanted it at first sight, but I had stipulations.

The biggest one being that Budd and I retain all rights. The second one being that no one touch a word of anything we turned in. Warren agreed, drew up the papers and the Rook was launched."[1]

The series, initially drawn by Luis Bermejo, debuted with "The Man That Time Forgot" in *Eerie* #82 (March 1977), and continued through #105. The readers were enthusiastic, and, according to DuBay, Warren told him that the sales of that title

Detail from the cover of *The Rook* #2, painted by Bob Larkin.

increased with that issue. "Eventually [Warren] proposed a *Rook* one-shot," he recalled. "The sales figures of that trial issue justified the publication of a regular *Rook* title." DuBay agreed to edit it.

Warren's attempts to move the Vampirella movie along proved to be an exercise in futility. "I rejected the first two scripts," he said. "They were awful. I also rejected the producer's first half-dozen or so proposed choices for the Vampirella role. The business end of the deal called for me to receive specific cash payments on scheduled dates. It turned out the production company could not make the payments. The movie deal was over. Finished. Hammer made efforts to revive it. The efforts were unsuccessful. The aborted feature film died a natural death when Hammer Films later went into bankruptcy. A few years later producer Henry White died, followed afterwards by Hammer Films president Michael Carreras."[2] Even though both Hammer and Warren announced Barbara Leigh as the actress who would play Vampirella in the movie, Warren said her casting was never finalized because the required screen test never happened. He summed up his experience with Hammer: "Michael Carreras was a likeable guy but a complete rascal."[3] He tried to interest others in the property, but to no avail.[4]

Nevertheless, Barbara Leigh appeared on the covers of seven issues of *Vampirella* magazine in the period that stretched from #67 (March 1978)

Barbara Leigh as Vampirella.

to #78 (May 1979). Leigh told interviewer Richard Arndt, "By the time I started appearing on the actual covers, the movie was already cancelled." Of her relationship with the publisher, she said, "I regret the way things ended with us. We had issues with how the cover photos were handled. I don't want to get into specifics here but the way it turned out didn't set well with Jim. There was some bitterness. We settled and I received $500. I was supposed to get all my art back but I only received three or four pictures out of the eight. So, someone, somewhere, has the original artwork of the rest. I wish it didn't end the way it did but he was a New Yorker, very hard-nosed. He was angry, a matter of pride, I suppose."[5]

Although new horror movies came along from time to time (films such as *Texas Chainsaw Massacre* and *Halloween*), they often didn't lend themselves to the young readership of *Famous Monsters of Filmland* and interest in the classic

monsters of yesteryear wasn't what it once had been. Covers feature *Westworld, The Exorcist* and the new *King Kong,* which Ackerman hated. The future of the magazine was beginning to look uncertain until a movie called *Star Wars* hit theaters in May 1977, and became a media sensation. Warren was quick to jump on the *Star Wars* bandwagon, featuring the movie on the covers of *FM* #137–139, and rushing out the *Famous Monsters Star Wars Spectacular* which appeared a couple of months after the film's release. The Captain Company pages swelled with offerings of *Star Wars* models, posters, books, etc., and related SF franchises (such as *Star Trek*) were also mined for merchandise possibilities. While the magazine would never achieve the sales levels of its glory days (during the monster craze of 1964 and 1965), figures provided in the magazines themselves showed that the total paid circulation went from 86,765 to a high of 121,085 as a result of the coverage of *Star Wars.*[6] Ackerman quickly tired of devoting pages to the space opera set "a long time ago, in a galaxy far, far away," but Bill Mohalley wanted it featured somewhere in issue after issue, and the Californian wasn't in a position to refuse.

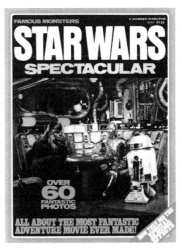

July 1977

Randy Palmer, a California-based assistant to Ackerman on *Famous Monsters,* stated, "All Mohalley had to do was locate a nice color photo from the film, construct a *Famous Monsters* cover around it, and slap on a '*Star Wars*—More about it!' blurb. Courtesy of George Lucas's galactic joyride, Warren Publishing Company began rolling in dough. James Warren treated his staff generously: catered affairs at his Long Island homestead, at Warren headquarters and, once, on a yacht."[7]

Warren negotiated for exclusive rights to do a magazine special on Steven Spielberg's *Close Encounters of the Third Kind,* which would be published before the November 1977 release of the movie. After the success of *Star*

Wars, and the fact that Spielberg's *Jaws* had been a blockbuster a couple of years earlier, there was enormous interest in the upcoming film, which had been produced under a veil of secrecy. Hence, he had high hopes for the sales of the magazine, which hinged on having the *only* photographs from the film for a specified window of time.

Meanwhile, Marvel Comics had the comic book rights for the film, to be adapted by Archie Goodwin, Walter Simonson and Klaus Janson. As the publication of Warren's magazine neared, Weezie happened to mention to him that Walter had "seen some cool photographs and the movie sounded great."[8] Unbeknownst to her, Warren became upset because he thought Marvel had photos from the movie that he didn't have for the magazine, and that even though the comic book wouldn't be published until February 1978, if freelancers had the photos, then they were probably already being shared with their friends and being disseminated, ruining his "exclusive." He called Columbia and raised a fuss, which, in turn, led to Columbia's representatives descending on Jim Galton, Archie Goodwin and Walt Simonson at the Marvel offices. It turned out that the Marvel people had been shown a few cropped photos of the mother ship, and a brief clip from the film, but had nothing on the premises.

The event blew over and no one got into serious trouble, but Weezie was upset that Warren had taken her offhand comments and blown them up into a big thing, getting Walter and Archie in trouble. The next day, a Friday, Weezie wrote a letter of resignation, and left it with Warren's secretary. Liz Alomar said that when Warren came into the office on Monday and read the letter, his face turned white. He immediately telephoned Weezie and apologized. She withdrew her resignation and went into work as usual the following day. Despite the behind-the-scenes tumult, copies of the forty-two-page *Close Encounters of the Third Kind* special sold in predictably high numbers.

AT THE 1969 NEW YORK COMIC ART CONVENTION, Warren had been asked if he would ever publish a magazine solely devoted to science fiction. He responded, "No, no, never, ever, never. The reason [is] that while sci-fi fans are notoriously vocal, they're not enough of them to make a publi-

cation really pay off."[9] An SF story appeared occasionally in *Creepy* and *Eerie*, but—Vampirella aside, with her quasi-science fiction origin—he authorized an entire issue devoted to the genre for the first time in the fall of 1976.

Nick Cuti, a prolific script writer for Warren, had been brought in as an assistant editor and done a good job. Weezie had experimented with theme issues, so when Cuti suggested an entire issue about the planet Mars, it sounded good to her. Cuti had always appreciated a parody of John Carter of Mars done just for fun by Wallace Wood and Ralph Reese titled "Warmonger of Mars," and realized it could be published by Warren, but only made sense as part of a SF theme issue. *Creepy* #87 (March 1977) featured stories in that genre written by Bruce Jones, Roger McKenzie, Bill DuBay and Al Sirois, and illustrated by Carmine Infantino, Gray Morrow, Martin Salvador and John Severin. The highlight was Cuti's own "A Martian Saga," which was drawn by Bernie Wrightson. "By this time," Cuti recalled, "Bernie was in demand, so when I asked him if he would do a story for the Mars issue, he said, 'Okay, but keep it short and simple.'"The resulting tale was told entirely in pages made up of four tall panels which accompany lines of a poem written by Cuti in the style of Robert W. Service. The unorthodox layouts and script seemed to inspire both writer and artist.

Given Warren's lack of faith in the commercial potential of science fiction, an advertisement of an ongoing all-SF magazine less than six months later would be unfathomable had it not been for the *Star Wars* phenomenon. He had been looking for "the next big thing" in vain since the monster craze. At various times, he considered publishing a Kung Fu comics magazine, and a magazine proposed by Josep Toutain with the unwieldy title *Yesterday, Today and Tomorrow* (which would consist of stories of the past, present and future). He even tried to put together a deal to buy *Cracked* magazine when it was up for sale. None of these panned out, but now, with the popularity of George Lucas's film, there was a genuine pop culture trend to exploit. The decision to do an SF-themed comics magazine was made in time for a full page in *Eerie* #86 (September 1977, an all-Corben yearbook) to announce: "WE DON'T PUBLISH A NEW MAGAZINE OFTEN! When we do, it's an earth-shattering event!" Under an image of space ships and an outer space

WE DON'T
PUBLISH
A NEW
MAGAZINE
OFTEN!

When we do, it's an
earth-shattering event!

Watch for WARREN's
explosive new comics magazine.

On sale soon.

From *Eerie* #86 (September 1977).

explosion, in smaller type: "Watch for Warren's explosive new comics magazine. On sale soon." No title, or even the words "science fiction," yet the genre of the new publication was clear.

Who would edit it? After the job he did on the all-Mars issue of *Creepy*, among other special issues, Nick Cuti would seem a logical choice. Or, it could be added to Weezie's editorial slate. But Warren had something else in mind, taking into account the successful launch of *Heavy Metal*, a slick SF comic book that appeared in January. It not only reprinted work from the French SF magazine *Métal Hurlant* by such talents as Philippe Druillet and Jean Giraud (Moebius), but ran stories by Warren favorite Richard Corben, as well as Vaughn Bodé. It was clearly a magazine for adults, and included sexual situations and nudity that were beyond what Warren had published before. A competing magazine from Warren would need to tread similar ground, and for that, the publisher wanted a male editor, one who could handle it with virtually no supervision. DuBay had helped revive his other comics magazines, and Warren took great stock in the younger man's abilities. There was just one problem: DuBay had sworn off working for Warren as an editor. It took some convincing, because the new magazine, which would be titled *1984*, didn't appear for eight months after the announcement (spring 1978). The Rook wouldn't break out into his own title until late 1979.

Worn down by the indefatigable Warren, DuBay accepted the job on the condition that the magazine would be produced out of his Cartoon Factory studio in Connecticut. "They still did all of the Captain Company ads

in house," he later said, "but we did the main production work. A lot of the artwork would come back from different countries—Spain, the Philippines, for example—and we would have to drop in the word balloons and the captions. It never worked to have the lettering done overseas. Also, for the most part, I didn't like the way they'd place balloons and captions, in terms of the continuity. There was a lot of heavy editing going on, in all stages."[10] Looking back, DuBay admitted, "I didn't know anything about science fiction, so I was really the wrong editor for that sort of thing. Jim wanted to do an adult magazine—'let's use words and phrases and figures that people haven't really seen before.'"[11] Per DuBay, Warren felt that sexual content would draw readers that straight SF would not, but really had little choice if he was to compete with *Heavy Metal.*

It was DuBay who brought in the Philippine artists, who had already been working for lower rates at DC. Alex Niño and Alfredo Alcala were the first to work for Warren in early 1977. Louise Jones assigned each to ink a story penciled by Carmine Infantino, and then gave them scripts to handle on their own. Rudy Nebres and others soon followed. Their craftsmanship, especially the detail and brushwork in their inking, rivaled the best of the Spanish artists. They were also prolific and dependable. Filipino artists (who also included Abel Laxamana, Delando Niño and Vic Catan, among others) would produce not only a large percentage of the artwork for the new SF magazine, but work regularly for all the other Warren titles.

DuBay wanted Jim Stenstrum to write for the magazine. Stenstrum recently characterized his relationship with DuBay as "complicated, to say the least. Bill would happily give you the shirt off his back one minute, and throw you to the wolves the next. This eccentric behavior was tough for me to navigate at first, being young and fresh to the business, but after a while I stopped taking his shit and he backed way off. DuBay never rewrote any of my stories. I never let him. Bill might have changed a word or two in my early stories, but by and large he left me alone. He knew I would give him holy hell if he made changes to any of my stories.

"Things were always weird around Bill," Stenstrum said. "For reasons I've never understood, he seemed to enjoy keeping everybody around him

off-balance. You never quite knew at any time where you stood with the guy. I adored Weezie, and wish I had done more stories for her. But I was also working for Bill DuBay at the time and he got upset whenever I turned in a script to her. He was possessive of the guys who worked for him."

On the cover of *1984* #1 (June 1978), painted by Richard Corben, the "adult" label is somewhat hidden in the catchphrase "Tomorrow's world of illustrated adult fantasy." The opening "statement of purpose" sounds a different note, seeming to speak to

1984 #1 (June 1978). Cover by Richard Corben.

the *Star Wars* fans: "We, at *1984*, are trying to recapture some of the fun of old. We've taken a dash of adventure, a smidgeon of excitement from the golden years of our youth, and mixed it with a healthy dose of relevant irreverence of today. We've tried to recapture the spirit of a time that didn't take itself as seriously, and mix it with healthy adult speculation of tomorrow."

The tone of much of the magazine, set by the first story in the first issue, was of a raunchier variety: "Last of the Really Great, All-American Joy Juice," written by DuBay, and drawn by José Ortiz, his favorite of the Spanish art-

Panels from "Last of the Really Great, All-American Joy Juice." Story by Bill DuBay, art by José Ortiz.

ists. Two cranky old men pilot a space junker, a debris collector rather than a sleek warship. The first words of dialogue are, "Look alive, ya wad a'dried up jizzum! There's a Commie warship chasing this floating junkyard!" They are soon boarded by a group of women who are there to take charge of their cargo: the combined inventory of every sperm bank in America, which has been sent into space to keep it safe because "the Reds launched their sterilization nukes right into the heart of America." The images of the elderly women which emphasize their sagging breasts is deliberately grotesque, and the profanity-laced dialogue seems to have something to offend everybody, even by the less-aware standards of the time: deeply ingrained misogyny, racism, homophobia and a great deal of scatological humor. This was hardly a propitious beginning to a magazine purporting to offer "fun of old."

"Mutant World," a collaboration between Jan S. Strnad and Richard Corben, ran from *1984* #1 through #8. Strnad: "We discovered that the dialogue had been rewritten by DuBay when we received our copies of the magazine. We protested loudly. He ignored us. DuBay pissed off a number of creators by bastardizing their work for *1984*, including the late Wally Wood."[12] The final "Mutant World" episode in *1984* #8 (September 1979) was Richard Corben's last interior work for the publisher. In 1998, he told an interviewer, "When the series was finished in the magazine, they wanted to issue a graphic album and we said, 'No Way.' That got Warren Publishing mad at us. I wanted to do other stuff, and I didn't like the direction [Warren] was going. I thought [*1984*] was getting kind of sleazy, and they kept doing so many reprints, and I thought—'I've got to find something else.'"[13] (When "Mutant World" was published in a collection by Corben's Fantagor Press, the original text was restored.)

Jim Stenstrum: "I was excited about *1984* magazine at first. Finally, there was going to be a quality science fiction comic magazine from Warren. And why not? Warren had already copied *Tales from the Crypt* (*Creepy*) and *Frontline Combat* (*Blazing Combat*), so why not *Weird Science* as well? DuBay told me he wanted to do quality science fiction stories and adaptations by famous SF authors, including Kurt Vonnegut, Roger Zelazny, John Varley, Harlan Ellison and others. He wanted to bring Al Williamson, Wallace Wood and

John Severin back into the fold to draw them, and really give *Heavy Metal* a run for its money.

"But then Bill sent me a copy of the first issue and I was horrified. Almost every story was chock full of gross humor—real adolescent shit—and virtually all serious intentions to do quality SF were abandoned. I urged Bill to downplay his penchant to pack every story with juvenile obscenities, but he wouldn't listen. In fact, he ordered me to put more profanity in my own stories. I always refused. I couldn't make myself climb down that creepy sewer with DuBay. I have no problem with randy dialogue or nudity when it serves the story, but for Bill it seemed like an obsession. What a wasted opportunity. A lot of great Warren artists had to draw a lot of skeevy stories to keep DuBay happy."

In *1984* #4 (October 1978), Stenstrum introduced his Rex Havoc and the Asskickers of the Fantastic, a humorous feature that would go on to have a total of four stories. Three of them were eventually gathered into an issue of *Warren Presents* (#14, November 1981) under the slightly altered title *Rex Havoc and the Raiders of the Fantastic*, with cover artwork designed to deliberately evoke the recently released film *Raiders of the Lost Ark*. Much of Stenstrum's other work for the magazine involved rewriting the captions and dialogue for stories coming from overseas which had acceptable art but poor writing. DuBay would ship the finished original art to him in Minneapolis. For those, Stenstrum used the pseudonym Alabaster Redstone. With issue #11 (February 1980), the magazine's title was changed to *1994*, "solely so that readers might not confuse *1984* the magazine with *1984* the classic novel, penned by George Orwell," according to the editorial page.

Although Warren claimed he read every magazine that his company published, it's clear that the contents of *1984/1994* had nothing to do with him except as an expression of his dependence on DuBay. Although the magazine sold well, at similar levels as *Creepy* and *Eerie,* its editor, in later years, seemed to want to distance himself from it. "So far as I'm concerned," DuBay told an interviewer in 1998, "it was an experiment, an interesting experiment at times. It's not something I'm particularly enamored of at this point. I like some of the things that came out. I had fun with *The Rook*, not so much fun

with *1984*."[14] Of *The Rook* magazine, which first appeared on newsstands at the end of August 1979, he said, "The book had a solid, loyal following, which I attribute in great part to the excellent caliber of art published throughout its run. Lee Elias, Luis Bermejo, Alex Toth, Nestor Redondo, Alfredo Alcala, José Ortiz, John Severin and so many others, produced the absolute best work of their long, lustrous careers."[15] With *The Rook* as an ongoing title, Warren was back to a full slate of six regular titles, two of them outsourced to the Cartoon Factory.

Alex Toth's "Bravo for Adventure" appeared in *The Rook* #3 (June 1980). Warren loved the Errol Flynn-like protagonist and aeronautical milieu.

Meanwhile, life at Warren Publishing often presented the unexpected. One day, Warren was sitting in his Manhattan office when his phone rang. "The FBI is here to see you," his secretary said. In a moment reminiscent of the *Eerie* #1 visit, two FBI agents entered and told him they caught one of his employees trying to smuggle a questionable substance into the country. It turned out to be dirt from Dracula's Castle, which Warren planned to package and market through Captain Company.

"I had sent an airline stewardess friend over to Transylvania to dig up and crate a couple pounds of dirt from the estate of Vlad the Impaler," Warren recounted. "A small scoop of the dirt was placed in tiny metal coffins which were hooked to necklaces [and it would become] another genius Captain Company item." After some careful explanation, the G-men decided to let me go with a warning."[16] The ads, which appeared in full-color in all his magazines except *1984* with September and October 1979 cover dates, read "Warren Publishing Co. proudly presents a unusual offer: Genuine Soil from Dracula's Castle." The cost? A mere $17.95, plus $2 handling and postage.

IN AN INTERVIEW IN LATER LIFE, Warren stated that he had always planned to retire from publishing at fifty: "I made those plans [in 1975] when I was forty-five. I knew I was going to say goodbye to the publishing world in 1980. I didn't bother telling anybody."[17] This partially explains why he shifted a great deal of his energy—an increasing amount, in the latter part of the 1970s—to matters apart from his publishing company. The change was gradual, but by 1978, it began to affect his staff, who had to work with him over the phone, or make trips to his apartment.

Kim McQuaite recalled, "Once, when I needed to get his final approval for a cover, and he wasn't in, I called him at home. He said, 'Describe it to me.' Other times, I'd have to take the artwork, jump into a cab, go uptown and show him the art. The sense was, the magazines were established by that point, which didn't necessarily require that he be there all the time, which freed him up to do other things. I don't know what those other things might have been. It wasn't that he was sick, or uninterested, it was that he had other things that he was doing." Weezie: "It became apparent that his interest had

moved somewhere else. He was in the office less. It was nice to have, like, total control, but it was really apparent that his interests had moved somewhere else. I don't know what it was. We would speculate that he was into real estate. Who knows?"

His father's passing in July 1978 could have had an effect on Warren's interest in the business. Part of Warren's drive for success was fueled by his desire to gain Ben Taubman's approval. He never forgot how, as a boy, when he'd told his father that he'd come in second "in the whole state of Pennsylvania" in the National Scholastic Art Competition, his father replied, "First would have been better." Impressing his father was no longer a factor.

There were distractions. Warren Publishing was part of the so-called "direct market," i.e., comic book shops, from its inception. One thing on Warren's mind was a lawsuit brought about by comics distributor New Media/Irjax against Phil Seuling's company Seagate Distributors in 1978, and the publishers (DC, Marvel, Archie and Warren) who had signed deals to give Seagate exclusive distribution of their comics and magazines to the growing comics shops market. Through the mid-1970s, his firm benefited from Seagate's "cash up front" policy with its customers, and its arrangement to ship to customers directly from the dock at World Color Press in Illinois. In 1979, the court sided with New Media/Irjax, which leveled the playing field, and allowed Seuling's sub-distributors to become independent distributors in their own right. Although the specific effect the settlement had on Warren is unknown, it had not gone in his favor, and it came at a time when his attention to his publishing business had noticeably begun to wander.

Warren was focusing his energy on preparing for retirement. This meant building up a nest egg. The investments could be in real estate, mutual funds or any other vehicle that small business owners use to provide for their later years. This sort of thing, especially real estate investing, involves meetings with financial advisors, planning and negotiation. He has never revealed the exact nature of the investments involved.

In any case, it doesn't bode well when an owner of a closely held small business gives signs of losing interest. There were all kinds of rumors—even that he was planning on shutting down the entire operation. In the past,

Weezie had fended off job offers from other publishers, but as she passed her fifth anniversary with Warren, she was not only feeling insecure about the company's future, she was ready for a new challenge. Jim Shooter, the editor in chief of Marvel Comics, asked her to lunch and offered her a job. She accepted. When she returned to the office, Weezie found that someone at Marvel had already phoned Warren with the news. Before she could say a word, he fired her. Losing an editor who was doing such a good job, and working smoothly with everyone, was a huge disaster for Warren. He had always had such a difficult time finding someone who could fill the editor's chair. And to lose her to Marvel, his hated rival? He was enraged. Weezie felt bad about that, because she had planned to break it to him gently. She had wanted to make sure he knew that she had enjoyed working for him, and that a part of her was sorry to be leaving. Instead, she packed up her things and left the premises. Her last appearances on the masthead were in *Creepy* #116 (March 1980), *Eerie* #110 (April) and *Vampirella* #86 (April).

With Weezie gone, Warren was in a tough spot, especially because her former assistant Nick Cuti left a year earlier for a job at DC Comics (after he refused to give him a raise), and her new assistant, Chris Adames, who came from one of the newspapers that folded in the mid-1970s, wasn't ready to move up. In the past, Warren had stepped in to fill the gap himself, but he wasn't willing to go through that again, even as a stop-gap measure. Instead, he phoned DuBay. Would he work as editor while training Adames? Warren would make it worth his while. DuBay, already editing *1984* and *The Rook*, reluctantly agreed.

The prospect of DuBay's return led to the resignation of the art director. McQuaite: "I left because Weezie left. I had a great working relationship with her. Now DuBay was coming in. I had worked with DuBay from time to time, nothing intensive, but I knew his personality. She was very much a collaborationist, 'I have my ideas, I want to hear your ideas.' Bill isn't. I knew it wouldn't work, and I'd be miserable. It was the only job I've ever left before I had another job to go to. So, I freelanced. Those three years with Warren were some of the best years of my life. I'm not a comics person myself, but I loved working with the comics crowd."

On the eve of a new decade, Warren suddenly found his company on shaky ground. The magazines sold well all through Louis Jones's tenure, but now *Famous Monsters* was (once again) fading, and the cost of the New York offices and warehouse space was rising. It was clear that the firm would only survive with him actively at the helm. As he'd said in his keynote speech at the 1971 New York comic con, "How do we survive? By finding the best talent to work for us. But more than anything else, we'll survive by making constantly correct business decisions, and nothing more."[18] Only Warren could make those "correct" decisions. He had the ingenuity and ability, but his motivation was lacking. He found the situation increasingly depressing.

CHAPTER SIXTEEN
THE END IN SLOW MOTION

THE FIRST THING DUBAY did when he assumed editorship of the line in 1980 was to institute a story freeze. It's not clear why this occurred. Every editor, Louise Jones included, had a backlog of scripts that were purchased but not used. They were works by established Warren writers that were set aside for various reasons (including being of lesser quality), or they were scripts that needed some, or a great deal, of rewriting. DuBay was never shy about reworking material from other writers, and he was fast, so he decided they should make what they could of this backlog.[1] The freeze didn't last long.

One of DuBay's stipulations was that he would use a pseudonym as editor. At a time when he was expanding his client base, he didn't want to appear to be going backward. Hence, the new editor would be known as Will Richardson, ostensibly the writer who had penned "The Greatest Editor Alive!" in *Creepy* #116, the issue before "Richardson" became editor. It's a story about an editor who is being driven mad by being stuck in the horror field for so long. "My whole professional career has been spent editing horror stories," the character thinks, which suggests that this tale is a sort of autobiographical musing by DuBay. There was no official welcome for Will Richardson in the magazine. The name simply began appearing as editor on the masthead with the issues dated May and June 1980. (Once "Richardson" was aboard, *The Comic Books*

column by Joe Brancatelli, a mainstay all through Jones's years as editor, was dropped. Brancatelli was never able to find out why.)

One of Warren's last major actions as publisher was to sign a new distribution deal, this time with Independent News. He soured on PDC because Larry Flynt had become its new owner, and because he had a chance to sign with "big time" distributor Independent News. But Independent wasn't what it used to be. During its heyday, it had been a juggernaut, ensuring DC Comics the best distribution of any comic book company. But newsstand distribution of comics (and related magazines) was in serious decline by 1980. The Mom and Pop candy stores, the traditional comic book outlets, were vanishing, and the circulations of all comic books had dropped over the past decade. Still, Independent News was the best option.

Then came an event that would give Warren Publishing a black eye at the worst possible moment. To quote the news report from *The Comics Journal*:

> Harlan Ellison has filed a plagiarism suit against Warren Publishing, publisher James Warren and editor Bill DuBay. According to Mike Donaldson, a Los Angeles attorney who is working on the case with Henry W. Holmes, Ellison's regular lawyer, the suit, which is for "an undisclosed sum in excess of $10,000," was filed on Monday, August 17 [1981] in the Los Angeles Federal Court. Ellison contends that a story which appeared in *1984* #4 [1978], a magazine published by Warren and edited by DuBay, plagiarizes his short story "A Boy and His Dog." The story, which won the prestigious Nebula Award in 1969 when it was first published, has been adapted to the screen by director L. Q. Jones.[2]

The falling out between Warren and Ellison over the ownership of the original art for "Rock God" in 1970 had never been patched up. Ellison told writer Clifford Meth, "Years later, he wanted to use 'A Boy and His Dog' for one of his magazines and he tried to get it from my then agent Robert Mills, who is now dead. He called Mills and Mills called me and I said, 'Absolutely not! He goes back on his promises.' What I didn't know was that he'd already

commissioned Alex Niño on the sly and hired Gerry Boudreau to adapt the story. He did this without permission and when he was turned down by me, he had Alex change it at his own expense!"[3] Ellison spoke as if this was all engineered by Warren. In fact, the publisher had nothing to do with it. The person who contacted Ellison's agent was Bill DuBay.

When *1984* was in its planning stages, DuBay wanted to feature adaptations of stories by famous SF authors. Toward that end, he asked for suggestions from his two favorite writers. Gerry Boudreau suggested Ellison's "A Boy and His Dog," and Jim Stenstrum suggested Kurt Vonnegut's "The Big Space Fuck." Confident he could obtain the permission of the authors, DuBay had them work on scripts. In the case of the Ellison story, he had Boudreau's script sent to Alex Niño to draw. Then DuBay was rebuffed by both authors. The Vonnegut adaptation never reached the illustration stage, but "A Boy and His Dog" was fully drawn. What to do with the pages, which had been completed by Alex Niño? He asked Niño to alter the artwork, changing the protagonist to female, and the dog to an alien creature. Then he ordered Boudreau to write a new story using none of Ellison's words, to fill in the panels.

Boudreau was antsy because, as he told *The Comics Journal*, "I wasn't too keen on the idea, and I sure didn't want to be in the middle of being sued—especially by Harlan." He called Ellison, who then called DuBay. DuBay told him that they were dropping the project. Actually, he had the pages for the story, now titled "Mondo Megillah," sent to Jim Stenstrum. In an interview for this book, Stenstrum said, "In 1977, I was working from my home in Minneapolis. One day I got a huge package of original art from DuBay, containing half a dozen stories he wanted me to rewrite. One of the stories in this package was by Alex Niño, and was about a girl and a monster roaming about an apocalyptic landscape. I didn't pay much attention to it until I noticed the script attached was Gerry Boudreau's adaptation of Harlan Ellison's 'A Boy and His Dog.' I was surprised to see this because Bill had told me he wasn't able to get the rights from Ellison and that Gerry's script had been tossed into the junk pile.

"I took a closer look at the script and saw that wherever it said 'boy' DuBay had replaced the word with 'girl' and wherever it said 'dog' he had

replaced it with 'monster'. I called Bill immediately to ask him about it, and he said he had completely run out of scripts and that he needed to keep Alex Niño busy. Alex Niño was a 'script eater.' He was very fast and could easily finish a story in a few days. He was DuBay's best and fastest artist, and Bill was terrified of losing him. So, Bill had done what he had done many times before, which was to grab a crappy script from the junk pile, let the artist draw it, and then he would completely rewrite the story when he got the artwork back. It wasn't a great system, but it worked in a pinch.

"So the story was already a 100 percent plagiarism when it was given to me. The whole thing stank and I really wanted nothing to do with it, but Bill pressed me and said he'd get into a shitload of trouble with Warren if he had to eat twelve pages of expensive Niño artwork. Grudgingly, I agreed to do it. I figured if anybody could save the damn thing and make sense out of it, I could probably do it. But I was wrong. Niño's artwork was still too identifiable as Ellison's story. I tried juggling the panels and changing every damn word, but the narrative was too strong. It was still a story about a human and a critter trying to survive in a post-apocalyptic world. I suppose I could've had the girl and the monster not talk to each other, but there are several panels where they are obviously talking to each other and it wouldn't have made any sense. Anyway, I guess you could call my contribution reverse plagiarism. I was trying to squeeze all the plagiaristic elements *out* of the thing and turn it into a brand-new story. But I wasn't successful."

"Mondo Megillah" was published in 1978. Three years later, in July 1981, Stenstrum had moved to New York City and had accepted the job as DuBay's successor as editor of the entire Warren line. Within a few weeks, Ellison filed the lawsuit. Stenstrum: "When Ellison threated legal action, DuBay freaked out. He ordered me to lie to Harlan, to tell him that I had never read his story and that it was all a crazy coincidence. When I refused to lie about it, DuBay went nuts. He first tried to bribe me, then intimidate me and finally threaten me, but I wouldn't give in. Three days later I collected my last paycheck and turned the keys over to my assistant Tim Moriarty. In the end, DuBay threw me under the bus and I became a pariah at Warren, never able to sell another story there. A couple weeks after I left, I went to work for Hanna-Barbera [in

California] and never looked back." Stenstrum agreed to testify on Ellison's behalf, saying at the time, "Morally and ethically, I feel that Ellison has been ripped off. I feel that I was sucked into this, and I'm sorry."[4]

When he filed the lawsuit, Ellison said, "The birds are coming home to roost for Mr. Warren. I'm going to take him for everything." Referring to Warren's replica of the Sopwith Camel, Ellison added, "I'm going to enjoy having a First World War plane in my back yard. I've always wanted one."[5]

About the Ellison lawsuit, DuBay said, "Jim laughed it off. His lawyers seemed to laugh it off."[6] At a time when it was struggling with weakening sales, Warren Publishing didn't need the negative publicity in the comics press. Despite Ellison's bluster, the eventual settlement was more an irritant than a decimation. Managing editor Chris Adames left the firm within days of Jim Stenstrum's exit, which meant DuBay was forced back into the editor chair, with the editorial support in the Manhattan office handled by a new assistant named Tim Moriarty. As a youth, the thirty-year-old Moriarty was obsessed with *Famous Monsters*: "I was a total bozo, subscriber, hoarder, re-reader. Huge fan of Forrest Ackerman. I ordered cheesy products from Captain Company. Remember how bad those Frankenstein masks smelled when you wore them?" He was hired as a part-time assistant editor by Chris Adames. "I believe I became editor in chief of the whole thing within a year. It was a bizarre situation. Bill DuBay and Chris really didn't like each other at all, and I was caught in the middle. Chris went on vacation, and never came back. I believe DuBay fired him, though I was told he quit. And then [DuBay] decided to quit. All I know is, I looked around, and suddenly I was top of the heap."[7]

Moriarty: "Jim Warren I met maybe twice. He was never there. But his office was just skyscrapers of paper. A mess. DuBay was a volatile guy. I learned a ton from him, about comic storytelling, writing cover blurbs, composition. We got on well. But toward the end, he was writing, what, sixty percent of the stories in the comics, and that one style was dominating. I felt the comics were getting stale. The company folded not long after he left, so I never got a chance to make my own imprint." Moriarty's first issue on the masthead as full editor was in *Creepy* #136 (March 1982). During his tenure, there was

good writing from Don McGregor (on stories such as "The Mist"); *Torpedo* by Jordi Bernet; an adaptation of an A. E. Van Vogt story; and a notable upswing in the quality of Vampirella stories. With DuBay's exit, *The Rook* magazine breathed its last (#14, the final issue, was dated April 1982). The magazines relied more and more on reprint issues dedicated to the work of a single popular artist: Al Williamson, Wallace Wood, Alex Toth, Angelo Torres, and Steve Ditko. Overseas artists Ramon Torrents, Félix Mas and Esteban Maroto also had reprints of their work fill entire issues. None of these artists (or the writers) were paid anew for the work. The reprints represented labor and cost savings for the now-ailing publisher.

Tim Moriarty's new assistant, David Allikas, recalled: "We were trying to use up a massive inventory of stories. Because the best had been used already, we were left with the dregs, including a lot of art for which the scripts were missing and we had to concoct brand new stories without even knowing the plot. Most of it could best be described not as inventory but as stuff that had been shelved because it was deemed unusable.

"Before I met Bill DuBay, one of the production artists described him as 'a prick, but a fair prick.' He created a lot of extra work for everyone by insisting that the magazines conform to rules that were important to him but probably didn't make them much better. Like, on the letter pages, a new letter had to begin at the top of each column. I think the problem was that Bill DuBay was at heart a big-budget guy in what was, or at least what had become, a small-budget company.

"I would say that if there was one person on the premises who truly loved the company, it was [Bill] Mohalley. He would get excited about little things like an ad pulling well and selling out our inventory on a particular toy."[8] His main job was writing ad copy for Captain Company, and retyping the scripts into captions and word balloons, a precursor to computer lettering programs. Allikas remembered most that it was "combat journalism, always racing deadlines.

"During my year at Warren, Jim Warren showed up twice, I think. His office was kept closed. One day I passed it to find the door open and him standing inside. His secretary happened to be there, so she introduced us.

He seemed very pleasant, very personable. Said something to me about how he planned to start coming in a lot more often and really get things in shape again. The next time I saw him was at the bankruptcy auction."

SALES OF THE WARREN MAGAZINES dropped precipitously across the board in the 1980s. The print runs were at an all-time low, and returns increased dramatically. While one can attribute some of the decline to the magazines' lack of freshness and the tastes of the public moving on, one can't help but notice that Curtis Publications had discontinued nearly all of the many Marvel black-and-white magazines by 1981. There were forces beyond the quality of the magazines themselves. Clearly, the rapid decline in newsstand distribution was dragging them down.

With the advent of the comic book store, creators who wanted to work outside the Comics Code had a somewhat older, ready-made audience for more mature stories. Having introduced the black-and-white comics magazine that wasn't under the Code's purview in 1965, Warren had remained the leader in the form when imitators and other comics in the same format came along. But in the late 1970s and early 1980s, books like Richard Corben's *Bloodstar* and Eclipse's *Sabre*, written by Don McGregor and drawn by Paul Gulacy, found their way to customers through the growing number of comic shops, and were soon followed by other items that caught the imagination of teenage and young adult comics readers (and could be profitable at lower circulations because of the non-returnable nature of the direct market). By the time the 1980s arrived, there was a growing tide of fresh competition that made the Warren books seem like dinosaurs.

As the end drew near for Warren Publishing in 1982, the unthinkable came to pass: Forrest J Ackerman was removed as editor of *Famous Monsters of Filmland*. He had long been dissatisfied with his treatment by Warren and certain members of his staff. High on Ackerman's list of complaints was the lack of a raise to his editorial fee since the early 1970s. The announcement of his "resignation" in *Fangoria* #23 (November 1982), created quite a sensation among fans of horror and fantasy cinema, as did Ackerman's article in the following issue.

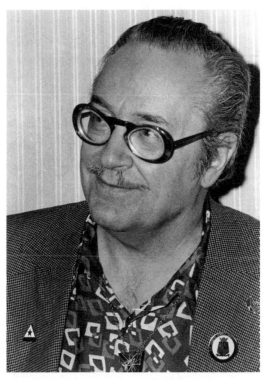
By the early 1980s, Forrest J Ackerman had lost influence with Warren. Courtesy of E. B. Boatner.

Of Warren, Ackerman wrote, "For twenty years we shared all kinds of confidences, the lush times and the lean, but in the past five years he's become as remote an enigma to me as the late Howard Hughes. On my sixtieth birthday [November 24, 1976] he was out in Los Angeles telling a couple hundred people what a great guy the Vice-President of the Warren Publications (me) was, how I was his 'oldest and most valued employee,' how he was going to put me in a brand-new Cadillac for my birthday, etc. He couldn't say enough nice things about me. Five years later—after about four years of silence—I didn't even get a card for my sixty-fifth. To this day, I don't hate Jim Warren—I'm baffled by him, I'm hurt, but I'm not mad at him."[9]

In July 1982, Ackerman turned sixty-six, and was in New York City on non-Warren business. He later said, "For years, whenever I was in New

York, I had gone up to the offices and there'd be a neon sign saying 'Guest Today: Forrest Ackerman,' and I would have a fun time with Warren. I felt so estranged that when I got to New York I decided I wasn't going up to the offices this time unless I was officially invited." He did receive a call from Liz Alomar, telling him Warren had "cleared the decks" for him, starting at 9:00 a.m. Monday morning. Then he was told the meeting had to be postponed, and, after being stood up for a scheduled breakfast meeting, Ackerman, his other business finished, got on a plane and returned to California. "[I] never laid eyes on him the whole time I was in New York. Got back to L.A. and received a telegram saying, 'Keep the faith, baby. Jim's coming the first of next month.'" Warren didn't show.[10]

Ackerman: "In August I got a real snide snooty snotty letter from someone signing themselves Secretary to Jeff Rovin [consulting editor of *FM* of late], informing me that, since I was getting weary of my work—on the contrary, I'm more active than ever!—I would no doubt be pleased to learn that Jim Warren had offered Jeff Rovin editorship of *FM* and that I was soon to be reduced to Editor Emeritus.[11] I feel abused; hypocritically, disrespectfully and cavalierly treated; so I quit before I was ousted, and I think it not surprising that should the 'wrong person' (in my estimation) take the reins, I would be gratified if the magazine to which I devoted the better part of my professional life would quickly fail."[12] That "wrong person" was Jeff Rovin, who Ackerman detested. (Since DuBay's original stint as editor, Rovin had been working in the Warren office as a writer, mostly on *Famous Monsters* material, as well as ad copy for Captain Company, and the occasional script for the comics magazines.)

Randy Palmer was offered the job of assistant editor of the magazine. He arrived in New York City and soon familiarized himself with his editorial duties. He was sad that Ackerman had resigned from the magazine, but wanted to keep a positive attitude since he and his wife had moved to the city to take this job. However, Palmer was shocked by what he found: "The company's way of doing business seemed to be, at times, haphazard and sloppy. This had not always been the case. Though I cannot speak from a 'hands-on experience' about this since I didn't become an official Warren

Publishing Company employee until the last-gasp final six months, in earlier years, James Warren and his associates maintained a much better handle on the monster market.

"Early in November of 1982, Bill Mohalley, Tim Moriarty, Jeff Rovin and I each received identical letters from Forry Ackerman. Another addressed simply to Warren Publishing Company read in part: 'For legal protection for yourselves, I am hereby cautioning you not on any of your own initiatives to reprint anything in future issues of *Famous Monsters* (beyond #190) which I wrote in past issues. This is a friendly . . . warning that such unauthorized usage would constitute a violation of my auctorial rights in the works and I would immediately inform my lawyer to take action. My educated guess is that Mr. Warren would summarily dismiss the danger of any legal action ensuing, but should you choose to disregard my warning I can only council you that you would do so at your own risk.'"[13]

Ackerman wrote a goodbye message for *Famous Monsters* #191 (March 1983), giving this as the reason for his departure: "The publisher has decided, since I have become a senior citizen, that it's time for a younger editor to take over and inject new blood." He ended it, "Thanks for the memories. My Last Pun: Forry Get Me Not."[14] It didn't see print. Instead, Palmer was told to write a false editorial to the readers to announce Ackerman's departure, which appeared as a sidebar in that issue's *Fang Mail* column. It ends, "Now after 190 issues of *FM*, Forry has decided it is time to move on to other things." The issue included a four-page tribute to Ackerman by Randy Palmer titled "The Angel among Monsters." On the masthead, Bill Mohalley was listed as managing editor, Tim Moriarty and Randy Palmer were listed as associate editors, and Jeff Rovin was listed as consulting editor. As it turned out, *FM* #191, and a subsequent *1983 Film Fantasy Yearbook*, were the last issues of its twenty-four-year run, three months short of its twenty-fifth anniversary.

An odd event occurred shortly after Randy Palmer arrived on the job. "Sometime during the wee hours of an autumn week night, the Warren Publishing Company offices were forcibly entered and some items were stolen. When I came in to the office the next morning, I was told the company had

been robbed." It turned out that the only thing stolen were some "important administrative papers." According to what Palmer heard, "the papers that were stolen were connected with . . . monetary matters. What [comptroller] Dan Tunick and [sales manager] Mike Schneider believed happened was that Warren himself engineered the break-in. They theorized that he had hired someone to rob his own company of these documents. The culprits were never caught, and the documents were never recovered." The perpetrator(s) of the theft, and the purpose behind it, remained a mystery.

By this time, it became clear that the end of Warren Publishing was near. The company had racked up an enormous debt to World Color Press, and the circulations of all its magazines were plummeting. Some still felt the situation could be salvaged. Palmer: "Mike Schneider told me that if the company could just 'get over a $10,000 hump,' there would be 'smooth sailing' for 1983. But such was not to be."

Tim Moriarty: "The final days (meaning weeks, months) were sad and frantic. A lot of artists and writers were begging for their payments. It gradually dawned on me that some would never be paid, which was heartbreaking. One by one, in-house people were being laid off. The editors were trying to return artwork we knew we wouldn't be able to use, and the big bosses [Tunick and Schneider] were bugging us about payments to the post office. We were working on stories we weren't sure would ever be printed, working with artwork and scripts that had sat on the junk pile for years, because there was no money to buy new work. People were looking for jobs while working this one. Some employees were snapping up Captain Company items (we had bins full of Star Wars action figures). If I'd been smart/unscrupulous I'd be a millionaire today. There was nothing sudden about it. For most of us, it was a slow death."

David Allikas: "Warren would call Dan [Tunick] every few months and order him to send whatever profits the company had made, and refuse to discuss business. Ultimately, Dan had to file for Chapter 11 without Warren's knowledge because he couldn't reach him. And then Warren threatened to sue Dan for ruining his company. DuBay and later Tim tried to hold it together, but the company didn't have the deep pockets it needed, and then of course

there was the problem of having an owner who gave every indication of having gone insane."

Moriarty's assessment of the reasons for the company's failure? "This was at a time when publishing was becoming more expensive with paper, printing costs, office rents and postage all on the rise. Meanwhile, if I remember correctly, [the traditional outlets for Warren magazines] were dying, and the industry was at an ebb. I also don't believe that Jim Warren was the most fiscally responsible person on the planet. So, it all added up to fizzle."

DuBay: "I think things degenerated simply because Jim didn't really have hands-on at the end, like he always had [before]. He felt the company was in good hands."[15] If Warren had been there, DuBay was convinced that the company would have survived. But he had no more explanation for Warren's absence in the face of economic disaster than anyone else in the office. Warren had constructed a wall and let no one through.

"When Warren ran into financial difficulty, his comptroller, Dan Tunick, called our studio and told me that the company's lawyer was advising me to come down and collect *The Rook* material because he was closing the office doors for good. Dan put the package together for me. I signed it out, dropped it off at a storage facility in Ridgefield, and proceeded with my life. Shortly thereafter, I found myself in California with a guy named Stan Lee who asked me to help him build a new animation company. A new facet of my life began."[16]

In December 1982, the last five Warren magazines were published. They were *Vampirella* #112, *Eerie* #139, *Creepy* #145, *1994* #29 and *Famous Monsters* #191.

Palmer wrote, "As of January 1, 1983, Warren Publishing Company laid off all its employees except management (Tunick and Schneider). Tim Moriarty's and Bill Mohalley's work schedules were reduced by over 50 percent. Both of them only came in two days a week from January to March, to 'tidy up.' There was still a slim chance Warren Publishing Company could get the ball rolling again. Everyone would know by late March. But when the time came we were simply informed that [the company] was going out of business for good."

Their last issues: *Famous Monsters* #191, *Creepy* #145, *Eerie* #139, *Vampirella* #112. All appeared on newsstands in December 1982.

ONCE WARREN PUBLISHING CLOSED its doors, and it was determined that it would not reopen, the wheels were set in motion for the legal dissolution of the firm and its assets. An ad in the *New York Times* announced an auction to liquidate the holdings of Warren Communications to be held August 29, 1983.

The main thing that drew people to the auction was a large amount of original art that had been stored on the premises. Bill DuBay later explained, "Most of the [artwork] had not been returned to the Philippines because there were massive amounts of it. The same thing with the Spanish art. All the early issues were there. Jim hung on to those. We had a locked room that was full of artwork from most of the issues. When issues came out, when we got the artwork back from the printer, we did our best to send out a lot of the artwork. For example, Rich Corben probably got back every piece that he'd ever done for us, and Alex Toth, Lee Elias—most of the American guys did. But on the other hand, all of the Spanish art—everything by Maroto or Ortiz or González, for example, should have been returned to Josep Toutain at Selecciones Ilustradas.

"José [Toutain] said, 'It's safe here. This is the perfect place for it. And left it there. Warren closed his doors suddenly. There was no time to go in and send any of that stuff off. I will say that in the last week, when [company controller] Dan Tunick said, 'This is going to happen,' I walked in and made piles of artwork with different people's names on it. 'This is González,' 'this is Ortiz,' etc. So that artwork had already been sorted out and was ready to be returned. Then the doors closed and no one got back in again. I know Stanley Harris didn't get his hands on any Ken Kelly or Frank Frazetta paintings, for example. Those had long since been returned. But . . . all that Spanish art was there.

"There were piles and piles of artwork by Alex Niño. I wasn't allowed to send that back to him, all the way to the Philippines. Dan [Tunick] wasn't about to allow us to pay to have this stuff shipped back. I asked Alex Niño what he wanted done with it. He said 'send it to Byron Preiss.'"[17]

In an article in *Comics Buyer's Guide*, auction attendee Howard Wood wrote, "By 11:15 a.m. on August 29, approximately two dozen comic book

1983 auction notice.

collectors, dealers and other interested parties had gathered around a thin, experienced auctioneer who quickly ran through the formalities necessary prior to an auction. Standing in the offices of the now-bankrupt Warren Publishing Co., he then offered up the items to be bid on: A warehouse full of comic books, first-time American re-publishing rights and artwork that should have been measured by the pound instead of the page."[18] Leftover Captain Company merchandise had already been auctioned off. "The artwork itself," Wood wrote, "was divided into categories of *Creepy*, *Eerie*, *Vampirella*, *1994* and miscellaneous, while ranging in height from 40 to 1,500 pages. The

piles I looked through contained paintings, sketches and full stories by Basil Gogos, Bernie Wrightson, Esteban Maroto, Tom Sutton, Reed Crandall, Mike Ploog and Frank Brunner. Work by Jim Steranko, Frank Frazetta and Steve Ditko was just not there."

The day before, Howard Wood had visited the sixth floor of a warehouse underneath the Brooklyn Bridge, when potential bidders could view and inspect the massive inventory of Warren magazines. "There were only two other people roaming through the warehouse the size of four full-sized professional basketball courts. Nearly everything Warren ever published was there. The auctioneer's catalog was 29 pages long and listed a total of 958,715 books."[19]

Magazine publisher Stanley Harris had been there at some point, and was in the offices for the auction the following day. He was persuaded to attend by original art dealer Tony Dispoto, who was interested in the art that remained by the classic Warren comics artists. Harris obtained the entirety of the artwork with a bid of $27,250. He won the entire backlog of Warren magazines for $67,000, for about 15 cents each.[20]

Sometime during the auction, Warren himself showed up. According to his friend Sam Sherman, "When his company went out of business, and they were having an auction, I went down there to be with him. I wanted to give him my support, and so I was with him at that time. I was concerned about him. I don't remember much about it. He was okay, he seemed strong." Warren later said that the items in his office vanished. "It pains me to say there are collectors out there who are buying and selling the early mint issues of magazines stolen from my office library. Art and personal items displayed in my office were stolen right off the walls."[21] At the time, he made no public pronouncements or issued a statement about his company's demise. In later years, speaking about the failure of *Blazing Combat*, Warren said words that seem to apply here: "[You] pour yourself into something and you see that end product. It's your baby. It's like a child. And the child is dead. You go to the funeral. And you weep a little. But you don't let anybody see you."[22]

On January 4, 1984, Judge John Galgay of the United States Southern District Court of New York allowed the sale of Warren Communications Cor-

poration (the parent company of Warren Publishing) to Harris Publications, Inc. Per Randy Palmer: "The remains of Warren Publishing were purchased for $110,790 cash. At the court hearing, Bill DuBay, artist Frank Thorne, who wrote and drew the Ghita strip for Warren's *1984/1994* magazine, and Forrest J Ackerman made the point that this sale would not include the rights to the material that they had created for the magazines, but Judge Galgay allowed it to take place anyway.

The question remained: Why had Warren backed away from his own company, which he had fought so hard to save in the late 1960s, when he could have done a great deal to save it?

CHAPTER SEVENTEEN
VANISHING ACT

WILD RUMORS FILLED THE VOID that was created when James Warren vanished after the auction. One rumor, according to Randy Palmer, was that "Warren was seen walking the streets of New York City, disheveled and dirty, mumbling to himself and at one point stood at the end of a pier along the East River waving a pistol in the air and shouting that he was going to 'get the bastards' who did him in."[1] Other rumors were that he was in a monastery in South America, living in a commune in Arizona or committed to a mental health facility in Connecticut. The most frequent rumor was that the publisher had died. What better way to explain why a showman who loved the spotlight suddenly disappeared from the stage? A more prosaic possibility was voiced by Gray Morrow: "The last I heard, Warren was retired and living in the Hamptons."[2]

Warren explained, "[I was] living in the places I called home. Often in a beach house on Long Island, sometimes in my apartments in New York and Philadelphia. I traveled some. I generally kept to myself. In 1983 one of my companies, Warren Communications Corporation, went into bankruptcy. When this company was no longer visible, many people assumed I was dead."[3]

In fact, he approached the edge of mortality on a couple of occasions, due to the onset of a mysterious illness and severe depression throughout the 1980s.

In 1998, when he sat for an extensive interview with Gary Groth and Michael Catron, Warren described his illness as best he could: "I've had many doctors give many opinions. Some say it was some kind of immune deficiency, in which I couldn't work, I couldn't move. And because I couldn't move I became depressed. Others say the depression came first. Who's to say? We don't know. But I was in bad shape for many, many years." Showing a photograph to Groth, he said, "You're looking at 119 pounds right there. My normal weight is 155. So, it was very bad. The depression was incredible. I don't know how much you know about depression, but it's a debilitating disease."

He read *Darkness Visible: A Memoir of Madness*, William Styron's 1990 book on depression, which helped him put the mental illness into perspective. When the Pulitzer Prize-winning author had stopped drinking abruptly, he spiraled into a year-long struggle with depression. Styron affirmed that it was an occupational hazard of creative people, and that "time and seclusion is what got him better." He ends his book quoting Dante to describe his emergence from the disease: "And so we came forth, and once again beheld the stars."

Styron appeared on the Charlie Rose show to discuss *Darkness Visible*. Warren found the discussion both fascinating and consoling: "[Depression] isn't unusual. Unless you have a massive amount of therapy, I don't think you know why. A lot of heavyweight extensive therapy. Not only Styron, but Rod Steiger went into a serious decline, which is why he didn't make a movie in twelve years. Nobody saw me for twelve years. We haven't found the answer yet. I think Styron enlightened a lot of people and made them aware of something that, to that point, nobody wanted to talk about. It's the kind of thing that you figure death is better than that kind of suffering."[4]

Whatever the cause and exact nature of Warren's disease, one event was too important to him to pass up: the fortieth anniversary of D-Day in

1984. His interest in history had never waned, nor had his regard for those who had waged war against Adolf Hitler. He had been to Europe for prior anniversaries and had developed friendships with members of the group who organized an event. This time, he had his photo taken with them and attended the ceremony at Pointe-du-Hoc when President Ronald Reagan spoke. This was completely off the radar of the comics and fan community.

A Warren retrospective of sorts occurred in 1986, when Imagine, Inc. published *Forrest J Ackerman, Famous Monster of Filmland*, a large, 152-page trade paperback book that printed excerpts from the first fifty issues of *FM*, plus behind-the-scenes commentary and gossip by Ackerman. At this time, Ackerman was still smarting from the way his relationship with the magazine had ended, but it nevertheless presented a rosy history of the monster magazine and a fairly positive view of Warren himself.

A second retrospective appeared that year in the first issue of Greg Theakston's magazine *Pure Images*. Theakston was a writer and artist who penned one script for Warren in *Creepy* #36 ("Forbidden Journey"), was drawn by Rich Buckler, and had worked for many comic book companies and paper-

Pure Images #1 (1986) and #3 (1991) included Warren retrospectives.

back publishers as a freelance artist. Theakston told Roger Hill, noted comics historian and original art expert, how he got ahold of the Warren file records: "Nobody at the auction seemed to care about Warren's files and records," Hill recounted. "Greg told me all the records and files were thrown into a giant dumpster that sat outside the building for a day or so. He said he spent five hours in that dumpster, sorting through that stuff, finding all kinds of records, memos, photographs, paycheck stubs, transparencies of paintings, and so on. Years ago, he started putting the stuff up on eBay and selling a lot of it."[5] Before he did, Theakston devoted most of *Pure Images* #1, 3 and 4 (1986–1991) to extensive articles on the history of Warren Publishing, which included rarities found in that dumpster such as alternative color photos of Warren and Marion Moore taken for the cover of *Famous Monsters of Filmland* #1, excerpts from correspondence, details about his arrangements with Ackerman, and so on. None of the material was sourced, nor was Warren quoted or his copyright affixed anywhere. While Warren hadn't collaborated with Theakston on the articles, the former publisher didn't object to them. In a letter in *Pure Images* #5 (1992), he wrote:

> Dear Mr. Theakston,
> I was delighted to receive copies of *Pure Images* #3 and #4, which contained your wonderful piece on monsters and my publishing company. I found it entertaining, enlightening, and extremely factual. You are to be credited for doing such a fine job of research. While there may be some fine points that I disagree with, the bulk of your article was perfectly acceptable.
> Yours Truly, James Warren

This letter not only attested to the accuracy and authenticity of Theakston's articles, but it let the comics community know that rumors of Warren's death had been greatly exaggerated. He was still alive, but the bankruptcy had wiped him out financially, according to what he said in a later interview: "The bankruptcy caused such deep personal pain. In addition, my financial advisors had put me into a series of large investments that just disappeared.

It was later discovered that some people involved in these businesses had been deceitful. Others were outright crooks. One committed suicide after fleeing the country. Another is now in a Federal Penitentiary. The end result was that I was left with no money, no assets, no home, no office, no facilities and a debilitating sickness that was bringing me close to thoughts of ending my life. I lost my health and was despondent beyond belief."[6]

He reached his lowest point in 1990, when he was forced to let go of his beach house in the Hamptons. Selling the place was upsetting in the extreme. He stood on the premises remembering his life as it had been in the 1970s, at the peak of his success. The lovingly fabricated replica of the Sopwith Camel was still on the grounds. It was a reminder of the time his father had taken him up in the plane when he was nine. "I couldn't use it anymore," he said, "and I didn't want anybody else to own it. It belonged to me. I could have moved it, but where was I going to put it? I couldn't put it anywhere. Eighteen organizations wanted me to donate it, but I didn't want to. I chain-sawed it to death."[7] The plane, which in so many ways represented his dream of success, was hacked into pieces. The dream was over.

Warren was living an isolated existence with his elderly mother in a high-rise apartment building in Philadelphia, with seemingly nothing to show for his three decades in publishing. "I was down and really out—sick, weary and weighing 119 pounds," he said. "I came close to killing myself twice."[8]

IN 1993, a development occurred that turned the sixty-three year old Warren's life around: the reappearance of his inspiration for Vampirella, his teenage sweetheart Gloria Reif, now Gloria Goldberg. Warren has described it as a chance encounter, but that isn't completely accurate. According to Gloria, "Actually, I called him. I heard there was a sighting. Somebody had said, 'Jimmy is in Philly.' They gave me his phone number. I had been widowed a couple of years. Friends of mine were encouraging me to date again. [They] were encouraging me: 'Jimmy's in town. You'll have a nice time. He's an old friend and you have a shared history.'"[9] She invited him over, and they soon both realized their mutual love was still there.

After Reif and Warren parted in 1948, she went to college to pursue a psychology degree. She married, became a mother, then a piano teacher and finally a psychologist. Warren: "This extraordinary woman, who I've loved all my life, took me into her home and gradually made me well."[10] When their romance was rekindled, Warren had a reason to strive. She fed and nurtured him. "She took me in, healed me and became my cheerleader. She saved me."[11] It's not clear how he conquered his depression, although he once acknowledged, "Prozac and the new generation of drugs have done remarkable things."[12] Over time, his mental and physical health improved. It didn't happen overnight, but as the decade unfolded, he grew stronger. He began seeing old friends more often, and started thinking about what, if anything, could be salvaged of his former life.

CHAPTER EIGHTEEN

THE RETURN OF JAMES WARREN

A RESTORED WARREN AGREED to be interviewed by Michael Catron for an upcoming reprinting of stories from *Blazing Combat*. In 1993, Catron acquired the rights to *Blazing Combat* and began republishing the original stories in a new series from his company Apple Comics. Apple published two issues each of *Blazing Combat: Vietnam and Korea* and *Blazing Combat: World War I and World War II*. As the interview on April 12, 1993 attests, it was clear that Warren had lost none of his aggression, or his sense of humor. It began:

> Warren: How much are you paying me for this, Mike?
>
> Catron: How much am I paying you for this?
>
> Warren: Yeah. In dollars. American dollars.
>
> Catron: I'm not paying you anything, Jim.
>
> Warren: You're a cheap bastard.
>
> Catron: If I may be so bold as to call you Jim.
>
> Warren: Boy, I've heard about you guys. I've heard about you publishers. I've heard what you do to creative talent.
>
> Catron: Yes, well, we were inspired by the generation that came before us.
>
> Warren: [*Laughs.*]
>
> Catron: And we hope to follow in their footsteps.

Warren: I'm not gonna open up my mouth unless I get paid. And
I'm serious. Now, how much are you gonna pay?

Catron: How about dinner the next time we get together?

Warren: Negative. I want coin of the realm.

Catron: Oh, God. How about fifty bucks?

Warren: Sold. See how easy that was? Okay, now, fire away.[1]

Later in the conversation, he let Catron off the hook for the fifty dollars. It was his way of taking control of the conversation from the start.

Another publishing event occurred in 1993 on which Warren looked with far less approval: the return of *Famous Monsters of Filmland*.[2] Ray Ferry, a New Jersey portrait photographer and monster movie fan whose research indicated that the magazine title hadn't been "maintained" under law, decided that he could bring it back. He hired Forrest J Ackerman to be the editor, and started his run with #200 with a cover by Kelly Freas,

Art by Wallace Wood.

with the Warren-esque cover blurb "Best Issue Ever." It was billed as the "35th Anniversary Spect-Ack-ular!" A few years later, Warren said, "I see Ray Ferry as a cheap parvenu, trading on the Warren legacy. He seized upon *FM* and now uses it to make a living by photocopying my original concepts, ideas, layouts, editorials, artwork, lettering, covers, copy, mail order ads—you name it. He's even sunken low enough to use the classic editorial names and expressions Ackerman coined in my issues."[3] Before long, Ferry and Ackerman had a falling out, which led to a court case.

What really caught Warren's attention was news of an upcoming movie starring Vampirella: "I got a phone call from someone who told me that a Vampirella major motion picture had been announced in the trades. I said, 'It can't be. It's impossible. He doesn't own those rights.'"[4] The movie was sched-

uled to appear on the Showtime cable channel as part of a series of low-budget debuts "presented by" B-movie impresario Roger Corman. Although he would later claim otherwise, Warren had to be aware that Stanley Harris was publishing comic books starring Vampirella at the time he was interviewed by Michael Catron in 1993. By then, Harris had published a new *Vampirella* miniseries in 1992–1993. There had also been a new *Creepy* miniseries at the same time. In any case, the movie galvanized Warren into action.

He began meeting with advisors and attorneys to consider his options. Meanwhile, as Michael Dean put it in his article "The Vampirella Wars" in *The Comics Journal*, Warren "came out of seclusion in a big way, announcing to the comics industry that he was back to claim what had been his. He took out ads, made convention appearances and granted interviews to the comics press. In a press release, he said, 'The Vampirella that Warren Publishing created would share my sense of injustice and would be right with me, fighting for my rights.'"[5]

He had his attorneys send a "cease and desist" letter to Stanley Harris, stating, "It is hereby demanded that you cease and desist from licensing, assigning, selling or holding yourself out as the owner of the movie rights to Vampirella. In addition, it is demanded that you take all action necessary to present Mr. Warren from sustaining further damage as a result of your misappropriation of Mr. Warren's intellectual property." A similar letter was sent to Showtime. Nevertheless, the channel broadcast the eighty-two-minute feature on September 28, 1996. Corman's name was over the title. Ackerman received a credit as the character's original writer. Trademark was attributed to Harris. No mention was made of Warren, who was arguably the principal creator of Vampi. The low-budget production, starring Talisa Soto, was directed by Jim Wynorski and was of poor quality. Reportedly, its only theatrical showing was in Singapore.

Harris Publication's position was that its original Bill of Sale in 1983 for all assets of Warren Communications, Inc. gave it unequivocal rights to Vampirella and all other Warren characters. Warren and his attorneys got to work, while he waged a public relations offensive to remind people who he was, and to rally support for his cause. Jon B. Cooke, editor of a new

magazine called *Comic Book Artist*, wrote, "I was astonished to find James Warren manning a booth at a Big Apple comic show in March 1998, and I worked up the chutzpah to approach him and ask him to write a tribute for the recently deceased Archie Goodwin. (Goodwin passed away on March 1, after a protracted battle with cancer.) Immediately he said yes—to a total stranger, yet—and since that moment we developed a friendship. I confess, I like Jim Warren."[6] This led to Warren sitting for two interviews (on October 17, 1998 and February 11, 1999) which became the centerpiece of *Comic Book Artist* #4 (Spring 1999). The reception was highly positive, which led to Cooke's *The Warren Companion* (TwoMorrows Publishing, 2001), a book which reprinted the interview and contained numerous other interviews with contributors to the Warren magazines.

In *Horror Biz*, Dave Baumuller wrote, "A few months ago I was invited to a warm, comfortable cottage surrounded by century-old trees in a lovely suburb of Philadelphia. It was the perfect setting for this issue's interview. James Warren and the magnificent Gloria . . . made me feel very much at home. During this rare session, Jim talked about his life, his work, his beloved Gloria, the legendary Warren Publishing Company, and the rumors,

Comic Book Artist #4 (art by Wrightson) and *Horror Biz* #4, both published in 1999.

innuendos and false reports circulated about him since he left the publishing spotlight over fifteen years ago."[7] The interview stretched over sixteen pages, and was accompanied by an article on the classic monster films of Universal Studios in the 1930s and 1940s.

Warren said that he had reconciled with Ackerman. There are photographs of the two of them at a San Diego con in the 1990s smiling together. When asked to characterize their current relationship, he replied: "Very friendly. We correspond regularly and speak on the phone often. He is still the same dear, sweet talented man he was during the twenty-five years we worked together. We had a wonderful reunion last summer at the San Diego Comic Convention. I kissed his Dracula ring, and he kissed the hem of my garment."[8] Ackerman's lawsuit against Ray Ferry was concluded on May 11, 2000, when the Los Angeles Superior Court jury decided in Ackerman's favor. The court awarded him $382,500 in compensatory damages and $342,000 in punitive damages. When an appellate court in California upheld the earlier verdict in 2002, Ferry filed for bankruptcy. Shortly thereafter, Philip Kim purchased the rights to the *Famous Monsters of Filmland* logo and title, and entered into an agreement with Ackerman to use his trademarks.

Warren's $80 million lawsuit had been filed against Harris Publications on May 19, 1998. It contended that the rights to the characters and other intellectual property of Warren Publishing Company had been given to him personally, rather than to Warren Communications, Inc., when the new corporation was set up in the early 1970s. From that point forward, he asserted, he was personally licensing the properties to his corporate entity (WCI). Hence, none of the properties or work created before the early 1970s were part of the assets purchased by Harris during the bankruptcy auction. The financial stakes for Warren were high from the moment he filed the suit. A settlement with Harris came on October 25, 2000. In *The Warren Companion*, Warren simply stated, as a coda to the interview, "By legal agreement, I am not permitted to talk about the settlement." When pressed, he said that he was "delighted" with it. "Ecstatic is probably a better word."[9] Based on subsequent events, it became clear that Harris gave up its claim to the rights to *Creepy* and *Eerie*, but, for an undisclosed sum, Harris Publications retained the rights to Vampirella.

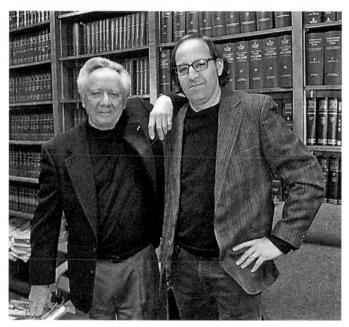

Dan Braun: "If you look closely you can see a 1930s aviation pulp maga-
zine near Jim's hand. I gave him five mint condition aviation pulps as a gift
after the closing. He was truly in awe of them and seemed to turn into a kid
of seven in front of my eyes." Courtesy of Dan Braun.

After the dust from the lawsuit settled, Warren considered offers for the
Creepy and *Eerie* properties. Two young entertainment entrepreneurs named
Dan Braun and Craig Haffner began a seven-year campaign to purchase
them outright. A couple of years after it was consummated, Braun recounted
the moment the deal was finalized: "Finally, in February 2007, we agreed we
would meet at the office of Jim's lawyer. When we arrived, Jim was in high
spirits, and so were we. The whole transaction went smoothly, and, unbeliev-
ably, finally and definitively, the deal was concluded. It was a beautiful sunny
winter day and we went out for the celebration lunch. Amidst some incredible
behind-the-scenes stories about *Creepy* and *Eerie* and the early days of War-
ren Publishing, Jim dramatically stopped the conversation and reached into
his bag. As if undertaking an ancient ceremony, he retrieved a small bag and
covertly removed its contents. He said he had a special gift for us. We each got

an original Uncle Creepy ring. That trinket, which originally cost $1.98, dazzled in the low light of the tavern. At that moment, it was a priceless treasure."[10]

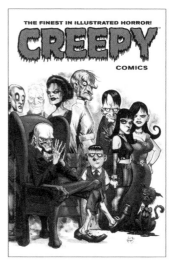

THE FINEST IN ILLUSTRATED HORROR!

CREEPY COMICS

The first act of their entity New Comic Company LLC was a deal with Dark Horse Books that led to the *Creepy Archives* and *Eerie Archives*, a deluxe, hardcover book series which reprinted each issue of the original magazine in order. When Warren saw the first book in the *Creepy Archives* series in 2009, he thought it was absolutely superlative and "didn't know how it could be done any better."[11] The first issue of the new *Creepy* comic book produced after the

Creepy Comics (2011). Cover by Eric Powell.

agreement was also published in 2009. It contained work by *Creepy* alumni Bernie Wrightson and Angelo Torres, and a gaggle of new writers and artists, including Braun and Haffner themselves.

Forrest J Ackerman passed away in Los Angeles on December 4, 2008, at age ninety-two. Whatever he did later, he would always mainly be known as the editor and principal writer of *Famous Monsters of Filmland*. His legacy was bringing classic screen performances and films from the 1920s through the 1940s to the baby boom generation, inspiring them to contribute to American popular culture in their own right. Ackerman's personal preference for science fiction is stated on his grave at Forest Lawn Memorial Park (Glendale), which reads, "Sci-Fi Was My High."

Philip Kim brought *Famous Monsters* back into print with #251 in 2010. Ed Blair was the executive editor of the magazine from #256 in 2011 through #282 in 2015, passing it to David Weiner, a thirteen-year veteran of the syndicated TV show *Entertainment Tonight*. Meanwhile, Warren himself announced the introduction of Warren Publishing Online on June 22, 2015, which he described in a press release as "a new company that will electronically publish vintage issues of the original Warren *Famous Monsters* magazines

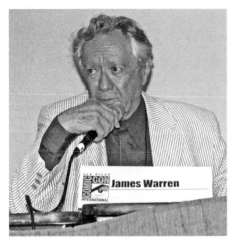
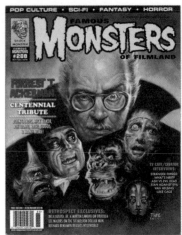

James Warren at Comic-Con International: San Diego in 2008. Courtesy of Jamie Coville.
FM #288 (2016). Art by Paul Wee.

and other publications. The first electronic issue available on-line is *Famous Monsters* #10, originally appearing on newsstands in October 1962."

JAMES WARREN TODAY, as he approaches ninety years old, lives with his beloved Gloria, and gets together regularly with a group of longtime friends such as Barton Banks. He has outlived most of his friends and colleagues, such as Bill DuBay who succumbed to cancer in 2010 at sixty-two. When one considers that Warren's mother Reba lived to 104 (having passed away on May 19, 2004), one has cause to believe that he may be around for quite some time. His hearing continues to deteriorate, making telephone communication difficult, but he does fine in person, aided by sophisticated, high-powered hearing aids.

His evenings today are much like those of his teenage years, when his parents let him stay up late, reading comics and science fiction. Now, he's more likely reading military history books rather than SF or comics. Still a night owl, he can be found reading or watching classic movies on cable TV until early morning. He has come through a dark time, and found a second life in his later years, with Gloria at his side. As such, he might well have cause to remember the quote from Dante that William Styron used to end *Darkness Visible*: "And so we came forth, and once again beheld the stars."

Unsurprisingly, he's not a fan of the modern horror film. In the *Famous Monster Chronicles II*, Warren said, "I don't like what's around today. It's not for me. Too much blood. Too much gore. Too much ugliness. Too much hideousness. Too much Texas Chainsaw. About 1980 I started to dislike many of the films being made. Then it got worse."[12]

On Hugh Hefner: "I think that his world has sort of passed us all by. He revolutionized the world to some degree. And now I have second thoughts as to whether or not it was a good thing. I'm not too sure whether the sexual liberation was that good of a thing. Back in the '50s, when he started, I think there was a need for that. I think repressed sex was very bad. But I think it was carried too far. But where can you end it? How can you end a tidal wave, once it gets up speed? How do you end an avalanche? You don't. You don't stop it. I don't know, I haven't really made up my mind on that. What I see, I don't like. And I don't know how much of it he caused or how much of it came from his liberating us sexually, which he did, singlehandedly, practically. Little Annie Fanny will be missed."[13]

On comics as literature, he's forgotten his statements in 1975 that comics are not art: "I'm glad I lived long enough to see comics accepted as literature. As graphic storytelling. I'd like to think we had a little bit of a hand in that. Because when we were preaching back in the old days, we were laughed at. Of course, nobody laughed at Will Eisner."[14]

When asked what he wanted his legacy to be, he said, "He made a contribution." Then he added, "When it comes down to it, it doesn't really matter what my legacy is, because I'll be dead and gone and won't ever know about it."[15] Yet, in his long lifetime, he has lived to see his magazines reprinted in book form, and many of the freelancers who worked in them go on to become giants in the comic art field.

His longtime friend, Sam Sherman, is now retired from the film business, and has done numerous commentaries for special DVD releases of genre films. He recently said of Warren, "The man is genius. There's no doubt about it. I never could have gone into business, and run a company, without being mentored by Jim Warren. I knew nothing about business, I only knew about movies."

Writing in 1981, Archie Goodwin summed up Warren's legacy: "Warren was the first new publisher to seriously enter the field since the '50s and the only one among a number who would follow to succeed. The Warren comics never seriously challenged larger companies such as Marvel and DC in sales, but they very successfully created their own special niche in the market and in comics history, providing an alternative to the mainstream emphasis on superheroes and a showcase for promising new talent as well as some of the greatest names in both the US and Europe."[16] One way of summarizing the quality of the Warren magazines is that they contained the work of more than thirty writers and artists who have been voted into the Will Eisner Comic Book Hall of Fame, work that in many cases demonstrated that comics could appeal to older readers, and to those not interested in super heroes. Some of them got their start or gained early exposure in the pages of *Creepy*, *Eerie* and *Vampirella*.

Some, certain employees and freelancers among them, will always look upon Warren in a negative light. Others, particularly those who got close to him, think of him in the warmest of terms. In the long run, the task he assumed was largely a thankless one, because it involved standing behind the scenes and letting the people who wrote and drew the magazines shine. They were the stars, and he was the man who presented their work. Or, to use his words, "Guys like me create work for guys like them."

The End

ACKNOWLEDGMENTS

My debts to others who helped with this biography are enormous. None is greater than my debt to Gary Groth, this book's publisher and editor, who gave me access to numerous interviews with former Warren freelancers which had been conducted in 1998, when he was preparing to interview Warren himself.

Although I was able to interview James Warren for my Harvey Kurtzman biography, he declined to be interviewed for this book because he was writing his memoir. Therefore, I had no choice but to rely heavily on a handful of key interviews with the man, starting with lengthy, previously unpublished interviews conducted by Gary Groth and Michael Catron in 1976, by Catron alone in 1993, and a third with Groth and Catron in 1998. These revealed aspects of Warren's personality and history that he didn't talk about anywhere else, and have never been known before. Some of Warren's other words are quoted from transcripts of panel discussions at the New York conventions of the 1960s, 1970s and later.

Jon B. Cooke's *Warren Companion* (TwoMorrows Publishing, 2001) is an invaluable reference book for any fan of Warren Publishing. It contains Cooke's lengthy interview with Warren, as well as interviews with many who worked for him. I have quoted, when necessary, from that book, as well as from Dave Baumuller's excellent talk with Warren for *Horror Biz* magazine. I extend my sincere thanks to both Jon and Dave for conducting and pub-

lishing these excellent interviews, which offer so much important history to comics fans and future scholars.

Along similar lines, I'm grateful to comics writer and historian Richard J. Arndt for his interviews with Warren personnel and associates. They can be found at www.enjolrasworld.com in their entirety. Richard's interview with Bill Harris in Roy Thomas's *Alter Ego* filled in another important piece of the puzzle. For additional interviews with Warren, I also thank Richard Anders, John Benson, Ron Carlson, Paul Kupperberg, Paul Levitz, April Smith and Duane Swierczynski.

Special thanks to two close friends of Jim Warren who consented to interviews. The first is Barton Banks, whose friendship with Jim Taubman began in college, and continues to the present day. His information and insights added a great deal to this telling of Warren's life, as did those of Samuel M. Sherman, filmmaker, a trusted friend and consultant over the years. Venerable cartoonist Arnold Roth also knew Warren when they were both attending Central High School in Philadelphia in the 1940s. Arnie's memories of those days added an important dimension to that part of the story, as did those of CHS alumnus David Kahn, who provided the photos of the class ring designed by Warren, as well as scans from *The Centralizer*.

I was extremely fortunate to be able to talk at length with Louise Simonson (formerly Louise Jones, b. Alexander), the editor of the Warren comics magazines in their second great period, as well as assistant editor and writer Nicola Cuti about his work for the company. I also thank Bill Mohalley, the production manager for Warren, and Kim McQuaite, the art director in the late 1970s, for offering their memories and perspectives. More interviews were done with such folks as Trina Robbins, Bill Pearson, Angelo Torres, Anthony Tollin, Denis Kitchen and Sherry Berne Wallack, who all contributed important information about their contributions to the Warren saga. Thanks also to Bruce Jones and Jim Stenstrum, two of the finest writers ever to lend their talents to the Warren magazines, for their memories.

Arguably, Bill DuBay had, after Jim Warren himself, the greatest impact on the Warren line of comics. Archie Goodwin did a brilliant job, but was there as editor for three years; DuBay ushered in the resurgence of the mag-

azine in the 1970s, serving in an editorial position for the rest of the decade, albeit with a break of a little over a year. Therefore it was fortunate that not only had I interviewed him in 2008, but DuBay had been among the many who were interviewed by Gary Groth in 1998. Others interviewed by Groth at the time were Pat Boyette, J. R. Cochran, Ernie Colón, Frank Frazetta, Larry Ivie, Gray Morrow, Buddy Saunders, Kenneth Smith, Tom Sutton, Len Wein, Ted White, Al Williamson, Bernie Wrightson and Marvin Wolfman. I offer all these people my thanks, some who have since passed away, for telling their part of the story.

I'm much indebted to Warren expert David Horne, author of the book *Gathering Horror: A Completist Collector's Catalogue and Index for Warren Publishing* (2010), a 700-page guide that's an invaluable (and hard to find, given its limited print run) resource. David not only contributed a great deal of information and many images to this book, but he also checked the manuscript for errors.

For photographs, I'm grateful that Sylvia Plachy (the mother of actor Adrien Brody), who took photos of Jim Warren in 1974 for the *Village Voice* article, allowed me to publish a previously unseen photograph from that session. My thanks for photographs also go to Jerry Bails, John Benson, E. B. Boatner, Michael Catron, Jamie Coville, Gary Groth, Jack C. Harris, David Lofvers, Louise Simonson, Sherry Berne Wallack and Mike Zeck.

As with my prior biographies on Harvey Kurtzman and John Stanley, John Benson provided substantial help which made a real difference in the quality of this book. He was able to offer his perspective as an author of a handful of scripts for *Creepy* and *Eerie*, as well as the earliest known interviews with Warren (in the *Help* magazine offices). He unearthed a letter from Warren to Harry Chester of *Humbug* magazine in 1957 from the Kurtzman archives when they were under the care of Denis Kitchen. And, as before, John reviewed the manuscript and offered suggestions and guidance.

Important contributions and other assistance came from Al Bradford, Dan Braun, Aaron Caplan, Michael Dean, Clark Dimond, Jackie Estrada, Jeff Gelb, Michael T. Gilbert, Heritage Auctions, Roger Hill, Jim Korkis, Batton Lash, Randy Palmer, Ron Parker, Barry Pearl, S. C. Ringgenberg, Mike Royer,

Walt Simonson, Philip Smith, Gloria Steinem, Greg Theakston, Jim Van Hise, Mike Voiles and John Workman. Also, thanks to Forrest J Ackerman, Archie Goodwin and Harvey Kurtzman, the Warren editors who are no longer with us, for their memories of working with James Warren which were available in interviews and articles.

Finally, I'm grateful to everyone at Fantagraphics Books for making this book possible at all. As always, it's been a pleasure. Special thanks to Kristy Valenti and designer Keeli McCarthy.

ENDNOTES

All unattributed quotations are from the author's interviews with the subjects conducted in 2016 and 2017.

CHAPTER 1—The Boy Who Would Fly

1 David A. Roach and Jon B. Cooke, eds., *The Warren Companion* (Raleigh: TwoMorrows Publishing, 2001), 14.

2 Roach and Cooke, *Warren Companion*, 16.

3 Dave Baumuller, "The Most Famous Monster of All," *Horror Biz Magazine*, Spring–Summer 1999, 17.

4 Roach and Cooke, *Warren Companion*, 14.

5 Richard Anders, "Jim Warren Interview," *Infinity* #1, Summer 1970, 26.

6 April Smith, "Citizen Pain," *Rolling Stone*, April 25, 1974, 36.

7 Baumuller, "Most Famous Monster," 17.

8 Roach and Cooke, *Warren Companion*, 15.

9 Roach and Cooke, *Warren Companion*, 15.

10 Manuel Auad, ed., "Introduction by James Warren," *Toth Black & White* (San Francisco: Auad Publishing, 1999), 4.

11 Auad, "Introduction," 5.

12 D. Michaels, "Once Upon a Neighborhood: Jewish Life in Philadelphia," *Jewish Exponent*, August 12, 2014, http://jewishexponent.com/2014/08/12/once-upon-a-neighborhood-jewish-life-in-philadelphia/

13 Michael Dean, "The Vampirella Wars," *The Comics Journal* #253, June 2003, 22.

14 Paul Kupperberg, "They Don't Got Jim Warren!," October 27, 2017, unexpurgated interview by Paul Levitz and Paul Kupperberg, https://kupps.malibulist.com/2015/10/27/they-dont-got-jim-warren/

15 Baumuller, "Most Famous Monster," 18.

16 Baumuller, "Most Famous Monster," 18. All quotations in this paragraph are from this source.

17 Michael Catron, "Warren interview," *Blazing Combat* (Seattle: Fantagraphics Books, 2009), 192.

18 Ron Carlson, "The Man Behind the Monsters," *The Village Voice*, November 7, 1974, 16.

19 Michael Catron, raw transcript of James Warren interview for a comic book reprinting stories from *Blazing Combat*, April 12, 1993.

20 Carlson, "Man Behind the Monsters," 16.

21 Duane Swierczynski, "Jim Warren Meets Vampirella," January 6, 2005, https://mycitypaper.com/articles/2005-01-06/cover.shtml

22 Catron, "Warren interview," 192.

23 Catron, "Warren interview," 194.

24 Letter from Warren to Larry Trepel, April 5, 1974.

25 Letter from Warren to Larry Trepel, April 5, 1974.

26 Baumuller, "Most Famous Monster," 17.

27 Alma Mater, Central High School Yearbook, 190th Class, 121.

CHAPTER 2—College, Military, and Making a Living

1 Roach and Cooke, *Warren Companion*, 17.

2 *The Centralizer*, June 16, 1948.

3 Catron, raw interview transcript.

4 Baumuller, "Most Famous Monster," 17.

5 Carlson, "Man Behind the Monsters," 16.

6 Roach and Cooke, *Warren Companion*, 18.

7 Baumuller, "Most Famous Monster," 17.

8 Roach and Cooke, *Warren Companion*, 18.

9 Baumuller, "Most Famous Monster," 17.

10 Carlson, "Man Behind the Monsters," 16.

11 Greg Theakston, "Monster Mania '57," *Pure Images* #3, March–April, 1991. Greg Theakston's article in this and the next issue of *Pure Images* is the source for a great deal of information about Warren's life in the 1950s, the early days of *Famous Monsters of Filmland* and Warren's interactions with personnel at Kable News. After the Warren bankruptcy, the office files were trashed, and only survived because Theakston retrieved some of them, as described in Chapter 17. In the subsequent years, Theakston disseminated material from those files through eBay auctions. Therefore, the author has relied on the information in those *Pure Images* articles. In a letter in *Pure Images* #5, James Warren himself stated that the information was highly accurate. *Pure Images* did not have numbered pages.

12 Steven Watts, *Mr. Playboy: Hugh Hefner and the American Dream*, (Hoboken: John Wiley & Sons, Inc., 2008), chapters 4 and 5.

13 Swierczynski, "Jim Warren Meets Vampirella."

14 Watts, *Mr. Playboy*, 103–4.

15 Swierczynski, "Jim Warren Meets Vampirella."

16 Catron, raw interview transcript.

17 James Warren, *After Hours* #1, 1957, 2.

18 Smith, "Citizen Pain," 33.

19 Smith, "Citizen Pain," 33.

20 Catron, raw interview transcript.

21 Catron, raw interview transcript.

22 Smith, "Citizen Pain," 33.

CHAPTER 3—"Welcome, Monster Lovers"

1 Forrest J Ackerman, *Forest J Ackerman, Famous Monster of Filmland*, Imagine, Inc., 1986, 10.

2 Forrest J Ackerman, "Birth of a Notion," *Famous Monsters of Filmland: The Annotated Issue* #1, Movieland Classics, LLC, 2011, 7. The magazine's actual title was simply *Cinéma*, with the numerals adjusted every twelve months.

3 Baumuller, "Most Famous Monster of All," 18.

4 Forrest J Ackerman, "A History of Famous Monsters," *Guts* #4, September 1968, 14.

5 Baumuller, "Most Famous Monster of All," 18.

6 Roach and Cooke, *Warren Companion*, 23.

7 Ackerman, *Famous Monster of Filmland*, 11.

8 At a 2008 Comic-Con International: San Diego panel, Warren claimed that he "thought about" taking a bus but didn't, and actually flew all the way.

9 Baumuller, "Most Famous Monster of All," 18.

10 Ackerman, *Famous Monster of Filmland*, 12.

11 Ackerman, *Famous Monster of Filmland*, 13.

12 Greg Theakston, "Monster Mania '57," *Pure Images* #3, March–April 1991.

13 Theakston, "Monster Mania."

14 Baumuller, "Most Famous Monster of All," 18.

15 James Warren, "Publishing Pragmati$m," *Enclave* #1, February 1963, 6.

16 Basil Gogos, *Famous Monsters Chronicles II*. Kindle, 20.

17 *Famous Monsters* #1 was published in England (by a British publisher) around June 1958, with slightly altered contents, followed by a second issue in 1959. After that, US versions of the magazine were imported and sold there (with British pricing stickers or stamps). Sales information on British editions and imports is unknown, but they must have had an impact on Warren's income. (This information is from Warren expert David Horne.)

18 Information in this and prior paragraph drawn from Greg Theakston's "The Warren Report" article in *Pure Images* #4, 1991.

19 Theakston, "Warren Report," *Pure Images* #4.

20 Warren and Banks (his silent partner) suspected, and soon became convinced, that Kable News was falsifying sales reports and underpaying them for the magazine. Source: Barton Banks's e-book *The Book I Wrote on Humility* (2004) in the chapter titled "The Rock 'n' Shock Show."

21 Banks, *The Book I Wrote*.

22 Baumuller, "Most Famous Monster of All," 18.

23 Thomas Skulan, "Interview with James Warren," *Famous Monsters Chronicles II*. (FantaCo Publications, 2017) 17.

24 Catron, raw interview transcript.

25 Catron, raw interview transcript.

26 Theakston, "Warren Report."

27 Smith, "Citizen Pain," 33.

CHAPTER 4—Expansion: 1960

1 Gary Groth and Michael Catron, unpublished James Warren interview, December 4, 1998.

2 Author's unpublished interview with James Warren.

3 Author's Warren interview.

4 The exclamation point in the title of *Help!* magazine has been omitted after the introduction and the first reference to the Kurtzman-edited periodical in the body of the manuscript.

5 Gloria Steinem at memorial for Harvey Kurtzman, 1993.

6 Author's Warren interview.

7 Author's Warren interview.

8 Author's Warren interview.

9 John Benson, "On Me in New York and at *Help* and the People I Met and All," *Squa Tront* #10, 43–4. The visit occurred on January 18, 1961. The piece originally appeared in Benson's fanzine *Image* #2 (1961).

10 Smith, "Citizen Pain," 34.

11 Groth and Catron's Warren interview, 1998.

12 Groth and Catron's Warren interview, 1998.

13 Ackerman, *Famous Monster of Filmland*, 38.

14 Theakston, "Warren Report."

15 Gogos, *Famous Monsters Chronicles II* [Kindle book]. Gogos quotations in this chapter are all from the interview in this 2017 book.

16 This is Gogos quoting Warren, from the interview in *Famous Monsters Chronicles II*, 8.

17 Harold Hayes's interview with Harvey Kurtzman on *Roundtable*, 1975.

18 Gary Groth's unpublished interview with Adele Kurtzman, 1998.

19 Groth and Catron's Warren interview, 1998.

20 Groth and Catron's Warren interview, 1998.

21 S. C. Ringgenberg, "Harvey Kurtzman, Memories Most *Mad*," *Comics Scene* #47, November 1994, 19.

22 Groth and Catron's Warren interview, 1998.

CHAPTER 5—Ups and Downs

1 Warren told David Horne that he chose the name "Captain Company" because he was following the "military motif" of General Promotions.

2 Swierczynski, "Warren Meets Vampirella."

3 John Benson, "An Interview with Jim Warren," *Squa Tront* #10, 46–8. This piece originally appeared in Benson's fanzine *Image* #3, 1961.

4 In 1962, Ralph Ginzburg gave the name *Eros* to his short-lived periodical with articles and photo-essays on love and sex.

5 Gary Groth's unpublished interview with Ted White, 1998.

6 Barton Banks's account doesn't exactly square with the way moneys flowed (or didn't flow) between the publisher, the distributor and the printer, but it establishes that he helped Warren upon occasion with a loan commitment letter.

7 Email to the author from Roger Hill, October 25, 2017.

8 Groth and Catron's Warren interview, 1998 is the source for this entire anecdote.

9 Theakston, "Warren Report."

10 Groth and Catron's Warren interview, 1998.

11 Author's Warren interview.

12 Raymond Young, "An Interview with Calvin Beck," 1981, http://21ca.com/flickhead/2_14_Beck_Interview.html

13 The only source the author found for the story of Beck's supposed claim (that Warren stole his idea) was Dennis Druktenis's *50th Anniversary Special: Castle of Frankenstein*, which published an article by Richard Bojarski titled "Monster Memories of Castle of Frankenstein, My Recollections of Calvin Beck and Castle," 75–6. In *Horror Biz* #4 (1998), Warren himself states that Beck was promulgating this story. Perhaps Beck's more benign story was transmuted into a claim of "idea theft" by overprotective *Castle of Frankenstein* partisans.

14 Archie Publications lawsuit letter.

15 Email from Denis Kitchen to the author.

16 John Benson, *A Talk with Harvey Kurtzman*, 34.

17 Terry Gilliam at the Harvey Kurtzman memorial, 1993.

18 Tom Weaver, ed., *It Came from Horrorwood* (Jefferson, McFarland & Co, 2004), 290.

19 Weaver, *Came From Horrorwood*, 290–1.

20 Russ Jones, "*Creepy* and *Eerie* Confidential," http://popfiction.com/hotad/html/monstermania/Creepy/index.html

21 Gary Groth's unpublished interview with Ernie Colón, 1998.

22 Swierczynski, "Warren Meets Vampirella."

23 Author's interview with Barton Banks.

24 Swierczynski "Warren Meets Vampirella."

25 Skulan, "Interview with Jim Warren," *Famous Monsters Chronicles II*, 22.

26 Paul Linden, interview with Forrest J Ackerman, *Famous Monsters of Filmland* #24, 32.

27 Roy Thomas, 1965 New York Con coverage in *Alter Ego* vol. 3, #20 (January 2003) 30–8.

28 Richard J. Arndt, "From Dell to Gold Key to King," Bill Harris interview, *Alter Ego* #144, January 2017. All Harris quotations are from this interview, which appeared on pages 35–53.

CHAPTER 6—*Creepy* Beginnings

1 Gary Groth's unpublished interview with Larry Ivie, 1998.

2 Larry Ivie, "Creepy, The Beginning," *Monster Memories* #5, Druktenis Publishing, 1997, 49.

3 Ivie, *Monster Memories* #5, 52.

4 Gary Groth's unpublished interview with Al Williamson.

5 Russ Jones, "*Creepy* and *Eerie* Confidential."

6 Jones, "*Creepy* and *Eerie* Confidential."

7 Jones, "*Creepy* and *Eerie* Confidential."

8 Steve Duin and Mike Richardson, *Comics Between the Panels*, (Milwaukie: Dark Horse Comics, Inc., 1998), 459.

9 Anders, "Jim Warren Interview," *Infinity* #1, 27–8.

10 Jones, "Creepy and Eerie Confidential."

11 Groth's Ivie interview.

12 Groth's Ivie interview.

13 Groth's Williamson interview.

14 Michael Dean, ed. *The Comics Journal Library* #8: *The EC Artists*, George Evans interview by Paul Wardle (Seattle: Fantagraphics Books, 2013), 146.

15 Groth's Ivie interview.

16 *The Comic Reader* #32, December 1964, is the source of the "one third" estimate.

17 S. C. Ringgenberg, with Kim Thompson assisting, Archie Goodwin interview, *The Comics Journal* #78, December 1982, 61–80.

18 Baumuller, "Most Famous Monster of All," 28.

19 Gary Groth, "Interview with Frank Frazetta," *The Comics Journal* #174, February 1995, 52–90.

20 Angelo Torres interview by Sam Henderson, *The Comics Journal Library* #8: *The EC Artists* (Seattle: Fantagraphics Books, 2013), 149–160.

21 Richard J. Arndt, "From Dell to Gold Key to King," 44–5. All Harris quotations in this chapter are from that interview, which appeared on pages 35–53.

22 Russ Jones, "*Creepy* and *Eerie* Confidential."

23 Catron, raw interview transcript.

24 Catron, raw interview transcript.

25 Jon B. Cooke, "Jim Warren Spotlight—50th Anniversary of Famous Monsters," SDCC, July 23–27, 2008. Transcribed from video.

26 Goodwin, Archie, letter of September 5, 1965.

27 Email to author from Mark Lewisohn.

28 Author's Warren interview.

29 Author's Warren interview.

30 Harold Hayes's interview with Harvey Kurtzman on *Roundtable*, 1975.

31 Extracted from: Gary Groth, R. Crumb interview "One of My Main Reasons to go on

Living Is I Still Think I Haven't Done My Best Work," *The Comics Journal Library* Vol. 3 (Seattle: Fantagraphics Books, Inc., 2004), 24.

32 Author's Warren interview.

33 Irgang had formerly worked for Warren, and helped him expand his merchandise operation in the early days. His name appeared on the *FM* masthead at the time.

34 Roach and Cooke, *Warren Companion*, 54.

35 Warren's comments are from the transcript of the 1965 panel in *Alter Ego* #20, January 2003, 30–8.

CHAPTER 7—On the Firing Line

1 Catron, *Blazing Combat*, 195.

2 Catron, *Blazing Combat*, 201.

3 Catron, *Blazing Combat*, 201–2.

4 Orlando quote extracted from: Catron, *Blazing Combat*, 201–2.

5 Gary Groth interview with John Severin, *The Comics Journal Library* #8 (Seattle: Fantagraphics Books, 2013), 195.

6 Groth's Severin interview, 225.

7 Catron, *Blazing Combat*, 202.

8 Groth and Catron's Warren interview, 1998.

9 Catron, *Blazing Combat*, 203.

10 Catron, *Blazing Combat*, 205.

11 Archie Goodwin letter to Ron Parker, September 5, 1965.

12 Michael Catron, "The Story of *Eerie* #1," unpublished. Some reports say that Warren printed as few as 200 copies of his *Eerie* #1 ashcan. According to Goodwin, there were "several hundred" copies made.

13 Catron, raw interview transcript.

14 Catron, *Blazing Combat*, 192.

15 Greg Sadowski, *Setting the Standard: Comics by Alex Toth* (Seattle: Fantagraphics Books, 2011), 30. Both Toth quotations are from this source.

16 Blake Bell, *I Have to Live with This Guy* (Raleigh: TwoMorrows Publishing, 2002), 119.

17 Catron, raw interview transcript.

CHAPTER 8—An Empire of Monsters

1 Catron, raw interview transcript.

2 Duin and Richardson, *Comics: Between the Panels*, 459–60.

3 Duin and Richardson, *Comics: Between the Panels*, 459–60.

4 Gary Groth's unpublished interview with Gray Morrow, 1998.

5 Groth's Morrow interview.

6 Blake Bell, *I Have to Live with This Guy*, 119.

7 Groth and Catron's Warren interview, 1998.

8 Groth and Catron's Warren interview, 1998.

9 Gary Groth and Michael Catron, unpublished James Warren interview, 1976.

10 Groth and Catron's Warren interview, 1976.

11 Gary Groth, interview with Harvey Kurtzman, *The Comics Journal* #67, October 1981, 12.

12 Groth and Catron's Warren interview, 1976.

13 Henderson, Torres interview.

14 Gary Groth, "Interview with Gil Kane," *The Comics Journal* #186, 79.

15 Groth's Kane interview.

16 Groth and Catron's Warren interview, 1998.

CHAPTER 9—Downturn

1 Ackerman, *Famous Monster of Filmland*, 131.

2 Mark L. Sielski, "An Interview with Forrest J Ackerman," *Magick Theatre* #8, 1987, 15.

3 Ackerman, *Famous Monster of Filmland*, 16.

4 A word about the Statements of Ownership, Management and Circulation: Despite Warren's affixed statement that the circulation numbers "are correct and complete" on the form, they are understandably viewed with skepticism as reliable sales figures. This is because there was no actual confirmation or auditing process to check on their accuracy. However, these figures are the best we have, as no actual in-house records exist for the purposes of comparison. Some of the unsold issues were stockpiled by Warren for later resale. In addition, in some cases, copies certified by the distributors as "unsold" apparently found their way into the hands of customers through unscrupulous wholesalers and news dealers.

5 "We lost about 25 percent . . ." from Forrest J Ackerman, "A History of Famous Monsters," *Guts* #4, September 1968, 15.

6 "When Batman became a hit television show . . ." is from Randy Palmer in "The Last Days of Famous Monsters, Part 1," *Ackermansion Memories* #2.

7 Roach and Cooke, *Warren Companion*, 90.

8 Blake Bell, *I Have to Live with This Guy*, 122.

9 Groth and Catron's Warren interview, 1976.

10 Groth's Frazetta interview.

11 Ackerman, "A History of Famous Monsters."

12 Roach and Cooke, *Warren Companion*, 96.

13 The lack of a work-for-hire contract at Warren came up after the firm declared bankruptcy, and the issue of who owned the stories was raised by Bill DuBay and others.

14 Richard J. Arndt, "The Clark Dimond Interview," *Spooky* Vol. 2, #5, 39.

15 Email to the author, July 28, 2017.

16 Gary Groth's unpublished interview with Tom Sutton, 1998.

17 Groth's Colón interview.

18 Gary Groth's unpublished interview with Buddy Saunders, 1998. Note: $25 in 1968 is $180 in 2017 dollars.

19 Roach and Cooke, *Warren Companion*, 90.

CHAPTER 10—Vampirella

1 Robert Cosgrove, "Economics and the Comics" panel, New York Comic Con 1969, *Comic Crusader* #7 (1969). All quotations from this panel are from this article.

2 Don and Maggie Thompson, *Newfangles* #25 (August 1969), 3.

3 This account of the Warren Award ceremony is drawn from Tom Fagan's article "The Warren Report," *Comic Crusader* #7.

4 Don and Maggie Thompson, *Newfangles* #24 (July 1969), 2.

5 Baumuller, "Most Famous Monster of All," 24.

6 Groth's Frazetta interview.

7 Baumuller, "Most Famous Monster of All," 29. The official version of the origin of the Vampirella character was published as a text feature in *Vampirella* #19: "A contest was held at Warren Publishing in New York to determine the name of the new character. It involved an open offer to several people working on the production of the book. Title winner was Ackerman himself who wrote her first and second segments."

8 Roach and Cooke, *Warren Companion*, 91.

9 Smith, "Citizen Pain," 34.

10 Meth, Clifford, *Comic Book Babylon* (Rockaway: Aardwolf Publishing), 2014. Kindle.

11 Piers Casimir, "Neal Adams," *Spooky* Vol. 2 #1, Autumn 2004, 8–10.

12 Meth, *Comic Book Babylon*.

13 Groth and Catron's Warren interview, 1998. Since only one Steranko painting appeared on a Warren magazine, Warren's use of the plural here makes one think that more than one were submitted, and this was the only one he felt was usable.

14 *Screw* magazine, CA. 1969.

15 Smith, "Citizen Pain," 34.

16 Ackerman, *Famous Monster of Filmland*, 38.

17 Email from Clark Dimond, June 2, 2015.

18 Email from Michael T. Gilbert, April 3, 2003.

19 Anders, "Jim Warren Interview," *Infinity* #1, 27.

20 Jon B. Cooke, "The Bernie Wrightson Interview," *Comic Book Creator* #7 (May 2015), 54.

21 Archie Goodwin, memo to James Warren, April 3, 1970. Provided by John Benson, with the cover note from Warren which read, "Archie Goodwin is helping us review and edit scripts for *Creepy*, *Eerie* and *Vampirella*. Accordingly, I'd like you to take the time to read the enclosed copy of a letter Arch sent me, spelling out the things we'd like to see in your future scripts."

22 S. C. Rinngenberg, Doug Moench interview, August 2010.

23 S. C. Ringgenberg, Ken Kelly interview, March 2013.

24 Catron, raw interview transcript.

25 Richard J. Arndt, interview with Don McGregor, www.enjolrasworld.com.

26 E. A. Fedory, "The Fedory File," *Canar* #7, March 1973, 2.

27 Groth's Sutton interview.

28 Ringgenberg's Moench interview.

29 Roach and Cooke, *Warren Companion*, 108.

30 Quotations in this section are from John Baljé's interview with John Cochran in *Canar* #31–32, 1976.

CHAPTER 11—Recovery

1 Roach and Cooke, *Warren Companion*, 129.

2 David A. Roach, *Masters of Spanish Comic Book Art* (Mount Laurel: Dynamite Entertainment, 2017), 29.

3 Per David Horne: "Warren had already been licensing for foreign sales on his own. He seems to have started in earnest around 1969, with *Creepy* and *Eerie* published by Publicness in France, and a *Creepy* compilation by Mondadori in Italy. There were also reprints of *Creepy* and *Eerie* material in Turkey the same year, and in Argentina beginning in 1970. In Spain, *Creepy* magazine was published by Garbo beginning in 1972." Toutain then entered the picture, arranging for reprints of Warren material in many more places, sometimes mixed with other material that never appeared in the North American issues. The amounts generated for Warren through these sales, and the details of his arrangement with Toutain, are unknown.

4 Gary Groth, unpublished Bill DuBay interview, 1998.

5 This isn't to suggest that Warren tracked down every freelancer who had given up asking to.be paid during his company's downturn.

6 Roach and Cooke, *Warren Companion*, 132.

7 Roach and Cooke, *Warren Companion*, 107.

8 Gary Groth's unpublished interview with Len Wein, 1998.

9 Mark Evanier, "Spotlight on Mike Royer," July 20, 2017, provided by Jamie Coville. Transcribed from video.

10 Gary Groth's unpublished interview with Nick Cuti, 1998. All quotations in this section are from this interview.

11 Carter Scholz, "Introduction & Transcription, James Warren: Keynote Address," *Fantastic Fanzine Special* #2, February 1972, 17–20. All quotations from Scholz's introduction, and Warren's address, are from this source.

12 Warren letter to Sutton, February 16, 1972. No other evidence indicates that a functioning Board of Directors existed for Warren Publishing Co., Inc. Its mention in this letter is more likely an example of Warren's (sometimes tongue-in-cheek) grandiosity.

13 Warren letter to Sutton, undated.

14 Warren letter to Sutton, undated. Refers to a story in *Eerie* #43 (November 1972).

15 Warren letter to Toth, January 19, 1972.

16 Tim Lynch, "My Visit to the Warren Office," *Spooky* Vol. 2 #5, 2005, 45–6. All quotations about the visit come from this article. (A slightly different version of this article first appeared in *Scary Monsters: Monster Memories* #7, in 1999.)

CHAPTER 12—Enter: Bill DuBay

1 Groth's DuBay interview, 1998.

2 Roach and Cooke, *Warren Companion*, 138.

3 Bill Schelly, *Founders of Comic Fandom* (Jefferson: McFarland, 2010), 144.

4 Groth's DuBay interview, 1998.

5 Warren letter to Tom Sutton, February 4, 1972. This letter is a key document, as it shows that Warren knew how difficult he was to work for. The difficulty in finding the right editor, who could also serve as his successor on a day-to-day basis, was an important factor in the demise of his company.

6 Groth's DuBay interview, 1998.

7 Wolfman discovered the story in Mike Garrett's fanzine *Comics Review* (1964), and got permission to reprint it.

8 Baumuller, "Most Famous Monster of All," 26.

9 Swierczynski, "Jim Warren Meets Vampirella," 2005.

10 Roach and Cooke, *Warren Companion*, 139.

11 Al Hewetson, "My Days in Horror Comics," *The Comics Journal* #127, March 1989, 92.

12 Groth's DuBay interview, 1998.

13 Groth and Catron's Warren interview, 1998.

14 Swierczynski, "Jim Warren Meets Vampirella," 2005.

15 Smith, "Citizen Pain," 34.

16 Anders, "Jim Warren Interview," *Infinity* #1, 31.

17 Roach and Cooke, *Warren Companion*, 132.

18 Mike Scott, "Rarest Warrens, Pt. 4," http://monstermagazines.blogspot.com, September 5, 2010.

19 Heidi Saha's appearance as Vampirella in 1973 was cast in a new, much more disturbing, light on January 30, 2018, when allegations of sexual harassment by Ackerman were made on the Classic Horror Film Board under the "Forrest J Ackerman's #MeToo Moment" header. (Originated by black civil rights activist Tarana Burke in 2006, according to Wikipedia.org, "The #MeToo movement . . . spread virally in October 2017 as a hashtag used on social media to help demonstrate the widespread prevalence of sexual assault and harassment, especially in the workplace.") During a discussion of Ackerman's virtues and faults, Lucy Chase Williams, a Vincent Price biographer and longtime monster fan, wrote, "Speaking of 'failures' (!), I guess this is the time to remind the boys here of #MeToo. I and other young women like me were subjected to

a different kind of 'Forry worship.' How differently would any of you have felt, when all you wanted was to talk about monsters with the 'over eager editor' of your favorite monster magazine, if your Uncle Forry had forced wet kisses on you? If he had put his hands all over you, pinching your 'naughty bottom' and squeezing your 'boobies'? If he had enthusiastically related with a big grin how he wanted to strip off your clothes with everybody watching? And if, in the face of your total refusal of any of his attentions every single time you saw him in person, he *never* didn't try again, and again, and again? And if for years, in between those times, he mailed you letters with pornographic photos, and original stories about how naughty you were, and how he wanted to hurt and abuse you, yet all the while make you weep and beg for more? And if he continued that behavior, despite written and verbal demands to cease, entirely unabashed for more than two decades? No, I can't forget him either -- or how he turned my childhood love of monsters into something adult and truly monstrous." Others on the board came forward with stories of similar harassment. At the 1973 New York Comic Art Convention, Heidi Saha was chaperoned by her parents, and has not (as far as is known) made allegations of inappropriate advances from Ackerman. Ref: https://www.tapatalk.com/groups/monsterkidclassichorrorforum/forrest-j-ackerman-s-metoo-moment-t68925.html.

20 Groth's DuBay interview, 1998.

21 "James Warren" profile, *Famous Monsters Convention* program, 1974, 29. This is another case of Warren admitting—nay bragging—that he was a difficult taskmaster.

22 Groth's DuBay interview, 1998.

23 Gary Groth's unpublished interview with Bernie Wrightson, 1998.

24 Gary Groth, "The Berni Wrightson Interview," *The Comics Journal* #76, October 1982, 106.

25 Groth's DuBay interview. Details of "Perma-loan" are sketchy, other than DuBay's confirmation that it existed in name and practice.

26 Smith, "Citizen Pain," 32.

27 Carlson, "Man Behind the Monsters," 17.

28 Smith, "Citizen Pain," 32.

29 Groth and Catron's Warren interview, 1998.

30 All quotations from here to the end of the chapter are from Gary Groth's unpublished interview with Bernie Wrightson, 1998.

CHAPTER 13—Will Eisner and *The Spirit* Magazine

1 When DuBay cites bonuses as high as $12,500 (roughly $72,000 in today's dollars), one must assume that he was speaking of his highest personal bonus, as editor, not those given to other employees. Even so, the author views this figure with skepticism.

2 Anders, "Jim Warren Interview," *Infinity* #1, 26-7.

3 David Caruba, "Catch the Spirit, An Interview with Will Eisner," by Joe Cicala, Jeff Kapalka, Will Murray and Brian Schlesinger, *Four Color* Vol. 1, No. 2, January 1987.

4 Baumuller, "Most Famous Monster of All," 18.

5 Smith, "Citizen Pain," 30.

6 Piers Casimir, "The Jack Butterworth Interview," *Spooky* Vol. 2, #5, 29–30, 33.

7 Roach and Cooke, *Warren Companion*, 132.

8 Groth and Catron's Warren interview, 1998.

9 Groth and Catron's Warren interview, 1998.

10 Groth and Catron's Warren interview, 1998.

11 Groth's DuBay interview.

12 *Famous Monster Convention program*, 1974, 2.

13 Piers Casimir, "The Neal Adams Interview," *Spooky* Vol. 2, #1, 12-3.

14 Groth and Catron's Warren interview, 1976.

15 Groth and Catron's Warren interview, 1976.

16 Baumuller, "Most Famous Monster of All," 29.

17 Richard J. Arndt, interview with Barbara Leigh, www.enjolrasworld.com.

18 Arndt's Leigh interview.

CHAPTER 14—Louise Jones, Editor

1 Murphy, *I Have to Live with this Guy*, 120.

2 Groth's DuBay interview, 1998. All DuBay quotations in the prior four paragraphs are from this interview.

3 Roach and Cooke, *Warren Companion*, 167.

4 Baumuller, "Most Famous Monster of All," 26. The print run of the authentic *Eerie* #1 ashcan has never been established. Reports range from one hundred to five hundred copies.

5 Archie Goodwin, "The Black-&-White World of Warren Publications," *Comic Book Artist* #4, 11.

6 Gary Groth's unpublished interview with Bruce Jones, 1998.

7 Ken Jones, "Interview with Russ Heath," *The Comics Journal* #117, September 1987, 88–100.

8 Al Williamson Interview, *The Comics Journal Library* #10, 103–4.

9 Groth and Catron's Warren interview, 1998.

10 Roach and Cooke, *Warren Companion*, 161.

11 Email from Denis Kitchen, 2017.

CHAPTER 15—Warren's Silver Age Continues

1 In 2017, Bill DuBay's nephew Benjamin DuBay sued Stephen King over similarities between *The Dark Tower* and Bill DuBay's character The Rook. In a deposition given on November 8, 2017, Warren disputed DuBay's version of the origin of The Rook, disavowed any knowledge of Howard Peretz or Package Play Company and maintained that he never formally gave DuBay and Lewis the rights to The Rook. https://ohdannyboy.blogspot.com/2018/09/benjamin-dubay-vs-stephen-king-jim.html

2 Baumuller, "Most Famous Monster of All," 29.

3 Baumuller, "Most Famous Monster of All," 29.

4 Randy Palmer, "The Last Daze of Famous Monsters, Part 2," *Ackermansion Memories* #2. According to Palmer, "Warren moved right along, first talking with the film producer/director Gordon Hessler about turning Vampi into a 'real life flesh-and-blood character' and then initiating discussion with NBC about the possibility of introducing a Vampirella cartoon series for Saturday morning children's television."

5 Arndt's Leigh interview.

6 The words "of Filmland" stopped appearing on the covers with *FM* #138, and disappeared from the interior masthead after #140. No reason was given for the change.

7 Randy Palmer, "The Last Daze of Famous Monsters, Part 1," *Ackermansion Memories* #2.

8 Roach and Cooke, *Warren Companion*, 171.

9 Tom Fagan, "The Warren Report," *Comic Crusader* #7.

10 Groth's DuBay interview, 1998.

11 Groth's DuBay interview, 1998.

12 Sid Keranen, "The Jan S. Strnad Interview," www.muuta.net/Ints/IntJanStrnad-A.html, February–March 2001.

13 Gary Groth's unpublished interview with Richard Corben, 1998.

14 Groth's DuBay interview, 1998.

15 Groth's DuBay interview, 1998.

16 Swierczynski, "Jim Warren Meets Vampirella," 2005.

17 Catron, raw interview transcript.

18 Carter Scholz, "Introduction & Transcription, James Warren: Keynote Address," *Fantastic Fanzine Special* #2, February 1972, 20.

CHAPTER 16—The End in Slow Motion

1 Script freeze is from Richard J. Arndt's interview with Don McGregor.

2 "Ellison Sues Warren for Plagiarism," *The Comics Journal* #67, October 1981, 11.

3 Meth, *Comic Book Babylon*.

4 "Ellison Sues Warren," 12.

5 "Ellison Sues Warren," 12.

6 Groth's DuBay interview, 1998.

7 Richard J. Arndt, interview with Tim Moriarty, www.enjolrasworld.com. All quotations from Moriarty are from this interview.

8 Richard J. Arndt, interview with David Allikas, www.enjolrasworld.com. All quotations from Allikas are from this interview.

9 Paul Linden, "Ackerman Quits Famous Monsters," *Fangoria* #24, December 1982, 24–5. "Paul Linden" is a pseudonym for Ackerman.

10 Mark L. Sielski, "An Interview with Forrest J Ackerman," *Magick Theatre* #8, 1987, 14.

11 Linden, "Ackerman Quits Famous Monsters," 25.

12 Linden, "Ackerman Quits Famous Monsters," 27.

13 Randy Palmer, "The Last Daze of Famous Monsters, Part 2." The rest of the quotations from Randy Palmer in this chapter are from this article.

14 This "goodbye message" from Ackerman appeared, instead of in *FM*, in *Fangoria* #25.

15 Groth's DuBay interview, 1998.

16 Groth's DuBay interview, 1998.

17 Groth's DuBay interview, 1998.

18 Howard Wood, "Walking Off with Warren," *Comics Buyer's Guide* #516, October 3, 1983, 1.

19 Wood, "Walking Off with Warren," 1.

20 Duin and Richardson, *Comics Between the Panels,* 460.

21 Baumuller, "Most Famous Monster of All," 31.

22 Catron, raw interview transcript.

CHAPTER 17—Vanishing Act

1 Palmer, "The Last Daze of Famous Monsters, Part 2."

2 Groth's unpublished Gray Morrow interview, 1998.

3 Baumuller, "Most Famous Monster of All," 20.

4 Groth and Catron's Warren interview, 1998.

5 Email to the author from Roger Hill. Repeated efforts of Hill and the author to get in touch with Greg Theakston were unsuccessful.

6 Baumuller, "Most Famous Monster of All," 31.

7 Groth and Catron's Warren interview, 1998.

8 Swierczynski, "Jim Warren Meets Vampirella."

9 Roach and Cooke, *Warren Companion*, 17.

10 Baumuller, "Most Famous Monster of All," 31.

11 Swierczynski, "Jim Warren Meets Vampirella."

12 Groth and Catron's Warren interview, 1998.

CHAPTER 18—The Return of James Warren

1 Catron, raw interview transcript.

2 In 1991, Fantagraphics had published two issues of *Monsterama*, edited by Ackerman, which was essentially *Famous Monsters* under another name.

3 Baumuller, "Most Famous Monster of All," 30.

4 Michael Dean, "The Vampirella Wars," *The Comics Journal* #253, June 2003, 25.

5 Dean, "Vampirella Wars," 25.

6 Jon B. Cooke, "Warren Interview," *Comic Book Artist* #4, 1999, 14.

7 Baumuller, "Most Famous Monster of All," 4.

8 Baumuller, "Most Famous Monster of All," 20.

9 Roach and Cooke, *Warren Companion*, 191.

10 Shawna Gore, *The Creepy Archives*, Volume 3, "Back from the Dead" by Dan Braun and Craig Haffner, June 2009, 6.

11 Gore, *Creepy Archives*, 6.

12 Dennis Daniel, Jim Warren interview, *Famous Monsters Chronicles II* [Kindle book], 2016, 22.

13 Catron, raw interview transcript.

14 Catron, raw interview transcript.

15 Dennis Daniel, Warren interview, *Famous Monsters*, 24.

16 Archie Goodwin, "The Black-&-White World of Warren Publications" by Archie Goodwin, *Comic Book Artist* #4, 8.

INDEX

PHOTO BY ADAM HANEY

BILL SCHELLY has been chronicling and adding to the pop culture fringes since the mid-1960s. He became widely known in the comics community as the editor of the popular fanzine *Sense of Wonder*. After researching the history of comic book fandom in the early 1990s, he published *The Golden Age of Comic Fandom* (1995) which was nominated for the Will Eisner Comics Industry Award. His memoir *Sense of Wonder, My Life in Comic Fandom—The Whole Story* was released by North Atlantic Books in 2018.

James Warren, Empire of Monsters is Bill Schelly's seventh book from Fantagraphics. In order, the others are *Man of Rock, A Biography of Joe Kubert* (2008), *The Art of Joe Kubert* (2011), *Weird Horrors and Daring Adventures* (2012), *Black Light: The World of L. B. Cole* (2015), *Harvey Kurtzman, The Man Who Created Mad and Revolutionized Humor in America* (2015), and *John Stanley, Giving Life to Little Lulu* (2017). His Kurtzman biography received the Eisner Award for Best Comics-Related Book in 2016. Schelly's website is www.billschelly.net.